Bridge to Wonder

Bridge to Wonder

Art as a Gospel of Beauty

Cecilia González-Andrieu

BAYLOR UNIVERSITY PRESS

Cover Design by Pamela Poll
Cover Image: Alfredo González Cardentey (b. 1933, Cuba), La Catedral de mis sueños (The Cathedral I Dreamt), 1996. Used by permission.

Library of Congress Cataloging-in-Publication Data

González-Andrieu, Cecilia.
 Bridge to wonder : art as a gospel of beauty / Cecilia González-Andrieu.
 p. cm.
 Includes bibliographical references and index.
 ISBN 978-1-60258-351-1 (hardback : alk. paper)
 1. Christianity and the arts. I. Title.
 BR115.A8G66 2012
 261.5'7--dc23

 2011032294

BAYLOR
UNIVERSITY

Printed in the United States of America on acid-free paper with a minimum of 30% PCW recycled content.

For my most beloved husband and children, Jean-Paul, Elise, and Andrés.
And for my *familia* Alfredo, *el papi que es pintor,*
Hortensia, *la mami que es música,*
Isa, the sister who sings, and Maruchi, the sister who dances,
and for my brother Alfre, a gifted artist.
And in memory of those who are now in the company of the saints in
God's glory
abuela Lolita, *abuelo* Jesús,
abuelo Vicente, *abuela* Juanita,
pépé Yvon,
y Aida Rosa, *que tenía voz de angel.*
Con mucho cariño.

Contents

List of Illustrations

Figures

Color Plates

Acknowledgments y
Agradecimientos

The first person any author should thank is his or her reader, so thank you. I am grateful that you are entering this conversation with me, and I hope it will be fruitful and serve to prompt many insights. As you will read in more detail, my curiosity about experiences of beauty as communicative of the deepest religious insights began because there were many people who facilitated such experiences. For this, thanks go to my grandparents, my parents, and the members of my church community when I was a small child in Havana. I want especially to remember my pastor, Fr. Teodoro Becerril, who died shortly before I finished this manuscript. He encouraged the exploration and making of art as integral to the religious life of our faith community, and today I appreciate what an insightful and formative practice this was.

Coming closer to the present, I am also most grateful for the support of my studies. Beginning with my uncle, Javier Lanza, who helped me fund my elementary education when I only understood about five English words, all the way to the Graduate Theological Union (Berkeley), which helped fund my doctorate—a young displaced person who has no financial resources depends on such generosity. The initial research for this project was also supported by the Hispanic Theological Initiative in Princeton and their award-winning program to aid Latinas and Latinos completing doctoral studies. At HTI, I need to thank Joanne Rodríguez, Maria Kennedy, Angela

Schoepf, and editor Ulrike Guthrie, who painstakingly checked and encouraged early portions of my research. I also owe a debt of gratitude to my HTI mentor, Fr. Raúl Gomez-Ruíz, for his guidance and wisdom. At the Graduate Theological Union, I am indebted to a great many people who supported my doctoral work, especially Maureen Maloney, Kathleen Kook, Bonnie Hardwick, and Arthur Holder. My colleagues Jenny Patten, N. Frances Hioki, and John Handley are stimulating conversation partners and I very much look forward to our continued work together.

I am also grateful for my colleagues at Fuller Theological Seminary (Pasadena), most especially Catherine Barsotti, who read an early draft and passed it along to Robert K. Johnston and William Dyrness. It was Rob's gracious determination that created the bridge to Baylor University Press. He and Cathy are quite deserving of my most profound gratitude.

I was able to complete the book thanks to the generosity of Loyola Marymount University (Los Angeles) and the Bellarmine College of Liberal Arts, which provided me with a semester-long writing sabbatical and two fruitful writing retreats. I am especially grateful to those who have led the department of theological studies since my days there as a graduate student to my present position as a member of the faculty: Jeffrey Siker, Michael Horan, Fr. Thomas P. Rausch, S.J., and John Connolly—they are mentors, great colleagues, and friends. I am indebted to those in leadership at my college for their support, and I thank them, especially Paul Tiyambe Zeleza and Jeffrey Wilson. At LMU, I have been blessed with a constant stream of gifted and imaginative students. I am especially grateful to those who lent their work for this publication: Maggie Assad, Daniel García, and Camille Werstler. I am most proud of them. It has been crucial to the development of this work to be able to walk into the living laboratory of our classroom and learn together during our courses. I am always moved by the work of these young people during our end-of-the-semester art exhibitions and performances, and by the theologies they help us glimpse; there is undoubtedly a bit of each of my students sprinkled through these pages like stardust. Thank you, young theologians. Also at LMU, I want especially to thank Tony Alonso, Marty Roers, Cynthia Becht, and Tony Amodeo—musician, campus minister, head of special collections, and theology librarian, respectively, and all extraordinary practitioners of their specialties who so graciously and

generously collaborate with me. We are all blessed by your abundant talent and kindness.

My research assistant, graduate student Magalí del Bueno Riancho, helped me in the complex work of tracking down images and texts, and also became ever more intrigued with the possibilities presented by theological aesthetics for her own theological work. I hope this experience has inspired her; she will do great things for our *comunidad*. Magalí also joined the very able team at Baylor University Press in coordinating and keeping this work on track. My thanks go to Jenny Hunt, Diane Smith, Jordan Fannin, and the whole of Baylor University Press' dedicated staff. It has been a delight to work with such a supportive publisher and the best editor any writer could wish for, Carey Newman. Carey deserves several pages of repeated thanks from me in many languages. Whether from airplanes flying across the globe or from a makeshift desk at a library because his office had lost electric power, Carey has been a singularly inspirational colleague. This book really took shape as a result of our scribbled conversations over pages as we built a beautiful bridge between an Anglo American Protestant and a Roman Catholic Latina.

My initial interests in this area of study would never have taken root without the awakening of my imagination and the nurturing of questions from three extraordinary mentors. At the University of California, Berkeley, literary scholar Dru Dougherty's expertise and affinity with early twentieth-century Spanish literature and especially with Federico García Lorca helped me immensely. It was my desire to appreciate Lorca's works more fully as theology that led to my first questions surrounding the building of bridges between the arts and the religious. Dru's insights, which often revealed a keen theological understanding, did much to convince me of the fruitfulness of interlacing the artistic and the theological. He was a model of grace, scholarship, and warmth, and I hope to continue what we began on a future volume dedicated to García Lorca's theology.

Across the street at the Graduate Theological Union, it was Doug Adams (1945–2007), Professor of Christianity and the Arts, who encouraged and prodded me. Doug showed me the difference between a print of a Rembrandt etching and the real thing, which took my breath away. As he began each semester by throwing syllabi in the air, and as he lived every single moment dearly in love with the entire world, Doug Adams was a living example to generations of

students of what can happen when Christianity and the arts are really woven together.

Before paying tribute to my final mentor, I want to mention the artists who fill me with appreciative wonder. It was an honor to be able to study with legendary art and religion scholar Jane Dillenberger, whose Berkeley home—filled with original works from friends like Barnett Newman and Stephen De Staebler—taught me that a scholar must cultivate personal relationships with artists. Thus, I am grateful for conversations around canvases and paint, in prayer and in community, with Fr. Arthur Poulin, Mel Ahlborn, and Sasha Zorin. Their view of the world is enchanting and I look forward to spending more time with their art. I am also grateful for the poets, especially my longtime friend Frank Desiderio—you *do* what I can only speak about. I have been blessed to witness firsthand and deeply admire the work and grace of playwright Luis Valdéz; it is extremely helpful to know the artist and the community behind the art as we notice the religious utterances that works disclose. My thanks go to the team at El Teatro Campesino and Louisa Muñoz for their help.

Most of all I am indebted to three artists: one an established master, one a young and emerging phenomenon, and the third, my beloved father. John August Swanson's luminous art must be appreciated in person; he is truly a great master whose faith and kindness is as overflowing as his talent. I have spent much blissful time enthralled by the profusion of images at his nearby studio. His generosity with my students is like his love of planting gardens—it will all bear much fruit. The complex, talented, and committed Sergio Gomez, thirty years his junior, is strikingly similar to Swanson. Both make art because they want to help build the reign of God, and both are motivated by their unwavering faith and commitment to justice. After being deeply intrigued by their many-layered works, it is an honor today to call them my friends. Finally, there is my *papá*, who in his honesty has taught me about the suffering behind the beauty on a canvas, and about tenacity and faith-filled hope. He encouraged me every bit of the way during my work on this book. My choice of his painting, *The Cathedral I Dreamt*, for the cover was most natural, as it encapsulates in the gracefulness of one image what I hope this book may say in the more labored form of scholarship.

I said earlier that I had three extraordinary mentors, and thus, alongside Dru Dougherty and Doug Adams, stands the one who told

me, "You need to do this work of theological aesthetics," and whose early death has left a void in the world—Alejandro García-Rivera (1951–2010). I can still hear Alex's gentle voice, and have not yet come to accept completely that I will not hear it again on this side of Paradise. Although he was not able to read this manuscript (and thus mistakes are entirely mine), his mentorship and guidance helped me fall in love with the work of theological aesthetics. Alex's legacy will be continued and celebrated by those of us who were blessed to be taught by him and to be his friends. He was an extraordinary scholar and a man of faith. Alex, here it is. *Por fin lo terminé con la ayuda de Dios.*

Cecilia González-Andrieu
Loyola Marymount University
Los Angeles, California

1

Introduction

*E*ven though his works are part of art collections from the Vatican to the Smithsonian, John August Swanson (American, b. 1938) routinely admits to feeling like an amateur, even after four decades as an artist.[1] In one of his early works, the beautifully rendered visual story *Inventor* (1975, Plate 1.1), he summarizes the work of the artist and the humility he feels every time he works. The eight panels present an artist, as the newspaper headline announces, who claims to have invented a machine that transforms junk into beauty. Juxtaposed between this claim and the last panel, Swanson presents the young inventor working and draws the beauty that emerges as swirling colors, spheres, concentric circles, and stars. The last panel reports, this time through an old radio, that "an amateur is someone who doesn't know something can't be done, so he does it." My students, who have often had the blessing of interviewing Swanson in our class, are routinely mesmerized by this work and by the honesty of Swanson's humility.[2] In *Inventor* as well as in his disarming encounter with them, Swanson calls into question the image of artists as geniuses and of art as an elite pursuit. As he speaks with them from his heart, he makes visible what philosopher John Dewey contends is "inherent in the work of an artist, the necessity of sincerity; the necessity that he shall not fake or compromise."[3] The wonder my students experience at the beauty of Swanson's art and the

fruitfulness of his commitment to sincerity are two guiding principles for me as I undertake this work.

My interest in the relationship of the artistic and the religious can be traced to repeated experiences with art (both self-consciously religious and not so much) during my childhood. I recall being asked as a young adult to search out my first awareness of Jesus Christ. As I pondered the question, it was a large mural or painting (I am unsure which) that immediately flooded my memory. I was very young, probably about six years old, and although the sermons preached at my parish of Nuestra Señora del Carmen in La Habana were often beyond my reach, the art was not. I frequently sat, rapturously contemplating this large image showing Jesus on the cross, flanked by the two thieves under a furiously dark and stormy sky. It was an image of Calvary not for the squeamish, and yet even to a child, it was incongruously beautiful. I also discerned a difference between the way I entered that work, forgetting everything around me, and the kind of interest I felt in following the labyrinthine lines of one of my father's few experiments with abstract painting.[4] Calvary had a profound relationship with me, while the abstract lines simply invited me to play. One haunted me, the other was fun . . . but forgettable.

But it was not only pictorial art that engrossed me. In Communist-ruled Cuba electricity was scarce, and many evenings were spent mainly in the dark as the government imposed "energy-saving" blackouts on the centuries-old colonial city. Again, quite paradoxically, these times were filled with creativity. Neighbors often shared porches and conversations, depending on the starlight, the moon, and each other to dispel the physical and emotional gloom, and children found ways to create shadow puppet theaters with a single candle, an old sheet, and many funny voices. We were well past the midpoint of the twentieth century, yet we often lived in a medieval world.

One of my favorite survival strategies during those nights without electricity was to play the piano or listen to my mother play.[5] Not needing light to play, fingers nimbly searched out the keys and beautiful sounds filled the night, wafting through the tall open windows. All seemed right then, even in the midst of the chaos and hunger that was life in La Habana. On afternoons, returning home from school under a dictatorship that attempted to control our every thought, I would do my homework in the room closest to the living room. There I could listen as my grandmother's gifted students practiced

vocal scales and finished by singing stunning arias.[6] I fell madly in love with opera then, a love that today comfortably snuggles up intimately with Gregorian chant, Afro Cuban music, and American jazz. Back in our art-filled church, the creative and inventive community found ways to put on many plays, and also to recreate (behind the safety of the fortress-like parish walls, because public displays of religion were outlawed) rituals and stories from more beautiful times. In the church basement, yellowing and threadbare robes were washed and pressed by loving mothers so little children could be *angelitos* in May singing praises to Mary, or in December exuberantly announcing the birth of the Savior.

After leaving Cuba for the United States, I have often pondered the relationship between those experiences of beauty in community and the profound longing that their tragic loss evoked. What I most missed, as many others forced to leave their homes have recounted, was indeed the beauty that insisted on appearing in the most unlikely places. Transplanted to a land lacking one's cultural markers and the familiarity of those relationships, it is the gift of spaces in which to recover and rebuild these markers and relationships that brings comfort. The power of our symbols becomes heightened when these are denied to us. I could relate to our forebears in exile, who wrote in their agonized song,

> By the rivers of Babylon—
> there we sat down and there we wept
> when we remembered Zion.
> On the willows there
> we hung up our harps.
> For there our captors
> asked us for songs,
> and our tormentors asked for mirth, saying,
> "Sing us one of the songs of Zion!"
>
> How could we sing the LORD's song
> in a foreign land? (Ps 137:1-4)

Eventually, it was precisely learning to sing the Lord's songs in a foreign land that returned to me a sense of home. Here was the power of shared symbol. As a displaced refugee, I finally felt loved and welcomed as I sang and prayed inside the beautiful church space of Sacred Heart Chapel at Loyola Marymount University.[7] On many afternoons in my

late teens, I sat in the church as the sunset set the stained glass windows aflame, outlining in iridescent light the solitary figure of Christ on the cross over the main altar. This Christ is very alone, and his aloneness moves me exceedingly to this day. Just behind the altar and hidden by the large wooden screen is the apse, which in those days included a series of small radiating altars surmounted by magnificent stained-glass windows.[8] Here, the student choristers would wait together for our turn to sing for the university's choral concerts. It was here, not as I sang, but as I listened behind the screen to the men's chorus sing, that my heart was filled with an indescribable peace as I recognized our common song of praise and prayer, our shared cosmic music. The land stopped being "foreign" because the music united heaven and earth and all separations (at least momentarily) ceased.

I have never returned to Cuba, and I am often asked why. Beyond the obvious answers of the ongoing political turmoil, my parents' fears that something might happen to me, and my stance against doing anything that would prop up regimes that abuse the God-given dignity of other human beings, there is a deeper reason, and that reason is beauty. Memory, when attuned to beauty, can be an abundant and lasting gift. It can hold before us the tiny face of our child when she first looked at us, or the sound of our grandmother's gentle voice telling bedtime stories. In my case, my memory holds in all its fragility the beauty of that land where I was born and first became aware of God's constant and loving companionship. Today, much of La Habana of my parents' day is just rubble, destroyed under the weight of totalitarian cruelty and geopolitical forces that have looked the other way. And I know that if I were to see it, to walk down its streets again, the beautiful city that has taken refuge in my memory would be gone forever, shattered like a rock smashes the image in a beloved stained-glass window. I hope to return someday, I pray to do so, but grieving for the loss of the city's and my community's beauty would only make sense if my return would help someone, help rebuild. Beauty would then find a new luminescent home in the many of us who would lovingly restore dilapidated walls, feed hungry children, shine the bright light of dignity and education, and more importantly love the land and its people back into being. Beauty transcends destruction, as Christ on the cross unflinchingly shows us, and shines most brightly in resurrection.

This, then, is the life that sets the contours of my theological questions. Such questions arise from this tapestry woven by the power

of beauty to reveal, lift, move, sustain, and transform, and from my solidarity with persons on the margins who long to feel at home and who have stories to tell.[9] Since my early teens I have lived in Los Angeles, a land of deep Spanish Mexican roots that are uncomfortably juxtaposed against Hollywood's troubling artificiality and sunk into many layers of ethnic and financial exclusion. Yet, Los Angeles can also be a land of awe-inspiring diversity, like a field of exceptional wildflowers that share a small space of earth, brimming in the colors of many languages, foods, and rituals. Here, I first discovered Shakespeare and the wonders of the English language, Japanese food, Gospel and Arab music, and the ongoing feasts of Mexican trios. In my early thirties, and after growing up in L.A. always aware of my "otherness," I recall one memorable sunny afternoon when, as I participated with a praying community in a liturgy where an image of Our Lady of Guadalupe was carried in procession, the tears in my eyes told me I was no longer "other." I was grafted by love into this Mexican American community because I loved her too. I know that if we can begin to share each other's songs, images, and memories, we can connect to each other and to that ineffable One who makes us family by loving us all without distinction, the One that poet Federico García Lorca calls "Love liberated from time."[10]

A central image of Christianity is derived from St. Paul and his insistence on the difference *and* unity of the many parts (Christians) that make up the Body of Christ (1 Cor 12:12-14). This is an image that finds resonance in creative works and the perplexing alchemy that unites notes into song, speech into drama, and minerals into shape. This appreciation of the multiplicity and variety of gifts and of callings also gives hope to those who strive to contribute to the building of the reign of God, even as they stand outside the centers of power.

Yet, such radical difference as that between an ear and an eye (1 Cor 12:16) seems insurmountable at times, and we long for the stable feeling of homogeneity.[11] How does an ear know what seeing is, or an eye know about hearing? The work of speaking across disciplines (in my case chiefly the arts and theology with all their tributary disciplines) can sometimes feel impossible or at least unstable. Different modes of argumentation, which are not propositional but unfold as experiences, are sometimes necessary. Similarly, given its subject, language that could be terse and sparse often flowers into poetry.[12]

The work of interdisciplinarity and interculturality is in many ways quite new, replacing universalizing tendencies with self-consciously transparent particularity that speaks from its location yet insistently seeks the other. Consequently, the book you are holding or perhaps reading on a glowing screen (something the previous generation of theologians could not have imagined) may be unusual in the strands that make it up and the way in which I invite us to interlace these together.[13] I ask for your patience and companionship as strands of theology wind around strands of art, as threads of U.S. Hispanicity (itself a complex mixture) encounter the otherness of London or of Paris at another time. At times my view will benefit from my belonging to a community and at others my radical distance will also be acknowledged. To borrow a thought from theologian Roberto Goizueta, when we choose to walk with those who are other to us, those experiences force us "to be honest about reality by forcing us to recognize the intrinsically relational, or communal character of all human persons and human action."[14] Our potential for unity is most realized when we become aware that this is a difficult and challenging task.

This book, then, is an invitation to join me in discovering ways we can initiate new and fruitful encounters by cultivating our ability to engage works of human creativity, most often represented in what we call the "arts." These works are a way to know one another through our questions and our experiences as we search and sometimes indeed beautifully find the shimmering glow of the presence of God.

Because scintillating starlight and an expressive world are certainly not exclusive to Cuba or to childhood, I have tried to recognize these qualities wherever I meet them. During graduate school, the bounty of kindness allowed my little family and I to share the home of a retired lady, which overlooked another bay over two thousand miles from the bay of Havana. There, the ocean shimmered—sometimes with a blinding sunlight and at other times with furious white-caps—and just at the edge of the bay, apparently linking together the whole world, was the Golden Gate Bridge (Plate 1.3). From our home in Berkeley, we watched as the passing of the year and the earth's tilt became playfully apparent in the always changing position of the setting sun in relation to the bridge. From this high vantage point, we watched the bay often completely shrouded in a diaphanous fog, while above it a bright silver moon shone brightly. Looking

out toward the bridge, I often marveled at the seamless collaboration between the natural world, with its cliffs and craggy rocks flanking the sea, and human ingenuity, as the orange-red bridge completed the scene. It is difficult to imagine San Francisco Bay without the Golden Gate Bridge: it seems like it was always meant to be there. Nature and human have worked together, and this collaboration is truly a monumental work of art.

So let me suggest the Golden Gate Bridge as a metaphor for this book. Our destination may be somewhere on the far side of an occasionally stormy and invariably windy bay, but what I hope we can do as we move toward it is to notice the bridge itself. As we imagine the furiously windy bay, we must also imagine that the Golden Gate Bridge has not been built . . . yet. It is exhilarating to visualize building it, but in order to build and then to experience a passage, we clearly need to want to do it. So we need a reason for wanting to cross. The very storminess of the bay dissuades us, and we wonder if there could really be anything worth seeing over there. Maybe we should just turn around and ignore this bay and what lies beyond it. This is not an idle temptation; we live in a time when our grip on "reality" and on what matters about our existence seems to be fading, as the "virtual" world envelops us and provides a buffer between us and what earlier generations would have understood as real suffering and also as very real joy. We busy ourselves with cell phones and iPads and strange plastic Blackberrys (which, unlike the real version, do not taste very good). Perhaps we busy ourselves precisely because we do not want to look past ourselves, toward what is other and therefore what may ask something of us.

Yet, somewhat inexplicably, hundreds of people walk, drive, and bicycle across the Golden Gate Bridge everyday—not because they want to get to the other side, but because the experience is so beautiful. The revelatory and transforming beauty of the suspended bridge and its impossibly precarious dance above the waters beckons us. After all, there are other ways to get to the other side of San Francisco Bay. There are ferries, and there is the long way around through land; these also get us there, eventually, but nothing is like the bridge. Ask anyone who has crossed it, the bridge is magical.

So this book is about art.

The Golden Gate Bridge is made up of art in its architecture, in its service, and most importantly, by the very way it completes a natural

landscape by introducing the creativity of human persons into the vast expanse of what appears as a separation between what is here and what is there. However, in the process of connecting here and there by means of human creativity, you might encounter some unexpected turns on your building project and excursion. There might even be some opposition. For instance, you will meet Plato, who thinks that what matters are ideas (and ways to control society), and who wants as a result to get rid of the poets. And you may run into some moderns, who think that religion is nonsense and insist that art has nothing to do with faith, even when it is art for the Church. You may also catch a glimpse of some empiricists, who cannot find a way to stick either religious faith or art into test tubes, and who therefore think that all creative works are just infantile illusions. Perhaps you will notice a group of drab utilitarians, who can see no use for either talk of God or art, and who profess that a gray, mechanistic universe is just fine with them (unless they actually had to live in one). You and I may also run into some outrageously dressed artists who want sole credit for being geniuses (which of course swells their wallets), and insist that art has nothing to do with life or religious questions (they might have to develop a social conscience if it did). We may also expect to encounter groups of avowedly religious people who are suspicious of embodiment, sensuality, and the affections awakened by art, and instead much prefer to burn books and put loincloths on the figures in the Sistine Chapel. And clinging to the railings we may find some disconcerted theologians who, used to looking for religious utterances in a small, circumscribed space, get vertigo thinking that so many varied communities can really be talking about God and in so many places. Finally, you will certainly see some fundamentalists waving you away from art and its ambiguity, warning that it is too dangerous to have something say so many things at once, you will get confused, turn back now.

But there is a timeless artfulness to bridges and to crossing them with helpful companions, and so you will also meet friends such as Aristotle, who, unlike his teacher Plato, thinks weeping with abandon at a play is actually good for you. You will marvel at the artists who dare to ask questions in art that no one wants to ask in church, and at the scientists who test the plausibility of theories by their beauty and who are routinely surprised by the beautiful intricacy of a spider web. On the bridge you will become aware of countless artists who never

signed their names to the works they bequeathed to us in prehistoric caves, medieval churches, and enduring hymns, and you will rejoice in the communities who created art together and then gave it away. You will also be intrigued by great and thoughtful theologians who see in creativity concrete expressions of some of the most profound Christian doctrines. They walk hand in hand with religious people, contemplatives, and activists, who have understood embodiment as a gift and whose poetry, music, plays, buildings, and paintings all speak appreciatively of the incarnated quality of human life.

Theologians before the modern period were boldly unafraid of the aesthetic and understood its value. Beginning in the Hebrew Scriptures, they also used the symbolic, analogical, and sensorial to express paradoxically their understanding of the relationship between the human person and the wholly other God. Today, as we attempt bridge-building and crossing, recovering these qualities can help us fend off the winds of "isms" swirling violently about, which try to make us flee into the simplicity and safety of fundamentalism, literalism, reductionism, essentialism, and propaganda.

Building bridges is hard work. As one very wise religious woman told me once about the life of being a Hispanic American in the United States, "You know what happens to bridges—they get walked on." Of course this refers to the difficulty of the task of connecting, but in another way we can see its Christlike posture. As St. John of Damascus, one of the very first defenders of images and thus of art, famously wrote in the eighth century, "The kingdom of heaven does not consist of words, but of deeds."[15]

2

This Book Is Not about Art

*T*o say this book is not about art is to imply that it is about something else, and one way to begin exploring this something else is to examine first the *work* of art. By this, clearly, I do not mean an artwork, but rather the work—the "tasks"—that art accomplishes. In an analogy of a bridge, an initial task might be articulated as the work of making possible the crossing of vast expanses. The question then turns on what to cross and the means to cross it.

Almost at the end of the second millennium of Christianity, theologian Avery Dulles noted a worrisome problem: the Christian church was caught in a circularity that threatened the dynamism of theological thought and the relevance of Christian practice. Dulles warned that the church had been lulled into taking for granted "the existence and content of revelation" and assuming that the job of "convincing the unconvinced" was simply and essentially to affirm official Church teaching.[1]

Despite the repeated earthquakes caused by reformers, both Protestant and Catholic, the very foundation of the edifice of the Christian church—that God reveals God's self to humanity—remained largely unexamined.[2] "How does the Church itself find out what revelation is?" asked Dulles pointedly.[3] His questions, although articulated as a problem of method, reveal his concern that apologetic and dogmatic approaches had sidestepped the question of the existence of revelation

itself, since "theological method generally presupposes a doctrine of revelation and uses revelation as a norm."[4] In other words, how could theologians speak of *what* was understood to be revealed without first attempting to show that *it had been* revealed? Can we tell others about what we have heard, if they do not know anything about the experience of hearing? From a lesser theologian the question might have appeared impertinent or even schismatic, but from the future Cardinal Dulles it was prescient and important.[5]

To answer his question, Dulles looked carefully at symptoms of the age's malaise, which had been compounded by the church's failure to deal openly and creatively with the problems posed by the idea of revelation. Philosophical agnosticism, he noted, reduced what the church called revelation to an insubstantial mix of myth and metaphor developed by human persons to speak of a God that could not be known.[6] Linguistic analysis also had great difficulty assigning authoritative weight to language about God, due to the discipline's methodological inability to grapple with paradox and symbol.[7] Theories of knowing that grew out of modernity—which stressed the limits of human knowledge and understandably questioned ideas of revelation when it was expressed as a "transfusion from the divine mind"—needed to be addressed, not ignored.[8] Dulles also took seriously the difficulties arising out of empirical psychology while pointing out the reductionism of the most extreme positions that assigned psychiatric explanations to all revelatory experiences recounted by mystics both ancient and modern.[9] Additionally, he noted that even biblical criticism and doctrinal pronouncements (coming as they often did from opposite poles of the theological spectrum), by focusing on the lack of historical reliability of biblical texts, reduced their reception as revelation to a choice between a critical dismissal on the one hand, and an uncritical and naive piety on the other.[10]

Venturing even further, Dulles found that well-meaning attempts at the work of comparative religion were routinely unable to deal with the apparent plurality of revelation and thus unwittingly reduced all talk of divine revelation to "human attempts to probe the depths of truth and goodness."[11] If the parameters were such that they could recognize no possibility of diversity in divine revelation, then all revelation was dismissed. Finally, as Dulles saw it, the growing influence of the social sciences stressed the well-founded suspicion that, often, "appeal[s] to divine authority can be a hidden way of obtaining

conformity and of suppressing doubt and dissent."[12] The result was that the existence of something that could be called divine revelation was anything but a foregone conclusion. Without revelation, theology would have nothing to speak about, since one way to describe theology's task is precisely as that of pondering critically humanity's reception of and response to revelation.[13]

The Problem of Revelation

Through the symptoms then, Dulles identified the problem. Historically, the major issues dividing the Church internally as well as the Church and the world externally had centered on *how* to interpret revelation, all the while taking for granted that revelation existed and that it could be fought over and debated. The contemporary question had shifted dramatically, and Dulles saw it. He articulated it guardedly, as we have already seen: "How does the Church itself find out what revelation is?"[14] But the question implies a much deeper and more startling abyss, as the prolific and outspoken theologian Richard McBrien put it, candidly, "How would we know there *is* a God unless God were somehow available to us? And how can God be available to us except through the created order?"[15] Clearly, then, as we attend to the question of the existence of revelation we can recognize the more familiar and universal question of humanity: "Is there a God?" The chasm that Dulles identified was gaping and perilous because it was not about theological method at all. The chasm was about the very existence of God.

The answer to the question of the existence of God for me, as a Christian theologian, is an unqualified "yes." But what is clear is that we need new ways to answer "yes" that move beyond simple apologetics and do not rely just on the biblical witness, since this witness is itself part of revelation. One solution, Dulles suggests, is to embrace the depth and power of "the revelatory symbol."[16] Our desire to find and our ability to interact with revelatory symbols is one way to provide a positive answer to the question about the existence of God, and also to cultivate an experience that will effectively and affectively continue to activate this answer in the human person.[17]

Careful parsing of Dulles' proposal for a theology of revelation becomes even more fruitful as he surprisingly turns *to artists* for help. Dulles looked beyond the customary boundaries of theological reflection for a theological category that would break through the

objections articulated by contemporary critical thought. He turned
to artists because they expressed experiences of revelation beyond the
confines of traditional theological categories. If an assertion about
the very real nature of revelation could not be made from inside the
tradition, perhaps it could come from outside of it.[18]

Dulles found an ally in Samuel Taylor Coleridge (British, 1772–
1834), who Dulles quotes briefly as saying, "It is by Symbols alone
that we can acquire intellectual knowledge of the Divine."[19] The
Divine was known to artists like Coleridge, and this knowledge was
symbolically mediated and had intellectual content. Coleridge's state-
ment is both simple and ambiguous; he does not locate revelation
in any one particular source or religious tradition, referring only to
the mysterious human encounter with the Divine. But it was in the
second poet Dulles queried that he found the important answer to
the question of the *how* of revelation. The insight is made even more
profound by looking at the astounding trio of artists who indirectly
contributed to it.

The concept of symbolic revelation, which forms the foundation
of Dulles' theology of revelation, was suggested to him by a com-
ment from William Butler Yeats on the art that William Blake made
to visually interpret Dante's *Divine Comedy*.[20] Yeats (Irish, 1865–1939)
was an Anglican, Blake (British, 1757–1827) was a profoundly unorth-
odox Anglican, and Dante Alighieri (Italian, 1265–1321) was a Catho-
lic. It is perhaps the unlikely interlacing of these three artists and the
communities and religious traditions they represent (or in some cases
confront) that makes Yeats' proposal so affecting to the late twentieth-
century Dulles. "A symbol," writes Yeats, "is indeed the only pos-
sible expression of some invisible essence, a transparent lamp about a
spiritual flame."[21] To this Dulles adds that a symbol is "an externally
perceived sign that works mysteriously on the human consciousness so
as to suggest more than it can clearly describe or define."[22]

Thus we might deduce two significant proposals here. First, that
artists through the creation or extension of symbols witness to the
existence of and participate actively in the work of mediating revela-
tion. And second, that it is the mysterious task of symbols to convey
humanity toward revelatory moments. Artists attest to the actual-
ity of revelation through their participation in symbol-making, and
they do so in our world. The desperate chasm of a void without God
is routinely crossed and conquered by those who like Coleridge, Yeats,

Blake, and Dante are, in the words of the poet Federico García Lorca, "wounded wrist[s] probing the things of the other side."[23] One of the tasks of art is to create bridges to revelatory wonder through works of art.[24] As Dulles clarifies, "Revelatory symbols are those which express and mediate God's self-communication."[25]

Of course Dulles' use of the term "revelatory symbol" goes much beyond what we routinely understand as art. This is a helpful corrective, since it makes evident that the modern idea of art is unproductively narrow. If we take seriously the category of revelatory symbols, then this necessitates an expansion of what we consider "art" to include a much wider range of aesthetic experience and creative making. Indeed, many contemporary efforts point to this same yearning.[26]

After Dulles, two key figures for Catholic Christians added significant nuances to an exploration of the revelatory power of art. In his *Letter to Artists* (1999), Pope John Paul II eloquently highlights the role of artists in mediating the image of God as Creator to the human community. Through our experience of artists and their relationship to their creative works, we come to know "something of the pathos with which God at the dawn of creation looked upon the work of his hands." Contrasting Creator (God) with craftsman (artist), the pontiff describes how the artist is involved in a process of giving "form and meaning" to the bountiful elements given to humanity by the one Creator. It is in the work of creating that the human person, made in the image of the Creator, is most faithfully living out the promise inherent in "the visible world as a vast field in which human inventiveness might assert itself."[27]

In John Paul II's understanding, the "spark" of God's "surpassing wisdom" is given to the artist as a way to "share in [God's] creative power."[28] This is a stunning image that grants artists a privileged place in relation to perceiving and relating to God's communicative voice similar to that reserved for the prophets.[29] The pope thus argues that artists must come to discern their role within the human community as one that is a "vocation" and a "mission."[30] The idea that "beauty saves" because it is "the visible form of the good" gives artists the "obligation" to put their talent at the service of communicating and evoking such beauty for "humanity as a whole."[31] While he acknowledges the limits artists face and cautions against idolatrous practices that would reduce God to visible beauty, the pope proposes that what is happening in artistic intuition "goes beyond what the senses

perceive and, reaching beneath reality's surface, strives to interpret its hidden mystery."[32]

John Paul II's successor, Pope Benedict XVI, delivered an address three years later, while still Cardinal Joseph Ratzinger, in which he expanded on the question of the saving power of beauty. Here, the future pope untangles the paradox presented by Scripture through its proclamation of Jesus Christ as the "fairest of the children of men" alongside Isaiah's haunting image of the one who had no beauty, and who was utterly wretched and despised (Isaiah 53:2). This juxtaposition, which he sees as a "contrast and not contradiction" forces a radical redefining of what beauty is. Just as John Paul II emphasizes beauty as the way to make the good visible, so Ratzinger stresses beauty as truth. Ratzinger argues that the Christ paradox allows us to understand that as truth beauty "also embraces offence, pain, and even the dark mystery of death . . . found in accepting suffering, not in ignoring it."[33] As the truth of Christ redefines what beauty is, Ratzinger adds that such beauty "wounds," and in this way calls the human person "to his final destiny."[34]

As he speaks of the work of the artist, Ratzinger also highlights the need for the one involved in creative making to "acquire a new and deeper capacity to see, to perform the passage from what is merely external to the profundity of reality."[35] What is more, he stresses the quality of knowing imparted through experiences of the beautiful as a superior type of knowledge, quoting the Byzantine theologian Nicholas Cabasilas (1320–1390) that the experience of the beautiful "is knowing that causes love and gives birth to it."[36] Furthermore, for the future pope, experiences of the truly beautiful must happen in our world and are not the exclusive domain of the world to come. As he recounts his own rapturous response as he listened to a Bach cantata conducted by Leonard Bernstein he adds, "the music had such an extraordinary force of reality that we realized, no longer by deduction, but by the impact on our hearts, that it could not have originated from nothingness, but could only have come to be through the power of the Truth that became real in the composer's inspiration."[37]

Ratzinger does not use the term "revelation," but his description leaves little doubt about the power, depth, and, most centrally, truth of the knowing imparted through his experience of Bach's music. He tells his companion at the concert, "Anyone who has heard this, knows that the faith is true."[38] John Paul II, for his part, recognizes

a "special bond between art and Christian revelation," insisting that "Christianity offers artists a horizon especially rich with inspiration."[39] In his letter, the pope draws an unmistakably direct line from creative works to their revelatory power as he asserts that "the creation awaits the revelation of the children of God also through art and in art." He insists that to make this possible is the "task" of artists, as humanity "looks to works of art to shed light upon its path and its destiny."[40]

It Is Not Either/Or

Looking at the work that art accomplishes by mediating revelatory experiences expands the boundaries of what we might consider art, and also calls into question other artificial boundaries and oppositions. The hesitation of contemporary critical theories and theologies to accept *a priori* totalizing assumptions and meta-narratives is in many ways a salutary development, and one we can see reflected in the modern challenges to the idea of revelation catalogued by Dulles.[41] Perhaps we are searching for ways to unite a sense of ourselves as embodied while also spiritual by resisting a dualistic view of reality that separates "this-worldliness" from "other-worldliness." In his proposal of the revelatory symbol Dulles opens the possibility of reuniting the two.[42]

The problem of dualistic thinking is not new to our time, but can be seen lurking in the depths of many philosophies and societies. Dualistic thinking can favor the material or the spiritual, the body or the mind, the seen or the unseen, but its one defining characteristic is separation. As theologian and physicist Alejandro García-Rivera notes in his elaboration of a holistic cosmology, we have inherited theologies based on Plato's separated worlds of the "invisible, eternal, permanent archetypes of ultimate reality" and the "changeable, visible, sensible copies of these."[43] He also notes how such separation between the "realm of eternal being, heaven, and the phenomenal world of death, earth" had "disastrous results to a proper understanding of Christ's redeeming message."[44] That message, the theologian explains, is that "Christ is now reconciling heaven and earth taking the cosmos to a redeeming end that, ultimately, is a place, a place where every tear shall be wiped away."[45] Christ is about the renewed relationship of all to all, and in Christ's redemption the very idea of separation is vanquished.

Working Art

We have identified two tasks then where art can be helpful to the work of theology. The first is in its role as witness and producer of revelatory symbols, which speak eloquently of the veracity of a communicating mutuality with the Divine. In the creativity of art as making and of art as experienced, we can be brought face to face with an undeniable otherness, that which Yeats calls "a spiritual flame." But the very materiality of creative works—the fact that they occur in our world, and that they are sometimes carefully crafted by us as "transparent lamps"— should help us overcome the reduction of our experience of God as purely "other-worldly" that contemporary thought has rightly come to question. The idea of a "supernatural" that is revealed should not devolve into an inaccessible, holy "there" juxtaposed against a sensible, profane "here," but rather into the felt understanding of "life abundant . . . gifted givenness . . . graced nature."[46] Such abundant life is not dualistic but "embodied . . . it has shape and spirit, story and openness, structure and dynamism, matter and life."[47]

Dualisms always posit either/or questions, as Dulles' survey of modernity's objections clearly shows. In the objections Dulles investigated, we note the privileging of a type of reason that attaches cognitive value only to what is literally verifiable, and the way it is pitted against any possible value in myth and metaphor.[48] Related to this is the predilection for precise propositional language, which also refuses to grant cognitive content to what is paradoxical or symbolic.[49] Finally, human knowing is exclusively understood "as a product of the knower's own powers," which, in seeing the human cognitive process as exclusively subjective, severs any communicative density or relationship beyond the human self.[50] A consequence of this permanent separation between the human person and the Divine Other is the reduction of what we might call mystical or revelatory experiences to the subject's own "pathological states of mind."[51]

If we assert that revelatory symbols unite spirit and matter, then we might expect great resistance to this possibility from systems of thought that are essentialist and dualistic. The dualisms that split spirit from matter have a long history in Western thought, and they crept into the Christian tradition, taking on different language (i.e., nature versus grace) and forms.[52] We may note that the most seminal thinker of Western civilization, Plato, introduced dualistic thinking while

at the same time mounting an all-out war on artists and the arts. In looking at Plato we note the correlation between his mind/body dualism, repudiation of the arts, and tendency toward totalitarianism.[53] In the dialogues, and most centrally in *The Republic*, Plato has his fictionally artistic construction of Socrates (something I find quite amusing) lead a long and carefully constructed attack against artists, chiefly the poets but also painters.[54] In this impassioned argument his principal target is "the imitator or maker of the image [who] knows nothing of true existence; he knows appearances only."[55]

Looking at Plato's quarrel with the arts, we can sense that the real question for him is knowledge and the real issue is truth. We are told that Plato placed over the door of the academy an inscription: "Let no one enter who is ignorant of mathematics."[56] This may help us discern three possible objections to the possibility of revelatory symbols and thus to the saving work of the arts. First, mathematics uses ciphers or indicative signs "which lack intrinsic interest. We interpret them as mere observers without being deeply moved by the signs themselves."[57] As such, mathematical signs have no materiality of their own but are clearly only referents for abstract ideas. Because of this, in deciphering mathematics we become self-consciously aware of our own powers of reasoning. The prodigious workings of our mind take center stage. Finally, mathematical signs depend on the stability and univocity of what they signify. In this rests their predictability and repeatability.

By juxtaposing Plato's banishment of artists with his preference for mathematics we can make some deductions about the possibility of revelatory power inherent in the arts. Plato's distrust may tell us that the arts reveal by involving us deeply as more than mere observers;[58] that they confound and complicate things so that our mind has to relinquish its illusions of power and control;[59] that they are embodied and attest to our embodiment;[60] and finally that they are "polysemic," always suggesting more than can be clearly stated.[61] Because of all this the arts have the potential to confront and undo dogmatism, fundamentalism, and totalitarianism.

We could argue that Plato's adamant opposition to the arts is a clear result of his vertical view of reality and the separation he posits between the "intelligible world," comprising at its highest point "the Good," "the Forms," and "Mathematical Objects," and what lies on the other side of the dividing line—"the visible world." In this lower part of the hierarchy, "Visible things" are included, and "Images"

constitute the very bottom. Thus, Plato can say, "Now you may take, as corresponding to the four sections, these four states of mind: intelligence for the highest, thinking for the second, belief for the third and for the last imagining."[62] What precisely it is that Plato is describing has its own ambiguity. Some recent interpretations present Plato's description horizontally, so that although it is clear that the type of knowledge available in the physical world is more limited (conjecture and belief belong to the realm of opinion, as opposed to understanding and the exercise of reason, which are identified as knowledge), there remains what appears to be a multiplicity of approaches to knowing and to what is true.[63] This does not seem to square with the text. By contrast, in the earlier vertical interpretation, it is clear that "Images" lie at the very bottom of Plato's schema and are quite distant from "the Intelligible World" and thus from "the Good."[64]

Plato's vehement condemnation of poetry rests on two premises: that the visible world is a mere shadow; and that what artists do, by "imitating" what is itself only a copy, is essentially to be deceived and to deceive.[65] Because Plato divides the world, he holds that all that artists see is "the appearance, and not the reality," and that because of this artists "will copy the vague notions of beauty which prevail among the uninformed multitude."[66] And this betrays Plato's second objection: the persuasiveness and communicative capacity of the arts. Thus, while he may rant about how artists are ignorant, and spread ignorance, the fact is that they do spread it, but not to the "best part" of the soul "which relies on measurement and calculation."[67] Plato continues his objections, calling art "a worthless mistress and the parent of a worthless progeny" that leads the soul away from truth and from wisdom.[68]

Famously, and after setting forth his studied argument for the superiority of (male) rationality above all other human faculties, the philosopher banishes all artists from his proposed ideal state, "refusing to admit him [the artist] into a state that would fain enjoy a good constitution, because he excites and feeds and strengthens this worthless part of the soul, and thus destroys the rational part."[69] Finally, in fairness to Plato, he does admit that an "old antagonism" exists between philosophy and poetry, hinting that the competition between artists and philosophers in ancient Greece had much to do with their work in society.[70] Who could best persuade? Who could best teach? Who had access to truth and who lied? In short, Plato

believes that the arts imitate the visible world without understanding it and that they engage the "lower" passions (even while admitting to his own delight in poetry).[71] According to this understanding, works of art (as attested to by their popularity) represent the ignorant views of the "masses" and appeal to emotional states that persons secretly feel but would not dare admit in public because such behavior is "not manly."[72] In this way, they undermine the primacy of the rational and the law.

The View from Here

The situation today is strangely similar, if quite unconsciously so. It is not that the arts are denigrated or artists purposefully banished, but rather that the dualisms of mind/body, sensible/intellectual, and image/idea have taken on a new urgency with the advent of something we call "virtual reality" and the technologies, which make "imitation" so flawlessly possible.[73] Here some of Plato's objections about shallow copying may be worthwhile to consider.

For example, in the film *Inception* we discern a bleak mirror of the contemporary severability of mind from body and self from community.[74] After 128 minutes of engagement with the film, a few of us may come to the exasperating realization, obliquely suggested by the spinning top on the table, that we have spent all that time caught inside the individualistic and adolescent "shoot 'em up" fantasies of one man's mind. The extreme subjectivity of the film suggests that all "reality" may be of our mind's own making, an endless labyrinth of often hostile "projections" in which there is never an "other" to be encountered. Unable to deal with myth or metaphor, as earlier generations have done, the generation mirrored in *Inception* is forced to reduce its existential questions to a technologically controlled and chemically produced dream state. "The movie is all about process, about fighting our way through enveloping sheets of reality and dream, reality within dreams, dreams without reality," as critic Roger Ebert put it, in his review of the film.[75] *Inception*'s hero, far from possessing the self-sacrificial qualities valued by most ancient traditions, cares exclusively about himself; yet this single-minded self-absorption is not critiqued or problematized in the film. He is still the hero, even in the total meaninglessness of an existence that the film shows to be pathologically self-enclosed.

If this is a proposal for our times, it is suicidal, since it glories in selfish individuality and an inability to deal with the questions of existence in the real world, and ends without having moved audience or protagonists. Robotic in its displacement of reality for the flashy effects of dreams, and amoral in its character depictions, the film forces conscience into a place of no consequence, as all actions are in the end only imitating reality.[76] What is most disturbing about *Inception* is that the horror of such meaninglessness does not seem to occur to anyone on camera or off. Unlike Sartre's frightfully urbane image of hell in *No Exit*—in which Garcin exclaims to his cellmates, "Anything, anything would be better than this agony of mind, this creeping pain that gnaws and fumbles and caresses one and never hurts quite enough"—in *Inception*, although there is no exit, *no one cares*.[77] The film is, to paraphrase Shakespeare, a whole lot of ado about absolutely nothing, the materiality of the stunning special effects merely seducing the audience into thinking the film has something to say. As one insightful critic explains, "Though there is a lot to see in 'Inception,' there is nothing that counts as genuine vision. Mr. Nolan's idea of the mind is too literal, too logical, too rule-bound to allow the full measure of madness—the risk of real confusion, of delirium, of ineffable ambiguity—that this subject requires."[78] It is this very literalness, linearity, and logic devoid of the openness and complexity of symbol that underlies modernity's critiques of the idea of revelation.

I bring up *Inception* then to highlight three problems that must also be reckoned with in any search for ways to engage creative works in their full revelatory potential. First, creative works can lie. Unlike Sartre's stark and ugly truth telling in *No Exit*, *Inception*'s cleverly disguised and beautifully executed banality subverts the work the arts can accomplish of conveying us to revelatory experiences. Through the film we are tricked by facile answers that make us quite comfortable in our stupor.[79] The second problem this hugely successful film makes evident is that dualistic thinking has become profoundly engrained in contemporary culture. The constant pursuit of material luxury and ease is blithely set against an oversimplified "spiritual" realm devoid of myth, metaphor, and most importantly, real questions. The conclusion we might draw from all this is that what can be counted and verified as a commodity is all there is; after all, in *Inception* dreaming is undertaken as a "job" facilitated by drugs and technology with the single purpose of earning a reward from the powerful. Everything, including

dreaming, is for sale. More tragically, and referring back to the chasm I pointed to earlier, in such a universe of our own making we are indeed completely alone. The most complex of problems arises as we lose the ability to recognize what is truly beautiful, and what is its opposite, in spite of appearances. As is evident in the juxtaposition of the insightful yet ugly (and avowedly atheist) *No Exit* and the seductively superficial yet apparently beautiful *Inception*, there is a moral dimension to all this. We must be able to grasp the difference between beauty and glamour if beauty is to help lead us toward the good.

Molding Matter, Matter Molding Us

In order to create art that can function as a revelatory symbol, we must believe that what is spiritual and what is matter shine through in one another. As Yeats experienced in looking at Blake looking at Dante looking critically at faith, the tactile matter of paints and paper, ink and words, became both the transparent lamps and the flame of what was revealed as it shimmered through them.[80] As John Paul II writes in his pastoral letter *To Artists* (1999), "Where theology produced the Summa of Saint Thomas, church art molded matter in a way which led to adoration of the mystery, and a wonderful poet like Dante Alighieri could compose 'the sacred poem, to which both heaven and earth have turned their hand.'"[81] What honest creative works promise us are fully embodied revelatory experiences that point to truth and goodness through the way they engage us in beauty or its heartbreaking absence. For North American scholar and churchman Von Ogden Vogt (1879–1964), "The true and the good are beautiful. The beautiful, most highly speaking, is both true and good."[82] John Paul II goes even further, asserting, "In perceiving that all he had created was good, God saw that it was beautiful as well. . . . In a certain sense, beauty is the visible form of the good, just as the good is the metaphysical condition of beauty."[83] Perhaps this is what Dostoyevsky meant when he said that "beauty saves."[84] The "theological" in the theological aesthetics proposition is precisely this—that even while on this side of the veil of eternity, we have access to revelatory experiences of truth and goodness and we can bring near the insights others have about truth and goodness. As understood in popular religious practices and often by the arts, beauty, truth, and goodness are markers, pointers, and reflections of the shimmering glow left in our world by the presence of God.

In Western culture, we have many bad habits to overcome that we have built up for centuries. Enamored of our own powers of analysis, we lost sight of mystery, and with its loss we stopped feeling the presence of God. We became obsessed with debating what revelation was saying, and we forgot those beyond us for whom there was only silence. We have allowed ways of thinking into the Christian life that have little in common with the gospel of a God so in love with humanity that he took on flesh to live and die with us. In doing this, we have privileged minds and ideas, and disparaged bodies and intuitions; in short, we have become less human. We have forgotten the beautiful vulnerability of the Last Supper as we tried to control the world through our intellect and power. Today, in what is becoming a world culture of symbol-making and symbol-sharing, we have an opportunity to take a fresh look at the arts as they disclose what is most beautiful in us and as they also unmask what is most destructive. In this, they can do the work of the revelatory symbol and remind us that God is still speaking.

My proposal then is that we look at the arts not simply as objects or objectified performances, but as intimately tied to complex functions, indeed only fully discernible in relation to those functions. For those of us concerned with questions of ultimate meaning—the theologically minded—the arts present themselves as testimonies, material instances of God's continuing relationship with God's creation. Revelation, in order to be known by us, must happen in our midst and in our world, and a renewed understanding of the power of revelatory symbols makes us aware of revelatory moments (for us and for those who came before us). In Christ, the exquisite Prince of Peace and the despised, battered, and bleeding man are paradoxically united, constituting the deepest insight into the nature of the beautiful. What is beautiful can be so most powerfully in that it wounds us and directs us to the longing our wounds reveal. In this beauty that is most fully revealed in Christ, the good and true are woven together and made sensible, so we may want them, grasp them, inhabit them, and love them.

3

In Search of Wonder

One way to frame the capacity of art to be theological is in terms of its ability to facilitate theological "work." Creative work (as an activity) and creative works (in their many roles) often explore and also evoke experiences that have all the characteristics of revelation.[1] The power of revelation is evident when art has the capacity to participate in communicating the divine in-breaking into human history and its concomitant invitation to respond.[2] In this sense, the initial experience we have with creative works is what might be characterized as a first act.[3] The first encounter any of us has with art is pre-theological, meaning that its occurrence precedes any theological reflection that might follow. The tears I suddenly notice welling in my eyes as I listen to Mozart's *Requiem Mass* happen much before I have a chance to reflect on why.[4] In the experience of art, the community in front of the work is given an opportunity to have what we might call a "religious feeling," even if "the religious" is not even part of their vocabulary.[5] In those unexpected tears, one is led to a moment of revelatory wonder.[6]

A linear argument that proposes and then proves wonder's provenance might seem necessary here, but even if this were possible to produce, it would undo the very nature of our subject, which is, in the end, mystery. I do not mean "mystery" in the way my Catholic grandmother meant it when I asked yet one more time if she would explain the Trinity. Her answer would always be, "It's a *misterio*." It

was a good answer, in that it called for humility and silence, but I sus-
pect mystery was also a code word for "impossible to know." Despite
the influence of the great Thomas Aquinas on Spanish Catholicism,
as he famously said, "We cannot know what God is but only what
God is not," I was convinced that my grandmother knew God inti-
mately.[7] At any time of the day, if she was sitting anywhere alone, she
was always quietly praying. One wonders if she could really love so
deeply and converse so often with someone she did not know. Here
was a mystery.

My grandmother's prayerfulness was an enigma I returned to
often. As I witnessed it, I also noticed her joyfulness, her insatiable
love of music and the liturgy, and her refusal ever to participate in acts
that lacked love. Thus, in retrospect, I can see that it was her grateful
and joyful self, what she sought in the beauty of life that aided her to
live as she did. The ethical implications that defined her actions made
my grandmother who she was. In appreciating and also in giving
beauty (as an accomplished classical singer and choral teacher), my
grandmother expressed and simultaneously nurtured her graceful and
grateful stance before God. Such examples live in us, and the wonder-
ment of knowing her and the mystery of the God she clearly loved
grew, expanded, and led me to new glimpses and new questions.[8]

I am convinced that this is how beauty works: while no human
experience can disclose *what* the mystery of God is, experiences that
brim with beauty (or point poignantly to beauty's absence) can sud-
denly make us aware of the enticing mystery enveloping us. We are
caught in its midst, and "wonder is the only appropriate attitude."[9]

Like my grandmother's beautiful life,[10] creative works engender
wonder and are also witnesses to someone else's state of wonder.[11] We
know the first act of a revelatory encounter has happened because all
our words break down, into what many religious traditions call "inef-
fability."[12] To our modern mind, this could signal an emotional state
without any content, like being inebriated. Perhaps much of what
has passed for art in modernity has remained at this stage. However,
art, as such, is closer to what has been observed at work in genuine
mystical states, that is, an experience of ineffability in which content
provides "insight into depths of truth unplumbed by the discursive
intellect."[13] This could suggest that as experiences of ineffability are
felt by creative persons they need to be shared, and it is through artful-
ness that such sharing happens. "Painting," writes artist and novelist

Gao Xingjian, "and it is true of other creative modes of expression as well, begins where language fails."[14] If the use of symbols is "another way of remaining silent . . . [because] symbolic language is the language of love that transcends words," then works of art can testify to the experience of love in those whose symbols we have been given in the work—the artists and the communities behind them.[15] However, as with the biblical witness, what the symbols may record could just as well be experiences of radical doubt, the denial that there could be such a thing as love for God and from God, and a wrestling search for such a love.[16] The wonder before such signs should lead us to compassion.

Experiencing Wonder

If we use the classical categories of the work of theology as made up of a first act, "contemplation and practice," and a second act, "theologizing," these stop making sense once we enter the world of theological aesthetics.[17] We need new ways to name what is happening theologically in our encounters with the beautiful. To understand art's revelatory work, we cannot separate the means from the ends.[18] The stirring glimpses of mystery that the arts provide are like the bits of pigment that make up a color, and the beads of color that make a brushstroke, and the overlapping brushstrokes that build up a shape, and the many shapes that make up a painting—the revelatory power of art is best understood by the way it works.

When I was in graduate school, I was invited by a friend to see a play a few weeks before Christmas.[19] The work was authored by a respected playwright, and the theater company was legendary. I put down my books, we called for tickets, and on the appointed night drove a couple of hours south. From that moment on, the evening took a series of unexpected turns. Arriving at the tiny town surrounded by farms and fallow fields, I realized we were not going to a theater at all. The play was being staged in a church building, and not just any building, but the centuries-old mission church of San Juan Bautista.[20] Once inside the beautiful sacred space, I saw an audience (or should I say congregation?) made up of farm workers and their visibly excited children.[21] As the music started, it was clear there would be no curtain, but rather the entire church interior was the stage. Scenes unfolded on a raised platform running the length of

the center aisle, the choir loft and staircases were peopled with sur-
prising characters, and the extraordinary final scene made full use of
the main altar. Paulina had invited me to experience *La Pastorela* by
Luis Valdéz (Mexican American, b. 1940),[22] brought to life by his
company El Teatro Campesino (Plate 3.1).[23]

I am centering my attempt to articulate carefully the aesthetic
qualities shared by the genuinely artistic and the religious on *La Pas-
torela*, as it is one of the best examples of the convergence of sacrality
and artfulness I have ever encountered. Although I will not be cri-
tiquing the play and its performance (a task meriting its own volume
and multiple viewings), I believe the complexity of this work of art
provides a concrete way to investigate what bits and pieces may make
up the underlying structure of a bridge to wonder.

Although the play and its performance are clearly deeply rooted
in the particularity of U.S. Latino experience (and even more pre-
cisely the Mexican American context of those who feed the rest of
us by working the land), the insights that arise may be, indeed *should*
be, a source of unity and understanding for the wider Christian com-
munity. As theologian Roberto Goizueta insists, "before there can
be authentic pluralism there must be authentic justice" and such jus-
tice eludes us if we continue to conceive of the world as a collec-
tion of separate individuals. "Where there is no necessary connection
between persons there can be no necessary ethical-political imperative
to love others."[24] The arts are indeed one very effective way to forge
such connections, as they engender a knowing that overcomes barri-
ers because in the fullness that our heart experiences we are called to
love more deeply.[25]

La Pastorela is a particular work of art, not theoretical but realized,
and I personally experienced it in the fullness of its possibilities.[26]
There are many works of art I could write about as a scholar, but the
point here is that revelatory wonder *happens to someone* and in this case
it happened to me.[27] I know whereof I speak. In this we recognize the
way the Jewish and Christian Scriptures are stories of events, of signs
that speak eloquently because someone is paying attention to them.

The quality of embodiment cannot be overstated in the way the
religious and the aesthetic interact with the human person. The first
step toward teasing out an understanding of how it is that the arts can
mediate revelation is to acknowledge that the artistic and the religious
begin in experience. "There an angel of the LORD appeared to him

in a flame of fire out of a bush; he looked, and the bush was blazing, yet it was not consumed. Then Moses said, 'I must turn aside and look at this great sight, and see why the bush is not burned up'" (Exod 3:2-3).

Moses' experience as told in the book of Exodus is clearly *sui generis*, yet, for thousands of years we have repeated the story for one another in all kinds of ways. What this attests to is the understanding of the centrality of this experience for the Jewish and Christian religious traditions, coupled with humanity's optimistic sense that even if we cannot replicate an experience, we can approximate something of the effects of its encounter.

I am neither playwright, painter, nor composer, but if I were I might be able to approximate the lights that turned on inside me while at San Juan Bautista by producing a creative work of my own.[28] Although I am regrettably reduced only to speaking about something that must be experienced to be known, I can attest to the overpowering nature of the wonder occasioned by the experience itself.[29] In my lack, we can note that the arts fill the gap between a theoretical understanding of experiences of wonder and the one who actually wants to know such experiences by making experiences of overpowering wonder possible, purposively and concretely so.

The great Spanish mystics, Teresa de Avila (1515–1582) and Juan de la Cruz (John of the Cross, 1542–1591), experienced a radical union with God that moved them beyond the silence normally associated with mystics. Although they wrote explanatory texts about their spirituality (most often at the insistence of their superiors or those wanting instruction), their experience of union with the Divine made them into poets.[30] Their poetry is not telling the reader about a rapturous experience of God as much as trying to recreate something of that union's overwhelming beauty through their gift of creativity.

> Oh, flame-lit lamps,
> in whose radiance
> the cavernous depths of the senses
> once darkened and blind,
> now with peculiar beauties
> warmth and light give forth with their beloved!
> Lavishly mild and loving
> abide you in my breast,
> alone and in secret dwelling;
> and in delicious breath

with good and glory brimming,
how gently you charm me into love![31]

Juan de la Cruz' last two stanzas of "The Living Flame of Love" provoke a state of appreciative wonder in a Christian reader; in this is the possibility of the reader's coming awake to their own deep thirst for God. Just as I have proposed that our experience with works of art is at first pre-theological, only moving to an interpretive and reflexive mode as a second step, so an artwork is often the evidence bequeathed to the rest of us of the "glimmer of the splendor which flared for a moment before the eyes of [an artist's] spirit."[32] Juan de la Cruz and Luis Valdéz are telling us *how the glory of God feels to them, and has been revealed to them, by evoking an analogous feeling in us through the shared power of beauty.*

Lacking their talent, I cannot communicate the beauty of that starlit and chilly December night in San Juan Bautista in any way that remotely approximates it. In a flash of lights and sounds, the cavalier and handsome Luzbel rides into the church on a horse, seductively inviting the shepherds to follow him so they will not meet the Christ Child.[33] The children in the audience shriek, trying to warn the shepherds (played by members of the local farm worker community) not to listen to this Tempter and the others in different guises that follow him. Moving from past to present, from Spanish to English and back again, the play is a luminous dream we are dreaming together and that most of us understand in our very depths. The many young angels, dressed in blues, golds, and whites, crowd around the final manger scene with an intensity (mirrored in my young son's wide eyes) that for a moment causes us to believe we are witnessing the birth of Christ (even if the setting has absolutely nothing to do with historical verisimilitude). Placed in a manger in front of the Mission Church's main altar, the living figures and those carved and painted in the venerable surrounding structure all seem to merge. Then, in a moment with more power than any treatise on redemption could possibly generate, Luzbel, also overcome by the beauty of Christ, walks up and kneels in humility in front of the manger.

A few minutes and much applause later, standing outside under the stars as rolling fields stretch into the distance, my young son says, "I feel all of the people who lived here from a long time ago, Mommy, they are all here, and they are happy." We all agree. The power of

redemption was presented theologically in the conversion of Luz-
bel (an abbreviation for "beautiful light"), but it was the beauty of
that conversion at the foot of the manger, as angels looked on, that
suddenly made our community materially present, in our bodies and
in our hearts, to the glory of God. Such glory cannot be contained,
and as my son noted, it spilled out into the fields, into the night, and
into the lives of those who walked home in the dark, holding their
children's trusting hands, keenly aware of their blissful and intimate
companionship with those in heaven.

At San Juan Bautista and all around us, encounters with creative
works happen through the senses as human persons interact with
the world. A sensually mediated aesthetic encounter that actualizes its
potential to be revelatory situates the human community within Cre-
ation while pointing to Creation's mysterious depth.[34] As was evident
in the Mission Church, creative works do not take place in a void,
but are part of the continuum of human life and depend on a culture's
ability to share symbols; in this, they necessarily engage and hopefully
also create community. Thus the experience of aesthetic encounter
that brings us to wonder is at once introspective and also oriented out
toward the other: "Being is unbelievable. We are amazed at seeing
anything at all; amazed not only at particular values and things but *at
the unexpectedness of being as such.*"[35] The experience of encountering
such awe-inspiring creativity makes it very clear that being—life—is
present in abundance in us and in all that surrounds us. As Jesus told
us, such abundant life was the reason he came (John 10:10). As the
manger scene unfolds, we understand this perhaps more deeply than
we have ever understood it before.

In the particularity of *La Pastorela*, we did not encounter an inde-
terminate and philosophical category of "being," but were concretely
awakened to the giftedness intrinsically present in the distinctiveness
of life as Hispanic American Catholics. Creative works, like religious
rituals, are intricately tied to a community from which they come and
a community with which they speak. The full experience of Valdéz'
play depends on the ability of those present to move swiftly between
languages, a feature that is specific to the U.S. experience of His-
panicity.[36] Additionally, the intricacy of the story hinges on a full
appreciation of the charged symbols of Spanish Catholicism and their
reinterpretation as they mix with indigenous cultures in the land of
California. The deepening theological reflection of Jesus' poverty and

marginality, and the liberative message of his birth in a stable, relies on an understanding of the present day struggle of farm workers and the history of the farm worker movement as it is integrally connected to the gospel.[37] More personally, the story of salvation plays out on stage and inside each heart as the sundry temptations in the story hold up cautionary mirrors to our own flaws.

In looking at how wonder is activated during the play, we can readily recognize its interiority (we are asked to examine our lives and our choices) and exteriority (the goodness, truth, and beauty of our choices are incarnated in the entire community of heaven and earth). Interiority and exteriority are processes intentionally cultivated and evoked in the arts and in religious practices, which is why for millennia art and religion were (and often in many communities still are) inseparable.

However, I do not want to claim universality for an experience that is in no way universal. I know that the intense unity of truth and goodness in the beauty the audience/congregation experienced during *La Pastorela* was very specific to *this* community. It is very possible that those lacking the requisite individual and communal memories, and the ability to decode the uniqueness of the symbolic language, would just be puzzled by the work. The hope is that in cultivating openness to the unfamiliar and the new as a necessary good, our encounters with something very "other" can be fruitful.[38]

There is just one more caution to raise and it is this—the arts are today far from reliable and truthful bridges to wonder, often having fallen prey to the false deity of money.[39] In the twentieth century, "the art world" has contributed substantially to the perception of elitism and decadence associated with it. In 2010 a bronze sculpture by Alberto Giacometti sold for a record $104 million.[40] Even more tellingly, one of the first reports of this sale was in the "Investment" section of *The Wall Street Journal*, which gleefully quoted an art dealer as saying, "The sale shows that after a weak year, the wealthy are once again 'parking their cash in art.'"[41] Comic, playwright, and novelist Steve Martin shines a wry light on this phenomenon in his novel about the late twentieth-century art world, *An Object of Beauty* (2010). As the central character (a recently graduated art historian) begins work at Sotheby's auction house, she starts her descent into unethical behavior. Through her character, Martin stresses the tragic central thesis of his novel: "her toe crossed ground from which it is difficult to return: she

started converting objects of beauty into objects of value."[42] The price we pay for making art into a commodity is very high; it is the loss of beauty.

Making Friends with the Arts in a Broken World

What I hope the example of La Pastorela's biannual reenactment in a Mission Church, for the poor and by the poor, for the last forty years makes clear is that to think and write about "aesthetics" today is not a luxury or a frivolous pursuit, which glaringly contrasts with the reality of suffering. As genocide and torture are widely reported, and xenophobia and racism grip many nations, our world seems caught in the relentless clutch of violence and poverty. Concurrently, the planet's ecological stability is under serious threat, and epidemics in the animal and human world, now ominously identified as "pandemics," threaten to wipe out entire communities of organisms. The Earth is experiencing death on a monumental scale.

In contrast to this suffering world (or perhaps to escape from attending to it), a technologically facilitated global culture has taken hold that values fame for its own sake, resulting in the quest for celebrity at all costs. As a result, excessive consumerism linked to status seems limitless (as exemplified by the sinfulness of a private home built at a cost of $1 billion during the first decade of the twenty-first century, while all around it people starve).[43] Also closely connected with the vacuousness of this celebrity culture is the inordinate number of cosmetic surgeries performed in affluent countries; it is a wasteful expenditure linked to consumerism that chips away at humanity's very sense of beauty. In 2009 there were over 12 million cosmetic surgical procedures performed in the United States,[44] with the goal of fitting into an idea of beauty that has very little to do with the sort of beauty theological aesthetics explores.[45] This trend is particularly troubling because of its effect on girls, with many teens now incongruously requesting surgeries as high school graduation presents.[46]

As the experience of La Pastorela shows, it is the ability to recognize the truly beautiful in all its complexity that returns us to life. The gift of God we recognize in La Pastorela, as the play presents each part of creation (including the very flawed and fallen Luzbel) as beloved and involves us in their loveliness, would disappear if we come to believe what advertising all around us proclaims: that beauty is not

inherently ours at all, but it is for sale. Our humanity is no longer good enough.[47] In such commercializing of beauty there is something insidious, a new kind of victim and victimizer as the world is robbed of its very ability to know itself good and beautiful.

A young woman who rejects herself enough to purchase larger breasts or a smaller nose is losing her very moorings as a child of God. She can no longer see herself as the image of God, and because of the solution presented to her unworthiness, she also replaces God with a new god—the money that can give her this artificially construed beauty. The loss of a capacity to know our own beauty, so apparent in consumerism and celebrity culture, radically clouds our ability to experience ourselves as *imago Dei*, and makes us idolatrous to a system that gives us instead an *imago fallax*, deceitful and unreal.

The worth of life can be affirmed only by seeing the truth and goodness that surrounds us, and it is beauty that leads us there, since "beauty is the most visible sign of the work of the Holy Spirit."[48] In our encounter with beauty, we enter a world "where egotism is not made the measure of reality and value, [and where] we are citizens of this vast world beyond ourselves, and any intense realization of its presence with and in us brings a peculiarly satisfying sense of unity in itself and with ourselves."[49] This is impossible when we answer the question of the worth of life by trying to buy our way *out* of the question.

It is difficult to speak of aesthetics in the midst of a suffering world, to a hedonistic and consumerist culture. It is also hard to argue for the validity of something (art) that has recently become an expression of that same consumerism and hedonism.

If the inordinate suffering in our world is incited by selfishness and greed, which is itself meant to mask our sense of worthlessness, and if our contemporary response is to flee knowledge of this suffering in the idolatry of consumerism and glamour, may this not be a result of our collective inability or unwillingness to engage in a process of interiority and exteriority, of "soul-searching"?[50] *La Pastorela's* insight about the life-affirming power of beauty, as the shepherds seek the One who is the ultimate form of all that is beautiful,[51] helps us to understand the kind of beauty that the sixth-century mystic theologian Pseudo-Dionysius carefully defined by the way it worked in Creation:[52]

Beauty "bids" all things to itself (whence it is called "beauty") and gathers everything into itself. . . . From this beauty comes the existence of everything, each being exhibiting its own way of beauty. For beauty is the cause of harmony, of sympathy, of community. Beauty unites all things and is the source of all things. It is the great creating cause which bestirs the world and holds all things in existence by the longing inside them to have beauty.[53]

Pseudo-Dionysius' insight is that Creation's longing for beauty is what orients us toward a whole life, toward the source of all beauty, which is God.[54] Art and religion pioneer Von Ogden Vogt struck a similar chord, when, following the horrors of two World Wars, he argued that the ethics of life are revealed by the aesthetics of life. Ethical questions are for him "the struggle of human life to have a larger share in the beauty of life."[55] As he argues, our inability to recognize beauty makes us blind to what is ethical (the good) and what is revealed (the true).

In harnessing our longing for beauty so that it may orient us toward the good and also help us to recognize what is true, the wonder caused by creative works becomes prophetic. If we ask ourselves *why* life should be lived, noticing the beauty-filled moments of our life educates us back into recognizing the value of life in truth and goodness. In this way, the sounds of a symphony or of one lone guitar become pointers toward true beauty, which we learn once more to hear. As we awaken to experiences of beauty, we feel that life is indeed good, and we recognize the truth of this because of the smile on our face. An experience with beauty like that of *La Pastorela* makes us aware of wonder in ourselves and helps us understand its prophetic power. But how are we brought to prophetic wonder?

First we must simply *see*.[56] This is the noticing and awakening that was incessantly called for by the Hebrew prophets.[57] But to "see" is a complex proposition for Christians, since we are conscious of existing in a world that as it reveals great glories and beauties, also conceals these. As Jesus stresses in the Gospel of John, "I will be with you a little while longer, and then I am going to him who sent me. You will search for me, but you will not find me; and where I am, you cannot come" (John 7:33-34). Our engagement with what is beautiful, truthful, and wonder-making will always be partial and incomplete. This humble awareness of the limits of our knowing must be cultivated. Yet at the same time, what the seeing occasioned

by an experience with creativity can activate is the expansion of our imagination.

El Teatro Campesino was founded as a response to pain and injustice. In the creativity of its artists, many of whom toil in the fields by day and in the theater by night, a new world is imagined and partially, if imperfectly, brought into being. This world is one predicated on what St. Paul and the Fourth Gospel simply call *love*.[58] In the practice of *seeing and then imagining in love*, humanity is given something—an insight, a yearning for, and a willingness to work toward a better, truer, and more beautiful life. The prophetic is generally understood more readily as a call to repentance, but when we look at the terms of seeing and imagining joined in love we can see it more dynamically as a call for life-affirming transformation. Once we see, we must care.

As history shows, human beings fight with passion and conviction to save their own land and people—what they hold sacred and love. Perhaps the failures of history point to the disconnect human beings experience from abstract ideas or ideals. It becomes difficult to right wrongs if we hold nothing sacred, because we are unable to find beauty in anything, and thus unable to care. Without an ability to recognize the truly beautiful, we cannot mourn its absence, and thus wrong or sin becomes difficult to identify, let alone oppose. Finding something very beautiful is to have it awaken love in us. This is the unique work achieved by wonder.[59]

One of the many possible ways to translate the word "wonder" into Spanish is *asombro*. When someone is *asombrado*, there is an understanding that something has acted upon them and that there has been a response, they have become wonder-filled beings. The word gives no clue as to the positivity or negativity of the encounter, which could have produced genuine fear, a moment of profound questioning, or the feeling of utter surprise or overwhelming delight. What is clear is that the encounter precipitates an awakening response and that the moment of *asombro*/wonder can have a variety of results, depending on what is encountered and how the human person or persons involved in the encounter react. At its most basic, wonder stops what is routine and causes *asombro*. When we become *asombrados* we are no longer able to cling to the illusion of control and omnipotence. We have been made small and take on the characteristics (in ourselves) of our awe-filled response.[60]

I find the radical ambiguity of wonder as *asombro* helpful. It forms a corrective against "prettiness," or a surface understanding of wonder as only occasioned by what is perceived as uncomplicated and pleasing. The confrontation that brings us to wonder may also be one that centers on the exposition of evil. As John Paul II carefully notes, "Even when they explore the darkest depths of the soul or the most unsettling aspects of evil, artists give voice in a way to the universal desire for redemption."[61] Christ on the cross is the ultimate expression of this most frightening—and because of its redemptive character, also most beautiful—encounter.

I believe that loving "wonder" may be evoked by the arts, whether religiously intentioned or not,[62] and that the evocation of wonder can constitute a transforming moment in the life of the human person. We need to see with humility if we are to become aware of our pain, and through the awakening of wonder to imaginatively love, so that the pain may be transformed into promise. It is in a universal sense that we need to know and love "the world"—to see its (and our) innate beauty in order to envision, and build, with exuberant ingenuity that which will turn our world's sadness into joy.[63] What prophetic wonder does is help us face the difficult questions, and answer these in ways that give us life.[64]

Along with all of the other vantage points from which to see and contend with what is destructive, we need one that will show us the beauty of all that we must preserve and redeem. There is an interplay between seeing and the wakefulness brought by art's complication of the world, and through it we can renew our love of creation and of ourselves. This renewed humility can sometimes reveal our need of salvation, by laying bare the depth of our longing or of our emptiness. In wonder, we are brought face to face with our desire for wholeness and our hope of healing. If art and the beautiful are to move beyond the generally prophetic and into the properly theological, they must provide insight into our own and the world's brokenness. This must be followed by the further revelation of glimpses of what salvation, fullness, and healing might be like. Art here becomes a gospel, an announcement of the good news of our beloved status as children of God. In the beauty that delights us or breaks our heart, something is offered and understood, briefly, as wholeness and healing, and that "something" changes everything.

Seeing the Aesthetic in Christ

We are perhaps unaccustomed to noticing the aesthetic dimension of Jesus Christ and his saving mission; I believe it is urgent we try. While sharing this broken and beautiful world with us, Jesus pithily summarized his work:[65] "Go and tell John," he answered his questioners (the disciples of John the Baptist), "what you have *seen* and *heard*: the blind receive their *sight*, the lame *walk*, the lepers are *cleansed*, the deaf *hear*, the *dead are raised*, the poor have *good news* brought to them. And *blessed* is anyone who takes no offense at me" (Luke 7:22-23).[66] Jesus speaks in aesthetic terms here; he speaks of the senses and their relationship to his mission to bring us to a fully lived life. Jesus ushers in genuine seeing and imagining through the restoration of sight, of the power of voice, of the ability to walk and act; he speaks of cleansing and the renewal of hearing—in short, he offers a glimpse of what God's kingdom might be like. In this he awakens a capacity to hope, to imagine, to dream. The dead are raised because Christ makes everything radically new again, and it is the good news of God's closeness and love that he comes to bring—in sight, in sound, in touch, in movement. It is this that transforms everything. Jesus came to embody aesthetically in his life and death what it is to be human and to be loved by God.

To be a Christian is not only to be loved, but also to be a lover, to love and care for *the gift* given. As we are renewed in Christ to see anew, hear for the first time, walk with unsteady gait, act in proclamation, and bring life where death has been, we reveal a loving Creator and a Creation that must be loved. The loving of the gift is an act that begins with seeing it. Although we can debate just what it is we see and how we go about seeing it, we might perhaps agree on this— theology cannot turn away from the world, but must push the horizons of what it can see, so that in this truthfulness it may teach love. Theology is in need of constant renewal and is most alive when it is in sustained engagement with the world.[67] Such theological engagement must maintain two impulses simultaneously—one of critiquing and one of celebrating. We can also sense critique and celebration working in many products of human creativity as they move us to wonder.

Sometimes the critique and celebration are simultaneous, as in Thornton Wilder's *Our Town* or the brightly colored murals anonymously gracing and denouncing the dilapidated walls of inner cities.[68] And, sometimes the celebration and critique are quite distinct and

univocal as in Beethoven's celebratory *Ode to Joy*[69] or Picasso's heart-wrenchingly critical *Guernica*.[70] In the prophetic wonder evoked by these works of creativity, we suddenly see and imagine new possibilities: we are *asombrados* into noticing the gift of life, and moved to love it.[71] In the artistic evocation of wonder and *asombramiento*, we notice that the point is not only to critique, or only to energize—it is indeed to do both.

Perhaps one way to characterize the work of theological aesthetics is its potential to unmask unnecessary divisions or false dichotomies; the aesthetic properly understood is always about depth and expansion. When applied to the work of theology and the classical division of a first stage as silence and a second as *speech*,[72] aesthetics invites us to take notice of other moments to insert into this schema. The first apparent "silence" may be utterly full of the revelatory symbols that flower when our words break down. When the symbols are shared with another (as Valdéz does in *La Pastorela*), the symbols then speak and speak wondrously. In speaking from the silence, the arts (even when they use words, as in drama) can evoke a spiritual silence in their audiences: the silence of wonder. Yet, the symbols, at the same time as they reveal a first moment of silent encounter with divine gift, may also simultaneously reveal the speech about God of a community. For instance, the symbols may also embody the stage of reflection, as in the long tradition of the shepherd's play/*La Pastorela* and its theology of redemption. What this means is that the revelatory moment cannot be neatly divided into silence and speech, but is full of multiplicity as it occasions and also expresses wonder. What is more, what may be evoked in the audience is action.[73]

Awakened to Love

What a play like *La Pastorela* activates in us is exactly what the Gospel accounts of God's gift of Christ should—we know ourselves loved, and we are also called to love unconditionally. Any kind of world that would demean those whom God so dearly loves (here embodied by the poor shepherds/farm workers) is critiqued. Thus the experience of the play should move us to denounce a system that treats those who toil in the fields as lesser human beings, and to question forcefully an economic structure that thrives on their poverty and marginality.[74] The many beauties involved in the play—from the Nativity story, to

the crèche tradition, to the varied types of music, to the bilingual-
ity and biculturality in the diverse persons from infants to the elderly
gracing the stage—invite us to become wonder-filled, and as Pseudo-
Dionysius encourages, to follow the gift to the One who gives it, the
source of all Beauty.

The urgency of the impulse of critique and reinvention is central
to human survival: in order to reinvent, our powers of seeing, of sens-
ing, of becoming aware of what must be reinvented, must be awak-
ened.[75] Prophetic reinventing and celebrating is compelled by seeing
that awakens a type of love that results in creative action. The present
world crises need addressing from a consciousness that breaks past
an unloving complacency, what a theologian would call *sin*. Blind-
ness has consequences and a vicious circularity. Given the force of
contemporary media, its artfulness can be engaged to awaken us, or
to fatally deaden our ability to recognize beauty.[76] Consequently, the
creative power of art must be tapped as a catalyst for seeing, instead
of becoming a vehicle that sustains blindness and facilitates a facile
accommodation to sin.[77] A prophetically charged work of art can help
to create a community of resistance; it can bring what has become
an abstraction back to life, by questioning it and in this way giving it
renewed power.

The Promise of Joining the Arts and the Religious

How we bring about a prophetic consciousness through seeing and
imagining that will lead to loving Creation truly is a question for both
art and theology. Cultural forces such as the arts, which could be at the
service of seeing, are often perpetuating blindness, but then . . . so are
religious forces. When religious traditions foster fundamentalist and
triumphalist understandings of themselves that center on having all the
answers, wonder becomes impossible. Prophetic insight depends on
our willingness to be open to an encounter that could knock us off our
feet; nowhere is this clearer than in the beautiful story of the burning
bush in Exodus. The quality of *asombro*/wonder also requires us to be
willing to see the darkness, and perceive beauty in that darkness by the
very fact that a song is sung—a song that says: we need salvation, salva-
tion is at hand, wake up and see.

One of our contemporary difficulties is not only the blindness, but
the perceived barrenness, of ethical concepts like goodness and truth,

which seem to be both precursor and result of the lack of imagination and depth that stymies revelation. Works of art do not always express optimism, and clearly they should not. Art's responsibility to truth includes the representation of evil. And, if "we sin when our choices consciously contradict the self we know we ought to become," then an awareness and experience of such sin is important in art.[78] But not all art that treats evil is created equally, and a great majority of contemporary works glorify and glamorize what in earlier generations would have been meant to cause an edifying horror or sanctifying compassion.[79] In theological aesthetics, the question of the response evoked by the representation of evil must be addressed. Here we return to the idea of wonder as *asombro*. When art does not give us something lovely and life-giving but ugly and distorted, its prophetic potential lies in the exposing and unmasking of evil.[80] Thus, it can point in the right direction—the wonder that heartbreaking or frightening works of art foster in us, when these are understood as heartbreaking and frightening, has the potential to lead a viewer to choose life.[81]

In a Christian understanding, seeing what is wrong and then imagining something better that includes truth, goodness, and beauty is what can return life, what can save as it activates ethical action. Yet the vexing question is that seeing, and the awakening of the imagination that aids in unveiling truth, goodness, and beauty into consciousness, cannot be conjured up at will, nor can that which energizes and celebrates be expediently manufactured. Something quite elusive is needed to activate such loving wakefulness. Toward the goal of creating the conditions that will bring about *asombro* with a flowering of seeing and imagining, religion and art can be understood as tilling the same prophetic soil.

Art, like religious faith, can foster a different kind of consciousness, and the religious life must also tap into the potential brought about by wonder that can lead to transformation—or, in religious terms, conversion. In experiencing art that causes *asombro*/wonder, we move past certainty into humility, where we are surprised by what we see and presented with the opportunity to reflect upon our choices.

The quality of wonderment caused by encountering mystery is the catalyst for the awakening of seeing, which in turn produces the fruit of transformation through imagining. Mystery is a difficult quality to identify in art, and although often spoken about in theology (as

my grandmother and Aquinas demonstrate), it frequently appears as
an evasion. In the Christian tradition, the understanding of awesome-
ness has been varied and we could even say at times contradictory.
However, in relation to seeing and imagining, it seems enough to
acknowledge art's privileged position in creating that sense of a mys-
tery that wants to be known, and which initiates the process of won-
der. If we agree that critiquing and energizing moments are urgently
needed, *their irruption into our consciousness has to be aided*. The very
nature of a consumerist society colludes to blind us, and religious fun-
damentalism also thrives in this blindness. The fate of our beautiful
blue planet and its many lively inhabitants may depend on our capac-
ity to see the good, the true, and the beautiful.[82]

As we explore the experience of wonder, we note that creative
works are efficient activators of an irruption of new consciousness
in the human community. However, most traditional approaches to
the study of the arts do not have their religiously revelatory role as a
primary question (many times it is not a question at all). In desiring to
notice our need for prophetic wonder and to build a bridge to revela-
tory moments, we must develop a productive way to deal with the
arts. This method must seek to relate the arts and theology in such a
way that artistic works can fulfill their potential for prompting revela-
tory wonder. As we see positively in *La Pastorela* and sometimes nega-
tively in works that break our heart, art's revelatory work is centered
on bringing the human person to the awareness that they are alive
and free and that transformation is possible.[83] The arts can be sites
of resistance to repression, superficiality, self-centered idolatry, and
easy answers. Religious insight in a work of art is not simply about
its obvious spiritual or religious dimension, what we might call its
devotional function. To activate religious insight is to set in motion a
transformation in the viewer such that it "evokes loyalty and devotion
to one another and to the divine."[84]

Works of human creativity can remind, challenge, argue with,
and inspire us back to embrace the difficulty of a truthful engagement
with life, even when such engagement is uncomfortable and destabi-
lizing. Art can function as theological reflection, as theology, when it
prompts such a movement of seeing and imagining, and when it pro-
poses a possibility that answers, at least partially, the question, "What
do we do now that we see?" Works of creativity may do this by
pointing beyond the pain to the source of hope and by invoking the

possibility of building a community of resistance and then of vision. García-Rivera calls this "loyalty and devotion to one another," and as such it could theoretically function in a secular way. Yet what theological reflection interlaced with such art can disclose is that to work affectively to bring about transformation, an entity beyond ourselves, an entity that unifies us into an "ourselves" rather than a succession of separate "selves," must somehow be glimpsed. Thus, García-Rivera's complete thought is that religious insight evokes "loyalty and devotion to one another and *to the divine*."[85]

In prompting love for one another united to the divine, we note that the aesthetic is constitutive of the ethical.[86] The word community/*comunidad* alludes to a perceived unity, and the unity that people experience in aesthetic objects produced by persons and civilizations often long dead must of necessity appeal to something beyond time and beyond the material, otherwise such a perception of community (as elusive as it is) would be impossible. Theological aesthetics can help unpack this *pointing beyond* that is implicit in much art, as a moment that effectively opens us up to the infinite. "What do we do now that we see?" is not just a question of outward ethical action, but of fundamental beliefs, of inner transformation.[87]

Theology can help unpack the insight of what it means *to see and to care that others also see*. Works of art can be redemptive if they help build communities of vision and renewed purpose; art and theological reflection may work together to bring to light what is wrong by imagining how something may be righted. As philosopher Josiah Royce perceived, "unsettlement" does not mean that "truth is inaccessible . . . [or] transient" but that there is something he termed "the eternal," which requires a search.[88] In the end, art that is redemptive will be so because it makes the promise of truth and the eternal awesomely *felt*.[89] Art wounds us, and then offers the possibility of a balm, which mysteriously comes from somewhere much beyond us.[90]

Creative works engender wonder in us because they effectively pass along someone else's experiences of wonder in a way that approximates such experiences. With proper theological tools, we may also be able to recognize the pain expressed in works that have not yet found love and thus convey search, despair, or loss. What is counter to the work of wonder is not the revelation of difficulty, but the deadening of our questions through superficial evasion. Consumerism and materialism stand between us and the truth of our humanity because

they substitute love of God with the pursuit of *what is not* God, which promises the lie of fulfillment. Experiences of wonder through the arts can help us distinguish between the lie of invulnerability and the truth of our dependence on God. Jesus' summation of his work among us was about awakening all our senses and bringing fullness of life.

Having established this common ground for art and the religious in the joint imperatives of seeing and imagining prompted by revelatory wonder, in the following chapter I want to look at another specific event. I believe that through the examination of this exhibition, some of the questions inherent in the relationship between art and the religious may also be . . . felt.

4

Seeing (as) Salvation, the Hope of Art and Religion

*I*n an earlier period of history, the work I wish to do in this chapter would have been next to impossible. *Seeing Salvation* is an art exhibition I did not visit, taking place in London while I was a struggling graduate student living over 5,000 miles away in Los Angeles. But today, technology allows me to view the exhibition on video, as well as delight in gazing at stunning full color digital reproductions of the works.[1] Beyond this, powerful search engines and databases allow me to visit libraries around the globe and read newspapers, magazines, church bulletins, and transcripts of radio and television accounts all commenting on this one event. My experience, although from a distance, benefits from these multiple perspectives. Happily, over a decade later, my visit to London's National Gallery finally allowed me to encounter many of the works in person, and confirmed their wonder-making power.

As a scholar, I am an outsider to this event, and if there are books to be written about behind-the-scenes plans that fell apart, negotiations, or compromises, those will have to be written by others. In a way, although this exhibition is contemporaneous with me, I have a distance from it that mirrors the kind of gap we sometimes disregard as we look back at history or engage communities that are very "other" to us. I acknowledge this gap and also find it enticing.

From my vantage point, one of the factors contributing to my curiosity about this art and religion event was its title—*Seeing Salvation.*

The exhibition's very name suggests the awakening of revelatory wonder through seeing and imagining, and the commonality of this impulse for both art and religion. My interjection of the adverb "as" suggests a look at this exhibition in tandem with theology.[2] Through this exhibition we can explore how "seeing" is an artistic category referring to the senses, while also being a theological category referring to a fullness of life in God. Through this we arrive at a corrective against dualism that interlaces sensual seeing with spiritual seeing. *Seeing Salvation* could refer simply to the process of walking through a museum looking at paintings about Jesus, wonderful for their form and execution. Yet, the binomial *Seeing Salvation* makes explicit that what is being seen in these portrayals of the life and death of Jesus is *Jesus as the Christ.*

Analogous to the work of the Gospels, both for those producing the art and for those who may receive it in its fullness, "salvation" is the subject matter, and Jesus Christ is the One who brings it. From this the name of the exhibition takes its inspiration. What the expansion to Seeing "as" Salvation makes explicit is how this art functions theologically: it is in the very process of "seeing" this art, and engaging what has been called the "Catholic" or "analogical" imagination,[3] that we are opened up to "an insight into the need and way of salvation"[4]—Seeing (as) Salvation.

Pushing Boundaries

The decision to study this singular exhibition in London allows me to set forth a number of central considerations. Although an artwork may fall into traditional categories such as sculpture or painting, in approaching it theologically it is helpful to situate it more broadly in the general world of art. Second, although a work is particularly located in a historical, ethnic, racial, or gendered context, it is important to resist reducing it only to that context. Third, although a work of art may arise out of a very particular religious milieu, the differences and debates even within that religious community should not be overlooked. Finally, a work may have been produced in a time period that is quite remote from our own; however, a theological approach should also make an effort to have it address contemporary concerns.

In a broader sense, in looking at the situation of art and the religious within the context of our age, what I want to address is *art as*

creative making that expresses humanity's deepest longings: "[Religious art] is the visual language in which the great artists—Rembrandt, Michelangelo—have spoken to us about the biggest things. . . . Christian imagery has given European art a visual vocabulary in which to talk about love and loss and hope."[5] It is this articulation of "the biggest things" that helps us situate the inseparability of art and religion. It is indeed a seeing and imagining that is "more than mere enlightenment but also redemptive."[6]

The exhibition *Seeing Salvation: Images of Christ in Art*[7] ran from February 26 to May 7 , 2000, at the National Gallery in London,[8] and presents a singularly fruitful opportunity for "pulse-taking" of the state of the relationship of art and religion in the English-speaking world. Granted, some aspects of the event are reminiscent of an earlier time, since a venerable art institution in a European capital mounted the exhibition.[9] Yet this was not simply a nostalgic nod to Europe's glorious (and imperial) past, something that by itself would not speak and perhaps even be inimical to the present situation. As a millennial exhibition marking the start of the twenty-first century, the radical difference inherent in the historical circumstances of the present world lent *Seeing Salvation* an unmistakable air of controversy. The exhibition provides a framework through which questions about the current state of the relationship between the artistic and religious can be discerned and analyzed.

The Religious and the Secular

Scholars of art from Leo Steinberg (writing in the 1970s) to Neil MacGregor (preparing the *Seeing Salvation* exhibition thirty years later) have understood that secularizing tendencies can be profoundly problematic to the reception of art.[10] Undoubtedly, by the beginning of the twenty-first century, the problems that Steinberg had categorized as nineteenth-century scientism had deepened.[11] As Pope John Paul II notes in his millennial *Letter to Artists*, humanism became bifurcated in the modern era. While Christian humanism "continued to produce important works of culture and art another kind of humanism, marked by the absence of God and often by opposition to God, has gradually asserted itself. . . . [Consequently] many artists have a diminished interest in religious themes."[12]

What John Paul II identified as a disjunction in modernity between the realm of the arts and the realm of religion, is indeed most readily noted in the decrease in the production of works with explicitly religious subjects. Yet this is only the proverbial tip of the iceberg. That very same year, John Paul II himself was unveiled as a work of art in Maurizio Cattelan's life-sized installation *La Nona Ora* (*The Ninth Hour*).[13] Even though the BBC described the piece with implausible nonchalance as "the pope being hit by a meteor," *La Nona Ora* confronted patrons at the Royal Academy's *Apocalypse* exhibition with something surprising and shocking.[14] In it, a hyperrealistic, life-sized, fully dressed wax sculpture of Pope John Paul II lies prostrate on the floor. The pope holds his shepherd's staff before him (topped by the figure of the crucified Christ) and is apparently struggling to get up as a very large meteor holds him down. In the installation, the meteor is presented as having just struck the pontiff, and there is broken glass strewn about. The Italian Foundation that commissioned the work explained that Cattelan's art functions as "a personal theatre of the absurd," and added that the artist takes no "moral or ideological position, concentrating instead on reproducing reality in all its complexities."[15] Although *La Nona Ora* deserves a lengthy discussion, I want to make just a few quick observations since the close, yet oppositional, relationship between the National Gallery's *Seeing Salvation* and the Royal Academy's *Apocalypse* did not go unnoticed and is helpful to the broader discussion.[16]

Unlike the problem identified by John Paul II of artists no longer being interested in religious subjects, *La Nona Ora* presented a decidedly religious subject: the pope dressed in liturgical vestments. Thus, rather than avoiding controversy, *La Nona Ora* was baiting it, perhaps even banking on it for commercial reasons.[17] Surprisingly, the "controversy" paid off in the art world but did not bring in viewers. As reported by the BBC, attendance suggests that visitors preferred *Seeing Salvation* over *Apocalypse* by a ratio of five to one.[18] The reasons for this overwhelming preference are difficult to determine, but a sociological study of *Seeing Salvation* attempted to gauge responses to this exhibition. These responses give us a glimpse of what *Apocalypse* may have been missing. In interviews and analyses of written materials, what emerged was a picture of visitors and critics who had reactions to *Seeing Salvation* on a spectrum that ran from a highly charged "sense of presence," which we might associate with liturgical spaces

and rituals, to a sense that the visit constituted an actual devotional "pilgrimage."

Even as the responses became less religiously and confessionally specific, there was often a sense of spiritual awakening. Only one quarter of responses were essentially disengaged or had a negative reaction to the *Seeing Salvation* exhibition. What is more, these responses seem aimed at a general dislike of Christianity, which for me raises the question of why these persons went to the exhibition in the first place.[19]

As the overwhelming majority of the responses suggest, *Seeing Salvation* engaged its visitors in a healing relationship, while *Apocalypse* quite self-consciously shocked and destabilized. What is noticeable here is that the beneficial relationship between the art and the religious was mutual in *Seeing Salvation*. The bridge was a real bridge; it went both ways. Religion clearly benefited, as one visitor explained, "Art drew people to God once—perhaps it can do so again?"[20] But art benefited as well, as another visitor explained, "I came to this exhibition as a Christian, but now I wish to visit the Gallery as an art lover (in training)."[21]

As exemplified by *La Nona Ora* and Cattelan's alleged refusal to take "a moral or ideological position,"[22] art is attractive because it engages viewers even if artists allege that their completely relativist attitude absolves them. There are moral and ideological positions that are explicit in *La Nona Ora*, even if some are indeed quite ambiguous. But then, ambiguity itself is a moral and ideological position.[23] The intent to shock through the use of a figure of a revered spiritual leader insinuates a stance where such depictions are sanctioned either as mockery or as signs of resistance.[24] Also, whether the meteorite striking John Paul II is interpreted as heaven's last word before the Apocalypse, or as a rock thrown by the secular world at the most recognized human symbol of organized religion, or in myriad other ways ranging from the respectful (the pope appears to be valiantly struggling against what has felled him) to the camp (the figure of the pope as twentieth-century kitsch), Christianity, and most specifically Catholicism, is the undeniable object of the commentary. There are "ideological or moral" positions being questioned and/or ridiculed by this piece of art.

Most intriguing though, is that the disjunction *La Nona Ora* discloses is not between art and religion, but between "art" and the

viewing public. Indeed, what critics found most puzzling was that the British public preferred "the traditional" *Seeing Salvation* to "the shocking" *Apocalypse*.[25] As the sociological study of *Seeing Salvation* concludes, the exhibition shows that "it is still possible to pick up signals of transcendence—to gain a glimpse of the grace that is to be found in, with and beneath the empirical reality of our lives."[26]

Thirst is not quenched by being mocked for having it, but by receiving water.

The "Art World" or Art in the World?

Seeing Salvation, which was the single most attended British art exhibition in two decades, should not have been successful.[27] Not according to the critics anyway. Here we had an event full of "dead artists and traditional themes" that was deeply appreciated by the public while the new and daring work at *Apocalypse* played to empty rooms.[28] Critics struggled with the meaning of visitors flocking to see images of Jesus, and this provides an opportunity to explore the relationship between the art world and art in the world. [29] For instance, a radio report from Australia's Radio National offers an arresting interpretation, pointing out that the exhibition provided "a great meditation . . . on the central question of all: How we have seen Christ, how we have formed his image, and how his image has formed us as a civilization over 2,000 years." This was, they added, editorializing, a triumph by the museum "where the churches have failed."[30] In this broadcast, the divide between Art and (organized) Religion is deliberately emphasized and the exhibition positioned confrontationally against the church. Yet, while calling attention to the failure of the churches (a predictably secularist position), the report notes it as a *religious failure*, not one of attendance numbers, revenues, or political clout. The divide is articulated as art's superior ability (by contrast to the way many contemporary churches approach it) to make Jesus Christ visible, central, and accessible to the culture. We can note here the reviewer's appreciation of the efficient working of the evocation of wonder in *Seeing Salvation*; through the exhibition, religious art newly enters the world in a transformative way. The commentary is that the churches are largely irrelevant precisely because they have failed in bringing people to the kind of felt relationship with Christ that the exhibition achieved.

Simultaneously, *Time Europe* was centering their report of the exhibition on the idea that "Christian imagery has formed the foundation of Western culture," and that "the show is not about organized religion, but rather Christianity as a cultural and historical force."[31] In *Time's* approach, along with a biting critique of organized religion, there is added the dismissal of the religious. Two realms rightly separated in the Australian broadcast—the religious and the organized structure of religion meant to support it—are here conflated. For *Time*, it is not only the evangelizing work of the church that has become irrelevant, "the religious" as a valid category for a contemporary exhibition is rejected. In this view, art matters and a religious worldview, well . . . we are over it. The report reinforces this negative view of religion with quotes from a visitor who says, "I wouldn't call myself a raving religious nut, and I don't go to church, but I can still appreciate the art." A cultural critic adds, "Unless you're completely illiterate, these things have got allusions, nostalgic reminiscences, tattered memories. . . . If you prize the great rich past of European imagination you cannot possibly rid yourself of that."[32] Thus, despite its title, *Time* saw the exhibition as being only about art, and from their polemical comments we can surmise that a group of artworks about sailing ships might have been just as compelling.

In stark contrast to *Time's* studied distancing of the exhibition from its Christian content, *Seeing Salvation's* curator Gabriele Finaldi saw it quite differently. The exhibition, he contends, centrally explored "how the challenge of representing Christ has been confronted over two millennia." He adds that the questions the artists explore are Christological questions demanding "that artists choose what kind of Christ they wish to show," and that the artwork is "therefore in some sense a statement of belief, a sort of visual theology."[33] Finaldi shows a renewed ease with the inseparability of art and religion that is both admirable and heartening. *Seeing Salvation*—the exhibition he understood as being simultaneously about art and about faith in Christ—was in his view poised to restate productively some important theological questions.

Fine Art for the Few or Great Art for the Many?

While helping us see more clearly the implications of our contemporary secular/religious divide, the *Seeing Salvation* exhibition also confronted

elitist attitudes about art. Since its inception in 1824, Britain's National Gallery was conceived not as a privileged and rarefied place, as many modern art museums have regrettably become, but rather as "a gallery for all."[34] Although it is clear that the National Gallery does not explicitly challenge the concept of "fine art" as such, its stated mission is to make art it considers fine available and accessible to the entire community.

That art has a certain universality which makes it accessible to the many and not just the few is not a tangential issue when it comes to the work that art and religion can accomplish together. Referring to the activation of seeing and imagining, when this possibility is restricted to select groups it fails to penetrate the culture in a prophetic way. There will always be "insiders and outsiders" in any symbolic system,[35] but the wonder evoked by aesthetic encounters can provide a crucial first step in getting to know the "other." It is clear that both art and religion can fall into exclusivist categories and hermetic, self-referential spaces. These become mute spaces where little is seen or imagined. As García-Rivera stresses, genuine art "does not take place in some isolated place away from the ordinary cares of the world but in the midst of the garden of good and evil."[36] Thus, the positioning of art in relation not only to the secular culture, but to class, ethnic, gender, and other presumed divisions within a culture, can likewise challenge theology to engage the community's reality. Exploring who is invited to be part of the community it is addressing is a fruitful question that should be asked by both art and religion.

Because attendance numbers rarely disclose the nuances that the question of who is invited poses, I also looked at the "buzz" surrounding this exhibition; it is here that the culture as interlocutor can be discerned. One particularly interesting preamble to *Seeing Salvation* that implicitly emphasized the question of who the exhibition was addressing was the exposition of Mark Wallinger's *Ecce Homo*, 1999, outside the National Gallery (Plate 4.1).[37] Although preceding *Seeing Salvation*'s official opening, it is included in the exhibition catalogue and clearly understood to be related.[38] The sculpture, conceived for the "empty fourth plinth" of Trafalgar Square, was taken down just before the opening of *Seeing Salvation*.[39]

The depiction of Jesus Christ at the moment in Scripture when Pilate presents him to the mob (John 19:5, a favorite of artists from Murillo to Rembrandt) was instantly controversial and a theologically

charged provocation. By design only one journalist was present at the
statue's unveiling, and he begins his report by noting that unlike in
Catholic countries, public images of Christ or the Virgin are rare in
Britain. He also notes that Trafalgar Square has become a quintes-
sentially commercial spot, and we are certainly unlikely to encounter
Christ at one of the shops.[40] The exclusive article for *The Guardian*
newspaper's Arts Features, cheekily titled "The Day I Met the Son of
God," demonstrates the kind of contradictions that are often a hall-
mark of contemporary urban consciousness. It merits quoting:

> Ecce Homo is life-sized, and appears to be carved from marble. . . .
> The figure looks unclothed—not heroically naked, but undressed.
> . . . This is a putative Christ for our times: uncertain, vulnera-
> ble, introspective. It is an almost kitsch, very nearly camp figure.
> Christ's lack of muscle, his pallor and unfixable expression, his still-
> ness even, faintly recalls Piero della Francesca.[41] But he also, inad-
> vertently yet inescapably, brings to mind a fashionable gay clubber
> on bondage night, in ironic biblical drag.
>
> It would be a mistake to regard Ecce Homo as a purely, pro-
> vocatively religious sculpture. Perhaps we shouldn't see it as a
> sculpture at all. It raises questions about symbolic value, place and
> placement, private belief and public statement and affirmation, at
> the occasion of the millennium. Whether or not Wallinger is a
> Christian (he says he used to be an atheist, now he's agnostic) is also
> irrelevant. Plenty of lousy artists have profound convictions. But it
> is clear that he is not immune to the work he's made. Looking at
> the figure with him last week, it was clear that he is still coming to
> terms with it.[42]

Searle clearly wants his article to be disarmingly cool in order to ensure
access to the nonconformist hip art aficionados we can assume to be
his readers. Yet through *Ecce Homo* he is confronted by something else:
by universality, by timelessness, and by the paradoxical everydayness
of the Incarnation. His critique is brilliantly crafted because he does
not minimize these apparently opposing poles but articulates them in
all their contradictory richness. Here the "ambiguity" of art resonates,
opening the work to multiple readings by multiple audiences. One
can sense in the art (and in Searle's response to it) something of what
American critic and poet James Longebach calls "composed wonder."
A wonder that does not depend on a "recovery of ignorance, as if
such a thing were possible, but on the recognition that knowledge is

beside the point," this kind of wonder, the poet suggests, is aroused in us not only by the "argument" of a work but by the very shape and way it is said, how it is "composed."[43]

Ecce Homo indeed engenders composed wonder as it places one Jesus of Nazareth in front of the people he has come simply to love, only to be condemned and crucified by them. The wonder of having his figure stand before us is that in this sculptural composition we are apparently placed as judges, yet instead the work judges us. The interaction with us of the young man (the one we know and yet do not know) on the plinth rushes over us in myriad and contradictory feelings. We are judged by *Ecce Homo* and made vulnerable by his disarming vulnerability. From the plinth, standing precariously in the elements, Christ newly imaged for the twenty-first century is exposed to and confronts the city of London in paradoxical serenity. Christ is alone; will anyone come? Will anyone see? Paraphrasing Joan Osborne's 1995 megahit, what if the Son of God "is just a slob like one of us?"[44] The traditional art question about the original placement of a work *in situ*[45] here refers to Jesus Christ in the contemporary world and in relation to us all.

Religious Literacy or Religious Indifference

As Wallinger's Christ seemed to wait quietly for humanity to notice him, the question many were asking was if humanity would come. Would anyone care? *Time* magazine's report stresses that the response of viewers depends greatly "on religious background" since, due to decreasing church attendance, it can be surmised that "the theology that underpins the paintings, and much of the symbolism is lost on a modern audience."[46] *Time*'s underscoring of the problem of religious indifference is supported by a number of studies. In England, where church attendance and participation have been declining steadily, the figures are clearly troubling for the church. Yet, the National Gallery's insight in planning the exhibition was to note that a religiously disaffected public is also problematic for the continued relevance and appreciation of the arts, and quite pragmatically, for the National Gallery itself:

> When you walk through any of the world's great collections of European painting, you cannot fail to notice how many of the

pictures—and how many of the greatest—deal with the life and death of Jesus Christ. . . .

Presumably these pictures and sculptures are still likely to be of interest to believing Christians whose faith they were made to strengthen. But most of the National Gallery's visitors today, like most of the population of Europe and America,[47] are not believing Christians, and these pictures may well appear remote or daunting.[48]

The gallery's director here sees both sides of a complex equation. On the one hand, in the last decades of the twentieth century fewer and fewer people were being baptized in England every year. At the other end of the lifespan, the believing community was slowly graying out of existence as funerals (51 percent) far outnumbered those being received into the church (35 percent). In a country with a population of 49 million,[49] the Church of England reported a Sunday attendance of a scant 1 million.[50] The millennium presented a unique opportunity, but one that the churches seemed unprepared to seize. As an article in the *Anglican Theological Review* bemoaned, hanging banners about Jesus' "2000th birthday" was not very "likely to encourage the unchurched to enter the doors."[51]

With evangelization clearly floundering and religion becoming irrelevant, we can expect a lack of formation in the Christian faith. Yet, the church's problem of declining membership is also the culture's problem, for the public's ability to access the symbols of Christianity, and of Europe's religiously complex cultural history, is indeed also waning.[52] The other side of the lack of church attendance, then, is what Neil MacGregor sagely noticed: illiteracy about the culture's symbolic legacy. Yet, it is more than this too: along with the inability to experience revelatory symbols, we lose the possibility of knowing the inner-life of the persons and communities who produced and received them.[53] The result is that the human person is severed from its past and from each other.

Art here embodies two functions then. The first, as noted by MacGregor and his team, is to provide cultural continuity, by defining and preserving the insights of a particular heritage through a communal symbolic world. It is a means of seeing that can promote unity between the individual and a larger world and culture in the repeated telling of the common human story. The second function is what provides the content for the first: the imaginative inner life of human

persons, their deepest concerns, and the very intimate questions of the human heart asked by those who have preceded us in our collective history. This encounter with mystery, with our personal, communal, and cosmically inscrutable depth, discloses our humanity, where we share our most intimate longings and also our despair.

In sharing our revelatory symbols, we witness the process of seeing that, through imagination, leads to insight, what critic Stephen Greenblatt calls "resonance." In a moving account of the beautiful (and I would add sacred) objects at the State Jewish Museum in Prague, he explains that

> resonance depends not upon visual stimulation but upon a felt intensity of names and, behind the names, as the very term *resonance* suggests, of voices: the voices of those who chanted, studied, muttered their prayers, wept, and then were forever silenced.[54]

The question of the consequences that follow from a culture's loss of its ability to understand its religiously revelatory art is vital. At the wider cultural level, secularized Western persons run the risk of losing much of their identity, because Western culture is intricately woven through with the Christian worldview.[55] In losing access to the multiple allusions that contribute to the resonance of an object, the culture loses the possibility of encountering all of the vital insights that the art is communicating, preserving, and celebrating. A culture that shares no symbols would lose its ability to think diachronically with any depth. The possibility of knowing how those who came before us *felt* is never more apparent than in their symbolic languages. I know the depth of mourning of human persons in Mozart's time best by the wounding of my heart caused by the notes of the *Requiem*: "aesthetics has existed since the first human heart was moved by the influence of the beautiful."[56]

The Christian tradition affirms that Jesus Christ teaches us how to be fully human. The beautiful in art can move our heart at its depths, bringing us to a state in which we are open to seeing Christ and imagining the reign of God he came to usher in. Aesthetics is about hope and the "theological dimension of art lies in that, ultimately, art interprets humanity to the human."[57] In this, art mirrors and makes transparent one of the ways Christ brings salvation. Just as a poet sees the wonder that art evokes as 'the reinvention of humility" and "the means by which we fall in love with the world," so

the faith that Jesus preaches and lives is best embodied as "admitting human powerlessness," which then opens us "to something other, something new, something to come."[58]

During the London Blitz, when all art was removed from the National Gallery, the decision was made to allow one lone work to be set up for viewing, a work to be chosen by the people of London. Of everything in the Gallery's extensive collection, two paintings were immediately clamored for: El Greco's *Agony in the Garden* and Titian's *Noli me tangere*.[59] The former is a moment when we can keep Christ company as his grief and foreboding overwhelm him on the Mount of Olives, and the latter, a view of Christ, triumphant after the Resurrection yet very human, loved, and very, very near. The people of London, it seems, needed Jesus Christ's presence and accompaniment as they suffered, so they could survive the horrors of the bombings.[60]

What the community's relationship to its art revealed was a profound theological insight about Christ's role in their lives. "Every month tens of thousands came to contemplate one picture. . . . In a way rarely before experienced in modern times, great paintings became part of everyday life."[61] Would twenty-first century people come see these same paintings? This was the question many were asking.

The Seeing Salvation Anomaly

Even if *Seeing Salvation* seems to have "triumphed where churches failed," there remains the bare fact that this was not a religious event but an "art exhibition" organized by a secular institution. As such, we can ask if such a religiously themed museum exhibition was anomalous at the beginning of the new century. I turn to the statistics for that year. The most visited art exhibition in the world in 2000 was *El Greco: Identity and Transformation* at the Athens National Gallery. The Greek Spanish painter's eminent status in religious art is indisputable, as is the religious nature of a great number of his works, but the exhibition was about one artist, not about his religious works. Beyond this, a look at the top eighty exhibitions in the world for 2000 reveal very few of what could be interpreted as possibly religiously evocative titles. We can count the two already mentioned, *Seeing Salvation* and *Apocalypse*, along with *Earthly Art—Heavenly Beauty*, Russia (St. Petersburg); *Sinai: Byzantium*, Russia (St. Petersburg); *Egyptian Art in the Age of the Pyramids* (New York); *Pharaohs of the Sun* (Boston, Chicago);

Kingdom Come: Botticelli's Nativity (London); *1,700 years of Christianity in Armenia* (St. Petersburg); *Regarding Beauty* (Washington); *10 Religious Masterpieces* (Newcastle); and *The Cross* (Naples). Among these, *Regarding Beauty* at the Smithsonian's Hirshhorn Museum was centrally concerned with aesthetics, yet steered clear of the theological questions that aesthetics stimulates. As one critic asked, is "the thing to take away from the exhibition . . . that every expectation that the beautiful have a canon, a form, an order, or even some weird sense of perfection is merely a self-fulfilling prophesy yielding something about beauty, but never what it is?"[62]

Clearly, beauty raises more questions than it answers, and this is fertile ground. To note the very inaccessibility of something that is experienced in sensorial terms is the kind of paradox that theology struggles with continually. The question of immanence (God in our midst) and the question of transcendence (the wholly unknowable God) must exist side by side in a constant and unresolved tension. As John Paul II writes, "If the intimate reality of things is always 'beyond' the powers of human perception, how much more so is God in the depths of [God's] unfathomable mystery!"[63]

Beauty, then, in its accessible inaccessibility through a work of art, can make us aware of this profound complexity—not only by the symbolic representation of the beautiful, but by prompting the movement of our heart in the quest of unattainable Beauty. As a poet explains about poetry, and which could be said about many artful things, "The poem lives not by its wisdom, which we already know anyway, but by enacting the discovery of its wisdom."[64] Art's theological function is this "enacting" of a process, which consists of "a rhythmic development arising from the interaction of the organism and the object leading toward a sense of purpose, wholeness, and integration, closing in a pervasive sense of meaning."[65] The promise that aesthetic experiences hold is of the most profound importance to our very being, because as St. Bonaventure comments about St. Francis of Assisi, "In things of beauty, [Francis] contemplated the One who is supremely beautiful, and led by the footprints he found in creatures, he followed the Beloved everywhere."[66]

In dealing with a religious subject, *Seeing Salvation* was an anomaly, and anomalies sometimes point the way to the future.[67] Noting the exhibition's singularity sheds light on its prophetic qualities. First, *Seeing Salvation* presented canonically religious art to a scarcely

religious world and it did this within a secular museum setting, while transparently acknowledging this setting itself to be an almost insurmountable problem. As the exhibition catalogue notes,

> the pictures, made to inspire and strengthen faith through public and private devotion, have been removed from the churches or domestic settings for which they were intended and hang now in the chronological sequences of the Gallery, not to the glory of God, but as part of a narrative of human artistic achievement.[68]

The overarching importance of original setting and function, now lost, was the National Gallery's problem. The gallery's team attempted to ameliorate it by employing another anomalous strategy, the organizing of the exhibition along Christological questions.[69] The sequencing of galleries began with the community's initial communication of Christ as "sign and symbol": this was Christ proclaimed and understood in relation to the human question of salvation. From there, the next grouping shifted focus to the fundamental question of Christ's human and divine nature. Here art shows its ability to speak where words cannot, as the impossible complication of the Christological formula of Christ's "dual nature" is transcended in carved marble, or painted in the luminescence of a sleeping Christ Child on his strangely somber mother's lap.[70] Not shying away from the most difficult theological questions, this gallery explored Christ in himself.

The next gallery set out to query the enigma and endurance of Christ's image, going further than sign and symbol; now the art explored the healing and other miraculous powers attributed to images of Christ, and the provenance of his iconic "portrait." In this gallery, then, the viewer was introduced to the idea of devotion and the job of art in fostering a relationship between the devotee and Christ, so that in the following two galleries the central subject of many Christian devotional practices, the Passion of Christ, could be explored. The works in these galleries presented the intense complexity of the way some Christian communities related to Christ's suffering, and especially the appeal to the viewer for compassion. The sixth gallery grouped works alluding to the Resurrection (*Noli me tangere*),[71] postresurrection appearances (*The Incredulity of Saint Thomas*),[72] and the Eucharist (*The Institution of the Eucharist* and *Christ in a Chalice Sustained by Angels*),[73] weaving these together so they interpret one another and open up the theologically rich theme of the saving body of Christ.

The last gallery brought out some of the great works of twentieth-century images of Christ. There, "the huge Dali *Christ of Saint John of the Cross* hung opposite Stanley Spencer's *The Resurrection at Cookham* . . . a huge painting, depicting the general resurrection at the end of time . . . it creates an atmosphere of delight and ease which evokes the joyousness of resurrection. It was a perfect close to the exhibition."[74]

Thus, and to general astonishment, *Seeing Salvation* became the fourth most attended art exhibition in the world in 2000, the third most popular in the "Old Masters" category, and the hands-down most successful exhibition of the year in London.[75] Tellingly as well, the two texts produced for the exhibition, *The Image of Christ: The Catalogue for the Exhibition "Seeing Salvation"* and *Seeing Salvation: Images of Christ in Art* are widely used in theology courses, exemplary in their successful engagement of Christology through the arts.[76]

Clearly, the unique features of the exhibition were many and their summary above suggests that it succeeded in effacing boundaries and long-held oppositional attitudes. Art "triumphed" in making Jesus Christ relevant to the culture where the churches were failing. The museum evangelized the church. The boundaries of inclusion and exclusion were pushed by making the exhibition free to the public and inaugurating it with a piece of outdoor public art (Wallinger's *Ecce Homo*). The exhibition tried to overcome the problem of the removal of the objects from their original religious settings by grouping the works according to theological categories instead of following a conventional art history scheme.

Additionally, the exhibition's success in contrast to *Apocalypse* also pointed to the disjunction between the "shock" the commercial art world thought would sell, and the nourishing "tradition" the public clearly preferred. Finally, the exhibition catalogues, reviews, and magazine and newspaper reports acknowledged that the complexity, contradictions, paradoxes, and sheer affective pull of this art could not be appreciated through exclusively formal approaches or through a conventional aesthetic. It is here that the theological function of art asserted itself, in evoking—as so beautifully represented in Wallinger's *Ecce Homo*—a prophetic wonder, as it met humanity's questions, not with propositions, but with an appeal to the heart. As one visitor expressed, "I am not a practicing Christian, I was moved to tears by many of the images."[77]

Even within the confines of museums and away from the religious functions creative works once fulfilled, the theological questions of God's immanence and transcendence and of our profound need for salvation rise to the surface in new ways. Perhaps there was even a bittersweetness to the museum setting, making believers and unbelievers alike aware of complex human communities that preceded us and are now long gone, a disclosure of our finitude and the creatureliness that is essential to the Christian life.[78] An event like *Seeing Salvation* has the possibility of functioning to disclose "the human need of salvation and also the way of that salvation."[79]

As the success of *Seeing Salvation* makes apparent, the community before the art (its audience) appreciated the coherence the organizers achieved in acknowledging that the works on display had a particular function beyond their formal beauty and that their function was theological. The insight about contemporary society that the National Gallery made evident was that the loss of literacy about Christianity would also mean that some of the greatest works of art in history could become irrelevant mute ciphers. The inclusion of one new work in the public square, Mark Wallinger's *Ecce Homo*, provided a glimpse into how the more historically remote art in the galleries functioned in its setting and in its time. The exhibition's unprecedented reach should also speak to the church about the thirst in the culture for the healing and wholeness so many reported experiencing as they visited the exhibition.

However, some of the circumstances of *Seeing Salvation* also reinforced the status quo inherited from modernity. Using aesthetic terms we might say that as much as the setting of *Seeing Salvation* revealed the hope-filled *chiaro* of the possibilities for the art and theology environment, it also exposed the very important *oscuro* of the limitations. Consequently, although scholars and the popular press touted the phenomenal success of *Seeing Salvation* as evidence that the icy relationship between art and religion was thawing out, when approached critically the exhibition and books embody some of the very divisions that the organizers professed to want to overcome. In the following chapter, I want to explore some of the difficulties that surface when we look at *Seeing Salvation* more closely.

5

Beautiful Differences

*I*t is fitting to celebrate the mingling of art and the religious in their common work of facilitating revelatory wonder-making. *Seeing Salvation* was a significant achievement as it brought the religious and artistic together in the midst of the aggressively secular environment of twenty-first century London.[1] The exhibition made evident renewal and appreciation, not only of classic religious works but of surprising contemporary explorations like Wallinger's *Ecce Homo*. These are hopeful signs, yet in that same panorama, difficulties in relating the arts and the religious also come into view. We could just ignore these disjunctures,[2] or, conversely, we could highlight them in such a way that we capitalize on the controversy. I propose we do neither and adopt a third posture. This third type of engagement does not minimize differences or difficulties, nor does it blow them up into a polemical frenzy, but rather notices them as productive sites for generating new knowledge. Those of us who have lived as "the other" for any significant amount of time often propose this third way as a fruitful way to engage. Past the equally unproductive temptations of forced homogeneity or confrontational polemics, there is thoughtful and respectful engagement.[3]

Of course, in order to interact productively with the difficulties in the relationship between the arts and the religious, we first have to notice these. The challenge is to see them in such a way that we

will not get hopelessly lost in them. Our purpose of building a bridge needs solid materials, and I propose we gain solidity by limiting our view and moving from abstractions to concreteness. Clearly, the engagement of difficulties cannot happen if we look only for commonalities in the way that is most often called the "intersection" of art and religion.[4] By "commonalities" I do not mean that which is in agreement, but that which is easily recognizable by both sides. If we visualize it, an "intersection" describes two discrete objects that cross. The moment of intersection is temporally brief and spatially limited, localized at a very precise point through which both lines pass at the same time: *this* is the mutually recognizable point.

For instance, art historians will readily concede that Barnett Newman's (American, 1905–1970) *The Stations of the Cross* series (1958–1964) has a title referencing Christianity. This is an obvious point of intersection. The longer title *The Stations of the Cross: Lema Sabachtani* may also be noticed, along with Newman's own explanation that "the theme of the series was the 'unanswerable question of human suffering,' underscored by Jesus' words on the cross, in the Hebrew subtitle, meaning 'Why did you forsake me?'"[5] This is promising, but it is at this very point that the moment of intersection ends. Without further engagement, the "you" of Newman's subtitle is meaningless. We do not know who it is Jesus is addressing, and knowing this is central to the work. Without reference to Jesus' agonized appeal to God, and without engaging thoughtful interpretations of the Scripture verse, Newman's series of paintings become tragically, and I stress *unnecessarily*, mute.

Regrettably, this type of intersection describes a great deal of scholarly work in the field of art and religion—brief, limited, begun apart, and continued apart. It is an "intersection" that, due to the lack of mutually recognizable signposts, too often leads to an accident.[6] This seems to be a problem of method, because the search for "intersections" requires seeking commonalities, and often commonalities can be forced and superficial. It also generally overlooks disparities and challenges that clearly diverge, which, as we will see, can be very fruitful loci for further inquiry.

Theology, speech about humanity's experience of God, cannot be appreciated in the reduced space of an "intersection" but demands the unity of an "insight." Although the term "insight" is sometimes understood as a sudden and temporary flash of knowledge, religious

insight is "more than a psychological event," engaging "the intellect as well as the senses in the context of a communal process of interpreting life and its reality."[7] What such a complex interaction suggests is that the religious insights made possible by wonder-filled encounters with art, and the further teasing out of complex theological "speech"[8] as revealed through these works, calls for a method that appreciates the uniqueness of aesthetic experience as dynamic and unitive.[9] As the American pragmatist philosophers, most especially John Dewey, point out, it is the very relationship between how something acts upon us (receiving) and our own actions (doing) that constitutes the aesthetic in human experience. Here, aesthetic experience is a process that results in the growth of meaning, and that needs development, space, and time "to unfold."[10] If religious experience and theological reflection are also constituted along the same dynamic continuum,[11] then intersection language, which homogenizes momentarily and separates eventually, is ultimately non-aesthetic, "proceeding from parts having only a mechanical connection with one another."[12]

Aware of the overwhelming influence that longstanding dualisms continue to have on Western culture, such that spirit/matter, the religious/secular, emotion/reason, and imagination/intellect are routinely pitted against one another, we can now look at *Seeing Salvation* to see how these play out in the particularity of this setting. Through the event of the exhibition, we can outline multiple considerations to guide a method that unifies while it maintains distinctiveness. *Seeing Salvation* was foremost an exhibition, but it was thoughtfully prepared, and then reflected upon. The texts *Seeing Salvation: Images of Christ in Art* and *The Image of Christ: The Catalogue of the Exhibition "Seeing Salvation"* reward the careful reader with a behind-the-scenes look at the show, and the motivations, methodological preconceptions, successes, and challenges encountered by its organizers.

The Problem of Art and Truth

As both exhibition texts and many of the media reports underscore, what we have noted as a triumph, namely mounting the exhibition at all in the midst of Western Europe's aggressive secularism, also allows us to glimpse the context of fear and constraint these conditions create. In such an environment, the National Gallery and its director are forced to walk a tightrope as they try to steer clear of any perception

of religious commitment. Their repeated explanations of the motivation for mounting the exhibition center on highlighting that for most of European history "the fact and meaning of Christ's life and death were the most important *notions* that could be addressed."[13] The use of language here is curious but explainable given the circumstances; nevertheless it has an unintended consequence—it forces the exhibition's organizers to implicitly deny the truth claims of the faith communities that produced the works.

Perhaps for the art historian or critic, an artwork's technical virtuosity in illustrating some now far-off (quaint or strange) idea is enough. Yet, this fails to respect the integrity of the work and those for whom (and from whom) it was made. Christianity is not an ancient dead religion: it is very much alive.[14] What noticing this disjuncture makes evident is that when a work of art is produced in the context of a religious tradition, the truth claims of that tradition are inseparable from the work's artfulness and beauty.

I have no doubt that the National Gallery was keenly aware that untold numbers of persons have preferred death to acting in a way contrary to their Christian faith. Again, we are not speaking of an ancient phenomenon. In England, just two years before *Seeing Salvation* opened, Westminster Abbey unveiled a series of statues for its exterior niches commemorating some of the best known Christian martyrs of "our century, which has been the most violent in recorded history, [and] has created a roll of Christian martyrs far exceeding that of any previous period."[15] Among those memorialized were Dietrich Bonhoeffer (d. 1945), Martin Luther King Jr. (d. 1968), and Archbishop Oscar Romero (d. 1980). We cannot attribute their unflinching steadfastness in Christ to the secular understanding suggested by a "notion."[16] Thus, we note that even if speaking of Christianity as a "notion" puts at ease a secularized public suspicious of religion, it also labels the entire content of the exhibition "notional," which means speculative or theoretical—the word also used in other reports.[17] To say that Romero, King, and Bonhoeffer died for a notion must be denounced as a lie, and this helps us understand the truth claims of Christian art.[18]

The fear of losing favor from a secular majority causes art institutions to distance art from its historic and enduring religious commitments, and thus reduces art to illustration. Yet, this impoverishment cannot be blamed solely on secularism, since the church has often

contributed to this interpretation. From the time of Pope Gregory the Great (540–604), the defense of the use of images in church buildings against iconoclastic critique has often centered on the argument that images must be allowed so that "those who are ignorant of letters may at least read what they cannot read in books by looking at the walls."[19] Gregory would be surprised to find out that rather than strengthening the evangelizing reach of the faith through art, this view can be used to diminish it. If the religious "books" the pope alludes to are no longer perceived as truth, then the artworks become once-removed illustrations of now-discredited "notions." If, as reports surrounding the exhibition show, an encounter with art may sometimes awaken faith even when the traditional propositions of religion are failing,[20] then art is not merely illustrative—it, like the martyrs, makes a bold claim to truth. Art is testimonial and witness.

As the depth of truth revealed by the faith of martyrs (a religious insight) helps us better understand art's claim to truth and its evangelizing function within the society, so the *way* art appeals to truth (an aesthetic insight) may help better articulate what the church means by religious truth. The difficulty of clearly communicating the key beliefs of the Christian faith is well catalogued in the long history of the church and its many councils and schisms. Concepts, such as the nature of Christ, were passionately debated and argued over, and eventually, the church's authoritative body settled on careful language to resolve the matter. The language of the Council of Chalcedon (451 A.D.)— "We confess that one and the same Christ, Lord, and only-begotten Son is to be acknowledged in two natures without confusion, change division or separation"[21]—was meant to set the boundaries of orthodoxy, but it clearly did not intend to exhaust the mystery of the faith. Yet, since Chalcedon and in many of the expressions of Christianity, the positing of truth as a single propositional utterance has contributed to bitter separation and disinterested disaffection, impoverishing the revelatory power of the church's confession.

Art as Such

In contrast to the limiting univocity of a dogmatic statement, art can do two things at once: it can present truth unapologetically and also expansively. In this sense, art can function in a way that is dynamically responsive. For instance, in looking at John August Swanson's

serigraph *The Last Supper* (2009, Plate 5.1), I may be initially attracted to it because of its beauty in the shimmer of colors and the harmony of forms.[22] We might call this quality "firstness" or "presentness."[23] When applied to a work of creativity, it reveals it as quite other than ourselves, endowing it with the potential to act unexpectedly upon us. The otherness of the art—its integrity as being something in itself and not simply an extension of my self[24]—is an important distinction because as such it resists subordinating the work to the kind of self-referent individuality and subjectivity that only focuses on "what *it* (the creative work) means to me." At the moment of encounter, *The Last Supper* exists,[25] and how it and I will interact is not yet fully realized; it is a possibility that is full of mystery.[26] In this radical otherness of the art from ourselves is the promise of surprise and wonder, which can only happen when we are open to a "radical receptivity."[27]

In trying to understand the expansive nature of aesthetic experience, this quality of firstness, or of the "subject's being positively such as it is regardless of ought else,"[28] is important to recognize and preserve, and contributes to preserving truth claims against a diluted subjectivity. *The Last Supper* is about Jesus the Christ in itself and this claim is incontrovertible.

It is my encounter with the work, and the painting's encounter with me, that begins to actualize the possibility latent in the artwork's existence and mine. *The Last Supper* and I begin a dance in a very particular moment of time and space, in an "interplay of action and reaction"[29] that moves us both into the uniqueness of a relationship. If I have been open to this initial otherness, as I gaze at the work there will be an experience that could result in the activation of my powers of reflection.[30] Because of the encounter, each of us (the artwork and I) will acquire "an element of being what another makes [us] to be."[31] In other words, once we have met and begun to dance, there is no going back. In this instance of "secondness" there is constituted an "event . . . of the general nature of *experience* or *information*."[32] As we are first our *selves*, secondly, we are brought together—changed by this moment of contact.

This idea of secondness makes us aware of the irreducible dynamism of experience. Just as we respect the otherness of art from ourselves, here we come to notice the element of action in our life. *The Last Supper* and I may have met by chance, or I may have been actively seeking it, but either way, something happens, and in that happening

is revealed a religiously significant feature of encountering creative works—the importance of cultivation and practice. By this I mean that the activity of going out of ourselves and encountering the otherness in the experience of art can be a spiritually fruitful practice because it fosters self-emptying, humility, and being present.[33] The cultivation of this "disposition"[34] to openness and receptivity, which is activated by art, can bear fruit in all aspects of human life. Even before being interpreted and at its most basic level, my encounter with Swanson's *Last Supper* can have the salutary effect of increasing my awareness of the intensity and diversity of color, of experiences, of sharing food, of starlit skies, and of the beauty of community. *The Last Supper* thus makes my subsequent encounters with colors and suppers and stars all come alive, and thus helps me notice that aesthetic experience is integral to the "processes of living."[35]

Swanson's work, and indeed most truthful works of art,[36] develop and accentuate "what is characteristically valuable in things of everyday enjoyment."[37] In this event of encounter, we do not yet have any content or reflection, but an appreciative and enlivening unfolding of the mysterious depth of life.

It is through what may be called "thirdness" that what we commonly understand as "knowing" actually begins. By acknowledging the otherness of what is not me, and by being confronted by something that enlivens reality, I am already significantly engaged and changed. In thirdness, the event of encounter now bears more fruit and "brings information into the mind, or determines the idea and gives it body [as] informing thought or *cognition*."[38] What helps to differentiate further art's expansiveness from the demarcating nature of dogmatic propositions or creedal statements is that it is the combination of the otherness of art and its life-affirming confrontation with me that finally "renders reality significant and therefore intelligible."[39] Returning to the idea of art's role of mediating revelation, by positing firstness as the artwork's individual existence, and secondness as the event whereby we are brought into contact with it, we have allowed the experience of art to have a life outside our subjectivity, thus affirming "that human knowing has a sensuous origin and engages symbolic mediation."[40]

The complexity of this unfolding interaction brings to the foreground the unity of past and present. Every rendering of the Last Supper I have known (persisting somewhere in my memory, even

if half-forgotten) will inform my relationship with Swanson's work, as will my knowledge of the Scripture passages he is interpreting (or my ignorance of them). Beyond this, family meals, soup kitchens, student pizza parties, and ritual food sharing of all sorts will find their way into my expanding conversation with Swanson's work. However, it is the confluence of Swanson's Latino Catholicism and mine that will most vividly bring into focus every Holy Thursday liturgy I can recall and yield multiple religious insights.[41]

The sheer amount of explicit connections I can make with Swanson's *Last Supper* is evidently staggering, and this multiplies exponentially when I engage with what might be implicit, uncomfortable, and contradictory, and most especially, what displaces *what I thought I knew* about Jesus' last meal with his friends and its meaning. It takes me an instant to recognize Swanson's serigraph as a depiction of the Last Supper. In the rapidity of my visual decoding of the work is the evidence of its continuity with a long iconographic tradition. To engage its viewers, the work depends on our ability to recognize it and be attracted to it. What is familiar here (owing much to Leonardo's paradigmatic depiction; see Plate 5.2) includes Jesus being placed in the center, three windows framing the background, and twelve disciples. These elements, we might say, are analogous to a proposition—repeated and familiar. But the more time we spend with the work, the more we may see. Is that really a halo on Christ's head or is it the moon in the window? Where is Judas; why can I not pick him out? Why is the wine not bloodred but more like raspberries? Why is the table round instead of a long rectangle?[42]

These musings lead us to question the overemphasis on Judas' betrayal by noting his intentional displacement and anonymity in Swanson's theology. The unconventional raspberry-colored wine reminds us that before it was the blood of Christ, this was the sweet wine of this Jewish community's celebration, or, vice versa, that the sweetest of all wines is the blood of Christ. As we continue, we note the inviting, nonhierarchical, and close-knit setting of the round table, and so on and so forth. The powerful truth of Jesus' gift of himself to human history shines unabashedly in the work, but in it we are also led to reflect and to question. In this, what happens as we experience art is a knowing of a different order that "transcends mere subjectivity, and draws the mind toward things known and towards knowing more."[43]

As with Swanson's example, the art exhibited in *Seeing Salvation* resists being reduced to illustrating ideas precisely because it *is art*. The process I outlined above, of encountering multiplicity and the limits of our initial understanding, forces upon us an attitude of humility. The encounter with a creative work of complexity "enhances self-awareness" and makes us productively awake.[44] Religiously, the works have to do with the unity of our life to the cosmic story of salvation, and with intricate relationships, both personal and communal. The art authoritatively explores an ontological reality that some may argue is materially inaccessible, yet to its communities of production and reception is utterly real, not notional; truth-filled, not imaginary. It is a truth that is more than logic and proof that pulses inside the Christian gospel. This depth of mystery is then brought into the material world through human creativity in art. The mystery confronts us in a way that a propositional statement never can because "for everyone, believers or not, the works of art inspired by Scripture remain a reflection of the unfathomable mystery which engulfs and inhabits the world."[45]

The works gathered for *Seeing Salvation* offer us a fleeting glimpse of the truth that was central to those who made and received the works. If we understand, as curator Finaldi saw, that the "early Christians did not represent the person of Jesus, so much as the belief that he was the Messiah, the Anointed One—'Christ' in Greek—the Saviour," then we are brought to encounter the depth of gospel proclamation, not only in the most ancient and most highly symbolic artifacts, but in all subsequent works about Christ.[46] These creative works are about salvation in Christ, believed and hoped for in the depths of the human soul.

I see a key to *Seeing Salvation*'s affinity to a theological understanding of art in Finaldi's use of the plural "Christians." As we have noted, by linking the truth claims of Christian art to those whose lives have been given for those truths, these works provide windows into the communities *behind* the art. These are works tied to a tradition, even if at times they may uncomfortably question that tradition.[47] It is by seeing these works in their full relation to Christians, that we note the difficulties that seeing Christian art as notional posits.[48] If the spring from which art flows is devalued (in this case by defining Christianity as speculative, ideal, or imaginary), the art flowing from it is also devalued. Further, if the ideas supposedly being "illustrated"

by the art lose their power, the art is made powerless as well. Art that is understood as springing from the depths and truth claims of a community retains its integrity and revelatory power. Additionally, as the arts arouse a revelatory wonder, they can invert the equation as understood by Pope Gregory and return the power of truth to the "books."

Art as Communication Problem

Having identified the problems posed by the question of truth, we can glimpse another related problem in the exhibition's organization. In his introductory essay, the National Gallery's director preemptively argues that there cannot be any expectation that *Seeing Salvation* will delve into "the theological intricacies of the Incarnation," yet what it is important to note here is that the exhibition *does precisely this*.[49] With the living community of faith in the background, the works quite purposefully delve into "theological intricacies," not supplanting the Chalcedonian formula, but exploring it anew through human capacities that expand upon rationality and argument.[50]

If we return to Pope Gregory's reasoning for art being the books of the illiterate, although art may indeed function legitimately in such a way, most art we have come to see as religious may be better defined not as a book, but as a bridge. Art can function simultaneously as theological reflection (speech about God) and as the experience that occasions such reflection (silence before God); in this, art becomes "living theology," and it does this not through proposing but through evoking.[51]

Although applying categories from communications theory to Pope Gregory is patently anachronistic, we can say that this is where the problem is situated. The pope's thought was that art could serve to *communicate* information that needed to be learned. This is indeed an impoverishment of what is understood as aesthetic experience.[52] From our vantage point, we can see that the art in the exhibition was not passively transmitting information but was arising out of a tradition reaching deep and wrestling with "theological intricacies" as living theology, and in every encounter it is potentially as alive today as when it was first articulated.

If we return to one common ground we have established for what is artistic and what is truly religious—the awakening of prophetic wonder through seeing and imagining—it becomes evident

that seeing must involve much more than the imparting of information if it is going to penetrate into "the biggest things" and, having penetrated these, move through to imagining.[53] The prophetic wonder at the heart of both the theological and the truly artistic cannot be nurtured (as it needs to be) by critique (seeing) and renewing (imagining) without a much broader understanding of human aesthetic experience than an exchange of information. Prophetic wonder involves the whole self. In both art and the religious, not only is *the way* we know different (not a passive passing on of information), but *what* we know (an insight that moves the human heart) is likely not accessible by any other means.[54]

A Different Way of Knowing

In one of his more theoretical texts, the poet Federico García Lorca wrestled with the questions of art's power. In "Imaginación, inspiración, evasión," Lorca defines the "mission of the poet" as "to animate, in its exact sense: to endow with soul."[55] Lorca contends that "the imagination is synonymous with the aptitude for discovery." The imagination is able to add a bit of light to the "penumbra where all the infinite possibilities, forms and numbers" exist and in this way "locate and give clarity to the fragments of invisible reality where the human being moves." From this exchange is born the power of the metaphor, but, Lorca insists, the "imagination is limited by reality: one cannot imagine what is non-existent." Thus he understands what we call imagination to have its boundaries, limitations imposed by reason from which it cannot break. Lorca pronounces the imagination often impoverished, and this is because he finds reality so much richer. For him, life contains secrets that are more astounding than the poetic imagination could ever contrive.

The real difficulty, as Lorca sees it, is that as much as an artist may wish to penetrate deep into the secrets of life, he/she will have to make use of what is generally perceived as real in order to do so. He cites the example of caves, and how the human imagination at first explained their existence by imagining a race of giants who carved them out. These giant miners were projections of the real world, where persons affect their environment through their labor, but imagined at a colossal level. Yet, the "secret" was much more beautiful and unimaginable—the drop of water working for eons,

quietly carving out the vault of a cave. Here Lorca's aesthetic rumina-
tions turn theological:

> The poet wanting to liberate himself from the imaginative realm,
> and not live exclusively from the image produced by real objects,
> stops dreaming and stops caring. He no longer cares, he loves. He
> passes from the "imagination" which is an event of the soul, to
> "inspiration" which is a state of the soul. He passes from analysis
> to faith. Here things are because they must be, without any expli-
> cable cause or effect. There are no longer either terms or limits,
> admirable freedom![56]

Lorca is a singularly gifted poet who speaks from experience, and his
insights explain that the process whereby artistic creativity is reached
and expressed must move into the ineffable and the unnamable, into
the "silence." As in the traditions of Christian contemplation, it is
here that the artist encounters and harnesses the power of love, which
in the Christian tradition is the power of God. Lorca's is a metaphysi-
cal stance, an implicit appeal to transcendence reminiscent of St. Paul's
poetically expressed theology, "for we walk by faith, not by sight"
(2 Cor 5:7).

If we further extend Lorca's reflection to radiate out from the
experiences of the poet to reflect those of the receiving community as
well, then we see the radical nature of this power in art that motivates
not an "event of the soul" but a "state of the soul," not a doing but a
being that leads the artist and the viewer "from analysis to faith." Art's
capacity to bring to faith does not spring from its didactic functions,
but from being an instance of "inspiration," drawing in breath, being
infused with Spirit. Some art has the ability not only to "deepen the
faith of the beholder" but actually "to activate it."[57]

Art as Catechetical Problem

Approaching *Seeing Salvation* with a willingness to deal with what
is difficult in the relationship between the arts and the religious has
helped to identify two concerns thus far. First, institutions outside of
the properly religious (museums, galleries, universities) may be tempted
to underscore their commitment to a secular world by reducing the
religious realm to the speculative and notional. Second, the exhibition
texts expose a related impulse to align works of art with the imparting

of information, with an impoverished modern rationality. These attitudes are united in *purpose*, which in this case appears to be to defend the National Gallery's decision to mount an exhibition of Christian art. Yet, these difficulties also help us notice the church's tendency toward propositional rigidity and the subsequent reduction in what the arts may be capable of accomplishing.

Along with these two difficulties, the exhibition texts posit a third as they explain that the artworks in the exhibition "were made to strengthen" the faith of believing Christians.[58] Many problems arise from this claim for the joint work of art and the religious. As we have already seen in the misapplication of Pope Gregory's argument, such a claim limits art to illustrative and didactic functions, the assumption being that there are canonical texts (such as the Gospel accounts of the Last Supper) that are subsequently imaginatively illustrated by artists (like Leonardo da Vinci and John August Swanson). In this interpretation, art is understood as useful; it has a defined and circumscribed teaching purpose. However, if the works were made to strengthen faith, the implication is that there can be no religious reflection or theology in and through art that is not explicitly and intentionally made as a support to orthodox faith. Further, art made exclusively to fulfill a doctrinal function cannot exist outside the boundaries of current ecclesial concerns, and is thus precluded from expressing a critiquing/renewing prophetic voice. Finally, if art is made solely to strengthen the faith of believing Christians, this makes it much less relevant to a less-than-Christian world, not more. In this case, we can surmise that the majority of the gallery's presumed non-Christian public would be woefully uninterested in the works presented in the exhibition.[59] I want to examine these questions carefully.

Is Art Catechesis?

It is true that works of art readily recognized as religious within a tradition bear within them the possibility of strengthening a believer's faith, but they may also threaten or challenge that faith or, more pointedly, its complacency. The prophetic role joins celebration and denunciation, and even a work that could appear to be merely illustrative, such as an image of Our Lady of Guadalupe, can be a site of resistance and a cry against a dehumanizing status quo, as in the murals of Mission Dolores in East Los Angeles.[60] Here, the image of *La Virgen de*

Guadalupe watches over a community in need of love and hope (Plate 5.3). Executed on an old, partially crumbling wall, in the midst of the city's poorest housing projects, homeless men and those who feed and provide a place to sleep for them walk under her gaze every day. Her bold colors speak prophetically of the undiscovered beauty in each of her children and proclaim solidarity with them in the midst of the most abject poverty.[61] The image stands as a witness to the community's faith, and an invitation to those others who would call themselves Christians to take action with and for them, to envision and activate their role in facilitating an overabundance of beauty that may spill into the threadbare sleeping bags at her feet.

Beyond challenging the conventionality and comfort of those claiming to be religious, art can also daringly confront the unbeliever. One such instance is recorded in a mesmerizing piece of literature by philosopher José Ortega y Gasset.[62] In the first-person essay, a modern Spanish man who describes himself as completely lacking imagination tells his reader about his experience of entering a Gothic cathedral. We can sense how disconcerted the man becomes as he confesses that he "did not know that inside a Gothic cathedral there is always a raging whirlwind." The man describes breathlessly how when "I had barely set my foot inside when I was snatched away from my own weight on earth." The tug of war that ensues is between the snatching whirlwind of God's overwhelming presence,[63] and the "earth where everything is firm and clear and where one may touch things and see where they begin and where they end." A key to the passage is that the man is *not* seeking a religious encounter, and even more, that his belief in the comforting limits set by the empirical (what may be touched and has a beginning and end) is completely destabilized not by intellectual arguments, but by his senses. He tells us that what before entering the cathedral he believed to be only imaginary "rushed upon me in an instant; every single thing was waiting for me in its hideaway or its angle as if knowing I was to arrive at that very minute on that very afternoon, alertly keeping watch, neck outstretched and muscles tensed, prepared for the jump into the emptiness." As the man tells the story, the encounter is inexplicably sudden and comes as "from a thousand places, from the highest dark corners, from the chaotic glass of the windows, from the capitals, from the remote signs, from the interminable angles, there leapt on me myriad of fantastic beings." Clearly, the man is not "reading a story" in the stained glass (as Pope

Gregory explained) but is instead fiercely jolted out of his illusory
safety by the intensity of all he encounters inside the cathedral. The
encounter is pre-reflexive and its evangelizing power is in its chaotic
and sensorial force. Ortega y Gasset continues,

> I could give a more conventional account of that commotion, of
> that mobilized *pandemonium*, of that self-propelled and aggressive
> reality; every single thing, in effect, reached me through a breath-
> less aerial race, exhausted, urgent, as if wanting to give me the
> news in velocious phrases, halting, yearning, of I don't know what
> terrible event, boundless, unique, decisive, that had taken place a
> few moments before, there above . . . I undid the step taken, closed
> the door behind me and found myself sitting outside, looking at
> the earth . . . then I remembered that obeying just for an instant the
> madness of the inhabitants of the temple's interior, I had looked up,
> there, to the most high, curious to know the supreme event that
> was announced to me.[64]

Didactic art could never accomplish this *pandemonium*. What Ortega
recounts is not a lesson but an interrogation, a living "commotion."
And what the practical Spanish man of the story encounters is an
opportunity for the wisdom offered in the experience of "the fear of
the Lord" brought about by the encounter with the whirlwind (Job
28:28).[65] If art is kept to the univocal function of strengthening faith, it
can only materialize as a second step, following on the heels of estab-
lished doctrine. In entering the cathedral, the one without faith, for
whom doctrine is at this point meaningless, is practically ambushed
by the art in its loud proclamation of a mystery wanting to be known.
As well-meaning efforts at the "modernization" of Roman Catholic
churches in the wake of the liturgical reforms of the Second Vatican
Council have demonstrated, the conflation of doctrinal clarity with
aesthetic sparseness negates the centuries of encounters with Christ
evoked and sustained in such mad beauty. Without that first awe-
inspiring moment of silent confrontation in my own experience as a
child with the image of Christ in Golgotha, I may have never taken the
second step of wanting to know more, of seeking the mystery. In the
end, past every doctrine, we will be sustained in our quest for God by
these moments of silence-filled wonder.[66]

 If created only to support or catechize (certainly one of the many
possible results of an honest interaction with art), art may perhaps be

classified as illustrating doctrine but it is denuded of the possibility of functioning as "inspiration," as an activation of a state in the soul that longs for the transcendent. Art as catechesis is certainly a "safer" and more conventional task for art but this seriously confines it. Restraining art is to go against its very central function of expanding and enlivening human existence.[67] The tendency of those in authority to attempt to limit art's voice is probably one of the principal reasons that in modernity artists, art critics, and others within the art world have been so adamant in proclaiming art's autonomy. As we will see when we study the strange case of the Church at Assy (chap. 9), the reasons for such proclamations are understandable from the point of view of art as restricted to illustration, but when they result in divorcing art from community and from life they hurt art's depth and relevance. Conversely, when art's expansiveness results in its banishment from our churches, this hurts the possibility of wonder-filled experiences for the people of God.

Finally (and this is certainly a more complex interaction), to see religious art as "strengthening" the beliefs of the faithful may (in an oblique way) acknowledge the "sacramental" nature of religious art, which goes much beyond teaching. If by strengthening we do not mean doctrinal assent, but rather the result in the human will and affections of encountering "a presence-filled event in which God gratuitously enables us to welcome the message of salvation,"[68] this allows a glimpse of the possibility of transformation that inheres in the moment of *asombramiento* made possible through art. Also, this expansion of the idea of "strengthening faith," made evident when we look at art, can help us better grasp the deep workings of the sacramental, which in classic definitions "cause what they signify."[69]

Perhaps the reports of reverent silence in the galleries of *Seeing Salvation*, the astonished newspaper essay about Wallinger's young Christ, the unexpected thousands of visitors, and the exhibition's continued reach into theological and religious studies through two richly illustrated catalogues make evident that in spite the many protestations to the contrary, the museum made possible a religious event. The works could not be reduced or contained because they provided "an aesthetic experience that offers not only insight but religious insight into the need and way of salvation."[70]

Through looking at this one exemplary instance of an exhibition of religious works of creativity in a secular setting, the complexity of

these works and their functions becomes more apparent. It is precisely because of the museum's repeated attempts to distance itself from the religious commitments of the works, and their complete inability to do so, that we can better understand the power of these objects as they come into contact with the human heart. Many of the works at the gallery, and in countless museum contexts throughout the world, were never considered "art" by the communities behind them; if we can glimpse the multiplicity of the ways they functioned (and still may function today), we allow these works an honest autonomy. Real autonomy does not rest on the "right" of art to be unique and rare and to exist solely for the delight of aesthetic contemplation; this reduces art. Rather, the autonomy we must grant these works is the respect of allowing them to be true to their function, what it is they actually are and do, their "firstness" or suchness. In the case of the collection assembled by the National Gallery, this means to allow these works to exist within the religious tradition, in a continuity that does not bracket out transgression. In safeguarding this kind of autonomy, we allow the multiplicity of roles played by these objects to retain their complexity and intricacy.

At this point another concrete example would be helpful, so I propose we take a brief look at *the* most normative *Last Supper* in all of art, Leonardo da Vinci's mural in Milan (Plate 5.2).[71] Although a full treatment of this studied work would be much longer than this book, a quick look is helpful.[72] At its most basic level, *The Last Supper* fulfills the "book" function Pope Gregory alluded to: a practicing Christian in almost any period of history, even if unable to read Scripture, should recognize the Savior and be intrigued by the story heard from the pulpit coming to life in Leonardo's rendition. The image stays in the imagination even if the words from the pulpit may not. However, if we note what is being "read" as we look at *The Last Supper*, we can ascribe an engagement that is more complete than passive reading. The image functions in a way similar to religious ritual in that it preserves and transmits the historical recollection of a central event in salvation history.[73]

The Last Supper also has the "strengthening" capacity of sending the literate Christian back to reread with renewed interest the accounts of that most pivotal meal in the Scriptures, and perhaps even extending an invitation to explore other interpretations of the Last Supper in the Christian tradition. Thus, the possibility of receiving instruction

about concrete articles of faith such as the person of Jesus Christ, the Eucharist, and discipleship is activated. Meanwhile, on the affective side, the illiterate (and young) and the literate are invited to the glad recognition of the love awakened in their hearts as their eyes sweep the exceedingly beautiful mural. In that moment they may become conscious of their response to what is revealed: this is Jesus Christ, the one who so loved the world that shortly after this meal's conclusion he gave his life for that love. The Christian's response of loving gratitude is the response of faith.[74] In this we discern that sacramental quality of materiality linked to an experience of grace. It is the "significance" of the act depicted, the very fact that Jesus *pours his life out for love of the one viewing the image*, that may suddenly become intelligible and exceedingly moving. The recognition brings pain in our knowing of Jesus' self-sacrificial choice and also profound joy as we are opened up to the unfathomable depth of God's love.[75] It is the "meaning of that act of sacrifice begun by Jesus in the upper room . . . that has made the redemptive act of Christ a privileged object of contemplation."[76] The sign of the historical Last Supper made present by Leonardo's creative imaging of it in his *Last Supper* affects the believer by engendering love and aiding in the maturation of faith.[77]

Leonardo's work was not part of the *Seeing Salvation* exhibition, even though it is indeed one of the most important artworks of Western Christianity. The reason for its exclusion is so obvious that its meaning may elude us. *The Last Supper* cannot be moved. The mural is part of the very environment where it was created and inseparable from it.[78] Of course Leonardo's image has been copied and reinterpreted countless times,[79] but none of these attempts can accomplish what we can imagine the original did in its time, and if we are in its presence know it could do again.[80] Art historians have studied the upper room painted by Leonardo in its original site in the friar's dining room of Santa Maria della Grazie, noting that the "evening light, entering from the left, bleaches—or appears to bleach—the depicted east wall of the painted chamber. As the western sun streams through the high windows in the west wall of the refectory, reality and illusion together are suffused in its radiance. . . . The assembled friars, seated at supper, were embraced in one glow with the sacred assembly."[81]

This is the kind of experience that the beautiful works inside the National Gallery can no longer activate. With the works torn from

the composed wonder made possible by time and space, we are left unable to glimpse them in their deepest possibilities.

Roughly four centuries before Leonardo, an enterprising monk by the name of Suger (1081–1151) was made Abbot of the royal Abbey of St.-Denis, just north of Paris. Suger's writings and the intensely beautiful abbey he renovated reveal foundational principles for the subsequently interlaced qualities of beauty and religious faith in Western Christianity. Suger not only believed, but *felt*, that it was the beauty of everything surrounding earthly religious life that allowed for a momentary awe-producing glimpse of heavenly life. As he recounts his experiences of the liturgy, when the religious ritual unfolded what was before him was a "chorus celestial rather than terrestrial."[82] In this the experience Suger describes is analogous to what many religious traditions call mystic states, a "quality that must be directly experienced: it cannot be imparted or transferred to others."[83] What is significant is that Suger believed such states could be produced or reached with the collaboration of earthly beauty and not by withdrawing from it. Also significantly, Suger stressed that the glorious nature of Christ necessitated the most exalted use of earthly materials to receive and worship him. Thus, his theological understanding of Christ's kinship over creation contributed to his insistence that beauty in "golden vessels, precious stones and whatever is most valued among created things, be laid out, with continual reverence and full devotion, for the reception of the blood of Christ."[84] Suger understood the beauty of worship spaces and rituals to be the most fitting use of the raw materials provided to humanity through God's generosity in creation.[85]

What Suger's insights reveal about Leonardo's *Last Supper* is that the work is intricately composed of a very precise spiritual practice that includes space, time, community, and even materials. *The Last Supper* not only made Christ's story visible to the friars who took their meals in the room, but allowed the friars to be momentarily in heaven. As they shared their meal, the monks acted for one another as embodiments of the realities taking place in the heavenly realm. Secondly, the work clearly functioned religiously to center the community's life and faith on their Savior. Christ was the one who presided at the meals, and over everything having to do with the life and death of the community.[86] This was a theological affirmation in the midst of daily life. Thirdly, the intense beauty of the work, engaging

for its production one of the most accomplished artists of the time, is also central to it. The beauty of the art praises creation, being made by the created and using creation's elements.

Arguably, only one image in the exhibition could activate these three qualities of being part of heaven—by referring daily life to its relation to Christ and arousing marvel and appreciation of human creativity—and this was Wallinger's *Ecce Homo*. Part of his story, like Leonardo's Christ, can be told only by the steely London sky above and his sudden and silent appearance at the turn of the century on what was normally an empty plinth. His vulnerability and small-ness accented by the many buildings, statues, and fountains that surrounded him, this young Christ must have been heartbreaking to behold. Meeting us in our world, momentarily, our very bewilderment would have judged us.

In the end, works of creativity need emotionally engaged interlocutors, and removing them from their original contexts makes the conversation much shallower. I knew this most pointedly when, after having loved Mozart's Requiem Mass in D minor for most of my life in recordings, movies, and concerts, I finally heard it sung by the choir of All Saints Church in Pasadena. As the music was lifted truthfully as prayer, as the congregation faithfully understood it as such, and as the flicker of candles, gothic vault ceilings, and stained glass windows lifted the entire moment right into heaven, the opening words *Requiem aeternam dona eis, Domine, et lux perpetua luceat eis* exploded with their full force.[87] The weeping that followed from most corners of the church attested that we all ached to understand and experience the meaning of Christian hope.

For a fruitful relationship to exist between art and religion, art has to be cut loose, as it were, from the need to teach by illustration, and allowed to embody these types of rich experiences, multiple and varied. Art cannot thrive if it is subjected to the perception that it is "controllable" and held to doctrinal standards of orthodoxy. Respect for the possibilities of art must acknowledge within it many potentialities; among these is the potential to teach, but just as real is the capability to challenge, to mislead, to obscure, and, yes, even to lie. To paraphrase the famous dictum of communications theory, art is the medium *and* the message, and its constructiveness and destructiveness have to be taken seriously enough to critique it, not to silence it.[88]

In the very critique of what disturbs us, prophetic seeing and imagining can occur.[89]

Art and religion are not about the pretty or the simple and pleasing; even when it is treating evil, the unveiling of sin and suffering is an important function of art. "The expulsion from Paradise, begins a journey of both learning and moral advancement. . . . One can get hurt on the way to Paradise. Yet such vulnerability is a condition to reach Paradise."[90]

Learning from Seeing Salvation

By going into this case study of one singular contemporary exhibition, and interlacing it with *The Last Supper* by Leonardo, we are brought face to face with one of the greatest challenges facing the contemporary, tenuous connection between the arts and the religious. Museums should not remove artwork from its religious settings, either in place or meaning. In turn, the church must work hard to preserve its heritage of creative works, and encourage new works (like Wallinger's that depend on composed wonder) to help us understand the sacred quality of time, place, and the communities that lie behind an artwork. Communities of faith must once more learn to value great works of creativity, foster them, and help make them possible.[91]

The exhibition also foregrounds some insightful ways to move this work forward. The grouping of the art along theological questions of Christ's nature and redemption respected the works as part of the tradition's two thousand years of maturing and deepening faith. In presenting these artful, theological, and devotional explorations diachronically, the exhibition made it possible for them to mutually inform, expand, and challenge one another.

Seeing Salvation does indeed represent a breakthrough in the current relationship between art and religion, but it also bears the marks of the long and difficult struggle that this discourse has faced since modernity. It is clear that declining church attendance in Western Europe has become a stumbling block to the reception of classic works of art, which can no longer be adequately decoded by contemporary viewers. Yet we should differentiate between church attendance and religious literacy; regular church attendance does not necessarily translate into religious literacy, whether in symbols or theologically,

especially in fundamentalist or iconoclastic churches, of which there are many to be found in the United States.

The gallery's inclusion of works that are now priceless objects, which were once anonymously devotional without any claim to greatness, should alert us to such creative expressions in contemporary communities. Works of art that speak religiously cannot be reduced only to the "classic" works. A recovery of humanity's religious utterances through art must be broadened to include works not generally thought of as "classic," such as folk, tribal, liturgical, and popular expressions. An efficient methodology for relating art and religion has to take into account the relationship of art to the community's faith life as diverse communities experienced faith and continue to experience it.

If we reduce Christianity to a "notion" or concept, it domesticates it so it can be spoken of as another human artifact to be creatively illustrated.[92] However, the respect due to the communities that produced and received these works of art, their histories, and their witness tells us that Christian faith cannot be reduced to an idea without also reducing everything connected to that faith, including works of art. An effective methodology for relating art and religion has to take seriously the faith experience of the communities producing and receiving the art, as well as to question overly rationalistic paradigms that remove the experiential from both art and theology.

The assumption from much of the media that *Seeing Salvation* would have few visitors, and that even those few might not understand the exhibition, devalued contemporary Christian communities and their reception of the images of Christ. Because symbolic worlds connected to a religious tradition cannot and should not be understood apart from that tradition, it is the present-day Christian community that can best help illuminate and appreciate the works. The images do not belong to a lost civilization, but to a living community. Consequently, art that deals with religious subjects cannot be reduced to didactic or evangelizing functions, but must be understood within the rich panoply of religious experience, liturgical practice, prophetic confrontation, eloquent witness, and cries of pain or of hope. An efficacious methodology for relating art and religion has to involve the Christian tradition as it has been practiced and is still practiced in living communities, while exploring the many facets of religious experience and insight expressed in the arts.

The historical-political situation surrounding a work of art is important, as is the citing of applicable religious texts. It is theology as critical reflection that can engage the historical situation and, hand-in-hand with the Scripture texts, arrive at a synthesis of some of the possible religious questions and issues the artwork is proposing, questioning, invoking, or celebrating. An effective methodology for relating art and religion needs to make respectful use of all the tools available; whether the approach is from art history or from theology, the other's discourse has to be included and fully used.

The "history" of a work of art is also tied to a community's view of history. Without an understanding of the Christian belief in the Incarnation and Resurrection of Christ as an enduring and real presence, the enigmas apparent in religious art are often solved only in the historical realm and not in the theological realm, where the articulation is actually occurring. An efficient methodology for relating art and religion must accept that the parameters of interpretation are set by the artwork itself. Thus, art coming from a particular Christian milieu cannot be adequately interpreted without accessing that community's theological tradition. Though scholars are specialists in particular fields and use specialized discourses, this cannot be seen as sanctioning an atomization of the works or phenomena under study. An effective methodology for relating art and religion fosters humility in scholarship where other fields and expertise are brought into the conversation as aids to understanding. No one can be an expert at everything; thus, the scholar's job has to be to interlace many different strands of expertise.

Seeing Salvation was an event embodying the relationship between art and the religious (not just an exhibition of religious art), and as such it had to contend with many traditional divides. I propose that fruitful engagements between art and theology will exist in this space, which, if forced to defend itself, can unconsciously accentuate the boundaries. In this sense, the art and religion space can become rigid, brittle, and unproductive. Conversely, openly acknowledging the real difficulties posed by the traditional divides, and probing these, we can opt for the fluidity of interlacing them.

We have looked carefully at the rich experience of the *Seeing Salvation* exhibition, a look that has helped us enter more fully into the difficult issues that relating the artistic and the religious present. In the next chapter I want to probe even more intently the question of

differences, a question crucial to this proposal, which wants to stress the need for the kind of mutual engagement inherent in interlacing, and not the mutual appeasement or exclusion that often occurs at intersections. To differences then, and to what they disclose.

6

Beyond Boundaries and Unknowable Otherness

*I*n contemporary terms, the predominant metaphor for the method of engagement between art and religion is "intersection,"[1] a word that has become quite popular to describe many diverse efforts of inter-disciplinary studies.[2] Yet in relation to art and religion, even intersection may be too generous of a concept. Some contemporary scholars argue that although the need for more interaction between art and religion is generally recognized, this has not materialized into many fruitful exchanges.[3] Although a scholarly discipline termed "Art and Religion" is named in some institutions and curricula, it more often than not represents an approach that arises from one of the contributing disciplines, such as art history, sociology, philosophy of religion, literary studies, cultural studies, or history. Thus "Art and Religion" seems to refer to *the kinds of things* one studies—but *how* it is one studies, or *what tools* one may bring to such study, has been little explored.[4] I propose that to understand and articulate how the arts work religiously and how the religious works aesthetically is a special kind of engagement in itself, constituted as it is in the *how* of interlacing the arts and the religious and the *what* of the uniqueness, integrity, differences, and questions of each, as these are seen in relation to each other.

This focus on the interplay of art and religion is not forced upon either the arts or the religious by a scholarly agenda but is intrinsic. Art and religion coexist for many artists and for the communities that

receive their art. Thus, the imperative for developing methodologies to study art as a source of theology or to include the religious in the study of art comes from the unity of the artistic and the religious in the works themselves. What is more, this unity is not just in what we know as "Fine Art," but in what we may call art (with a lower-case *a*), encompassing a variety of creative making that enlivens and expresses the faith lives of communities. Artists are often involved in reflecting upon the most important questions of existence and restating these artistically, and communities receive these works as genuine and important religious utterances. The separation between art and religion can then be understood as an external constraint, as we saw in dealing with the exhibition *Seeing Salvation*—art demands unity.

It is for this reason that I find the method of restricting critical study to discrete points of "intersection" problematic. On the one hand, this method may force the perception of commonalities that may not exist. On the other hand, it may unproductively accent boundaries, since without commonality the only other viable alternative seems to be a capitulation to mutual and unknowable otherness. As an alternative, I have suggested a method of interlacing engagement between the arts and the religious. The interlacing richness is already present in the art, and through an interlacing engagement, otherness can lead to insights, and differences may become a source of richness. In an intersection what is different inexorably continues to move apart, severely reducing the opportunities for contact. On the other hand, a braid—the geometric representation of interlacing—incorporates difference as beautiful. As we picture a braid, it is possible to appreciate that the uniqueness of each thread is precisely what contributes to the dynamism and complexity of a multistranded rope, and it is the action of intricate weaving that makes this possible. The different strands of a rope have a definite sense of openness and ongoing engagement, never moving swiftly apart as intersecting lines do, but rather continuing to come together. If we imagine the strands as areas of inquiry in the arts and the religious, we appreciate how such a model describes a fruitful engagement that neither forces sameness between the strands (to create more intersecting points), nor moves away (as inevitably happens in the intersecting model). It is important here to visualize the value of difference itself, because for most of the history of Western thought there has been a prevalent and false appeal to uniformity and universality in scholarship.

It is rare to find scholarly work prior to the last decades of the twentieth century in which thinkers formally acknowledge their diverse identities as culturally bound.[5] The question of someone's cultural setting or social location, the formation of their methodologies within prescribed schools of thought and norms, and the intimate issues of gender and ethnicity (along with a host of other qualifications) have been routinely ignored or minimized. Neither did these scholars (theologians, philosophers, art historians, et al.), whose thought we tend to employ today in our study, make precise distinctions regarding the religious or cultural traditions they were treating and the borderlands they were either crossing or ignoring. Conscious of this history, cultural critic bell hooks points to the necessity of developing processes that will lead to fostering awareness of these differences.[6] hooks explains that her generation of scholars felt there was a need to "finally . . . understand, accept, and affirm that our ways of knowing are forged in history and relations of power . . . and acknowledge that the education most of us had received and were giving was not and is never politically neutral."[7] Yet she also recognized the difficulties in this posture, given "the fear that any de-centering of Western civilizations, of the white male canon, is really an act of cultural genocide."[8] The fear of annihilation or assimilation hooks acknowledged comes from the perception that "everyone who supports cultural diversity wants to replace one dictatorship of knowing with another, changing one set way of thinking for another."[9]

True to an interlacing model, the awareness of difference I advocate does not seek to create some kind of utopian reading that encompasses all of humanity, erases all boundaries, or supplants one kind of (majority) reading with another (minority) reading. The strategy of interlacing is precisely to allow us to *notice differences*. Although there might be "majority" readings in the sense of their reach and prevalence, their dominance over other readings does not necessarily make them normative. All scholarship is contextual, and in noticing difference we should regard this very contextuality as enriching. Scholarship that is "de-centered" makes for better scholarship, by seeking specificity and by carefully qualifying opinions and observations. For this reason, scholarship must begin with the self-conscious examination of differences and limits. What such an awareness calls for methodologically is the understanding that the terminology often used in the academy, churches, and popular culture (words such as "art,"

"theology," and "religion") have to be read with suspicion and with a constant search for underlying assumptions. Vigilance in exposing presuppositions allows us to notice the limiting spaces of the subject and the inquirer. As we notice that we have multiple strands, we can appreciate that these are distinct, and that their interplay makes for more interesting and insightful scholarship.

The Differences of Cultural Space and Historical Distance

Let us examine an example. A central focus of my theological scholarship is the playwright Federico García Lorca. As I draw near his work, I do so as a bilingual and bicultural Latina theologian sharing the commonality of a Spanish heritage. Yet, I am also someone schooled in an English-speaking United States context more than a century after the poet's birth. My formation as a scholar brings the trappings of a twenty-first-century, English-speaking, Andy Warhol–literate, North American setting.[10] Mine is a decidedly different context from Federico García Lorca's early twentieth-century Spain (or even contemporary Spain). Even if I can find some familiar landmarks (or "points of intersection") in Lorca's writings from New York and Havana, there remains an insurmountable, and at the same time exciting, distance between us. We are both most definitely culturally bound.[11]

In order to thematize the complexity of the undertaking, I have begun calling the kind of work I do in theological aesthetics an *acercamiento* (not a critique or analysis). This Spanish word (which my students delight in attempting to pronounce) derives from the verb *acercar*, to bring something near, or to move ourselves to a point of nearness to something. The *acercamiento*, named for this movement from far to near, is the noun we use to designate this kind of critical work. The *acercamiento* stands as the chronicle of a moment when a multistranded cable is woven in order to connect me to the art and the art to me in intimate closeness.

Because I describe theological aesthetics as a method of engagement, it is crucial that I also identify the tools and the environment that make such engagement possible. A work like *La Pastorela* has the artistic and the theological so closely interlaced that an *acercamiento* must take account of both jointly. Such wondrous works most decidedly overflow metaphors like "intersection" and call for more

sustained engagement. The image of interlacing celebrates contextual particularity by proposing that multiple and discrete strands are enriching. In doing so, we also question totalizing language that proposes one discourse as normative and all the others as marginal, while being vigilant not to set up analogous hierarchies. Difference and distance create the ideal conditions for bridges; however, bridge building is not always a welcomed practice.

It is (sadly) a well-practiced tenet of contemporary society that religion and politics are topics generally avoided in polite conversation because they are deemed too private and can reveal divisions and give rise to heated arguments. In any discussion of the relationship between art and religion, this tendency toward evasion, or its opposite—exploitation—has to be examined. The respect for an artwork's unique internal structure, and thus its religious significance, may sometimes be seriously undermined by the "gatekeepers," that is, those who exhibit, teach, critique, or otherwise make the art accessible to its public.[12] Because of this, the avoidance of particularly difficult questions reduces conversation to the superficial.[13] In order to interlace effectively the religious and artistic, the underlying tensions that restrict art and try to silence it have to be explored. The celebrated cases of attempted censorship when art is perceived to threaten religious sensibilities get much press coverage, but they reveal only the most obvious and polarizing manifestation of the problem.[14] There is another type of subtle censorship, by evasion.[15] Whether the work never gets funded, is misinterpreted, mislabeled, censored, or otherwise suppressed, the outcome is the same: the difference and distinctiveness that could result in wonder, prompt new questions, or lead us into the fruitfulness of intellectual humility never happens.[16] Debate is a key feature of both art and religion (or at least it should be) because what is really significant arouses passions that become expressed in disagreements and controversy. However, when thoughtfully guided, such passionate engagement does not have to be synonymous with irrationality, and the discussion or disclosure of religious aspects in a work of art need not be seen as univocal, nor as normative—the greater the work of art, the more "polysemantic" it should be.[17] The truth and depth of one interpretation of an artwork does not deny the truth and depth of a second, or many more. It is just such openness that can make controversy productive artistically, theologically, and ethically, and can problematize its evasion.

The Problem of Mariana

In real life, such openness is elusive. Many years ago, during an interview, Federico García Lorca explained the plurality of meanings in his works to a journalist writing about his first major theatrical production, *Mariana Pineda*.[18] The historical Mariana Pineda ("illegitimate daughter" of a nobleman) was born in Granada (Lorca's hometown) in 1804. She was executed as a liberal conspirator in 1831, leaving behind two small children. Although she was the widow of a liberal military officer and apparently actively helped liberal causes, charges of treason against her were initially dropped. It was not until a new mayor of Granada was appointed who demanded sexual favors from Mariana and was refused by her that new charges were trumped up and she was executed.[19] Lorca's tragic retelling of the story on stage met with success in great part because of the political reading facilitated by an audience that saw in it a validation of their republican ideals. This was a prima facie interpretation of the play as a historical drama about Mariana Pineda, but Lorca did not write *Mariana Pineda* simply as a political play to support one side of a debate. Lorca explained to his interviewer that he had three versions of the play and that, "The one I'm staging implies a fusion, a synchronization. It has two planes: the first is broad, synthetic, and over it, the attention of the audience can hover without complications. The second—the deep meaning—will be grasped only by part of the audience."[20] Here we may hear something of the disconcerting quality of Jesus' parables.[21]

Scholars have tried to decode these two "planes" of meaning in the play, and the first, the political, is generally taken to be what Lorca calls the "broad" meaning. As Lorca's principal biographer searched for a second meaning, he concluded halfheartedly, "It seems probable . . . that Lorca was alluding to his treatment of love in the work. Mariana is above all a woman in love."[22] Other critics seem oblivious to the poet's own admission of multiple layers of interpretation. Another biographer opines that in Lorca's play, "Mariana's life and death are but another illustration of the futility of human desire."[23] If, as is evident in the plot, the political story is completely fused with the love story so that both are dependent upon one another dramatically, it is structurally impossible that the love story could constitute a second layer of meaning when it is intrinsic to the first layer, understood to be

political events. A theological *acercamiento* suggests the second meaning is christological.

Without doubt, the play deals with a historical character whose life and death belong to the realm of the political; however, Lorca made it a practice to immerse himself respectfully in popular sources as privileged sites for the transmission of tradition. These sources preserved the memory of the historical Mariana's death in a folk ballad he learned as a child.[24] As Lorca explained,

> Mariana Pineda had come seeking justice through a poet's voice. They surrounded her with trumpets and she was a lyre. They equated her to Judith and she walked in the shadow looking for Juliet's hand, her sister. They girded her broken throat with the color of an ode and she asked for a free madrigal. They all sang about an eagle that with one strike of its wing breaks the hard metal bars *and she cried out like the lamb, abandoned by all, held up only by the stars.* I have been true to my duty as a poet opposing a Mariana who is *alive, Christian and resplendent with heroism*, to the cold one, dressed as a foreigner and freethinker of the pedestal.[25]

Conscious of the community behind the art, the poet knew that the people of Granada saw in Mariana a local saint who imitated Christ in her total selfless love, even unto death, and so, this was perhaps the second meaning.[26] But as is evident, the generally reduced understanding of *Mariana Pineda* by critics illustrates what can happen when "controversy" and its evasion (or sometimes fostering) become factors in the reception of an artwork. The possibility of a religious reading of *Mariana Pineda* has been generally disallowed by Lorca scholars precisely because of political ideologies bent on bifurcating her self-sacrifice from her religious faith. Such an evasion of the complexity of Lorca's work continues even in the face of the playwright's own emphasis on the centrality of the heroine's Christian identity. Ideologically motivated limits and labels placed on art and artists point to the need for scholars to do research deliberately outside the canons of readily recognizable "religious" art. As this example illustrates, the theological undertones of an artwork may have been overlooked, avoided, misrepresented, or even hidden.

As with Lorca's many works, there are other astonishing treasures of theologically powerful art yet to be discovered. An example is the recovery of the religious art of Andy Warhol by art and religion scholar

Jane Dagett Dillenberger.[27] Through looking at Warhol's body of work, Dillenberger discovered that it is in the art itself that the sources for its more thorough reception are expressed. The critical scholar needs to be respectfully attentive to the different (yet equally problematic) tendencies to push for controversy or to deny it through evasion.

The Difference between Religious Art and Art That Is Religiously Significant

Jane Dillenberger's daring venture into the art of Andy Warhol accomplished two objectives: First (and this is certainly her principal claim), the pioneer art and religion historian demonstrated that "bad boy" Warhol had indeed produced religious art. His many works quoting Leonardo's *Last Supper* are explicitly religious works treating one of the most universally iconic religious subjects in Western art. But she also reached a second conclusion, not as obvious, but perhaps even more compelling: Warhol's "other" works, those dealing with apparently secular subjects, were also religiously significant. Our understanding of the context of Warhol's artistic production, including the influences on his work and the language of his symbolic universe, was inescapably altered by this new awareness of his deeply religious sensibilities. Such an opening into the theology of works of art that had been previously inaccessible represents a significant contribution. As an example, Dillenberger points to her new appreciation of "Warhol's most enigmatic paintings . . . the *Shadows* series of 1978."[28] Having recovered Warhol's religious works, Dillenberger is able then to shed some light on the enigma of his other works. "When one studies *Shadows*," she writes perceptively, "the eschatological question of mortality and the end time arises."[29]

In the exhibition *Seeing Salvation*, the possibility of the not explicitly religious expressing theological insights was present, but only tangentially. The opportunity to explore how what is not readily perceived as religious could indeed be theologically rich (such as the contrasting impulses of Christ/gay clubber in Wallinger's *Ecce Homo*[30]) can be strengthened in an event such as *Seeing Salvation* by the inclusion of more ambiguous and apparently secular works. There is vitality to the exploration of the discomfort produced by the confrontation between the classically religious and contemporary forms. This clash can be theologically productive, but it needs nuancing. In

art that questions us, the reality of Christ's Incarnation may reach us more fully with its scandalous testimony of a fully human God. As one reporter explained about Wallinger's *Ecce Homo*, "Crowded mental images form and change, leaping from 'Insignificant man' to 'Benign Overseer' to 'Prince of Peace' to 'Suffering Servant' . . . and back again, the way a credit card hologram changes with the slightest movement."[31] The insight into Christ's insignificance to his contemporaries was a new theological insight made possible by an encounter with this young Christ alone in Trafalgar Square.

A further challenge to what may be labeled religious art presents itself when we begin to question our lack of awareness of the depth of symbolic conditioning in Western culture. Three important works from *Seeing Salvation* are also helpful here. Without critical attentiveness we can be oblivious of the significant differences among (1) what is an explicitly religious subject, such as the crucified Christ in Dalí's *Christ of Saint John of the Cross* (1951);[32] (2) what is actually only a religious painting when one has access to the symbolic traditions of a particular faith, such as Francisco de Zurbarán's forlorn, bound lamb in *Agnus Dei* (1635–1640);[33] and (3) what is even more complex, combining religious tradition, cultural practices, and precise historical cues, as in Sir Stanley Spencer's *The Resurrection, Cookham* (1924–1926). Here, the resurrection of the dead at the end of history is powerfully imaged in the artist's own time, following the First World War, and in his hometown cemetery.[34]

The relationship of art and theology requires that the potential for religious significance in presumed secular art be respectfully explored. It also calls for a renewed appreciation of the often overlooked role of religious symbolic traditions, so that the subtle presence of the implicitly theological may also be recognized. As a documentary on the image of "Superman" in popular culture demonstrates, what may appear completely secular can indeed prove to be theological.[35] It is only when the question of religious symbolism is repeatedly pressed that those interviewed bring to consciousness the depth of the Christ-like qualities in the figure of Superman. It is only as they are forced by their interviewer to reflect on what is invisibly embedded in U.S. culture (the idea of self-sacrificial redemption) that those commenting begin to see Superman's religious roots in the Christ event. Significantly, having gained access to the Christ-figure symbolism, the commentators are then able to delve more fully into the iconography

of Superman and the reasons for its hold on the world's imagination. The connection is explicit in the film script (1978) as the no longer materially present Jor-El reveals to his son Kal-El (the future Superman) why he has been sent to Earth:

> JOR-EL: Live as one of them. . . . They can be a great people, Kal-El. They wish to be. They only lack the light to show the way. For this reason above all—their capacity for good—I have sent them you. My only son.[36]

The echoes of the Johannine Gospel are unmistakable, and as we note this interaction, the artistic and theological questions surrounding the myth of Superman begin to inform one another with the potential to reveal more about both. In juxtaposing Superman and Christ, a modern artistic invention and the ancient faith from which it drinks can be imaginatively intertwined—through them, humanity confronts its need and longing for salvation—and something can be discerned of the way or shape of that salvation.[37] It is through interlacing theology with art criticism that we can see that in a way *Mariana Pineda* and *Superman* are about the same thing: "No one has greater love than this, to lay down one's life for one's friends" (John 15:13).

The Difference between the Church and the church

Thus far we have explored difference through an honest awareness of cultural space and historical distance, of the challenges posed by tendencies toward controversy or evasion, and of the distinction between religious art and art that is religiously significant. This kind of careful "seeing" is necessary so that both art and theology can be more effective in their function of awakening our critical senses and imagination, thus nurturing our capacity to be brought to a prophetic consciousness. It is this prophetic quality that makes it necessary to further differentiate between the Church (official and hierarchical) and the church (referring to the people of God).

In order to be prophetic—to nurture renewed vision and imagining as an alternative consciousness—art must speak to both the Church and the church. It cannot speak solely to or from one and ignore the other. The same goes for theology, which must speak to the wider culture as well as to centers of faith. In order for this to happen, art has to be able to exist outside the boundaries of current ecclesial

concerns, just as theology must be practiced as critical study and not as having merely a supportive role to what is already established.[38] The prophetic implies a radical freedom, but this freedom is always rooted in the good and the true.[39]

Many creative works spring from an artist's quest for faith and provide evidence of that quest, yet they need not have any didactic or illustrative functions. Wallinger's *Ecce Homo* (Plate 4.1) and Swanson's *Last Supper* (Plate 5.1) were not commissioned as part of any official Church project, yet both works witness to a community's living faith, and both took form because of that faith. Religiously evocative works may make their viewers and readers uncomfortable as they brim over with troubling and difficult symbols and metaphors, but these will become fruitful only as they are interpreted with reference to the tradition. Prophetic works have to take account of the double work of speaking to the Church and to the church. As art expands what we can see and imagine beyond the boundaries of prescribed religious statements, it may facilitate an experience where God is "the wholly other [and] . . . also the wholly same: the wholly present . . . the *mysterium tremendum* that appears and overwhelms," but "also the mystery of the obvious that is closer to me than my own I."[40]

Doubtless a percentage of the world's religious art was and is commissioned by the official Church with didactic purposes in mind, but this cannot be posited as the only definition of religious art. An altered consciousness prompted by wonder needs the possibility of critiquing as much as celebrating.[41] Radical newness may manifest itself outside of ecclesial structures and what may at any particular point in time be considered orthodoxy. This potential for renewal has been a central feature of the Judeo-Christian tradition since its beginnings. The prophetic is not superfluous to the church, and if art embodies prophetic qualities these must be reflected upon seriously as possible sources of revelation. As the Nicene Creed states in its confession, it is the Holy Spirit that "has spoken through the Prophets." The poet/prophets of the Hebrew Scriptures often spoke as outsiders witnessing to a deep, sometimes searing faith, as we read in Ezekiel.[42]

As with Ezekiel and Lorca, the prophetic possibility of art and of the religious may originate outside of boundaries that might preclude seeing and imagining, wherever those rigid boundaries may be placed. Jesus thrived in noticing the difference between what had always been said, and what urgently needed to be said.

You have heard that it was said to those of ancient times, "You shall
not murder"; and "whoever murders shall be liable to judgement."
But I say to you that if you are angry with a brother or sister, you
will be liable to judgement; and if you insult a brother or sister, you
will be liable to the council; and if you say, "You fool," you will be
liable to the hell of fire. (Matt 5:21-22)

The young rabbi from Galilee was always ready to bring about a
new seeing and imagining, and in him and through him the prophetic
often presented itself as utterly perplexing.

We have been involved in a process of paying careful attention
to questions and nuances that have the potential to move the study
of art and the religious away from the limitations of an intersection
model. Through this kind of engagement the joint functions of the
arts and the religious can be better appreciated. If we can recover art
as a *"locus theologicus"*[43] we have a new window into God, an expanded
way to understand revelation. Theologian Paul Tillich proposed that
"everything that expresses ultimate reality expresses God whether it
intends to do so or not . . . everything that has being is an expression,
however preliminary and transitory it may be, of being-itself, of ulti-
mate reality."[44] As he posited this expansive understanding of God that
actively countered the limitations of an anthropomorphic theism, Til-
lich suggested three ways in which human beings, the only creatures
that "can distinguish ultimate reality and that in which it appears,"
can "experience and express ultimate reality."[45] Two of these ways are
philosophy and art, which Tillich characterizes as indirect ways. The
indirectness is because philosophy expresses what it encounters in real-
ity in concepts and art does so in images. Thus, the only "direct way"
is religion, where "ultimate reality becomes manifest through ecstatic
experiences of a concrete-revelatory character and is expressed in sym-
bols and myths." It is these myths and symbols that Tillich understands
as "the oldest and most fundamental expression of the experience of
ultimate reality." In separating these three ways, Tillich is cleaving
intentionally religious symbols and myths (which he understands as
part of religion) from what he terms "art." In doing this, he relegates
art to taking "from [the symbols' and myths'] depth and abundance."[46]

What Tillich's analysis betrays is the modern tendency to under-
stand art as that which hangs in museums or that which, even if in
religious settings, expresses itself only as "art." He seems to see reli-
gious symbols and myths as something different from art. I question

this separation, and using Tillich's own analysis, propose that the symbols and myths of religion in their creativity are indeed also art, which would acknowledge art as a direct experience and expression of ultimate reality as it joins religion.

I have proposed that the arts are one way we can attest to ongoing revelation from outside of revelation itself. The Jesuit theologian Karl Rahner felt the appropriation of the arts as theology was indispensable because the arts are "inspired and borne by divine revelation, by grace and by God's self-communication."[47] He further argues against the reduction of theology to what he calls "verbal theology," adding that this unjustifiably limits "the capacity of the arts to be used by God in his revelation."[48] Thus, to bracket out the arts from their importance and theological depth is in effect to deny that God has been speaking to humanity and to cripple humanity's possibilities for attending to God's voice. Art is revelatory when it makes "perceptible, and as far as possible attractive, the world of the spirit, of the invisible, of God."[49] In creative works of giftedness and truthfulness like *La Pastorela*, the awesome mystery of God is expressed through matter, reminding us of matter's sacredness and unity to its Creator, while also nourishing humanity's capacity for mystery not as unknowable otherness but as the start of a wonder-full dance.

However, the appreciation of art's role as revelatory and as a source of theology should not be the exclusive purview of theologians; it is art we are dealing with after all. Those working with the arts from any perspective should find the interlacing of theology with art to be an expansive way to approach art. The method takes its cue from the artwork itself, and is thus able to deal credibly with discovering the "traces of a spiritual struggle"[50] that the works disclose in the artists who produced them, the communities from which they spoke, the communities that received them, and every viewer, listener, or reader since. So, because creative works may be sites of theology, there is also a need to cultivate their respectful approach as art. Those interested in theology must attempt to understand the realm of art in order to enter the form that these creative theologies have taken. Equally, those involved in the history and criticism of particular works must not bracket out the theological concerns that may be present.

As the preceding arguments suggest, the work to be done to appreciate the joint work of the arts and theology cannot be accomplished

exclusively through critical theory or theological method. The complexity of their functions cannot be sufficiently accessed only through art history, or through systematic theology, or even through both as they intersect. Rather, the cables built for an *acercamiento* must interlace these discrete disciplines with the aid of aesthetics.[51] The choice of interlacing as a model effectively de-centers and subverts what would be a conventional path of study. It is also important that we not differentiate substantially between particular forms of art. It is rather "art" as the fruit of human creativity in its broadest sense that provides the best link to the religious. This assertion then demands a definition of art.

7

The Impossible Definition

*T*o define art seems impossible because "art" is a quintessentially contested statement and it is art's nature to be thus.[1] Definitions become static, creating sets of criteria that are then used to judge something *as or as not* something else. Because everything about the process of defining is conditioned by context and circumstance we need to be suspicious of it. However, if the very ambiguity of art is allowed to stand in for complete relativism and meaninglessness, a project such as this cannot proceed. As a precondition to the development of a bridge built by interlacing the arts and the religious in the work of theological aesthetics, the very difficulty of "art" as a category must first be tackled, even if briefly. Perhaps the best way to do this is to address some of the difficult questions that the idea of "art" brings up.

In our contemporary and postcolonial world consciousness we have come to realize that "the practices and roles of artists are amazingly multiple and elusive."[2] Yet, allowing for this multiplicity we notice broadly recognizable markers of what constitutes human artfulness. For instance, artists *do* something, and we can inquire about what it is that they do and how it is that a given society understands what they do in relation to that society's norm. Beyond this, to inquire what art is as it relates to questions of ultimate reality and revelation, necessitates an expansion of the idea of art to an unbounded panoply of forms, including myths, symbols, images,

songs, and rituals. If we include all of these ways of being creative, then we are asking fundamental questions about who may be called artists and also questioning exclusivist claims as to what may be called art.

As we consider the work of artists in society and the multiple forms in which art may be found, we can also factor in the question posed by the two extremes of fundamentalism and relativism. This question centers on meaning and the mutually exclusive positions that works of art must be about one single message, about nothing or about everything. The current debate centers on determining if there is such a thing as meaning in art.[3] As we will see when we explore one of the major clashes between art and religion of the twentieth century, the issue of how art is understood as either meaningful or meaning-less, and how it functions through univocity, multivocity, ambiguity, or shock, is intimately connected to the question of just *who* deter-mines what such meaning or lack of meaning might be. Keeping all of these tensions in mind provides a way to sketch an outline of what may be a helpful method for understanding art in the work of theo-logical aesthetics. I propose to do this by setting out some possible responses to the issues raised above.

The Task of the Artist

One initial way to explore what it is that artists do is to note that they routinely take the commonplace and defamiliarize it.[4] Artists "estrange" objects and complicate forms, making "perception long and laborious."[5] By taking what is familiar and complicating it, the artist returns life to the everyday; artists "make a stone feel stony" and arrest the fading of life into "nothingness."[6] We have been referring to this process as "seeing." In this practice artists thematize the experience of reawakened creativity within themselves, while also drawing others into an awareness of how art renews their world. As the great Marc Chagall (Russian French, 1887–1985) recounts, addressing his father, "You remember I made a study of you. Your portrait was to have had the effect of a candle that bursts into flame and goes out at the same moment. Its aroma—that of sleep."[7] Chagall was seeing, truly seeing, his father in ways much beyond the commonplace, and the complication, we can surmise, was transformative to their relationship. According to Aristotle, part of what an artist does is to deal with pos-sibility, not with "what has happened, but what may happen."[8] The

artist presents an imaginative vision in a universal way, and while in some ways "imitating" life, goes beyond what may have actually happened "to the law of the probable and the possible."[9]

Artists also build political force, ways for us to engage the constant tension between individuals, communities, and the state. The arts have the potential (repeatedly recognized by every effort to silence them) to subversively counter totalizing tendencies. This dangerous role of the artist is a service to the common good because as "long as the artist speaks the truth, he will, whenever the government is lying or has betrayed the people, become a political force whether he intends to or not."[10] The artist must also be selfless if she is to "sustain a pitched battle"[11] with the spiritual creative force that is "a power and not a doing, a struggling and not a thinking . . . creating as action."[12] Genuine artists do something that requires both ability and courage, and great artists "are able to converse with both forces and questions that most of us shun, repress, or simply are unaware of."[13] The artist is also involved in constructive innovation, advancing technical development by fostering "the link between art and common sense."[14] Artistic inventions create the way for new interpretations to be materially expressed, and often expand upon what up to that moment appeared as the only view. Artists should not effect an idealization of the abstract, but rather a synthesis of the living, we might say, what actually matters to human beings, which then becomes a vehicle for unifying "the beauty of forms and the goodness of the soul."[15]

But, lest we forget, not all views of what artists do are appreciative. Although it is tempting to dismiss Plato's negative assertions about artists in *The Republic*, we cannot. Plato's enormous influence on Western thought is indisputable and must be taken into account.[16] The philosopher has a particular idea of what it is that artists do, which does not include his own work in creating dramatic dialogues full of complex characters and fascinating conflicts.[17] In Plato's view, no one could be in touch with truth (as a philosopher) while simultaneously producing fiction (as an artist). What is most paradoxical to note is that he offers an example of this simultaneity of truthfulness and creative artifice in his own work.

Plato's vehement condemnation of poetry rests on two premises: that the visible world is an illusion, and that by "imitating" illusions what artists do is essentially to be deceived and to deceive.[18] Because Plato assumes all artists are capable of seeing "only the appearance,

and not the reality,"[19] the philosopher maintains that artists "will copy the vague notions of beauty which prevail among the uninformed multitude."[20] We note two important things here: he believes artists to be incapable of insights, and also that art has the possibility of reaching "the uninformed multitude." The universality and effective reach of art, which for Pope Gregory was one of art's great virtues, for Plato is one of its principal faults, and this brings us to our next issue.

The Work of the Artist and Society

In *The Republic*, Plato's fear is that a society can be swayed and corrupted by the work of artists. Reasonable people, according to the philosopher, must be "on guard against falling anew into that childish passion" that is the enjoyment of art.[21] Artists, then, also clearly provide a society with delight, and unify it through communal experiences such as the ones Plato relates when he speaks of the universal love and influence of Homer on Greek society, something he vehemently denounces. Plato's brilliant pupil Aristotle arrived at very different conclusions in the *Poetics*, the undisputed blueprint for Western theater. Unlike his teacher, Aristotle saw the arts as necessary expressions of what it means to be human. For him, the very necessity of dealing with ambiguity, context, and layers of possibility and probability in art fostered a beneficial exercise of multiple human faculties in those producing and receiving art. Rather than corrupting a society, artists provided a way for a more universal and insightful voice to be embodied. In this Aristotle was willing to confront his teacher head on, pronouncing poetry "a more philosophical and a higher thing than history."[22]

For Aristotle, the key to how art functions in a society is that it brings about pleasure. As humans, he contends, we have two natural tendencies, one is to imitate and the other is the pleasure experienced in the recognition of things imitated; a recognition which, he insists contra Plato, is linked intrinsically to learning.[23] Thus he notes that even though something may be painful in real life, once it becomes art it has the capacity to cause pleasure; real life has just been "complicated."[24] Aristotle says that this pleasure arises from two effects of art on a society. The first is the recognition, learning, and stimulation experienced when an audience identifies (or identifies with) something or someone they know. This reinforces his theme of art's

revelation of universality: "Even subjects that are known are known only to a few, and yet give pleasure to all."[25] The second is the more formally aesthetic effect of art on an audience, which, even if the art deals with something they have not themselves experienced, allows for the pleasure of appreciating the "execution, or coloring, or some other such cause."[26] Artists provide an experience of inclusivity to a community; we might even say he views them as fostering a sense of belonging. What is more, like the intentional inclusivity envisioned by Pope Gregory, for Aristotle, giving "pleasure to *all*" is important.

The primacy Aristotle gives to the "we" in the *Poetics*—to the shared humanity of artist, art, and audience—is truly remarkable. In stark contrast to Plato's solitary and deeply self-conscious "manly" man, who should never reveal a weakness or dwell on any personal pain, Aristotle celebrates art's ability to embrace what it is to be an ordinary human person. As he describes the ideal protagonist of a tragedy he says, it should be "a man who is not eminently good and just, yet whose misfortune is brought about not by vice or depravity, but by some error or frailty."[27] In one of the most important pieces of Western thought ever written, Aristotle adds simply, "Pity is aroused by unmerited misfortune, fear by the misfortune of a [human] like ourselves."[28] Through tragedy, artists provide a society with an opportunity to live through substantial mistakes and difficulties in a "what if" scenario. In giving voice to the Aristotelian tragic cornerstones of fear and pity, art can indeed enlighten and arguably even prevent terrible events from coming to fruition in a community's daily life, or at the very least allow a society to grieve openly and thus release its shared pain. The convergence of art and religious ritual is here unmistakable; both are intricately interlaced with the difficult business of living.[29]

In diametrical opposition to Aristotle's view, and reminiscent of Plato's excesses against art, we can also find those who claim complete autonomy for art. In this proposal it might not be art that corrupts society, but rather society that corrupts art through its demands. For those claiming such "absolute freedom," the society from which an artist rises and to which he or she speaks is at best inconsequential and at worst an oppressor.[30] Yet, we can argue that this extreme autonomy may have contributed greatly to present-day disaffection with modern art beyond the cognoscenti.[31] Without the balance provided by an honest mutual engagement with society, art denounces only to itself

(like a child throwing a tantrum), and thus is unable to announce anything to anyone. As we will see when we look at the case study of what happened in Assy, the excesses may get headlines, but they do not in any way bring about Aristotelian pity and fear, or a community's sympathetic sharing in human frailty.

Efforts at shock tactics in art sadly reinforce stereotypes of both spoiled artists and anti-intellectual publics, and fan the fires of censorship.[32] Surprisingly, it seems like some contemporary artists have understood the suicidal implications of radical autonomy and are denouncing it (in a wonderful turnabout) precisely through art. An example is the brilliantly executed art film/documentary/critical commentary *Exit Through the Giftshop* (2010).[33] As the film suggests, when "art" becomes exclusively about itself and about an artist's fame, it becomes a degrading commercial venture that devalues not only the art involved but all art. Thus, art must be about a community much wider than itself. *Exit Through the Giftshop* creatively reveals that the work of the artist in society must retain a prophetic edge, an ability to announce and denounce, and the autonomy of the artist is not to be found in absolute freedom or self-absorption but in purposeful anonymity and non-commercialization.[34]

Let me propose that one way to imagine a positive artist/society relationship is through the category of gift.[35] The arts can offer society the gift of being able to make sense of our experiences, of awakening our imaginations, and of allowing us to envision our lives and our future in new ways. The arts can offer a society a space beyond the known where we can journey into a new life, and also a way to connect with the gifts of the past so that "the dead may inform the living and the living preserve the spiritual treasures of the past."[36] The arts can be a way to build human solidarity. Whether in the very precise arts of a small clan, or the universal splendor that creates community across continents, the arts can encapsulate, express, and invigorate the human spirit.

The Artists among Us

By this point in our conversation, it should be becoming clear that to engage the tensions raised by the preceding questions we have to broaden significantly our perception of who artists are. Let us first consider the proposal by abstract artist Wassily Kandinsky (Russian,

1866–1944). Kandinsky's view of what constitutes an artist is diffi-
cult to engage, being at once insightful and also intolerably elitist and
self-absorbed. Writing in 1914, Kandinsky imagines the artist at the
"apex of the top segment" of a slowly moving pyramid. This artist, this
"man," is alone, misunderstood, "solitary and insulted."[37] The reason
for his aloneness is his vision, his enormous and unusual talent. Thus,
Kandinsky imagines the triangle of this pyramid horizontally sectioned
into segments, so that as the artist is at the very apex, it moves very
slowly and the lower parts of the segment may eventually come to
understand what only the artist at the very top previously understood.[38]
As with any pyramid, the lower the segment, the larger it is. As for
Plato, in Kandinsky's opinion this larger audience is not a good thing:
"those [artists] who are blind, or those who retard the movement of
the triangle for baser reasons," he asserts, "are fully understood by their
fellows and acclaimed for their genius."[39] For Kandinsky, not only
is the possibility of an artist's spiritual insight coexisting with broad
appeal impossible, but the likelihood of these "lower" segments of the
pyramid having anything of value to express is also remote. His is a
Darwinian conception of artistic genius where only the very fittest,
positioned at the top, deserve to be called artists, because they have
risen "alone and misunderstood" above the rest.

Nevertheless, Kandinsky also has an insight that perhaps unwit-
tingly exposes the very dangers of the solitary genius idea he is pro-
posing. He notes the temptation for an artist to "flatter his lower
needs" by making use of art to betray and confuse audiences, "while
they convince themselves and others that they are spiritually thirsty,
and that from this pure spring they may quench their thirst."[40] For
Kandinsky, then, artists are either geniuses or manipulators—they
provide spiritual food or pestilence—but they are always alone, always
individualists, and always unencumbered by a community or a soci-
ety. This radical autonomy and power is for him the strength of the
artist, but as we can see it is also his undoing.

Another view of who should be called an artist is the one put
forth by philosopher José Ortega y Gasset, writing a decade after
Kandinsky. Hopelessly entranced by the promise inherent in what he
terms "the new art," the philosopher explains that "the poet begins
where the man ends."[41] In this proposal, the difference between the
poet and the man is that the man's destiny is simply to live, while
the poet's is "to invent something that does not exist."[42] As he explains

this, he imagines the work of the poet as adding to the world of the real a measure of the unreal. This, he says, is what justifies the work of poetry. Also removing the artist from any relationship to anything around him, this view in effect validates Plato's suspicions of art as celebrating and perpetuating the unreal.

Chagall had a markedly different view from both Kandinsky and Ortega y Gasset. For Chagall, art and life, the fantastic and the ordinary, were inextricably intertwined, and he would have likely disagreed vehemently with Ortega's assertion that "the poet begins where the man ends":

> Will God, or somebody else, give me the power to breathe into my canvasses my sigh, the sigh of prayer and of sadness, the prayer of salvation, of rebirth?
>
> I recall that not a single day, not an hour passed now that I didn't tell myself: "I'm still a boy."[43]

It seems that Chagall saw artists as members of a community, chroniclers of its pains and joys, active participants in its life, always pulled toward it and never apart. He also saw artists as frail and fully human beings. As a young painter, he recounts his desperation as the German army advanced on Russia at the beginning of the First World War. First he prayed that the army would not reach his small town of Vitebsk, then as the army continued its violent march he recalls that, "the Jewish population retreated en masse, abandoning cities and villages. I longed to put them down on my canvases, to get them out of harm's way."[44]

Many years after Chagall, and from a decidedly different (yet surprisingly similar) setting, theologian Virgilio Elizondo recalled the myriad artists, unacknowledged and anonymous, that helped keep his impoverished Mexican American community alive. For this community it was the dancing, singing, and bringing of flowers to Our Lady of Guadalupe that continued to assure them God loved them. It was the job of each generation to pass "to the next the thread of life that binds us to our ancestors and projects us into the future. The annual celebration of the Guadalupe-event is not just a devotion or a large church gathering. It is the collective affirmation and cultic celebration of life in spite of the multiple threats of death."[45]

Returning once more to Federico García Lorca, he echoes Elizondo as he insists that artists are those recognized as such by the

community. It is the community's proclamation of the appearance of the mysterious force they call *duende* that anoints something as art and the one who manifests the *duende* as an artist. For Lorca, art and artists exist in a communal context that predicates the stature of art on the evidence presented by the "dark sounds" that "are the mystery, the roots that sink into the loam we all know, we all ignore, but from whence we receive what is truly substantial about art.[46] For Lorca, artists are those who are open to transmitting this creative force; it is the quality of what they give the community, the depth of what they express and embody, that makes someone an artist, not fame or perceived success.

True to this sense, Lorca collected lullabies from southern Spain, and in his lecture "Las Nanas Infantiles" ("Lullabies"), he consciously breaks the traditional confines of who may be considered an artist:

> Many years ago, strolling through Granada, I heard a woman from the town singing her child to sleep. I had always noticed the piercing sadness of the lullabies of our country: but never did I feel that truth as concretely as I did at that moment. Nearing the singer so I could write down the song I noticed that she was a beautiful Andalusian, joyful and without the smallest tinge of melancholy; but a living tradition worked within her executing orders faithfully, as if she heard the ancient voices full of authority sliding through her blood.[47]

Art as the carrier of tradition speaks to a community and thus can be an effective container and carrier of a community's sense of God, of its theology. It is because of this that beyond the usual religious documents and scholarly tomes, "theology is to be found . . . in the 'symbols, imagery and music' of our living faith."[48] Thus, as we broaden who can be called an artist, we also expand what may be considered theology, and who may be rightfully called theologians.

The Many Ways of Art

As we can see, the expansion of what we understand as the work of the artist extends the definition of what may be called art. Art appears as fluidly interlaced into the very fabric of a community's life; for them art is not only what hangs on museum walls, wafts through symphony halls, or lines the shelves of classical literature. What is it, then, that we may call art?

First, in spite of the many protestations to the contrary, the artist does not create out of nothing, the theological power of art rests in great part on the very fact that it witnesses to the wonder-filled qualities of Creation. The gift of having senses for perception and of a natural world that engages those senses becomes heightened through the transformation wrought upon it by the artist; in this, the artist is a craftsperson working with the bounty of materials provided by God.[49] Most great artists understand this role with humility, which the poet Charles Baudelaire writing in the mid-nineteenth century expounded:

> The creation of the artist is not *ex nihilo*, it proceeds from the natural, but is endowed with a "more" and the more has all the markings of the soul—it is an "ensouled" nature, beautiful and more than beautiful, strange and endowed with an impulsive life.[50]

In this view, art is defined from within, not from its form or technique; it is the "more," the "ensouled" nature that marks it as art, a nature that as Lorca specifies must be recognized by a receiving community. In this definition, the term art becomes elastic enough to include within it both Michelangelo's frescoes and Warhol's mother's well-worn holy card reproduction of Leonardo's *Last Supper*.[51] Such a view of art also embraces an *altarcito* to remember the dead,[52] an anonymous lullaby,[53] and the shell necklaces exchanged in the islands off New Guinea.[54]

My insistence on a very broad expanse where what is thought of as art may live is based on the incontrovertible awareness that our boundaries for what is art do not apply in many cultures and time periods, and also in a theological understanding rooted in Catholic Christianity.[55] To be Catholic has historically meant to encounter "God in all things," as taught by St. Ignatius of Loyola and beautifully lived by St. Francis of Assisi. Catholicism has, at its best moments, harnessed the force of the imagination to lift the community's gaze toward God in soaring cathedrals and haunting music. But beyond this, in its sacramentality, it has also lifted the ordinary—water, wine, bread, oil—seeing in it another dimension that allows us entry into God's imagination.[56] The "Catholic imagination" or the "analogical imagination" believes that "God is sufficiently like creation that creation not only tells us something about God but, by so doing also makes God present to us."[57]

In this way, for the Christian tradition, art can become a source of theology because it reaches wide and deep into creation. One way

that art may be described then is *as a work of human making that compli-cates the natural and as a gift that speaks to a community because it captures the spirit of that community; this work critiques and energizes, bringing new-ness and clarity.* The possibility of moving the definition of art into this space erases the customary distinctions between fine art and folk art, or high art and popular art, and also between the different art forms, such that we can speak of poetry, paintings, totems, and lullabies. This understanding of art allows a respectful approach to theological voices coming out of a Catholic tradition.[58]

What is more, such an expansive understanding is more in keep-ing with a contemporary world that has come to be thought of as a "global village." This term, coined by theorist Marshall McLuhan in 1962, has come to represent the unique opportunity offered by a "wired" world to know the other "tribes" of the world in inti-mate ways.[59] Although a fairly new development in terms of its instant accessibility—Australian aboriginal sacred art is now just a mouse-click away—the folding of otherness into our tribe is an ancient tradi-tion within Christianity. It is significant that while the otherness of a society's belief systems and laws might be rejected, artistic/ritualistic otherness is often embraced. That champion of the teaching potential of images, Pope Gregory, seems also to have understood much about this unifying use of symbols and their affective power. As he writes to those visiting Augustine of Canterbury, he tells them to

> tell [Augustine] what I have decided after long deliberation about the English people, namely that the idol temples of that race should by no means be destroyed, but only the idols in them. Take holy water and sprinkle it in these shrines, build altars and place relics in them. . . . When this people see that their shrines are not destroyed they will be able to banish error from their hearts and be more ready to come to the places they are familiar with, but now recog-nizing and worshipping the true God.[60]

Art, as an embodiment of the spirit of a community, has very often made it possible for that spirit to survive. In a way, Chagall did indeed take Russian Jews into his canvases, and kept them out of "harm's way" by rescuing them from oblivion. Almost four generations later, the depth and power of the religious traditions of his native Vitebsk continue to live and enliven the world from Chagall's enchanting canvases. Thus, we might call "art" the traditions in the daily life of Vitebsk that first

inspired Chagall and not just his paintings of those traditions. García Lorca's poetry based on Andalusian lullabies is certainly art, but clearly so are the songs the mothers sing on summer nights.[61]

The Many Meanings and Meaning-makers of Art

We needed to work through each of the preceding questions in order to provide a foundation for an inquiry into the nature of meaning in art. This question is probably one of the most hotly debated and I would even say "fashionable" issues in critical theory today. As such, it is beyond the scope of the present book, yet the proposal of a theological aesthetics of interlacing art and theology must include a position regarding art and meaning.

First, if by "meaning" we are referring to the reduction of an artwork to a message, this is a problematic proposition. As we note Jesus' artful storytelling, we also note that the effectiveness of his parables often hinges on their open-endedness, their reversals, and the multiplicity of interpretations possible.[62] Meaning is never singular, and meaning(s) are the result of honest engagement with art through a complex process of encounter and interpretation.[63] If we recall the categories of firstness (the art as such), secondness (our encounter), and thirdness (what happens as a result), it is in the continuum of the second and third moments that meaning may become apparent.

Art's meaning(s), as some artists contend, is not so much in what the art *says* as in what the art *does*. Art enlivens, transforms, and in some ways even restructures reality.[64] The playfulness of art's relationship to reality is quite meaningful to both the artist and the viewer. The transformation of reality, both in its desire and in its effects, is in itself revealing. Yet if meaning is also sought in what an artwork *says*, most artists do experience their creative-making as expressive:

> The potter . . . works at her craft in a particular time and place. Yet where her time intersects with history, there is of necessity something that the potter wishes to "say," something that speaks both to her time and to her tradition. That "something," I would assert, must be personal, beautiful, and lasting.[65]

Like this potter, many artists assert that their creations are indeed meaningful, and theories that propose art to be nothing but demonstrations of "the ceaseless play of the signifier" do violence to the labor

and the giftedness of those who produced it.[66] Somewhere between Kandinsky's superhuman artist and Jacques Derrida's rejection of interpretation and with it human subjectivity and historical causality, there is a more modest idea from artist/philosopher Gao Xingjian of what meaning an artist may impart in a work. As he stresses, "meaning in artistic creation" derives from "the way an artist turns feelings and ideas into a creative force and makes them a work of art by means that are his only."[67] The artist's feelings and ideas may even be about radical meaninglessness, nonpersonhood, or emptiness, yet these are indeed meanings.

In revealing beauty, or its absence, art meaningfully articulates categories that cannot be reduced to propositions or adequately expressed in any other form but the artistic. As the theologian and philosopher Boethius (c. 480–526)[68] deduces in speaking of music, art resonates uniquely with the human heart. As Boethius notes how "human nature" seems to be disposed to perceive and delight in musical harmony, he understands this very delight to communicate to us something about ourselves, namely that, like the music that brings us joy, we are also made to be harmonious and full of sweetness. As we are pleased by beauty in art, we learn of our own beauty.[69] In this we might understand art as having the capacity to return meaning to one's humanity.

Another central consideration is that when we speak of meaning(s) these cannot be predicated solely on authorial intention. As literary critics have noted, "If people approach literature with a desire to learn something about the world, and if it is indeed the case that the literary medium is non-transparent, then a study of its non-transparency is crucial."[70] The very opacity of an artwork contributes to its complication of reality, to how and what it is we learn, and to its status as art. Returning to our conversation on mystery, a work of art may often be mysterious even to the one producing it. Thus, an artist's intentions cannot be the sole measure of a work's meaning (or indeed the principal measure), for "many writers will testify that when the characters they create come alive, they become dangerously unpredictable!"[71] It seems that an appreciation of this opaqueness in art is indeed an appreciation of artfulness.

There is certainly danger in engaging in what some critics call "hypothetical intentionalism" that, absent evidence of authorial intention (or dealing with an unknown author), uses context and

convention to ascribe intention to an imaginary author.[72] Unlike a philosophical treatise in which "the goals of the whole enterprise" may be discerned and its coherence sought through the process of interpretation, there is no such "goal" readily apparent in most art, at least, no such single goal.[73] Thus, as art's meaningfulness cannot be reduced to the supposed intentions of the artist, or deduced logically through a systematic analysis of its parts, it also eludes us if we attempt to answer this question through looking at the work's genre. Often, but certainly even more since modernity, artists "deliberately produce genre-defying work."[74]

Most mysteriously, part of art's meaning(s) may be hermetically contained in the event of creation itself, an event not limited to the artist. Jackson Pollock (American, 1912–1956) claimed not to be representing nature so much as *becoming* nature in the act of making his paintings.[75] It can be argued that in viewing his paintings, we are likewise forced to be other than we are, leaving sciential paradigms behind. Like Pollock, Gao Xingjian understands the act of painting as a practice in itself meaningful that gives the artist the gift of returning to "intuition, . . . to sensations, to an existence full of life, to life itself. It's a return to the present moment, the eternal present moment."[76]

It is this inextricable connection between what is happening with/in/through the artist in the execution of art, its resultant manifestation in something that may be quite ephemeral, and the community that participates through recognition, which García Lorca so skillfully articulates. Unlike meaning that appears fixed, this is a relationship—dynamic and ever changing—which at the same time reveals eternal qualities that the community recognizes. It is precisely in the surrender to the spiritual force of art, when all signposts and external buttresses of "Art" have been given up that *duende*, the quality the community will proclaim as artistic greatness, makes its appearance.[77]

The denial of meaningfulness to art is also often selective, hidden behind ideological positions. We may assign meaning to art that openly questions or mocks what we do not like, and at the same time deny meaning to what confronts us or makes us uncomfortable, failing to be consistent in the understanding that questioning and mocking are always meaningful acts.[78] Claims of art's meaningfulness are often grounded on the idea of wholeness, as meaning is often "discerned and enacted through the activity and receptivity of one's 'whole being.'"[79] It is art's unique ability to address us in wholeness

that makes it imperative that the religious be (at least in part) aesthetic and artistic. "Among our symbolic and expressive forms, those that are markedly artistic seem best to be able to affect us in the totality of our being."[80]

The arts and the religious are linked in the way they function to address the human being. Were art to be denied this addressing capacity, it and the religious would cease to have any commonality. The possibility of disclosure of meaning(s) in art is a nonnegotiable principle for the interlacing of art and religion.

A better way to refer to meaning in the work of theological aesthetics may be insight.[81] "Insight is knowledge that not only has breadth and coherence but is also close and personal."[82] Insight is a kind of knowing that "makes us aware of the unity of many facts in one whole." In experiencing this unity, we then come "into intimate personal contact with these facts and with the whole wherein they are united."[83] We could argue that in the concept of prompting insight we can discern the convergence of our experiences of art and our experiences of revelation. Both the theological and the artistic are at their fullest when they "offer religious insight into the human condition," and because of this "art has much to teach theology about the struggle of the spirit in the world."[84] We can argue then that a marker for what constitutes meaningfulness in art as it is interlaced with theological concerns is the prompting of experiences that affect the totality of our being and result in insights that have breadth and coherence, and that bring us into a more intimate appreciation of the complexity of our human condition.

Some Conclusions

Although not an exhaustive definition of the idea of art, the preceding questions help set some parameters. Art defies definition, and this is part of what makes it art. Art "estranges" and complicates reality so we might see anew what had become commonplace. Art makes us aware of the processes within us that awaken our creativity and our intuition through new ways of knowing. Art deals with possibility, with what may happen and not only with what has happened, and it universalizes the particular, thus creating community.

Artists are engaged in political acts through giving voice to the spirit of a community and through critiquing what has become

ubiquitous or oppressive. Artists must have a level of boldness and selflessness in order to approach what escapes many of us. Artists are involved in constructive innovation, in bringing about new ways of seeing and imagining, and through this, new ways of unifying human experience. Artists are persuasive, and art's ability to give pleasure can also be subverted to lie and to harm, just as it can be used for the truthful and the good. The existence of a wider community from which the art arises and who also receive it functions as a corrective to artists' use of art toward selfish and destructive ends. That art may contribute to propagating either truths or lies is not because art is art, but because of how the wondrous human capacity for creativity can be used or misused.

An artwork allows for a community to experience, by means of a "what if" situation, difficulties and challenges that can awaken insights, so that in the fear and pity aroused, the human questions may be seen more clearly and coherently. In this way art can help us. Art that claims absolute autonomy from society and all other human endeavors ends up in a circular conversation that runs the danger of irrelevance. And artists are those involved in creative human making as gift. Art is not only in Chagall's canvases, but in the lives of the Russian Jews he immortalized in them. Art is art because it is recognized as such by a community in what Lorca calls the "dark sounds," and in unapologetic honesty. Art is art because of its multiplicity, richness, and depth in somehow capturing the religious experience of what Buber calls the *mysterium tremendum*.[85]

Art may function theologically, not by imparting one set meaning but by making us aware of an ever-receding "more." Art can bring about experiences of wholeness and give us the gift of religious insight. It is this "sense for the integrity of the human, its beauty and truth that makes art *art*."[86] I have stressed the dynamic nature of the arts and the religious as a relationship, as a doing, and as something complex and deeply embedded in the vicissitudes of human life. I have also proposed that some of the unique qualities of theologically complex art are that it does not abstract but embody, and is not about ideas, but much more concretely about insights. Such intricacy is always potentially unstable, and the next few chapters will help us chart where the stress points on the bridge may be found.

8

Beauty in Turmoil

*T*he exploration of the arts as effective bridges to experiences of revelatory wonder has at its core a hope. The hope is that human life may be more fully permeated with truth, goodness, and beauty. In the communities I belong to, this hope is not born of an improbable idealism, but of the experiences of beauty, truth, and goodness that are vitally present around us. Because this hope is nurtured and actualized through wonder-making experiences that lead human persons to religious insights, the renewal of a closer alliance between the artistic and the religious is needed, and it is needed in an ever present yet ever receding *now*.[1]

It is heartbreaking to read art and religion pioneer Von Ogden Vogt's impassioned plea for a renewal of our collective attention to beauty. Vogt called for beauty in the first edition of his book, *Art and Religion*, published in the aftermath of the First World War as *the way* to unite humanity. It is awe-inspiring to realize that he continued to cling to this hope in the midst of horror, issuing a new edition of the book after World War II.[2] For the hopeful Vogt, the disarray caused by the war would become "a time of reexamination of all things, a time of changes; profound and universal. . . . [T]he disorganization of normal life by the great war," he assures his readers, "has compelled a new openness of mind and roused new demands for better life."[3]

Over half a century later, we know that this positive outcome—of a newly enlightened and peaceful world resulting from the horror of the war that Vogt barely dared to name—never materialized. The urgent appeal Vogt presented to artists and religious people to join their efforts toward a just and peaceful world fell on deaf ears, as commerce and technology grew to be the central concerns of modern life, while carelessly disposing of the planet and its living beings. In this world there was no room for what Vogt understood, namely that "beauty is one of the essential necessities of human existence."[4] Apparently few were as convinced as he was that it was the lack of attention to beauty, goodness, and truth that had led the world to the brink of destruction.

Vogt and his particular historical situation are great teachers. In the apparent futility of his pleas and the downward spiral of the twentieth century in terms of both ethics and aesthetics, we have historical witness to the urgency of cultivating our capacity for wonder and our desire for beauty. One of the many ways the events of the twentieth century (the most horribly bloody epoch in human history) may be understood is as the dénouement of systems that became increasingly less human and cared about neither delight nor desolation. The unrelenting march of those on the winning side of history, driven by an unquenchable need for wealth and power, replaced the truly beautiful with an artificial and poor facsimile that was easy to manipulate.

The experience of *La Pastorela*, a story of the triumph of the human capacity for goodness in the face of temptation, enacted in childlike splendor *by* the poor and *for* them, has so little to do with the contemporary drive for power and wealth that it makes one wonder if we are even part of the same species. It is decidedly a "minority" voice, yet present in many articulations all over our world. Vogt imagined a renewed unity would come about in his lifetime,[5] but instead the world sank into an even deeper state of fragmentation. However, if Vogt was right and the arts do "constitute the description of the world as an age or people apprehends it,"[6] *we need to pay attention.*

The production of *La Pastorela* I saw in San Juan Bautista in the first decade of the twenty-first century was not the medieval shepherd's play our ancestors in the Old World knew, or even its adaptation to the California landscape by eighteenth-century missionaries. This was something radically new and in many ways disconcerting. The mind-bending mix of languages and time periods, of the Tempter

as colonial gentleman and California surfer, of farmworkers as actors, of actors as shepherds, of shepherds as farmworkers, and of angels on niches on walls and enfleshed, all created a spinning hall of mirrors, a reflection of a community caught in the midst of a whirlwind of contradictions and resisting the threat of nonbeing. Still, in the end, the chaos ceased in the paradoxical glory of the stillness of a manger, and Peace, brought by its Prince, was restored.

"The spiritual life of a time," Vogt tells us, "is depicted with inescapable exactness in its artistry."[7] La Pastorela found beauty in turmoil, strength in difference, and power in the powerless. Through beauty it found beauty's sisters—truth and goodness. La Pastorela represents the kind of voices we need to hear, the type of experiences we need to have. Theological aesthetics presents us with a double opportunity: to pay attention to what our arts are communicating theologically about our human struggles, and to encourage and support the production of art so we may have windows into these struggles. I find that these two impulses, to engage art and then to create it, work effectively in my undergraduate students. In class, after many weeks of wrestling jointly with the intricacies of the arts and the complexities of Christology, they "fly solo" and produce works of art. Their art projects move beyond what they might be able to express in a formal discursive paper, constructing courageous representations of the intricacies of theology and what it means for them as young people to wrestle with these questions in our day and time.

For instance, in Illumination (After the Shroud of Turin) (2010, Plate 8.1), Daniel A. García (Salvadoran American, b. 1989) reimagines the mysterious and controversial "Shroud of Turin."[8] García, an enterprising biochemistry major, used fluorescent paint, which is only visible under black light conditions, to reproduce the figure of Christ on a cloth with his own body as the medium of impression. The effect, only visible when the viewer enters a small and completely dark alcove, is heightened by the aloneness of the encounter and the mysterious nature of the figure suddenly becoming visible as it is exposed to black light. The ephemeral nature of the encounter is underscored as the image remains present only for a few minutes and slowly dissipates, returning the cloth to its ordinary blankness. Visitors are confronted and deeply intrigued by this work, which seems to capture so well our experience of wonderment as we consider the complexity of the incarnated God (the human body) and the transcendent God (the numinous) in Christ.

FIGURE 8.1
Hi, God!, 2010, by Camille Werstler. Courtesy of the artist.

Camille Werstler's (American, b. 1990) unconventional installation *Hi, God!* (2010, Figure 8.1) brings together her study of Barnett Newman's canvases and his use of minimalist lines, sometimes referred to as "zips." Newman's work reminded young Werstler, an art history major, of another "zip." As a small child, Werstler would lay in her bed contemplating a crack in her bedroom ceiling, convinced it was a "zipper" she could open to speak to God. It was thus that she began

her prayers every night. Her installation reproduces a small bed for reclining and her reinterpreted, Newman-like "zip" (a large black zipper attached to a textured white canvas on the ceiling) invites visitors to rest on the bed, look up, imaginatively unzip the ceiling, and begin a conversation by simply saying "Hi, God!" This was an invitation many of her fellow college students were delighted to accept.

Finally, Maggie Assad's (Egyptian American, b. 1987) *Christ Icon (Pantocrator)* (2009, Plate 8.2) involved her intense study of the ancient technique of Orthodox iconography through filmed demonstrations. Assad, a Coptic Orthodox Christian, saw this as an occasion to explore and preserve her persecuted community's venerable religious tradition of icon making. As an art and theology double major, Assad also saw this as an opportunity to share the details of the ancient process with her classmates. One of the more fascinating features of making the icon that she presented was the process for attaching the gold leaf of Christ's halo to the surface through the gentle warmth of the artist's breath, a truly evocative image full of interpretative possibilities.

As these works by college students (and their warm reception by their student peers) suggest, we need to listen intently to what the arts of our time are expressing. We also need to facilitate and encourage the expression of spiritual struggles, theological quandaries, and the reappropriation of religious traditions through the arts. "An age or a people that does not reach any self-realization or any unity of thought or feeling that breaks forth into artistic expression is nondescript," Vogt insisted. "Art is not something detached from life: it makes life and is made by it. It appears in every age and represents to us the life of which it is a part."[9]

The Work of Theological Aesthetics

Appreciating art's theological depth and encouraging its production are the pillars on which we can build the bridge to wonder. To know ourselves, express ourselves, and imagine our better selves through that reflection of God's vision for us that is wonder is a compelling reason to attend to art. Providentially, Vogt has counterparts in our day. Scholars Frank Burch Brown[10] and Alejandro García-Rivera[11] have ventured into the work of theological aesthetics with scholarship that has been preparing the way for a renewed relationship between the arts and the religious. They have been bold and also tentative, since the

complexity of navigating a field that is just emerging is difficult even for the seasoned traveler.

As we know, theological aesthetics is most fruitful when it deals with particular objects or events and when it tells stories. Part of the work of wonder is our reflective awareness of the experience of being *asombrado*, baffled and surprised at realizing that what appears random really is not, and what appears concealed suddenly reveals. This *asombramiento* was my experience when, as I read deeply into the works of Frank Burch Brown and Alex Garcia-Rivera, I realized that two of their texts were discussing the very same event and were exemplary in what they disclosed about the difficulties associated with the work of theological aesthetics.

García-Rivera's text interprets the Christmas experiences of two communities and their interaction with one another, as he observes and comments upon the religious aesthetics at work. Yet these are experiences that also touch him personally as a full participant in them, and have much to do with his own traditions (religious, cultural, and familial). Brown's text in turn interprets García-Rivera's text, adding yet another layer of questions of a religiously aesthetic nature. Twice removed from the Christmas experience being recalled, Brown's text is nevertheless also personal and also drinks heavily from his particular cultural, ethnic, and religious traditions. Through the interplay of these two texts—which is not without conflict—we come to see the complexity of this work.

Finally, and I believe this a crucial distinction in the work of theological aesthetics, we come to understand that when we deal with aesthetics we use human faculties that make us aware of the limitations of claims to objectivity in academic discourse. Attentiveness to the affective pull of aesthetic questions makes perceptible what is often subtly at work in all moments of interpretation. The aesthetic, as both scholars would agree, "works artfully with the mind and soul through the senses and imagination,"[12] and does this in such a way as to make the heart stop and then race with recognition.[13] The aesthetic matters, and as these two scholars show, it matters deeply.[14]

Brown and García-Rivera are formidable scholars, blazing a trail in theological aesthetics for appreciative colleagues and students who have been jolted out of their familiar surroundings in theology, art history, and criticism. Their work deserves a lengthier treatment than I can possibly give here. What I *can* do is to briefly juxtapose their

methods and insights as they actively do this work.[15] In this way, their work becomes another source to systematize constructively a method of inquiry through which those of us interested in the relationship between the arts and the religious may gain greater insights. I see their pioneering work as essential to building a bridge with the current questions surrounding religion and the arts by giving us solid theoretical foundations.

The Tale of Two Christmas Trees

Their retellings of the same Christmastime story (and divergent interpretations) introduce us to the differences between Brown, a Protestant Anglo American scholar, accomplished composer, and choral director, and García-Rivera, a Roman Catholic Hispanic American scholar whose background includes being a physicist and a Lutheran pastor. Brown retells and interprets an anecdote from García-Rivera's *The Community of the Beautiful* in his book *Good Taste, Bad Taste, and Christian Taste*. In the passage, García-Rivera recalls the conflict over the Christmas decorations of two communities sharing life in a small Lutheran church in Pennsylvania. As Brown tells the story, paraphrasing García-Rivera, "one was a church made up of mostly poor Hispanics who worshiped in a small, upstairs auditorium in a church building . . . the other was a church made up of English-speaking Lutherans who worshiped in the same building, but downstairs, in what was meant to be the church proper."[16]

The Christmas that García-Rivera recalls in his text (the very first these two different communities shared) they decorated their worship spaces quite differently. The English-speaking community "in the church proper" put up "a fifteen to eighteen foot natural fir tree next to the sanctuary," decorated in white lights and "Chrismons."[17] In glaring contrast, García-Rivera tells us, "the (very poor) largely Puerto Rican community" who met in the small upstairs space "had purchased a four foot artificial tree decorated with flashing colored lights, its limbs bending over by the weight of the tinsel that hung from every inch of available surface."[18] Additionally, the Hispanic community made life-sized cutouts from plywood to create a *nacimiento* (nativity scene), hanging a star above it that García-Rivera tells us they borrowed from "the Moravian community of nearby Bethlehem."[19] Thus far, the story foregrounds different aesthetics,

a familiar story about tastes and cultural clashes—the Anglo community finds the upstairs tree "gaudy" and the Hispanic community finds the downstairs tree "lifeless."[20]

As the story continues, García-Rivera tells us with a perceptible note of sadness that, "such differences would be repeated over and over again in all the details that make up a parish's life. It was inevitable, then, that the host church decided that the Hispanic community might be happier somewhere else."[21]

Similar to the game of "telephone," where children whisper a sentence around the circle to see how much it is altered in the retelling, it is instructive to note what Brown's paraphrasing of the original story emphasizes and what it leaves out. Brown stresses that the downstairs community are "Christians" and that the decorations of their "very large fir tree" are "simple." But two details are left out in this game of "telephone." Brown does not mention that the upstairs Hispanic community was "*very* poor," and he also leaves out who it was that lent them a star to hang over their homemade nativity scene, saying only that "they borrowed [the star] from a Moravian community nearby."[22]

What the divergent accounts suggest is that we are all, scholars included, not immune to the difficulties of navigating the religious, cultural, and ultimately aesthetic differences experienced by diverse communities. When our feelings become involved, and when these feelings become invested in an "us" versus "them" scenario, we can miss what should be in plain sight. Although Brown appreciates the story, he also critiques it. One particular issue for him is that at the time of García-Rivera's writing, he was no longer the pastor of this community or even a Lutheran. His statement that García-Rivera had "left the Lutheran denomination altogether" discloses the hurt of rejection for Brown's Protestant tradition.[23] Brown is also troubled by Garcia-Rivera's assertion that "Beauty . . . loved the Moravian star imported into the 'Catholic' nativity scene in the little Hispanic Lutheran church."[24] In this, Brown rightly reads García-Rivera's preference for the aesthetics of the upstairs community and assumes this preference is also a rejection of the aesthetics of the downstairs tree. The theological aesthetics question posed seems to Brown to be about the difference between an inclusive "eclecticism" (upstairs) and the exclusivity implied by the "discriminating taste" (downstairs).[25] However, García-Rivera has placed understated clues to the story's

meaning throughout, and if we miss these, the aesthetics become separated from the ethics. The beautiful is cleaved from the true and the good. What I want to do is pull back the curtain and, by interlacing the concerns of these two scholars, attempt a theological aesthetics *acercamiento* of the "tale of two Christmas trees."

The story as told by García-Rivera focuses on the controversy over the aesthetics of the Christmas trees, in order to subtly foreground issues of justice revealed in the encounter between the two communities. The underlying structure is *drama*, and to read the nuances of the story he recounts requires familiarity with the Hispanic community's symbolic universe. In Latin America and the parts of the United States that were founded by Spanish Catholics, Advent and Christmas are exceedingly important.[26] The observances of the season go back centuries, as we saw with *La Pastorela*, and exclude concerns over Santa Claus and shopping.[27] Although traditions vary greatly by regions, two seem to be behind García-Rivera's story: the tradition of asking for *posada*, and the building of Christmas crèches, *nacimientos*, in churches, homes, and public spaces.

The *Posadas* reenact Mary and Joseph's journey as they arrive in Bethlehem. Stretched as if in extreme slow motion for nine consecutive nights, the young couple searches for an inn (*posada* literally means a place to stop and rest). Depending on the community and their resources, the ritual may be as elaborate as to feature one of the pregnant young women in the community, joined by her husband, in full biblical costume, as she rides a small donkey.[28] The ritual is public, moving through the streets and involving the whole neighborhood as the procession that accompanies them makes its way to a variety of houses singing the familiar song:

> *En nombre del cielo, os pido posada, pues no puede andar, mi esposa amada.*[29]

> In the name of heaven, I ask you for a resting place, my beloved wife cannot continue journeying.

As they knock on doors Mary and Joseph are repeatedly turned away, until, at the final stop they (and all those accompanying them!) are invited in. The offer of *posada* thus culminates in a fiesta where food is brought out and shared. What García-Rivera's pointed references to the poverty of the upstairs community and the detail of the star's

provenance from nearby Bethlehem provide are clues to what the story of the two Christmas trees is really about. The "very poor" upstairs community was asking for *posada*, a place where they would be welcomed, where they would find rest. This was the story of that other Bethlehem, incarnated once more in Pennsylvania. The aesthetics of the story effectively point to the complicated ethics of the story. The exuberance of the longing expressed by the cheap decorations and life-sized nativity was a practice of hope in the midst of profound poverty and marginalization that is difficult to comprehend for those not privy to such experiences.[30] What may appear as eclecticism is beautiful not because of its admittedly messy form, but because of its witness as resisting the threat of nonbeing. A small, artificial tree wants to be beautiful, and the community needs a place to rest.

As the story and its interpretation disclose, the conversation between Protestants and Catholics, Anglos and Hispanics, English tradition and Latin American ways, remains fraught with profound problems. Even if we are toiling in the same field and coincide in almost every hope and conclusion, we often cannot understand each other. It is not just the artistic and the religious that are separated by difference, but everything else about us creates layers of separation, of possible misunderstanding, of distance from the great Heavenly Banquet (Luke 14:15-24).[31] Ideals are sometimes far from the reality of messy human life, and all of us can misunderstand or simply not see.[32] We repress much in our interpretations of others and of ourselves, yet attentiveness to this tendency can be instructive.

There is a marked difference between a Protestant aesthetic and a Catholic one, and this plays a part in this story. The upstairs and downstairs communities are not separated only by economics and language, but also by old divisions along sectarian lines that even in two nominally Lutheran congregations are still present. Images and ritual were (and often still are) the very visible battleground where the fights between Protestants and Catholics were fought. The power of the aesthetic is highlighted when images are destroyed or brought back because they express so fully the identity of a community. The bewildering difficulty apparent in this story is that even among Protestant Hispanics, Roman Catholic religious aesthetics persisted, including the community's decision to call themselves St. Martin de Porres Lutheran Church when they later set up a separate congregation with García-Rivera as their pastor.[33] Aesthetics disclose much,

even as they conceal, and indeed a longing for "the ecclesial tradition of the Latin Church of the Americas" eventually called García-Rivera back to the Roman Catholic tradition.[34]

The differences between these two communities were deep, and in the story this took visible form through two radically different Christmas trees. In spite of our very best ecumenical ideals, it remains agonizingly true that we are a tragically "separated" Christian church. The "us" always differentiates itself from the "them." I belong to García-Rivera's "us" and felt disconcerted when I did not know what "Chrismons" were.[35] The stylized ornaments may indeed be beautiful but they have no relationship to me; I do not know them. Perhaps I could understand them better, but my "place" up in the small auditorium might keep me from doing so. The separation is ubiquitously present, we are an "us" and a "them," and on this side of paradise we seem unable to overcome this.

The story of the two Christmas trees also discloses that as we cultivate our wakefulness to the religious in art, we also need to awaken to the artfulness of all life. If we do not interpret this story aesthetically, as drama, we are unable to glimpse its depth. As a Latino theologian, García-Rivera comes from a storytelling tradition, and thus this story is not just a factual report, but meant to be much more. As theological aesthetics aids in seeing the religious depth of art, it can also aid in seeing the artistic depth of daily life. When approached as an artistic retelling, the story discloses any number of insights.

For instance, there is a great difference between worshiping in a proper church sanctuary and in a small auditorium. This difference would be understood as a painful exclusion from Beauty (and analogically from being in the presence of God) by any community that prizes ritual and the sacredness of time and place. There is also the economic chasm we note between a "very poor" community that can only purchase a four-foot artificial tree and a community that can afford the expense of a fifteen- to eighteen-foot natural fir tree. Implied in the narrative is the lack of justice of such an overwhelming difference, and the unrealized beauty that could have resulted from sharing the expense for two more modest but naturally beautiful trees. At no point does the narrative suggest that the poor Puerto Rican community would have rejected such an offer or gift, especially given their humility in "borrowing" the Moravian community's star. The star, however, is at the very center of the story, as it hangs over the handmade crèche.

Yes, it might be only Bethlehem, Pennsylvania, but we can read into this detail of the story that this very poor Puerto Rican community is a contemporary embodiment of the Holy Family—homeless and seeking shelter in a land not their own. Noticing this, we suddenly see that they were consigned to a small and inadequate stable after being refused a place at the inn (the church proper). This is the reason why the fir tree and its "beautiful" Chrismons cannot be experienced as beautiful and life affirming by them. The trimmings lack a coherence that theological aesthetics notices; the tree speaks artistically of welcoming the Christ Child while religiously turning away the poor whom Jesus loved.

The story then turns on a question of exceptional importance to theological aesthetics—the difference between the superficially beautiful and true Beauty.[36] A Christian community with a beautifully decorated sanctuary that first banishes the "other" to a small auditorium, and then eventually decides that they "might be happier somewhere else," is only *illustrating* the Incarnation, not celebrating it, and certainly not sacramentally embodying it.[37] The fir tree with its meticulously made Chrismons becomes an anti-Christmas tree and this (not its aesthetic restraint) is what makes it lifeless.[38] The final tragedy of this story is that both the aesthetic pronouncements of the artificial tree's "gaudiness" (from *gaudir*, to rejoice) and the fir tree's "lifelessness" are true. And if such truths were seen, conversion and unity might follow close behind.

Theological aesthetics is a very different undertaking than simply looking at the aesthetics of religious art. Theological aesthetics asks theological questions that sometimes are only accessible if we pay attention to the aesthetic realm. An eighteen-foot tree covered in light and Chrismons in a sanctuary is only about itself when what we feel is the absence of the crudely cut-out figures of the nativity, the borrowed star of Bethlehem, and a community that was not welcomed and given a home.

The Theologically Aesthetic

As this complex story of two Christmas trees and two theologians shows, avoiding what is difficult is an all-too-common feature of the human condition; the very multiplicity of our "otherness" across cultures and traditions exacerbates the problem. Our feelings of "us-ness"

and "them-ness" very often get in the way of our seeing, urging us to overlook what we just *do not want* to see. Additionally, while our theorizing might wax poetic with ideals, it often falls very short of these in practice. Theological aesthetics has to go much beyond the appreciation of superficial beauty to the coherence such beauty has with the theological truths it is trying to convey and celebrate in the source of all Beauty.[39] Difficult and divisive things will often need to be said for the sake of the project of recovering aesthetics for the religious life; among these might be assessments that do not sound particularly "ecumenical," such as honestly acknowledging the iconoclasm of the Protestant Reformation and its consequences,[40] or the sometimes anti-aesthetic excesses of those interpreting the Second Vatican Council's liturgical renewal.[41]

Theological aesthetics is falling short of its considerable potential if it fails to make an effort to see the artistic in life while it tries to see the religious in the artistic. The potential for religious insight is much enhanced when the commonplace of a community's life can be approached with the same inquisitive appreciation we normally reserve for drama. In seeing the artfulness of life, something of God's authorship is already revealed. As the tale of two Christmas trees exemplifies, bridge-building is very difficult work, yet what the careful untangling of the many strands in this story helps us to see is that if we pay attention to what has gone wrong, we are rewarded with insights about how to do it right it. Theological aesthetics tools in hand, we are ready then to try our hand at building.

9

The Bridge to Wonder
Is Ours to Build

I once sailed under the Golden Gate Bridge.
　　When I was in college, a friend and I launched a laughably small and fragile catamaran out on the legendary San Francisco Bay. When we finally reached the bridge, we sat in awe of its towers rising above us over seven-hundred feet (about the size of a fifty-story building).[1] The enormity of the bridge was breathtaking, but even more so was its intricacy. The structure is almost two miles long and supports a steady stream of heavy traffic by literally suspending it above the water. The bridge can do this because it was designed to be part of the bay's eco-system. As the wind blows, the cables that hold up the main span move with it. The cables can do this because they are not single structures but tightly bundled multiple strands of steel wire, almost thirty-thousand of them. During a particularly fierce storm, the massive bridge actually bowed six feet, mimicking the adaptability of the fragile branches of a jacaranda tree.[2]

　　Along with the wind, the bridge also reacts to the sun, becoming a giant orange vermillion thermometer as the steel expands and contracts, moving the span up or down as much as sixteen feet; the bridge interprets the heat of the day or the cool of the evening. The Golden Gate Bridge is a community of intricately interlaced structures, itself existing in community with the natural world

that surrounds it. The Golden Gate Bridge is art. The Golden Gate Bridge is also somehow religious.

Art and religion, like the bridge, exist not as ends in themselves but as multistranded structures with a purpose. They are built from an abundance of distinct parts that also disclose a mysterious unity (1 Cor 12; Gal 3:28). The beauty of the bridge endures because of its relationship to the world it inhabits, its responsiveness to that world, and the care the human community it serves bestows upon it. Wind, cold, and heat would eventually destroy a rigid structure, but in the marvelous artfulness of the Golden Gate Bridge, it is the interlaced and nimble quality of its many parts that allows the bridge to react to what surrounds it. Through this relationship with nature, the bridge does not break but continues to do its beautiful work.

My view of the bridge as art and as religious is unconventional, but it is one way we can concretely visualize and articulate theological aesthetics as a method. A method is, simply stated, a way to accomplish something. There are many ways to focus on the bridge, many ways of *knowing* it. Architects will use a method that allows them to measure and trace, to do mathematical calculations and determine loads and distribution. Urban planners will look at the role the bridge plays in connecting and moving populations between different counties and routing traffic flows. Those charged with public safety will want to make sure the bridge and all those who cross it are safe. Conservationists will catalog the bridge's history, making sure its aesthetic integrity is respected while carefully monitoring innovations and restorations. And ecologists will vigilantly scrutinize the impact the bridge makes on the natural world, how the bridge may be in harmony with it and contribute to its flourishing. To look at the bridge through a theological aesthetics method, I actually needed all of these viewpoints, all of these strands, and then I needed to interlace them. The distinctiveness of these many strands helped lead me to the insight that the bridge's beauty and function is tightly woven with the adaptability of its structure.

Theological aesthetics method, as a way of approaching the bridge, is the theoretical articulation of the multiple encounters one could have with its orange. Something new is revealed with each approach. Viewed from across the bay, the bridge is tiny and fits between our fingers. Viewed from underneath, it is a marvel of awe-inspiring design and makes us feel miniscule. When we cross it, the bridge is

always different depending on how we cross it (car, bicycle, walk-
ing, alone, or with others) and why we are crossing it. The unique
qualities of the bay also add to the adventure of being on the bridge,
which may be completely shrouded in fog, brightly lit by a sunset, or
drenched in rain (sometimes all within the span of a couple of hours).

In systematizing a theological aesthetics methodology, I propose
the Golden Gate Bridge as an analogy for the structure that is created
when we effectively join the work of the arts and religion. The focus
on function[3] that the analogy of the bridge makes noticeable encour-
ages us to look past theories to actual experience.[4] In articulating a
method, I propose that we evaluate how effective art and the religious
are as they work together in their bridging function. What actually
happens because of the bridge is very elastic, and I am certain there
are categories beyond the three I will propose. But that is the beauty,
and I really mean *beauty*, of a method that is centrally concerned with
expansion and collaboration, with perspectives and also closeness,
with a destination and also with the delight of the journey. I call this
method interlacing, which means, with every strand we add we make
it sturdier and more capable of doing its work.[5]

Experiences and Objectivity

I love the Golden Gate Bridge. This admission will not surprise anyone
who has read thus far, yet we rarely make similar declarations when
we involve ourselves in study and research. What foregrounding my
affection for the bridge makes evident is that in the task of theological
aesthetics there is no such thing as "objectivity." In order to be carried
out effectively, theological aesthetics method must notice with care
how any one of us relates to the arts and to the religious, in community
or individually, concretely and also conceptually. Our emotional asso-
ciations are not extrinsic to this type of work, but should be acknowl-
edged as part of it and help to inform it.

It is difficult for me to imagine anyone disliking the bridge, or
thinking it ugly, or useless, but this is certainly possible. Awareness
of our affective relationship to the religious and to the arts makes our
judgments *ours* and necessitates a position of humility. This does not
mean that in this method of inquiry we do not make judgments; these
are necessary, but must also be questioned and supported.[6] What our
awareness of the affective quality of our experiences of the religious or

the artistic does is to force us to identify the multiple influences hidden behind those judgments and also to seek consensus and clarity through involving other interpreters beyond our subjectivity. Because the religious and the artistic both function primarily by engaging the human heart, the opacity of such emotional involvement can sometimes lead to the unyielding rigidity that causes bridges to disintegrate.

Thus far, we have looked at two major experiences of the effective bridging quality of the religious and the artistic. *Seeing Salvation* provided an experience that was broad, coherent, and constructive, and *La Pastorela* gave us a glimpse at a very particular and personal instance out of my own community. I now invite you to enter a third experience, one that is in many ways the opposite of the other two: a spectacular collapse of the bridge built by art and religion that happened at the exact midpoint of the twentieth century. It is a tale worth telling.

The Strange Case of the Little Church at Assy

Today, if people have heard about one of the most celebrated clashes between religion and art of the twentieth century, it is probably chiefly as an example of the Catholic Church's aesthetic backwardness and lack of sophistication in dealing with modern art.[7] The story is like a particularly messy tangle of debris that has washed up on shore. What I propose is to use the distance provided by half a century, along with the tools of theological aesthetics method, to try to sort carefully through the wreckage. We can use this particular experience to understand what happened, why it happened, and how we may keep it from happening again.

Once upon a time (in 1949 to be exact), a Dominican priest by the name of Marie-Alain Couturier, became an international cause célèbre when *Time* magazine reported on the work he was doing with modern artists in France.[8] Couturier, himself an artist, had "devoted his energies tirelessly to visiting the studios of artists everywhere and telling them that the Church is where their work belongs."[9] Or at least that was the public side of the story.

By August 1950, when the church he had been designing was consecrated *Notre-Dame-de-Toute-Grâce* in Le Plateau d'Assy,[10] Couturier had convinced some of the best-known European artists of his time to contribute their talents.[11] Today, a look at the plan for the church at Assy reads like a museum catalogue.[12] The artists, mostly

French, produced ceramic murals, tapestries, mosaics, stained glass windows, and sculptures to fill the small church; among the best known are: Fernand Léger (French, 1881–1955); Georges Rouault (French, 1871–1958); Georges Braque (French, 1882–1963); Henri Matisse (French, 1869–1954); and the Russian Jewish émigré Marc Chagall.[13] It is a stunning assembly of artistic talent that caused *Time* to praise Couturier for gathering "the best and most extreme moderns he could find to embellish a church at Assy."[14] I will return to these comments.

Among these "moderns," Couturier commissioned sculptor Germaine Richier (French, 1904–1959) to create a crucifix for the main altar.[15] What happened around this sculpture became a storm, and the bridge to beauty, wonder, and faith that becomes possible through the joint work of the arts and the religious became increasingly rigid and brittle, and eventually buckled and fell right into the sea.

News organizations, prone to accentuate controversy because it sells, explained events this way: the epic fight was between those seriously concerned with art (*Time* quoted as proof the "influential Paris weekly, *Arts*") and the hierarchy of the Catholic Church, represented by the local bishop,[16] who had Richier's sculpture *Christ d'Assy* (Plate 9.1) removed from the sanctuary of the church.[17] But there was a deeper and more problematic polemic at play, which seized upon the works of modern art at Assy as emblems of liberal Catholicism and even of a new form of "Gallicanism."[18] By contrast, all those who questioned the appropriateness of the modern art at the Assy Church or rejected it were disparagingly characterized as belonging to the party of "integrists . . . in the extreme right of the clergy and laity."[19]

What becomes clear as we sift through this very first layer of rubble is that the arts are exceptionally powerful symbols. As many times before and since (and not only in Christianity but in many other religious traditions), they were forcibly thrown into the limelight (like so many red herrings) in order to mask the real problems and also to galvanize group allegiances and loyalties.[20] In such circumstances, positions necessarily become hard and defensive because that is the very purpose the "arts" are serving, their visibility and materiality working as the opposite of a bridge, as they become a dividing line. The often unacknowledged (but just as often exploited) emotional responses awakened by the religious and the artistic can easily become gale force winds, and they did so at Assy. Art critics and journalists equated the

bishop's removal of the crucifix with totalitarianism, saying that "in the domain of art, 'our bishops are in accord with the Kremlin, the White House and the late Mr. Hitler.'"[21] On the other side, reactionaries hiding behind the label of Catholics mounted similarly incendiary campaigns, referring to modern art as involved in the "production of a pathological art, maneuvered by a heretic propaganda."[22] In this maelstrom, reasonable voices attempting to dialogue were drowned out, even as they stated that "fanaticism in matters of sacred art is an attitude that can lead to a decadence [in sacred art] more sterile than the one we are now endeavoring to overcome."[23]

What could have been supple and bent was hardened, and the bridge was overburdened, not by ferrying appreciative visitors, but by armies of fevered warriors. The intransigence from both sides hastened the collapse.

The polemical characterization of the event at Assy has persisted with scant inquiry into what in the bridge's design, construction, and maintenance could have contributed to its non-effectiveness and dangerous fragility.[24] If the Golden Gate Bridge fell into the sea, we can be fairly certain that the debris would be scrutinized for clues to the failure. As we can see through this analogy, the purpose of such an investigation would be the improvement of future bridges and their durability. If theological aesthetics method is a way for us to see how the arts and the religious function together, then a moment when their joint work spectacularly collapsed should provide hints about what kind of structure we are dealing with and also what can fatally undermine it. The way we experience art and religion was terribly distorted at Assy. Emotions were heightened through the use of ideology and propaganda, and the suppleness necessary for work that is undertaken jointly disappeared.

In a well-constructed suspension bridge, the work of bridging can be done because multiple moving parts interact. In the Assy story, we can categorize these parts as: the arts (the bridge proper), the artists (the ones who build it), the communities behind it (what contributes to its building), and the communities before it (those who have used it in the past, use it now, and will use it in the future). These parts need to be understood always in relation to one another and to their functions, and to appreciate the interaction between the functions and the parts we need tools—categories—that help us evaluate how well the parts are working.

First Function: Art as Effective and Affective Carrier
of a Religious Tradition

To begin, the acknowledgment of the pull of religion and of the arts on our hearts does not necessarily have to be understood as a negative feature that compromises some ideal of objectivity. Rather, the acknowledgement of our feelings can become a helpful methodological tool as we make explicit the emotional positions that affect our understandings and the understandings of others. We could call this tool, "Is it love or is it hate?"[25] If we note neither affection nor revulsion in questions of the religious and the artistic, this answer is also diagnostic because it tells us that something, which is meant to work on our heart does not.[26] The paradox here is that if the arts are to do the work of carrying a religious tradition, they can do so only if they engage our emotions.[27] At the same time, such affective engagement if left unexamined may turn destructively divisive.[28] We can evaluate Richier's *Christ d'Assy* as a carrier and sustainer of the tradition through this preliminary love-or-hate category.

As part of the community before the art, my initial reaction to photographs of *Christ d'Assy* was decidedly more on the "hate it" side than on the "love it" side. I have not seen the sculpture in person, but what I saw in the photos immediately provoked rejection in me.[29] Perhaps I was too much like the local bishop, who was somewhat mockingly reported to have "heard complaints about the crucifix . . . motored over to Assy, spent half an hour studying the sculpture, decided that it was 'a caricature representing nothing,' and ordered it removed."[30] This short report, when sifted apart, is packed with important clues. We note that the bishop "heard" complaints, and news reports preserve some first-person reactions from the local Catholic community:[31]

> "It [the crucifix] was evil," a woodcutter ventured. A young girl agreed: "The figure was thin and frightening. The colors of the other art in the church make me feel alive and strong, but this thing only scared me like a dark devil."[32]

In this version of the event, the rejection of *Christ d'Assy* appears to have arisen out of the community before the art,[33] and perhaps we should appreciate the bishop for listening to that community whose faith tradition the crucifix was meant to activate. In asking that the

crucifix be removed, the bishop was fulfilling his role as pastor of the local Church.[34] Yet, we should not take any of the events of Assy at face value because the situation was so highly politicized. Part of the lesson here is that such opaqueness is often the case in issues that matter to us, and our constant vigilance is needed.[35]

As is evident, *Christ d'Assy* as a case study reveals the power of religious aesthetics to function as a "thermometer," as the bridge responds to the surrounding environment. The ability to evoke and carry the tradition, or the failure to do so, tells us much about two relationships: the relationship of the church to the wider world, and the relationship the church has internally with its own tradition. What the convulsions around "sacred art" of the postwar period reveal is that the Christian church generally, and more particularly the Catholic part of that church, was teetering on "the brink of renewal."[36] The questions and accusations at their deepest level were about the relationship of the Church to the world, and about Catholic identity. These were the issues that in the 1960s most centrally occupied the Second Vatican Council, and it is clear that the most fundamental act of the Council was that it actualized the Church "*as* a world Church."[37] The issue of the Church's relationship to the world, exemplified through Assy as the friction between a static Christian iconographic tradition and the radical newness of the art of modernity, was a question that needed nuanced and thoughtful consideration. Unfortunately, nuance and thoughtfulness were in short supply.

If we place ourselves at the Church at Assy, or at one of the many screaming matches that ensued, we see a tragic moment. The event witnesses to what can go terribly wrong, and in this it can also help us understand why some religious communities are justifiably suspicious of the aesthetic realm. The extremes of love and hate we experience as we relate to creative works should make us cautious and humble as we approach art.[38] As we see at Assy, the fervor of such feelings can make us lose sight of the purpose of all Christian life, which is to live each moment through Jesus' great commandment to love one another as God loves us (Matt 22:36–40). When our emotions are engaged so as to make us less Christian instead of more, then the art, no matter how beautiful, innovative, or brilliant is incapable of carrying out its primary function of being "a reflection of the unfathomable mystery which engulfs and inhabits the world."[39]

Christ d'Assy is a work of art in form, but for a worshiping community what matters most is how such a creative work functions in connection to their religious faith.[40] A major difficulty, then, was the failure to take into consideration the affective role of a crucifix placed in a church, as the central symbol of Catholic Christianity. The crucifix encapsulates within it the whole of the Christian story, in a way that may be analogous to the role of the Bible in the Protestant tradition, or the Torah in Judaism.[41] In relation to art then, a work's placement within a place of worship elevates its function as carrier of the religious tradition and intimates a certain normativity. With *Christ d'Assy*, the misunderstanding of the role of art as sacred writing may have compounded the problem.

Cultivating Openness

As all of these complications reveal, to look beneath the surface of a work (and into ourselves, its makers, and the communities that affect or will be affected by it) has to be the next step beyond the immediacy of our experience of love or hate for an aesthetic work. This requires something of a spiritual practice—a willingness first to acknowledge our prejudices and then to make an effort to transcend them.[42] Even as I became aware of my resistance to *Christ d'Assy*, I had to put my reaction aside for the moment (always aware that my reaction is an important element) and try to find accounts of love or enthusiastic appreciation for the work. I certainly found multiple instances of those who defended the sculpture based on the ideas of modern art and the autonomous quality of art. What became clear was that these reactions were not about experiencing the sculpture as a depiction of Christ on the cross, but were about the idea of modern art represented by the work. Seen this way, *Christ d'Assy* is a representation of art as a world in itself, and this severs any connection it has to communities that may have influenced it, or that may be in relationship with it now or in the future.[43]

My question was not about *Christ d'Assy* as an expression of artistic prowess, but about its effectiveness in carrying the Christian tradition. The only way to measure this was to look at how the faithful received it.[44] There are a couple of examples, albeit encased within highly polemical reports (which makes them suspect), that some in the community before the art "were happy to pray before 'this man of sorrows, so fraternal to their sufferings.'"[45] This appreciation of the

religious tradition the work enlivened may have been significantly aided by Fr. Couturier placing a placard by the crucifix to contextualize the sculpture. The text, combining several snippets from Isaiah 53, read: "For he shall grow up . . . as a root out of a dry ground; he hath no form or comeliness . . . He is despised and rejected of men; a man of sorrows."[46]

What quickly becomes apparent is that this is the opposite of the way the stained glass windows of Gothic cathedrals, or frescoes like Leonardo's *Last Supper*, functioned. Those works carried and awakened the tradition through their aesthetic embodiment of it; through creativity they made it new and felt. *Christ d'Assy*, on the other hand, was mute without the explanation provided by the text.[47] After the problems at Assy, this necessity of explaining art was addressed by a document from the French bishops stating that the faithful had to be able to understand the art without the need "that one give them long intellectual explanations."[48] This is not only a caution for religious art, but truthfully, a caution for all art. As any first-year art student knows, if you have to explain it, it is not good. The problem that *Christ d'Assy* crystallized was that if modern art was to speak in ways that had any power to evoke a religious tradition and to initiate the wonder necessary for religious experience, it could not do so simply by arguing it was good art.[49] If Couturier was using the Assy Church as a laboratory, then, this part of the experiment had provided some important data about art's function in relation to a community of faith.

In an open and receptive state, I am able to see the suffering in *Christ d'Assy*, but this requires I take the step of placing the work in its full context and situate myself in mine. *Christ d'Assy* may create a relationship with a suffering believer, through the very denial of the form of Christ, and this takes us to art's second function.

Second Function: Art as a Source of Theology

The possibility that art may express a theology complicates and extends the first function of creative works as carriers of a religious tradition. The carrying and reinforcement function demands that art placed or enacted in a house of worship, or that quotes from a particular religious tradition, be "readable" by the faithful of that tradition.[50] At this level the work must create explicit emotional connections, which aid believers in devotional and spiritual practices. If destined for use by the faith

community, it must also provide a coherent support to the liturgical events that take place in the sacred environment. However, because it is less explicit, the second function of art as expressing a theology may be, as in *Christ d'Assy*, more difficult to ascertain, and its appreciation will need cultivation. The community may be invited to a relationship that is new or unusual, as a fresh form, instrument, material, or symbol is presented. Here the efficacy of the relationship created will rest on the deeper layer of the artwork as expressing a theology, as speaking of God. The few appreciative comments recorded about *Christ d'Assy* present just such an understanding.

Art Wrestling with Faith

In Assy we note that controversies are such because they remain univocal and only pay heed to one person's or group's particular feelings. If the approach to art remains at this level, it can reinforce an attitude of seeing art as ultimately irrelevant because any judgment about it is merely subjective. The self-centeredness of privileging individual subjectivity results in fostering what we might call *aesthetic partisanship*, and in the case of Assy this precluded the conversation that could have explored *Christ d'Assy* as a source of theology. To perceive what art may be saying theologically requires that we pay attention to the other three influences beyond ourselves that are bound up with the experience: the art, the artist, and the communities behind both.[51] What the exclusive attention to personal reactions accomplished at Assy was to create a battleground where a deceptive and simplified narrative took hold. The only movement of the heart apparent was the emotionally charged antagonisms between liberals and conservatives or between the art world and Church authorities. What this simplistic narrative failed to uncover was that there were not two sides caught in a debate, but rather that there was no debate, as debate requires common questions and responsiveness.

Like a cable that has completely snapped on our metaphorical bridge, at Assy both ends were flailing madly about without any connection. The extremists in the art world were busy defending its right to freedom of expression and artistic innovation,[52] and reactionary partisans were using art as a way to oppose the Church's growing relationship with the modern world. What became lost in the polemics were the few instances where the focus was where it needed

to be, on the theological questions. In the charged atmosphere, the bishop's comments appeared to call Richier's sculpture meaningless because he said the work "represented nothing."[53] But what could have made this a productive debate was to wrestle with the idea of "nothing." If we use a theological focus, two interpretations are possible: either that *Christ d'Assy* is devoid of meaning (irrelevant and only about itself), or that the crucifix is expressing "nothingness." At Assy, the interpretation of irrelevance cannot be sustained: the community reacted strongly to the crucifix because it moved them; it was definitely saying something about God. The theological question to be explored in community then is what that something might be. This is a coherent question that brings into focus the artist and the communities behind a work.

As we know, some of the more public debates surrounding Assy questioned the inclusion of "atheists" and "Communists"[54] as unseemly and contradictory. In response, the defenders of the art shifted the conversation to artistic autonomy. One journalist asked rhetorically, "Has an artist the right to paint Christ as he imagines Him, and above all, the right to translate Him into his [the artist's] formal conception?"[55] The answer from the Vatican was "Absolutely not."[56] Yet it was an answer that was nuanced, noting that, "The artist retains the liberty of compositional conception . . . expression . . . techniques," but artists are not at liberty "to deform the venerable character and *theological conception . . .* of the sacred representations."[57] A religious tradition is just that, a tradition: it needs to stand solidly behind a community of faith and must involve "two elements, the old with the new, or the historically given with its current form of reception."[58] The role of theology, and of art as a source of theology, is indeed to bridge two thousand years of the community's wisdom and experiences of God with a very particular current situation. In this, the art works only if it connects the tradition of the communities behind the art with the communities before it. When we understand this, we see that *Christ d'Assy* was set up to fail.

Fr. Couturier saw the church at Assy as "a practical laboratory in which to experiment with new theories of ecclesiastical art."[59] This seems to place theory before function and innovation before service to a community of faith. As art historian William Rubin states, "The absence of an indigenous population with deep-rooted local traditions and provincial biases is an important factor in the development of the

modern taste that came to characterize the church at Assy."[60] What this discloses is that modern religious art was understood in terms of its repudiation of tradition. It is also clear that there was a general disdain for the "average churchgoer," who was characterized as lacking taste and being pietistic, sentimental, and conformist.[61] The project of modern religious art was further removed from any connection to the faith community because it stood in conscious opposition to "the adaptation by the Church of today's 'popular' art . . . a submission to the taste of the 'Chrétien moyen.'"[62] Implausibly, even the Church's canonization of St. Thérèse of Lisieux (1873–1897, canonized 1925)[63] was mockingly criticized as representative of "the increasingly sentimental and bourgeois character of religious practice."[64] One of the Dominicans involved in the Assy project went so far as to state that the young saint's "personal bad taste" might have been a factor in her elevation to sainthood.[65] Under these circumstances, it is clear that theology, speaking about God from a community and for a community, was very far from the minds of those working at Assy.

Finally, the project was viewed as confrontational from the very start, as Fr. Couturier stated, "Our church art is in complete decay . . . dead, dusty, academic—imitations of imitations . . . with no power to speak to modern man."[66] If the intent was confrontation, the project worked and the Catholic community read it correctly, because, even if Assy lacked a stable local congregation, the universal Catholic Church did not. Theology was absent from the church at Assy because the project was about *art as art*, and about superimposing this idea on a two thousand year old tradition that understood art as a mirror of "the infinite, the divine."[67] The problem is obvious when we hear the comically bombastic Rubin proclaim, "Artistic truth is absolute—it 'bloweth where it listeth'—and in the end the Church must face the fact that creation is never a compromise."[68]

So a project presented ostensibly to bring about a renewal of the relationship between the Church and art was initiated in a way that sidelined the Church's theology and its communities of faith. When the Dominicans contracted artists based only on their artistic fame,[69] Couturier explained that it was "safer to turn to *geniuses without faith than to believers without talent.*"[70] The preeminence accorded to the artist as genius in this scheme precludes the possibility that the works may speak theologically with any breadth. At best they may be personal and individual expressions; these are valuable, but they run counter

to the purposes of a church structure and the communal aspect of the liturgy.[71] Even more problematic is personal expression when one has no connection at all to the community receiving it.

There is some evidence that Couturier imagined that working together could bring about the conversion of some of the "great modern masters" involved in his church projects.[72] Through their magazine *L'Art sacré*, Couturier and friends hoped to influence the public and the clergy. It is apparent though that by 1950 they had abandoned this hope, as "Father Régamey pessimistically admitted that he no longer believed 'anything more [could] be seriously done to bring about a real education of taste with respect to the faithful or the clergy.'"[73] What is disconcerting is that, according to Rubin, part of the education they hoped to impart to other priests was to train them to know how they "could help an artist to Christian awareness and in general stimulate interest in a vigorous sacred art by explaining the meaning of the liturgy and iconography."[74] This good plan was something the Dominicans themselves did not follow.

Instead of helping artists enter the Church's tradition by inviting them to imagine anew the Christian ways of articulating the relationship between humanity and God,[75] the Dominicans in charge of the project abdicated their role as effective guides and allowed the artists to dictate what work they were willing to do. Thus, although two young painters had begun a mural of the Sermon on the Mount on the façade of the church, when the much more famous Fernand Léger agreed to work on the project the priests set about trying to figure out what his work would be. Today, the strangeness and ineffectiveness of Léger's mosaic mural, with its reliance on simplistically rendered signs and explanatory text, is clarified when we read that, "Since the edifice was dedicated to the Virgin, her litanies were selected as appropriate to both the iconography of the church and *the limited possibilities of the artist, an avowed Communist*,"[76] and as such an atheist.

It seems impossible to believe that anyone could have thought that the iconography of the Church and atheism could coexist. The same was true of the entire church structure, as Rubin admits: "The decoration as a whole does not constitute a sequence, much less an inclusive affirmation of the essentials of the [Christian] religion."[77] More telling still is the large tapestry surmounting the sanctuary, which is "a fantasy of cosmic struggle between the Satanic beast and a woman 'clothed with the sun.'"[78] Rubin confesses that the "iconography is

divided and anti-climactic" and surmises that the choice of a subject matter was due to the fact that "no outstanding modern artist seems able to participate deeply enough in the spirit of a Pantocrator-type of dogmatic image to be able to render it."[79] Indeed, with the exception of the Catholic Rouault's small windows, the image of Christ is notably absent from Assy. This is a bizarre point of agreement between the conservative factions of the Church, which were inordinately Marian as a counterattack on Protestantism, and the atheist artists who clearly could not represent Christ.[80] Faced with "geniuses," the Dominicans tried to work somehow with "the limited liturgical possibilities of modern painters unwilling to sacrifice their integrity in commitment to an imagery they could not sincerely render."[81] The question then, was clearly not one of artistic freedom versus ecclesiastical constraints; rather, it was one of intentionally eliminating the theological function of the art because of the primacy given to the "integrity" of the artists who did not believe in God. What the polemicists failed to realize was that denial and exclusion also speak theologically; these are not silent positions.

Returning to *Christ d'Assy*, the rejection of the crucifix was not tied to art appreciation, but arose from reasons we can only see by noticing the communities behind and before the art, the very influences that were excluded. *Time* magazine stressed the originality of Richier's sculpture, irrespective of whether it was "valid church art or not."[82] This made plain that, as the moderns saw it, even when placed inside a church the Church's theology should not affect the art. Particularly in relation to the crucifix, Father Couturier "studiously refrained from trying to influence the outcome of the work; indeed, he did not even discuss the liturgical character and significance of the cult object with" Richier.[83]

The intense incompatibility of a position that tries to exclude theology from religious art reveals a major stress point. It is impossible for works that creatively and aesthetically explore a two-thousand-year-old religious tradition to claim, at the same time, total autonomy from that tradition, and for this disregard or rejection to be inconsequential. Any expression that is at odds with the tradition will necessarily be a theological position, whether intended confrontationally or not. Obviously, art that questions, confronts, or functions without deference to the religious tradition can indeed be effective, but only if the confrontation is acknowledged and the wrestling aspect it embodies is valued.

Germaine Richier was also an atheist,[84] a fact unapologetically
stated in Rubin's interview with her.[85] Yet it might be possible (though
unlikely) that Richier, the artist, could have transcended Richier's
individual ideology and created a work that faithfully expressed an
orthodox Christian theology (as any crucifix destined for use inside
a church building must). The overwhelming evidence though, is that
she did precisely the opposite.[86]

Richier's first reaction when she was asked to create a crucifix
for the Assy church was to decline. The artist's sense was to suggest
that she not make a crucifix, but rather "some sculptural decora-
tion in the form of a pure abstract sign."[87] In the end, she may have
produced just this, an abstract sign, and what it signified is what
met with such a strong rejection from the Catholic community. The
artist had never created any religious art and her only religiously
titled earlier work, *Head of Christ, 1931*,[88] was by her own admission
"really just a study in form."[89] Thus, although none of her contem-
poraries seem to have understood this, the reaction of fear and revul-
sion expressed by the community revealed that *Christ d'Assy* was a
theologically potent work of art. Without any theological guidance,
which Rubin suggests would not "have been profitable—or even
welcome,"[90] Richier's work was intensely personal and her theology
came through clearly.

Richier's exploration of the nonbeing of Christ in *Christ d'Assy*
is a powerful and legitimate examination of radical doubt, but it did
not belong in a church. Not only could her art not function to trans-
mit the Christian faith tradition, but the theological conclusion pos-
ited by her artwork was one that necessarily had to be rejected by
the Catholic community as frightening to them. As *Time* reported,
Richier explained that her crucifix had "no face because God is the
spirit and faceless."[91] As disingenuous as the phrase "God is" sounds
coming from an atheist, her statement about God constitutes a cat-
egorical denial of the doctrine of the Incarnation, which is centered
precisely on God taking on flesh to accompany humanity as the Sec-
ond Person of the Trinity. The opposite of faceless and pure spirit,
Christ's face and his embodiment became the theological basis for
legitimating the making of images.[92] As Pope John Paul II explains
in reference to the Council of Nicaea (787 A.D.), "If the Son of God
had come into the world of visible realities—his humanity building
a bridge between the visible and the invisible—then, by analogy, a

representation of the mystery could be used, within the logic of signs, as a sensory evocation of the mystery."[93]

The theological position Richier presented through her art was well understood, and it moved the Christians who faced it to fear it as "evil" and as analogous to the "devil." Even if Fr. Couturier wanted Richier to be free of all doctrinal instruction, the Christians who encountered the sculpture were not. Their rejection was a critique of an atheistic representation at odds with their faith. The bronze sculpture they asked be removed had *interpreted them*, and done so quite well. The art world derided the Catholic community's lack of artistic sophistication; we can, however, now appreciate their theological acumen as Christians.

As a source of theology, *Christ d'Assy* denies the Incarnation through dissolving the body of Christ; neither cross nor man is ultimately present; all that is left is a cipher. It is indeed the well-achieved artistic expression of an atheist. The Christians who encountered it perceived the depth of its despair and the void it reveals of an absent God, but they did not know how to respond. Framed as a question of autonomy and rights, there was no positive outcome for this situation; just as Richier had every right to explore her desolation artistically, so the Catholic community had every right to say this work had no place in their worship environment. However, if, instead of fanning the controversy over autonomy, the Catholic community could have been guided to reflect on what Richier's sculpture was actually saying theologically, then it is possible that instead of being moved to rejection and fear, they might have been moved to compassion for the many who like her who believed that God did not exist and Christ had not come. The theological position of an absent God, when understood this way, could have been a sanctifying moment for this community, opening their heart to the "others," the ones who desperately needed a moment of Christ's presence in their midst.[94] Just as the art failed, so the Church's enactment of the commandment to love also failed.

Third Function: Art as a Bridge to the Glory of God

The secular press praised Couturier for gathering "the best and most extreme moderns he could find to embellish a church at Assy."[95] If we are seeking a way for modern art to participate in the work of facilitating encounters with God, "extreme" is not a helpful way to

choose artists to contribute to a religious tradition spanning centuries. Clearly, the enlivening of a tradition for a contemporary community is best accomplished not through a strategy of extremism and shock, but through one of attraction and love.[96] Half a century later, as we look at the art at Assy, we note that *Time* magazine's comments were not entirely accurate, that two of the artists were neither extreme nor in many ways "modern," but avoided being subsumed into faddish movements. They were also men of profound faith, Catholic and Jewish. Today the art they produced for Assy may still become a path for contemplation and for wonderment before God—their names are Marc Chagall and Georges Rouault.[97]

From the present vantage point, which can begin to recognize art of the last century with the potential to speak for centuries to come, many of the other works at Assy are dated, simplistic, and ineffective, overly concerned with breaking established artistic norms and sadly inconsequential beyond the famous signatures attached to them. The works create no relationships with a viewer beyond the kind of curiosity that best belongs in museums.[98] Even before knowing the back story, we know that these works were art for innovation's sake and not, as *Time*'s earlier article had proclaimed, "Art for God's sake."[99] Additionally, the idea that works of art "embellish" a church also demonstrates a fundamental misunderstanding of the way the arts work religiously, spiritually, and theologically. Rather than a collection of objects that add to the prettiness of a place,[100] arts within a sacred setting serve a central function, which Pius XII articulated anew during the Assy controversy: "The function of all art lies in fact in breaking through the narrow and tortuous enclosure of the finite, in which man [*sic*] is immersed while living here below, and in providing a window to the infinite for his hungry soul."[101]

To look at the way this final function of facilitating experiences of transcendence may be working in art is really to see the unity. When they activate this capacity for wonderment, creative works are bringing together the resonance of all the stories and symbols that have contributed to it; they have an integrity in themselves that resolutely makes us aware of a bigger reality, as their materials are transformed by qualities that we are unable to explain or quantify. They tell us of their maker, individual or communal, famous or anonymous, and as with Richier's *Christ d'Assy*, if we are open to them, they may help us grow in generosity and holiness by asking us to enter into the

artist's pain, aloneness, or devastation. If we open ourselves to their otherness, works that break our heart through beauty or its absence will increase our capacity for love and for compassion. We will know ourselves small, and at the same time part of a greater whole. We will know we need God, and we will also momentarily catch a *destello*,[102] a glimmer of the fullness of a heart as it fills up with God.

The Assy controversy yielded good fruit as the Church tried to relearn how to articulate its faith creatively and how to work with the arts.[103] It was the decade following the Assy tremor that brought the Second Vatican Council. Perhaps the considerable difficulties made evident at Assy did what art should do—make us see, even if what we see is unpleasant. In the end, we may recognize that Couturier's efforts were coherent and later supported by the work of the Second Vatican Council on several fronts. The French Dominican was effectively trying to reconnect the Church and the culture, an urgent need that a decade later found expression in the "Pastoral Constitution on the Church in the Modern World" (*Gaudium et Spes*, 1965):

> At all times the Church carries the responsibility of reading the signs of the time and of interpreting them in the light of the Gospel, if it is to carry out its task. In language intelligible to every generation, she should be able to answer the ever recurring questions which [people] ask about the meaning of this present life and of the life to come, and how one is related to the other. We must be aware of and understand the aspirations, the yearnings, and the often dramatic features of the world in which we live.[104]

The Bishop at Assy was right in noting that the affront of Richier's crucifix was that it represented "nothing."[105] However, this was not because its language was unintelligible, but because her disfigured cross lacking a discernible savior pointed to the "nothing" with which she answered the question of God. In order to listen to the culture, the Church must pay attention even when what the culture is saying is indeed horrifying. At the same time, the Church needs to find ways to announce that "Christ, who died and was raised for the sake of all, can show man [sic] the way and strengthen him through the Spirit in order to be worthy of his destiny."[106] The Church needs to listen to the culture in both its joy and its anguish. What is more, while it listens to the new questions, the Church faces the challenge (as paradigmatically presented at Assy) of maintaining a balance that also acknowledges that

"beneath all that changes there is much that is unchanging, much that has its ultimate foundation in Christ, who is the same yesterday, and today, and forever."[107]

Thus we make a full circle to the question that began this project: Can we have experiences that will activate in us the awareness that God has revealed something? The arts help us ask questions; they become signs of our times we can read, and through which we can know one another's struggles and one another's joys. But theologically powerful arts must do more than expose problems; they must also make us *asombrados*, grateful and wonder-filled beings, and in this the arts' answer to the question of something being revealed is the opposite of "nothing," but is instead an ever-expanding fullness.[108]

I imagine that the twentieth century's Couturier and Vogt, and the twelfth century's Suger, might all be made quite ecstatic (and I use this word in its full meaning) by recent examples of the interlacing of artistic excellence with the beauty of the Church's theology. It is delightful to imagine how they might be *asombrados* by sacred places like the Cathedral of Christ the Light in Oakland (Plate 9.2)[109] or the Cathedral of Our Lady of the Angels in Los Angeles.[110] In these two decidedly postmodern houses of worship, talented architects and artists have come together to help worshiper and visitor have an experience of wonder that takes today's creative forms and vibrant theologies and unites these to the aspirations first articulated by Abbot Suger, who had the following inscribed "in copper-gilt letters" at St.-Denis:

> Bright is the noble work; but being nobly bright, the work
> Should brighten the minds, so that they may travel,
> through the true lights,
> To the True Light where Christ is the true door.
> In what manner it be inherent in this world the golden
> door defines:
> The dull mind rises to truth through that which is material
> And, in seeing this light, is resurrected from its
> former submersion.[111]

Religious works of art are not principally aesthetic objects, but they certainly are aesthetic objects intrinsically.[112] So the desire for beautiful works is legitimate and, indeed, Chagall and Rouault have left us stunning gifts at Assy, as did Suger at St.-Denis. What does not function (if we are attentive to the religious power of a creative work) is the

claim that art exists purely as an artist's self-expression and is not meant to be in relationship. Critical theories that today stress the need for careful attention to context and historical situation question the concepts of "artistic genius" so uncritically appropriated by earlier generations. This question of context and relationship is a necessary balance to totalizing tendencies. What appeared in 1950 as a conservative religious position—a crucifix should be recognizable to the community of faith—is today understood as saying something quite prophetic. Such awareness questions colonial and fundamentalist tendencies and supports diversity by reminding us that everything has a context.

Loving Bridges

The Golden Gate Bridge, as an aesthetic object, is something beautiful resulting from human creativity. We can readily see this in the arts, but it is often much more difficult to see it in religion, as we forget its human context and its inherent creativity. The bridge is beautiful in itself, but its beauty is inseparable from its function. I suspect that if it became uncrossable the bridge would eventually be torn down or replaced. This question of function and relevance should also be asked often of the arts and of religion. Further, the bridge can be both beautiful and functional because it is responsive to its surroundings. This points to the theological possibilities in the arts and in religion, as they relate to and reflect the winds and temperatures of human history, not by remaining static, but by adapting what is adaptable, so that what is unchangeable can continue to do its work.

I do not intend to interlace thirty-thousand discrete strands, as the bridge's massive cables do, but through this method I can indeed continue to add questions. For instance, we can take the analogy of the bridge even further by interlacing the strand of ethics and noting that its complex beauty can also be tragically distorted. Many heartbreaking suicides have been facilitated from the bridge's dizzying heights. And although what the bridge conveys across is almost always broadly smiling families and enthusiastic cyclists, it could also be explosives, or arms, or contraband. Art, religion, and the bridge are structures we have made with beautiful purposes, but they have been and continue to be terribly misused.[113] Our appreciation of the arts and of the religious cannot blind us to the ways that these can be used to convey what divides, deceives, or destroys.

In my analogy of the bridge, theological aesthetics method is not the bridge. The bridge is made up of multiply connecting, discrete, and interlaced experiences of creating and receiving human creativity through faith and through art. Theological aesthetics method is the tool that helps us to see the bridge, to understand its many parts, to assess how well it is serving its purpose, to be attentive to what could destroy it, and to make sure it lasts for a very long time.

PLATE 1.1

Inventor, 1975 (limited edition serigraph) by John August Swanson. Courtesy of the artist.

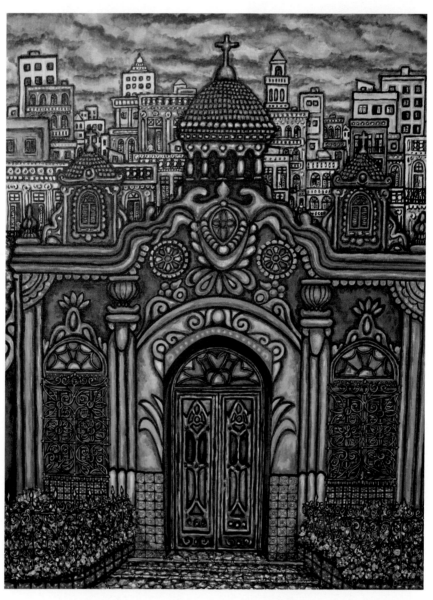

PLATE 1.2
La Catedral de mis sueños (*The Cathedral I Dreamt*), 1996 by Alfredo González Cardentey.

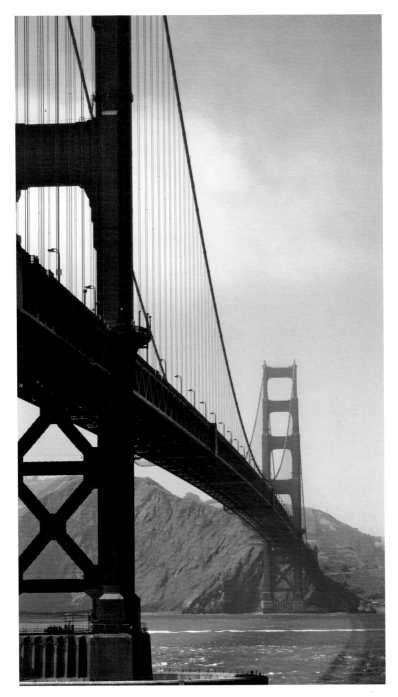

PLATE 1.3
The Golden Gate Bridge, San Francisco Bay, California, 2010. Photo: Andrés Andrieu.

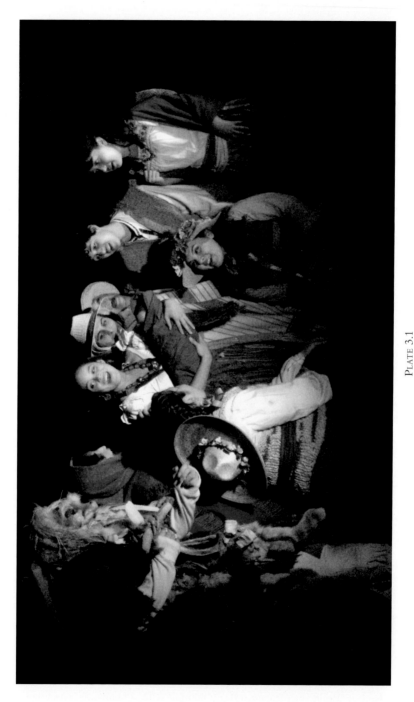

PLATE 3.1

"Pastores gather around Baby Jesus," *La Pastorela* by Luis Valdez. (Performance at Mission San Juan Bautista, California, December 2009). Photo: Anahuac Valdez. Courtesy of El Teatro Campesino.

PLATE 4.1
Ecce Homo, 1999 (marble resin) by Mark Wallinger.
Photo: Martin Argles. Copyright Guardian News & Media, 2004.

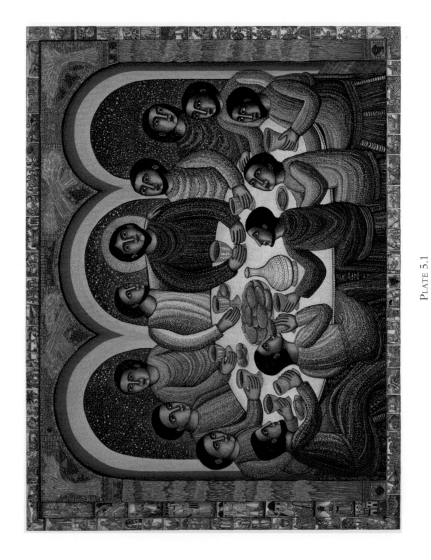

PLATE 5.1

The Last Supper, 2009 (limited edition aerigraph) by John August Swanson. Courtesy of artist.

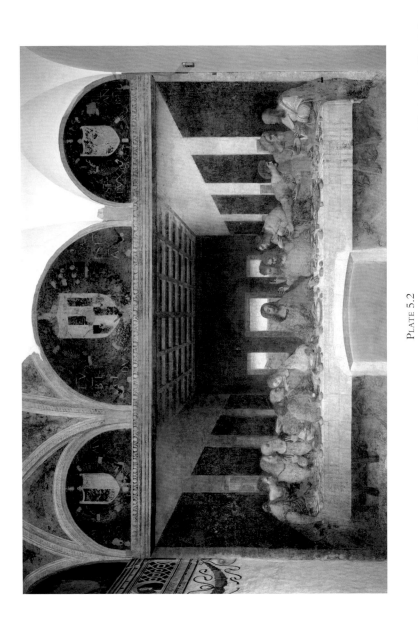

PLATE 5.2

The Last Supper, 1495–1497 (fresco, post-restoration) by Leonardo da Vinci (1452–1519), Santa Maria della Grazie, Milan, Italy. The Bridgeman Art Library.

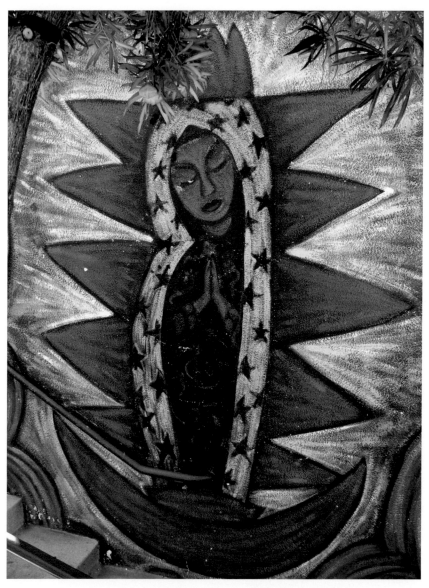

PLATE 5.3
La Virgen de Guadalupe, 1996 (mural) by José Ramirez.
Dolores Mission Church, Boyle Heights, California.
Photo: C. González-Andrieu.

PLATE 8.1
Illumination (After the Shroud of Turin), 2010
(canvas cloth, fluorescent paint, black light installation) by Daniel García.
Courtesy of artist.

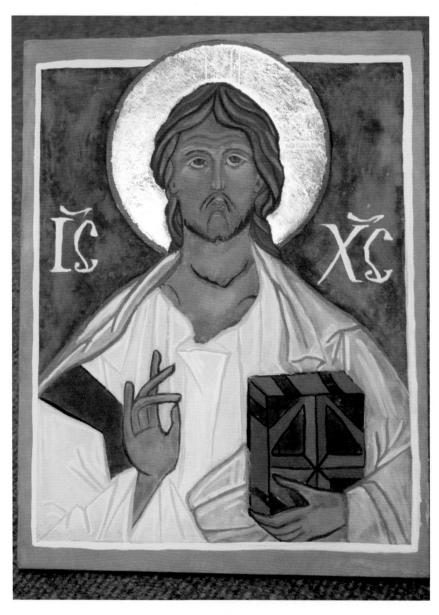

PLATE 8.2
Christ Icon (Pantocrator), 2009 (egg tempera and gold leaf on wood panel) by Maggie Assad.
Courtesy of artist.

PLATE 9.1

Christ d'Assy, 1949 (bronze) by Germaine Richier. Detail. At Notre-Dame de Toute Grâce du Plateau d'Assy. Courtesy of Notre-Dame de Toute Grâce.

Photo: Pierre Masson. © 2011 Artists Rights Society (ARS), New York/ADAGP, Paris.

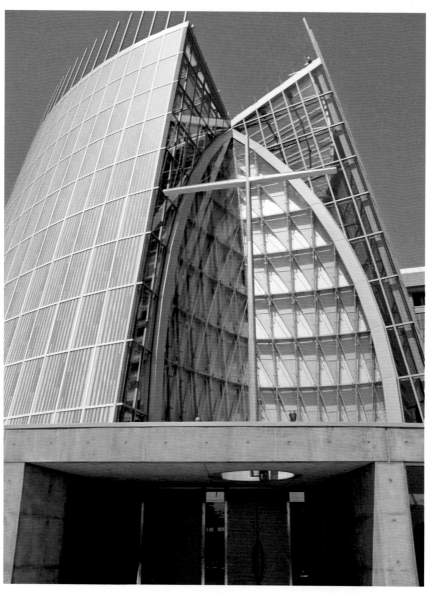

PLATE 9.2
Cathedral of Christ the Light, Oakland, California (2010). Photo: C. González-Andrieu.

PLATE 10.1
Vulnerable Man, 2005 (acrylic on paper/canvas) by Sergio Gomez.
Courtesy of artist.

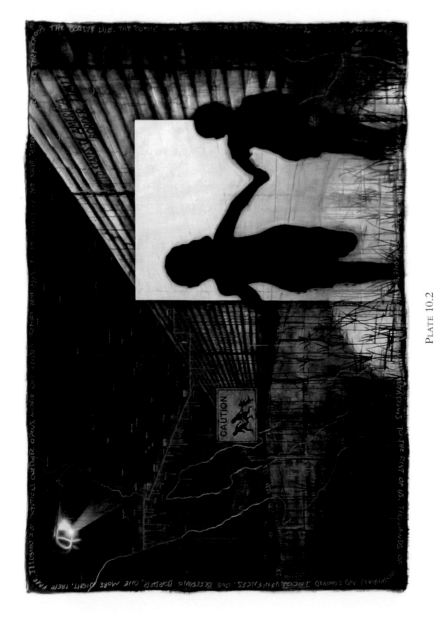

PLATE 10.2

The Bleeding Border, 2008 (acrylic on paper/canvas) by Sergio Gomez. Courtesy of artist.

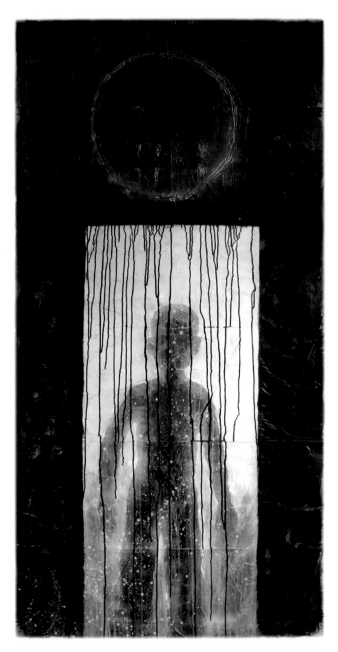

PLATE 10.3
Black Rain, 2006 (acrylic on paper/canvas) by Sergio Gomez. Courtesy of artist.

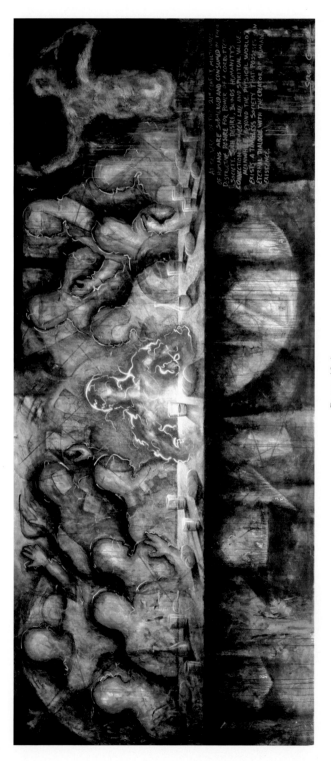

PLATE 10.4

The Last Supper, 1995 (acrylic on canvas) by Sergio Gomez. Courtesy of artist.

10

Glimpses and *Destellos*

Vulnerable and Prophetic

On a visit to Israel in my twenties, I recall the wonder of waiting for sunrise on a hill. We were sitting in the dark so we could film the beginnings of the day for a documentary. As dawn slowly transformed the landscape, I noticed a lone figure in the clearing beneath us, a woman, her skirts gathered up as she made her way between two tents barely silhouetted against the coming light. I stood on the hillside, wearing blue jeans, surrounded by technology, batteries humming, cameras and microphones at the ready, and she, she was about to make food for her family in exactly the same way as it had been done for millennia. It is not easy to describe what I felt at that moment, but the beauty of the scene caused a mix of complete identification with her, a knowing inside me of our deep and abiding kinship, of our familial ties, and at the same time a foreboding at what I suddenly realized was the radical otherness of my own life. I was in danger of forgetting the wonder of greeting the dawn and the preciousness of water and the purposeful walk of someone whose "work of human hands," to quote the Catholic liturgy, was truly needed. I felt humbled by that woman and I never forgot that privileged glimpse into her life.

I am similarly humbled by my awareness of the ways in which the wisdom of ages is passed from generation to generation in Jewish and

Christian communities; it is a wisdom that from our earliest recorded
history not only told us of our lovingly involved Creator, but involved
us in searching for the Creator's thunderous and also whispered vision
of who we *could* be. I also know that in faith communities are gathered
bouquets of life stories, lessons, and insights that far surpass anything
that my one life and limited horizons can possibly contribute. Each
member of a community brings worlds. Wisdom shared completes
what is lacking in our own experiences: this book is ultimately about
you and the communities that need the work of your hands.

So, back to the woman on the distant hillside in Judea. As I
became aware of that double truth—my otherness from her and also
our underlying sameness—I also noticed the mysterious nature of
human history. Why was I the researcher and filmmaker on the hill-
side, and she the woman in the tent? Why had my life transpired as
it had and hers been so different? Why did I routinely get water from
a water faucet in a big city, while she carried buckets through dirt
roads? History, when we look at it this way, is not a "given," where
some of us are somehow deserving of privilege while others lack what
is most basic to life. History, when seen this way, is radically contin-
gent. Even as we acknowledge God's plan for each of our lives, that
plan just asks for us to live God's vision for us, to be the best version
of ourselves wherever it is on the stage of history we find ourselves.[1]

Today, because of some mysterious music God is making, which
is too intricate for our small ears, you and I are meeting on this page,
at this instant. Think for a moment about all of the tiny contingencies
that led to this moment, or if we call them by their proper name, all
of the tiny miracles. When I think about it, I wonder if that moment
many years ago in the Judean hills was happening just so that I could
tell *you* about it and you would read it today—*this very day.*

God's ways are thus, so cultivating a sense of our smallness before
the mystery of history is crucial. Those things we think we can take
credit for, like our hard work, our intellect, our talent, our creativ-
ity, and the idea (to use the familiar phrase) that we have somehow
"risen above our circumstances," are all deceptive. God's generosity
gave us that intellect and capacity for hard work, and on the stage of
life we had an *opportunity* to use them. The difference between me and
the many other mothers in Los Angeles who wake up far from their
children, clean thirty hotel rooms even as they fear being deported,
and send their meager wages to another part of the world, where a

grandmother will use it to feed the family left behind . . . the differ-
ence between them and me should make me tremble as I realize how
undeserving I am of every privilege I have received. The difference
should make me kneel before God, not in thanksgiving for my privi-
leges, but to ask God honestly and humbly what I must do to lessen
their suffering.

On the hillside in Judea, I was conflicted by experiencing feelings
of sameness and otherness at the same time, but in the final analysis
there was one feeling that trumped all the others, a feeling that is very
simple to describe: love. The beauty that surrounded me made me
want to run down through the small bushes, greet that woman as my
sister, and sit at her feet so she would teach me. I wanted to know her
children and her grandmother, and I longed to tell her about mine.
At that moment I was experiencing God, because when beauty brings
us to love, it brings us to God.[2] In Israel those many years ago, that
woman and I never spoke—she never even knew I was there—but
the wonder of unexpectedly encountering her in the soft mist of the
holiness of Judea opened up my young heart. I am full of gratitude
for that opening.

That hillside is a good spot from which to begin to wrestle with
the difficult question of discerning the connection between what is
beautiful, what is true, and what is good—standing before God in
love and in humble gratitude. As a theologian, I understand my work
to be helping my religious tradition be reinvigorated and reincarnated
in the present situation, but this is work that every person of faith
should be doing, not just professional theologians. It is clear that many
artists have a similar calling to bring religious tradition and present
issues to bear upon one another in ways that will help illuminate both.
One task of the theologian and artist then can be defined as assisting
those who share a religious tradition in reaching back into sources and
creatively retrieving new and fruitful ways to wrestle with the most
difficult questions.[3] To conclude our look at how the arts and the
religious do the work of bridging us into wisdom and into a faith that
does justice, I want to explore one question of vital importance at this
very moment: "Who is my neighbor?"

The fact that people would even need to use the words "Who is?"
in relation to "neighbor" already points to a darkness that periodically
grows and covers up the most beautiful images of our tradition. As
the stories of creation in Genesis present it, a better question might

be "Who is *not*?" Is there anything in creation that is not a "neighbor" to me? In the stunning words of Genesis, as human persons are fashioned by the Creator's exuberance, it is clear that the "goodness" of creation, as God surveys all, belongs to all. The fish in the sea, and the crawling things, the birds in the air, and the day and the night all delight the Creator—we are not exclusively good, but communally good (Genesis 1).

To confess ourselves creatures of the one Creator is also to confess our very radical interconnectedness. The woman in Judea, and also the hillside, the water she was about to fetch, and the very soil on which she sleeps, and on which I stand now on the other side of the world, is, *all of it*, my neighbor. In Israel those many years ago, I did not feel pity for this woman, but something much more like awed wonder. She got up every morning hours before any of our alarm clocks chimed; she carried food and children on her body; she faced poverty and migration with dignity and strength; and in this I have met her many times and in many places, and she, with her many names, is deserving of my awe-filled respect. So, my acknowledgment of her as my neighbor does not assume that she is powerless, but it does acknowledge that she is vulnerable. In order to help our faith communities grapple with the very difficult practice of actually seeing and then unconditionally loving the neighbor, we need to foster the recognition of vulnerability in others and just as importantly in ourselves, and thus, we turn to art.

The *Vulnerable Man*

Chicago artist Sergio Gomez (Mexican American, b. 1971) has given us a window into a Christian understanding of vulnerability in his painting *Vulnerable Man* (2005, Plate 10.1). As we encounter the painting, we might be initially intrigued by *Vulnerable Man*'s perspective, which the painting invites us to enter. It is not a perspective as conclusion, or message, but as a place to stand so we may see; and the perspective of Gomez' painting is a door.[4] If we recall Rene Magritte's (Belgian, 1898–1967) characteristically enigmatic *The Unexpected Answer* (1933),[5] we can see Gomez' visual quote of this iconic door shape as the actual missing frame of *Vulnerable Man*. As Magritte presents it, a rather commonplace interior door is closed, but the door has been opened in the center through a large jagged hole about the right size and width for

a human being to step through. Thus in Magritte's rendering a door can be a barrier, or it can be blasted open. Three actions are captured in the painting: the closed door, the untidy and unexpected opening, and the one that has yet to happen—the stepping through of the viewer. The closed door is presented as the catalyst for a moment of action. In Gomez' painting, the door is suggested merely by its absence, and so this vulnerable man stands at a doorway made up of the surrounding space, the location where the actual painting hangs. The figure inhabits our world and, standing at this doorway, is implicitly about to become a part of it. As Magritte's work makes clear, a door is a packed symbol, and Gomez uses the metaphor of doors often. Let us look at two other examples.

In *The Bleeding Border* (2008, Plate 10.2), two small children run toward the viewer, framed by an open door behind them. In the light of the doorway there are words scarcely perceptible, lost within the field of white light: "security, human rights, pain, illusion, confession." The running children disclose that behind them is a jumble of feelings, which reveal hope and also terrible loss. Vulnerability is made up of a complex web of life experiences, and these are barely visible sometimes in the glare of what we may be running from.[6]

A second example of Gomez' use of the door metaphor is *Black Rain* (2006, Plate 10.3). Here it is the small child at the doorway who becomes a living door. The black silhouette of the child juxtaposed against white light invites our careful gaze. It is when we look inside the child that we begin to make out what look like whirling galaxies within, and/or softly falling snow without. The image hints at multiple interpretations, but one might be that inside the child (which would then suggest inside the universal human person) we see the fragility and vulnerability of everything. The universe as child is entirely dependent on its Creator. Here, the universe is vulnerable and very small—or, perhaps, a human child is much bigger than we ever imagined.

In *The Bleeding Border*, the door appears as a moment of communication between two worlds of human experience: the past with all its paradoxical complexity, and the unknown and dark future. In *Black Rain*, the double door of the doorway and child unites two realms, the human and the cosmic. All of these insights should help our *acercamiento* of *Vulnerable Man*, because in all three of Gomez' paintings the door is open, and thus we realize that someone has opened it. That

someone, all three paintings propose, is the viewer. Gomez' world is communitarian and engaged; the openness and action of the viewer is assumed just by the act of gazing at the painting. We have stopped at an open door, and we are now in relationship with the ones on the other side.

I saw these paintings at three separate exhibitions, and this was important to my experience. In all of them, the human figures are life-sized, so the relationship between us and the figure of *Vulnerable Man* has the force of realistic proportions, intimating that the conversation between us and the painting is happening now, and it is happening at a doorway we have opened. So, as he stands there, what can we discern about this man?

The first indicator that he is vulnerable is that he stands outside a doorway, while we are inside, in what we can assume to be a sheltered space. His very action of coming to our door has made him vulnerable. He has unmasked isolated individuality as an empty illusion, by the very humble action of knocking on our door. This man is vulnerable because he has given up that modern idea born out of privilege that we call "control," and in this we are reminded of another iconic "door" painting in Western Christianity, *The Light of the World* (1900–1904).[7] In this painting, which was part of the *Seeing Salvation* exhibition, William Holman Hunt (British, 1827–1910) paints Christ as a regally dressed king knocking on a door with no doorknob on the outside. The opposite of Magritte's blasted open door, the door in Hunt's work is resolutely closed and has not been used; unruly weeds crowd around it. This is the door to the "human heart," Hunt explained, "that can only be opened from the inside."[8] Here Christ, represented as the Prince of Peace, has given up control in favor of human freedom. We must choose to open up. Genuine relationship begins in the vulnerability that makes freedom possible.

Gomez is more optimistic than Hunt: he believes his viewer open, yet *Vulnerable Man* waits to be invited inside, not as the royal prince, but as the one who is poor. We must ask ourselves if we want to welcome him into our world, and if we do not, why not. We must face our fear of him. As we encounter the painting, our attention is drawn to the apparently moving life-sized hands, which are actual tracings of Sergio Gomez' own hands. His hands are open. So why are we afraid? As *Vulnerable Man* waits for us to choose to ask him inside, he reveals to us that he has nothing. We will choose him,

if we choose him at all, in his evident poverty and need. Is this what we fear? Even more tellingly, he stands frontally facing us. The figure reveals himself completely—his entire body visible and unguarded, even as he is somewhat concealed by the backlight, which reduces him to a silhouette. However, as we have seen, Gomez' consistent use of the silhouette in his work is an expansion into universal humanity.

There is also an undeniable specificity about this *Vulnerable Man*: he is a male; he is of slight build and wears baggy pants; he is in many ways quite real. Christ at our door is not a concept, but a living encounter. His incarnation into personhood reminds us that the vulnerable among us are also specific persons. As the psalmist tells us, they are loved by God in all their specificity, known by God intimately in their mother's womb, and wonderfully made (Ps 139:13-17).

As he waits outside the door, this man waits not as a no-one, but more expansively as a very specific some-one. Yet, admittedly the use of the silhouette aesthetically blurs and conceals his identity, suggesting the universality of the human condition of vulnerability, which makes us give up control, enter relationship, acknowledge complexity, and face fear. Vulnerability moves us from the recognition of truth into the possibility of goodness. So, vulnerable man is not a no-one, he is some-one, and as our hearts open we recognize he is every-one. Upon closer inspection, Gomez' painting reveals beautiful and fragile branches leading out from the man's body. The familiar halo of the Christlike figure is reinterpreted by Gomez as an organic circle connection that leads to life and witnesses to life. Vulnerability, Gomez suggests, is holy, life-giving, and community-making.

As we enter more deeply into our relationship with the painting, we also notice the orange glow encircling the figure. This odd glow is what gives the man solidity against the background. We are invited to follow this quivering orange to its source at the very bottom left corner of the painting. There we find an unexpected and strange symbol, a rather mundane looking electrical socket. The man's silhouette, made by the thin orange line, originates there. We again turn to Gomez' other works for help in decoding this symbol, and discover that the interpretive clue to *Vulnerable Man* is in his *Last Supper* (1995, Plate 10.4).

In his interpretation of the Last Supper (based on Leonardo's, Plate 5.2), Gomez presents Jesus as pure energy. Hunt's more cerebral, kingly Christ brings light to the human heart by carrying the lamp

of the Scriptures as the Word of God. In Gomez' more embodied interpretation, Jesus *is* the light; he is presented to us as pure Being in our midst, raw and boundless. Thus the orange glow of the vulnerable man (as the light socket discloses) is fed by Christ's awesome vulnerability at the Last Supper, when he, as St. Paul stresses, knowingly and willingly chooses to give up his life for us (Phil 2:5–8). The raw electric power in *The Last Supper* is imagined paradoxically as actually constituting vulnerability. Vulnerability then is not powerlessness. If Jesus is its source, as he prepares to walk freely to Calvary, then vulnerability can be transformed into a power, a doing, and a choice.

Vulnerability is an orange liveliness that connects us across miles of pulsing electrical wires with every other human person on the planet; it is our shared *being in* Christ. Vulnerability is experienced in relationship: it appeals to the "other" on the other side of the door, and it asks a question, "Will you invite me in?" The condition of being vulnerable pulses with the life-giving energy of raw love, it connects us, and it can be productive and energizing. We need to recognize it in one another, and we need to harness its power in ourselves.

My chance sighting of a woman in the Judean countryside helped me see how vulnerable we both were. Gomez' *Vulnerable Man* makes clear that in shared vulnerability the door can be opened and the stranger invited inside. What the *beauty* of Gomez' work helps us see most clearly is the *truth* of what is at stake when in concrete situations we are faced with the *ethical* choice between loving our vulnerable neighbor, turning away in fear, or even worse, adding to their suffering. His use of a creative form, in this case a painting, has the power to reveal the paradoxes in our belongingness and separateness in ways that unexpectedly open us up.

Gomez also invites us to discover and highlight the beauty in the other. We spend far too much time feeling "sorry" for people, and this diminishes their humanity. Celebrating what is beautiful in others fosters their dignity and undoes artificial boundaries. As an ancient proverb says, "Fall in love with the other's love."[9] If we work within our religious traditions, we find resources that help us see that the discovery of humility, vulnerability, and ultimately love for the other is a religiously and spiritually fruitful path. The practice of awakening ourselves to radical love is not "optional" or added to our life of faith, but a prerequisite. There is no faith without justice and no justice without faith.[10] Gomez' intertextuality between the contemporary

Vulnerable Man and the biblical *Last Supper* demonstrates the fruitfulness of speaking from the very particular in our faith tradition, our life experiences, and the people and issues that are vital to us right here, right now; this gives our religious insights solid grounding. Yet, because it is art, it also invites us to a universal experience, transcending our particularity so we can see what is global and, ultimately, cosmic. On the righthand corner of *The Last Supper*, Gomez has written in contrasting sky blue letters:

> At the verge of the 21st century, multitudes of humans are submerged and consumed in their destructive desire for power of a corrupted society. Such desire blinds humanity's connection between life and spiritual value. Meanwhile, beyond the physical world, exists a timeless society that possesses an eternal dialogue with the Creator of human existence.

Like other prophets before him, Gomez here appeals to the faith tradition he shares with his viewers as a "yardstick"—this is art's prophetic role of *denouncing*. His art is not shy about pointing out what is destructive and corrupting. Yet his images also point to those places in the tradition where very clear examples are given to the Christian community that preclude us from separating love of neighbor from love of God; in this, *The Last Supper* calls us to the fullness of the gospel.

Gomez appeals to the Christian tradition as "leaven," using Scripture as nourishment as he also activates the prophetic role of *announcing*. The Christian tradition vigorously critiques ways of being that create victims and assail creation, and this reinvigorates a different consciousness, allowing us to imagine and work toward God's vision for us.

When we interlace Gomez' work in *The Bleeding Border* into this account, we also learn that we must be explicit about unmasking systemic injustice and its consequences. By tying vulnerability to the suffering of innocent migrant children, Gomez' works exhort us to look at root causes. Our world specializes in creating false fronts and perpetuating lies; we must cultivate our ability to get to the truth by going beneath the surface with thoughtfulness and charity. Gomez' works foster an attitude of humility before the suffering neighbor in an "empty cup" attitude. He helps us realize that our own cup too is unfilled; we are not the savior, *Christ is*. As we stand side by side with our neighbors, it is they who must be protagonists in their own

lives. We are called to accompany them, to learn from them, and to help them have what they need to bring about change, knowing this journey will also change us. This also requires that we hold our faith communities accountable, because we open or close the door to Christ in exactly the measure that we are willing to come together as people of faith to lessen the suffering of the vulnerable.

Vulnerable Man's presence at our door reminds us that our spiritual life and our everyday life are not separate entities. The assertion that God is love cannot be a platitude; it must truly mean something right here and right now. As the paintings suggest, the radical nature of such a proposition will be uncomfortable and place demands upon us.

If, at its best, art is an invitation to relationship, the works of Sergio Gomez are bold and complex provocations to a series of inter-connected meetings. Gomez' use of the human figure grounds his work in the depth of human concerns; his art has our shared plight of suffering, of searching, and of triumph at its center. Far from a dualism that posits a separation between body and transcendence, Gomez' artful technique underscores how art points to the indissol-uble unity of what is matter and what is spirit. In Gomez' work, the use of multiple textures, visible seams, dripping paint, vibrant colors, and brushstrokes honors corporality, as his evocative figures celebrate personhood and the world in which we dwell. Yet Gomez' works also act like modern icons, opening windows and doors into the depths of Spirit, where death never has the last word and the sacred beckons.

In his beautiful, passionate, and passion-making art, Sergio Gomez tells a community's story, raises a cry of pain, mediates a vision of hope, and points with care and reverence toward that eternal Other whose love is brought by the very beauty of these works into relationship with a thankful world.

It Is All Interlaced

As beautiful as the Golden Gate Bridge is, what we have come to understand is that its beauty is united to its function and to the results that come about through its use. Correspondingly, the usefulness of the bridge built by the interlacing of art and religion becomes an able marker to the relevance, durability, and multiplicity of ways in which the creative and the religious can together convey us toward expe-riences we need to have in order to fully *be*. St. Irenaeus of Lyon

described the connection this way: "For the glory of God is a living [person]; and the life of [humanity] consists in beholding God."[11] Life and glory have a two-way relationship, where our aliveness is the most complete utterance of God's splendor. The opposite of remote or otherworldly, God's glory is manifested in the human person as we become more fully ourselves by "beholding God."

Humanity continues to tell one another about those moments when the "beholding of God" happens through word, painting, and song, and the relationship is a dynamic circle. The more we manifest the gift of our aliveness, the more it is our vision of God that is manifested; and the more we behold God, the more life we have in us. As Pius XII adds, two thousand years after Irenaeus, "Whatever in artistic beauty one may wish to grasp in the world, in nature and in [humanity], in order to express it in sound, in color, or in plays for the masses, such beauty cannot prescind from God. Whatever exists is bound to [God] by an essential relationship."[12]

Art then is a relationship that is honest, speaks of abundant life, and contributes to abundant life. And religion is a relationship that is honest, speaks of abundant life, and contributes to abundant life. The terms art and religion are here interchangeable, and when viewed together, their profoundly interlaced nature helps us understand, correct, question, and advance the work of each more fully.

Through the gift of art, we know we are connected to a human/ divine story that goes back millennia. It is in the breathtaking paintings preserved on the walls of the cave of Lascaux (c. 17,000 B.C.) that the paradigmatic moment of the awakening of human creativity, and with it the evidence of human thought, is preserved in "the interlacing of religion and art," suggesting that "religion is a fundamental dimension of art and that art is a fundamental dimension of our humanity."[13]

If we recall the tragic divisions brought about in modernity, the cave art at Lascaux exposes these as arbitrary and reproaches the smallness of our vision. The cave art is not religious art, not secular art, not fine art, and not folk art; it is not even "art" at all. Prehistoric cave paintings predate all our constructed distinctions and boundaries. At Lascaux, what we call art and religion are interlaced in the way the figure of a shaman in an apparent trance has survived millennia to reach us. Beyond this, at Lascaux we perceive the intense aliveness of human artistry, not only in the painting of the shaman,

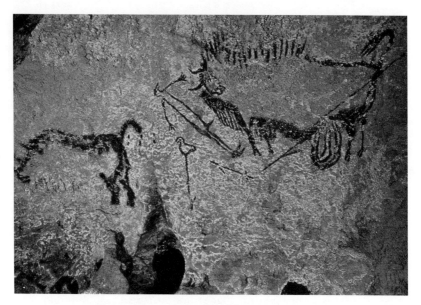

FIGURE 10.1
Rock painting of a hunting scene, c. 17,000 B.C. (cave painting),
Bridgeman Art Library

but in the religious ritual, the act of beholding God that the shaman seems to be involved in, as we note his bird-headed staff and exaggerated body position. The inseparability of what is art and what is religious becomes literally palpable in this cave painting, as interlacing evokes images of multiplicity, movement, playful mingling, and also discreteness.

The methodology I have proposed in the preceding chapters has been developed in the precariousness of the elements, so to speak, as was the building of the Golden Gate Bridge.[14] One of the most promising developments of this work is to witness how theological aesthetics as an interlacing of the artistic and the religious facilitates deep engagement. We know we are no longer a text-based world and our young people are inordinately gifted in decoding and creating symbolic systems. Image-making and image-sharing are instantaneous and plentiful today, and it is difficult to imagine where all of this is going. Even if we cannot predict where our facility with technology may take us, one thing is clear: it has expanded our appetite for symbol-making.

Like symbol-making, the work of theology is intricate and also quite natural. The great sources we read today as our primary theological texts were not academic exercises in their time, but rather the utterly real and deeply felt struggles of human beings with the questions of ultimate meaning. As we know, so is art when it is honest and truthful. What the intermingling of the religious and the artistic provides is a view of how preceding generations struggled with questions very similar to ours. Our creative ancestors engaged in symbol-making and decoding in ways that embodied their struggles, making them tactile and felt. What such intimacy with them as provided by art can do is to offer us their accompaniment and insights, emboldening us to take a chance and to ask difficult questions using our creative faculties.

Connected to this awareness of theological struggles as expressed creatively is the issue of accessibility. When we do theology by engaging the creative work of particular human communities, we are able to bring many more communities into the work of doing theology. A practice that understands the Christian gospel as the most powerful word of hope and liberation given by the Creator to suffering humanity must make an effort to learn actively from those who are suffering. Christianity is obligated to hear the voices of those "least" whom Jesus most loved and to amplify these voices (Matt 25:40). Through engaging creative works with respect, we bring into the room communities of people who are often excluded from mainstream theological, political, and ethical conversations. Their creative works are eloquent and efficient voices that not only inform us but, more importantly, move us to love and to action. Because of this, theological aesthetics constitutes a deeply liberative and community-making practice. What is beautiful is always pointing to the source of all beauty; we just need to be willing to look.

We often hear that we have nothing left to explore on our planet, that we must go to distant worlds to reignite our curiosity and to encounter mystery. I disagree. There is a vast area of our world that we have barely begun to explore and that part is—each other. Through the works of our religious senses and our artistic making, we can come to know one another better, to value the gift of mystery bestowed through radical otherness, and ultimately come to love one another truly. How we share the wisdom of our ancestors, how we glimpse the struggles of our young, how we denounce what is wrong

and celebrate what is right, how we build communities of compassion and instill compassion for the most marginal in our communities—all of this doing becomes possible when we come awake to the power of beauty.[15]

Beauty is not the ultimate good, God is, but since there is nothing more beautiful than God, then beauty is the best sign we have that we are on the right path.

Notes

Chapter 1: Introduction

1 Swanson's art is also part of the collections of the Tate Gallery, the Victoria and Albert Museum, the Art Institute of Chicago, and at least sixteen colleges and universities. For more on Swanson, see Cecilia González-Andrieu, ed. "The Art of John August Swanson: Symposium," in *ARTS: The Journal of the Society for the Arts in Religious and Theological Studies* 21, no. 2 (2010): 14–32.

2 Swanson has been a special guest presenter for several semesters for my upper division undergraduate course "Meeting Christ in Faith and Art" at Loyola Marymount University. His intimate interaction with students has been key in developing their scholarly voices as well as their (often untapped) artistic creativity.

3 John Dewey, *Art as Experience* (New York: Perigree Books, 2005), 197.

4 My father, Alfredo González Cardentey (Cuban, b. 1933), had two highly successful one-man shows in Havana and was heralded as one of the most interesting young artists to emerge in the early sixties. His career was tragically cut short by the Cuban Revolution and our forced exile, but he began painting once more in earnest after his retirement, first in Venezuela and then in the United States. The cover painting of this book, *La Catedral de mis sueños* (1996), is a beautifully complex achievement and one of my favorites among his works. See Plate 1.2.

5 My mother, Hortensia Lanza (Cuban, b. 1927), was trained as a pianist

and classical harpist and split her time between concerts, television, recordings, and the ministry of leading the choir at our parish.

6 My grandmother, Dolores (Lolita) Van der Gucht y Lopez (Cuban, b. 1895), was trained as an opera singer. She came from a long line of musicians and her grandfather was Anselmo Lopez, who ran the legendary publishing house and music store Casa de Música Anselmo Lopez in Havana. It was her grandfather who edited and published the very first score of the Cuban national anthem, *Himno Bayamés*, in the year 1899. It is intriguing to note that the score had an English version of the lyrics alongside the Spanish.

7 Loyola Marymount University is located in the city of Los Angeles, California, in the United States.

8 This space was eventually emptied and remodeled and is today called "Mary's Chapel."

9 Theologian Orlando Espín stresses that although Latina/o theologians are accountable to the academy and their disciplines, there is a more "important validation that we require and seek." This validation comes from the helpfulness of our work to the Latina/o community's struggles for justice and dignity while also challenging "our people to grow beyond *our* biases, *our* idols, and *our* sins." Orlando Espín, "The State of U.S. Latina/o Theology," in *Hispanic Christian Thought at the Dawn Hispanic Christian Thought at the Dawn of the 21st Century*, ed. Alvin Padilla, Roberto Goizueta and Eldín Villafañe (Nashville: Abingdon, 2005), 105; emphasis original.

10 Federico García Lorca, *Obras Completas*, 13th ed. (Madrid: Aguilar, S.A. de Ediciones, 1967), 118. This phrase is from the poet's lecture "Teoría y juego del duende" ("The Theory and Game of the Duende").

11 Biblical scholar Fernando Segovia points out that the myth that there is such a thing as an "objective or universal interpretation . . . involves the universalizing of one position or reading (and hence one social location) over all others, favoring and exalting thereby the one reading or position (and thus social location) in question while bypassing and denigrating all others in the process." "Two Places and No Place on Which to Stand: Mixture and Otherness in Hispanic American Theology," in *Mestizo Christianity: Theology from the Latino Perspective* (Maryknoll, N.Y.: Orbis Books, 1995), 29.

12 I am indebted to Dru Dougherty for his insight, that "A poem is not an argument." The pithy nature of his comment and its depth communicated to me in form and content that creative works function in a different way from other forms of discourse, especially the types of arguments that theological scholars sometimes favor.

13 For a helpful discussion of the methodological challenges of theological

aesthetics as it seeks "the insight of interconnections, not the strength of demonstration," see Alejandro García-Rivera, *The Garden of God* (Minneapolis: Fortress, 2009), ix–xii.

14 Roberto Goizueta, *Caminemos con Jesús: Toward a Hispanic/Latino Theology of Accompaniment* (Maryknoll, N.Y.: Orbis Books, 1995), 178.

15 St. John of Damascus, *On the Divine Images: Three Apologies against Those Who Attack the Divine Images*, trans. David Anderson (Crestwood, N.Y.: St. Vladimir's Seminary Press, 2000), 14.

Chapter 2

1 Avery Dulles, *Models of Revelation* (Garden City, N.Y.: Doubleday, 1983), vii. "Latina/o theology assumes that there has been divine revelation, of course, but there are some very important questions behind this assumption. For example, what is revelation, if we were to think of it from the Latino/a perspective?" Orlando Espín, "The State of U.S. Latina/o Theology," in *Hispanic Christian Thought at the Dawn of the 21st Century*, ed. Alvin Padilla, Roberto Goizueta, and Eldin Villafañe (Nashville: Abingdon, 2005), 113.

2 Although Dulles recognized the importance of the *Dogmatic Constitution on Divine Revelation—Dei Verbum* (1965), he saw it as quite limited, calling it "indicative but far too crude to do justice to the complexity of the matter." See Avery Dulles, "Revelation in Recent Catholic Theology," *Theology Today* 24, no. 3 (1967): 350–65.

3 Dulles, *Models of Revelation*, vii.

4 Dulles, *Models of Revelation*, vii.

5 Avery Dulles, S.J. (1918–2008) was a priest who was never a bishop and who dedicated his life to scholarship and teaching. The Jesuit was a surprising choice for elevation to cardinal, which John Paul II did in 2001, when Dulles was 82 years old. For a brief biography, see his obituary in the *New York Times*, December 12, 2008.

6 Dulles, *Models of Revelation*, 6.

7 Dulles, *Models of Revelation*, 6.

8 Clearly Dulles finds the questions of doubts accompanying what he terms modern epistemology to be serious, as they place "an emphatic question mark against the divine authority usually attributed to revelation." *Models of Revelation*, 6.

9 Dulles, *Models of Revelation*, 6–7. Noted psychologist and philosopher William James also finds fault with theories that reduce mystical states to medical diagnoses and thus dismiss them: "To pass a spiritual judgment upon these states, we must not content ourselves with superficial medical talk, but inquire into their fruits for life." *The Varieties of*

Religious Experience: A Study in Human Nature (Seattle: Pacific Publishing Studio, 2010), 174.

10 Dulles, *Models of Revelation*, 7, 207.

11 Dulles, *Models of Revelation*, 7–8.

12 Dulles, *Models of Revelation*, 8.

13 Dulles quotes Karl Rahner's definition: "Theology is the science of faith. It is the conscious and methodical explanation and explication of the divine revelation received and grasped in faith." *Models of Revelation*, 5.

14 Dulles, *Models of Revelation*, vii.

15 Richard P. McBrien, *Catholicism*, new ed. (San Francisco: HarperSanFrancisco, 1994), 255.

16 Dulles, *Models of Revelation*, 131.

17 After I had completed this manuscript, I discovered a text prepared by the Pontifical Council for Culture's plenary assembly in Rome, March 27–28, 2006. The document, titled *Via Pulchritudinis* ("Way of Beauty"), concretely proposes the cultivation of experiences of beauty as the best way to reach out to contemporary culture with the saving message of the Christian gospel. "Beginning with the simple experience of the marvel-arousing meeting with beauty, the *via pulchritudinis* can open the pathway for the search for God, and disposes the heart and spirit to meet Christ, who is the Beauty of Holiness Incarnate, offered by God to [people] for their salvation." "The *Via Pulchritudinis*: Privileged Pathway for Evangelisation and Dialogue" (Rome: The Vatican, 2006), II, 1.

18 Dulles states very clearly that "to employ a doctrine of revelation in the very investigation of revelation would be to presuppose the answer to the very question one was asking." Dulles, *Models of Revelation*, viii.

19 Quoted in Dulles, *Models of Revelation*, 131.

20 For the subject of Yeats' commentary, see William Blake, *Illustrations to Dante's Divine Comedy*, ed. Morris Eaves, Robert N. Essick, and Joseph Viscomi, in the William Blake Archive, http://www.blakearchive.org. Yeats was at once a "reader and scholar of Blake," as well as a "poet and follower of Blake." Ariana Antonielli, "William Butler Yeats's 'the Symbolic System' of William Blake," *Estudios Irlandeses* 3 (2008): 10.

21 W. B. Yeats, "William Blake and His Illustrations to the Divine Comedy," *Collected Works* (Stratford-on-Avon: Shakespeare Head Press, 1908), 6:138. Quoted in Dulles, *Models of Revelation*, 131.

22 Dulles, *Models of Revelation*, 131.

23 "Poema doble del lago Edem," in García Lorca, *Obras Completas*, 499.

24 Not all art creates bridges to wonder, and many artists, especially since modernity, would not recognize the work of mediating and activating revelation as the task of art. Yet I contend that much of the world's creative output is often involved in this task.

25 Dulles, *Models of Revelation*, 131.

26 One particularly powerful "art" movement in this direction is "reverse graffiti." This "art" is located in urban landscapes and instead of adding on spray-paint or other materials, it functions by creating beautiful forms (often trees and other natural landscapes) through the cleaning of grime and pollutants on the walls. The people involved consider themselves artists, while the work they do has a beauty that is temporary but also extends an ecological and ethical invitation. The movement is gaining a worldwide following. For more information, see http://www.environmental graffiti.com.featured/35-greatest-works-of-reverse-graffiti/1949.

27 Pope John Paul II, *Letter to Artists* (Rome: The Vatican, 1999), §1.

28 John Paul II, *Letter to Artists*, §1.

29 "It is the task of the prophetic imagination and ministry to bring people to engage the promise of newness that is at work in our history with God." Walter Brueggemann, *The Prophetic Imagination* (Philadelphia: Fortress, 1978), 62–63.

30 John Paul II, *Letter to Artists*, §1.

31 John Paul II, *Letter to Artists*, §§3 and 16.

32 John Paul II, *Letter to Artists*, §6.

33 Cardinal Joseph Ratzinger, "The Feeling of Things, the Contemplation of Beauty," in *The Essential Pope Benedict XVI: His Central Writings and Speeches*, ed. John F. Thorton and Susan B. Varenne (San Francisco: HarperSanFrancisco, 2007), 48.

34 Ratzinger, "Feeling of Things, the Contemplation of Beauty," 49.

35 Ratzinger, "Feeling of Things, the Contemplation of Beauty," 50.

36 Ratzinger, "Feeling of Things, the Contemplation of Beauty," 49.

37 Ratzinger, "Feeling of Things, the Contemplation of Beauty," 50.

38 Ratzinger, "Feeling of Things, the Contemplation of Beauty," 50.

39 John Paul II, *Letter to Artists*, §13.

40 John Paul II, *Letter to Artists*, §14.

41 In his encyclopedic study of the North American pragmatists C. S. Peirce and Josiah Royce, theologian Donald L. Gelpi stresses that "deconstructionists who reject indefensible forms of foundational ontological thinking need . . . to learn that foundational metaphysical thinking comes in many forms, including forms which avoid the fallacies of classical ontologies." *Varieties of Transcendental Experience: A Study in Constructive Postmodernism* (Collegeville, Minn.: Liturgical Press, 2000), ix.

42 Dulles underlines that "revelation never occurs in a purely interior experience or an unmediated encounter with God [other-worldly]. It is always mediated through symbol [this-worldly]." *Models of Revelation*, 131.

43 García-Rivera, *Garden of God*, 67.

44 García-Rivera, *Garden of God*, 63.

45 García-Rivera, *Garden of God*, 65.

46 García-Rivera, *Garden of God*, 99.

47 García-Rivera, *Garden of God*, 99.

48 Dulles, *Models of Revelation*, 6.

49 Dulles, *Models of Revelation*, 6.

50 Dulles, *Models of Revelation*, 6.

51 Dulles, *Models of Revelation*, 6–7.

52 Donald Gelpi argues convincingly that the religion of the powerful in North America, Deism, was "mired in the multiple dualisms of a classical Protestant, Augustinian, dialectical imagination." *Varieties of Transcendental Experience*, 78.

53 Although we may want to dismiss Plato's negative assertions about artists in *The Republic* (especially as these are overshadowed by the dialogue's misogynistic and eugenic overtones), it is clear that "Plato's political ideas had an immense influence down the centuries, and not least on the utopian totalitarian philosophies of Left and Right that characterized the 20th century." Bryan Magee, *The Story of Philosophy* (New York: DK Publishing, 1998), 30.

54 See esp. book X of *The Republic*, in Albert Hofstadter and Richard Kuhns, *Philosophies of Art and Beauty* (Chicago: University of Chicago Press, 1976), 30–45.

55 Hofstadter, *Philosophies of Art and Beauty*, 36.

56 Magee, *Story of Philosophy*, 25.

57 Dulles, *Models of Revelation*, 132.

58 Curiously, it was precisely the opposite observation that constituted Søren Kierkegaard's opposition to the arts. Clearly responding to the influence of Kant's aesthetics, which stressed the disinterested enjoyment of the arts, Kierkegaard saw no use for them in religious life, since to be moved and transformed in one's life is indeed the aim of religion. See Frank Burch Brown, *Good Taste, Bad Taste, and Christian Taste: Aesthetics in Religious Life* (New York: Oxford University Press, 2000), 31.

59 "In symbolic communication, the clues draw attention to themselves . . . and if we surrender to their power they carry us away, enabling us to integrate a wider range of impressions, memories, and affections." Dulles, *Models of Revelation*, 132.

60 "Creation is essentially a divine action, and . . . life itself began with art." Robin Margaret Jensen, *The Substance of Things Seen: Art, Faith, and the Christian Community*, The Calvin Institute of Christian Worship Liturgical Studies Series (Grand Rapids: Eerdmans, 2004), ix.

61 "A symbol is a sign pregnant with a plenitude of meaning which is evoked rather than explicitly stated." Dulles, *Models of Revelation*, 132.

62 Plato, *The Republic*, in *Philosophic Classics, Ancient Philosophy*, vol. 1, ed.

Forrest E. Baird and Walter Arnold Kaufmann (Upper Saddle River, N.J.: Prentice Hall, 2003), 281–83.

63 Kent A. Peacock, lecture notes on *Plato's Republic* from a lecture at the University of Lethbridge, 2006.

64 Plato, *The Republic*, trans. Reginald E. Allen (New Haven: Yale University Press, 2006), 226. A very similar figure is included in Baird and Kaufmann, 281.

65 Plato, "Analysis of the Republic," in *Republic of Plato*, xxvii. "Then must we not conclude that all writers of poetry, beginning with Homer, copy unsubstantial images of every subject about which they write, including virtue, and do not grasp the truth? . . . will not the painter, without understanding anything about shoemaking, paint what will be taken for a shoemaker by those who are as ignorant on the subject as himself, and who judge by the colors and forms?" Book X, 377.

66 Plato, *Republic of Plato*, book X, 377, 379.

67 Plato, *Republic of Plato*, book X, 381.

68 Plato, *Republic of Plato*, book X, 381. Plato's argument implicitly communicates his view that wisdom is male, and artistic "imitation" is female and thus a "worthless mistress."

69 Plato, *Republic of Plato*, book X, 384.

70 Plato, *Republic of Plato*, book X, 387.

71 Plato, *Republic of Plato*, book X, 387.

72 Plato, *Republic of Plato*, book X, 385.

73 After about an hour on his computer, my teenage son produced a photograph of himself sitting in an elegant drawing room with a lovely young woman. He posted the photograph on his Facebook page and within minutes all his friends wanted to know who his new girlfriend was. My son had put together several photographs and did not even know who the young model was that appeared to all to be his new love.

74 *Inception*, 2010. Written and directed by Christopher Nolan (British, b. 1970), produced by Warner Bros. Pictures, Legendary Pictures, Syncopy.

75 Roger Ebert, review of *Inception*, *Chicago Sun Times*, July 14, 2010.

76 The downgrading of human conscience can be interpreted as a denial of God's existence. Two theologians who pay close attention to the role of conscience in disclosing the presence of God are John Henry Newman, *An Essay in Aid of a Grammar of Assent* (New York: Oxford University Press, 1984); and Gregory Baum, *Faith and Doctrine: A Contemporary View*, The David S. Schaff Lectures (Paramus, N.J.: Newman, 1969).

77 Jean-Paul Sartre, *No Exit, and Three Other Plays* (New York: Vintage Books, 1956), 42.

78 A. O. Scott, "Inception: This Time the Dream's On Me," *The New York Times*, July 16, 2010.

79 As Robin Jensen insightfully stresses, "Art belongs to the secular as well as the sacred world, and in both realms is powerful as well as dangerous, beneficial as well as detrimental—to society as much as an individual soul." *Substance of Things Seen*, ix.

80 Yeats, "William Blake," in *Collected Works*, 138.

81 John Paul II, *Letter to Artists*, §8. John Paul II is quoting from Dante's *Paradiso*, XXV 1–2.

82 Von Ogden Vogt, *Art and Religion* (Boston: Beacon, 1948), 23.

83 John Paul II, *Letter to Artists*, §3.

84 Fyodor Dostoyevsky, *The Idiot: A Novel in Four Parts* (New York: Macmillan, 1916), 383.

Chapter 3

1 Although I propose that creative works as sources of revelation extend beyond visual art and also beyond visual art and also beyond religious art, the insight of how icons work within the Orthodox tradition supports the idea of the revelatory in what we would recognize as a creative work, in that "an icon is an instrument through which the knowledge of God, in his mysterious human incarnation becomes accessible . . . the physical witness to the sanctification of matter . . . and a means by which both the iconographer and worshiper can participate in the realm of eternity." Elizabeth Zelensky and Lela Gilbert, *Windows to Heaven: Introducing Icons to Protestants and Catholics* (Grand Rapids: Brazos, 2005), 22.

2 As he addresses artists, John Paul II makes an explicit connection between the arts and their work in the human person when he says, "May your art help to affirm that true beauty which, as a glimmer of the Spirit of God, will transfigure matter, opening the human soul to the sense of the eternal." *Letter to Artists*, §16.

3 Gustavo Gutiérrez, *On Job: God-Talk and the Suffering of the Innocent* (Maryknoll, N.Y.: Orbis Books, 1987), xiii.

4 This was Mozart's last work, left unfinished because of his early death.

5 John Dewey's identification of religious feeling in his philosophy of art helps a theologian "unpack" what this religious feeling might actually be: "A work of art elicits and accentuates . . . belonging to the larger, all-inclusive, whole which is the universe in which we live . . . that feeling of exquisite intelligibility we have in the presence of an object that is experienced with esthetic intensity. It explains also the religious feeling that accompanies intense esthetic perception." *Art as Experience*, 202.

6 The theologian and philosopher Jonathan Edwards (1703–1758), largely responsible for the "Awakenings" in colonial America, referred to this

kind of wakefulness as essential to what he termed "true religion." Edwards writes, "That religion which God requires, and will accept, does not consist in weak, dull and lifeless wouldings [wishing], raising us but a little above a state of indifference: God in his Word, greatly insists upon it, that we be in good earnest, fervent spirit, and our hearts vigorously engaged in religion: 'Be ye fervent in spirit, serving the Lord' (Rom. 12:11)." In *A Jonathan Edwards Reader*, ed. John Edwin Smith, Harry S. Stout, and Kenneth P. Minkema (New Haven: Yale University Press, 1995), 143.

7 Thomas Aquinas, *Summa Theologiae: 1a2ae*, 49–55, vol. 22, ed. Anthony Kenny (Cambridge: Cambridge University Press, 2006), I, question 3, "Of the Simplicity of God."

8 In his development of the idea of religious affections Jonathan Edwards makes the connection between interior faith and the way it shines forth in the faithful person. He explains that the early Christians "filled their minds with the light of God's glory, and made 'em themselves to shine with some communication of that glory." *Edwards*, 140.

9 John Paul II, *Letter to Artists*, §16.

10 John Paul II holds that all human beings are artists sharing in God's creative activity, as "all men and women are entrusted with the task of crafting their own life: in a certain sense, they are to make of it a work of art, a masterpiece." *Letter to Artists*, §2.

11 "Every genuine inspiration . . . contains some tremor of that 'breath' with which the Creator Spirit suffused the work of creation from the very beginning." John Paul II, *Letter to Artists*, §15.

12 William James, "Mysticism," in *Readings in the Philosophy of Religion: An Analytic Approach*, ed. Baruch A. Brody (Englewood Cliffs, N.J.: Prentice-Hall, 1974), 479.

13 Dewey, *Art as Experience*, 159.

14 Gao Xingjian, *Return to Painting*, trans. Nadia Benabid (New York: Perennial, 2002), 39.

15 Gutiérrez, *On Job*, xiv.

16 There are numerous instances of such problematic searches for love in Scripture, from the Book of Job to the embarrassment of Peter's denial (Matt 26:69-75; Mark 14:66-72).

17 Gutiérrez, *On Job*, xiii.

18 John Dewey's work is foundational to this insight as he states, "The organism which is the work of art is nothing different from its parts or members. It is the parts as members. . . . The resulting sense of totality is commemorative, expectant, insinuating, premonitory." *Art as Experience*, 200.

19 The year was 2005. I am grateful to Paulina Espinosa for the invitation.

20 Mission San Juan Bautista (named for John the Baptist) was founded
 due east of the Monterey Peninsula in Alta California in 1797. For more
 information, see John A. Berger, *The Franciscan Missions of California*
 (New York: G. P. Putnam's Sons, 1941). For primary documents about
 life in the California Missions, see Timothy M. Matovina and Ger-
 ald Eugene Poyo, *Presente!: U.S. Latino Catholics from Colonial Origins to
 the Present, American Catholic Identities* (Maryknoll, N.Y.: Orbis Books,
 2000), 37–43.

21 Unlike other instances where a church that is no longer in use becomes
 an art space, the Mission Church at San Juan Bautista is still very much
 a living parish.

22 "Luis Valdez is acknowledged as the founder of modern Chicano the-
 ater and film of the United States. Born to migrant farmworkers, Valdez
 spent his early life working in the fields with his family. He later joined
 the United Farm Workers, which led to the formation of his theater
 group, El Teatro Campesino." Luis Valdéz, *Mummified Deer and Other
 Plays* (Houston, Tex.: Arte Público Press, 2005).

23 Founded by Valdéz in 1965 as part of the farm worker movement led
 by César Chavez, the name Teatro Campesino means literally the Farm
 Worker Theater, not the theater of farm workers, which would be
 El Teatro de los Campesinos. I interpret the name to mean a theater
 company that understands itself to be a farm worker, a stance of great
 solidarity and subversive displacement of elitist art norms. See Ceci-
 lia J. Aragón, "Niños Y El Teatro: Critical Perspective of Children in
 Mexican-American Theatre," *Youth Theatre Journal* 22, no. 1 (2008).
 For information on the theater company, see www.elteatrocampesino
 .com. Their stunningly staged plays are made available to the commu-
 nity for less than the cost of a movie ticket.

24 Goizueta, *Caminemos con Jesús*, 173.

25 Ratzinger, "The Feeling of Things, the Contemplation of Beauty," 49.

26 I want to underscore the significant difference between seeing this play
 in its film version (part of the Great Performances series from PBS,
 1991, directed by Luis Valdéz, starring Linda Ronstadt and Paul Rodrí-
 guez) and seeing it live in its original setting of the Mission Church. For
 a treatment of the film version, see María Herrera-Sobek, "Luis Valdez's
 La Pastorela: 'The Shepherd's Play': Tradition, Hybridity, and Transfor-
 mation," in *Mexican American Religions: Spirituality, Activism, and Culture*,
 ed. Gastón Espinosa and Mario T. García (Durham: Duke University
 Press, 2008). The Hemispheric Institute Digital Video Library at NYU
 has a video recorded in 1995, which includes an introduction by Luis
 Valdéz but unfortunately ends before the play is finished. This produc-
 tion of the play does not much resemble the production I saw eleven

years later, which was superbly and expertly staged, but is a helpful record of the earlier incarnation of the performance and especially of the playwright's comments.

27 "The interpretation of art presupposes an awareness of what art is. The point of access to the artist's genuine inspiration must be an inspiration akin to the artist's. . . . Scholarly enquiry must become contemplation." Hans Urs von Balthasar, *The Glory of the Lord: A Theological Aesthetics*, vol. 1, *Seeing the Form*, ed. Joseph Fessio and John Riches, trans. Erasmo Leiva-Merikakis (San Francisco: Ignatius Press, 1983), 102.

28 Commenting on the writings of Dionysius the Pseudo-Areopagite (who was a foundational influence on Christian aesthetics), art historian Erwin Panofsky explains that for Dionysius "all visible things are 'material lights' that mirror the 'intelligible' ones and, ultimately, the vera lus of the Godhead Itself: 'Every creature, visible or invisible, is a light brought into being by the Father of the lights.'" Dionysius makes the explicit connection that things of this world, such as a stone, can enlighten us because in pondering them, "under the guidance of reason, I am led through all things to that cause of all things." In Abbot Suger, *Abbot Suger on the Abbey Church of St.-Denis and Its Art Treasures*, 2nd ed., ed. and trans. Erwin Panofsky and Gerda Panofsky-Soergel (Princeton: Princeton University Press, 1979), 20.

29 In his classic analysis of what he calls "the deepest and most fundamental element in all strong and sincerely felt religious emotion," Rudolf Otto (1869–1937) examines the idea of the mysterium tremendum, noting that it is characterized by that which causes "awe" in its noblest form, "where the soul, held speechless, trembles inwardly to the farthest fibre of its being" (17). To this, he adds a second element of being overpowered and brought to a state of humility, which he calls "majestas" (19–23), and a third element that produces what he calls "energy . . . vitality, passion" (23–24), which then results in the effect of "fascination" (31–40). The effect is an encounter with "the wholly other [which] will attach itself to, or sometimes be indirectly aroused by means of, objects which are already puzzling upon the 'natural' plane, or are of a surprising or astounding character" (27). Though Otto does not make the explicit connection here to the arts, liturgy, or rituals, his schema of these universal experiences of transcendence or sacredness can point to the "why" and the "how" of religiously evocative works of creativity. See Rudolf Otto, *The Idea of the Holy* (London: Oxford University Press, 1958), 17–40.

30 In his comprehensive study of mysticism, William James stresses that "the 'other-worldliness' encouraged by the mystical consciousness" can produce a paralyzing withdrawal from "practical life" in those he terms as having a "passive" and "feeble" character. He juxtaposes this

tendency against the Spanish mystics (Teresa of Avila, John of the Cross, and Ignatius of Loyola), who "for the most part have shown indomitable spirit and energy, and all the more so for the trances in which they indulged." *Varieties of Religious Experience*, 174.

31 ¡Oh lámparas de fuego,
 en cuyos resplandores
 las profundas cavernas del sentido,
 que estaba oscuro y ciego,
 con extraños primores
 calor y luz dan junto a su querido!
 ¡Cuán manso y amoroso
 recuerdas en mi seno,
 donde secretamente solo moras;
 y en tu aspirar sabroso,
 de bien y gloria lleno,
 cuán delicadamente me enamoras!

32 John Paul II, *Letter to Artists*, §6.

33 In the production I saw, this figure of the Tempter was played by playwright Luis Valdéz, an observation that adds yet one more layer to interpreting this event.

34 "Art must make perceptible, and as far as possible attractive, the world of the spirit, of the invisible, of God. It must therefore translate into meaningful terms that which is in itself ineffable. Art has a unique capacity to take one or other facet of the message and translate it into colours, shapes and sounds which nourish the intuition of those who look or listen. It does so without emptying the message itself of its transcendent value and its aura of mystery." John Paul II, *Letter to Artists*, §12.

35 Abraham Joshua Heschel, *Man Is Not Alone: A Philosophy of Religion* (New York: The Noonday Press, 1993), 12; emphasis in original.

36 Valdéz' script mixes a possible medieval source, which he says was passed along through one of the local families, with *Caló*, "'Chicano Spanglish' . . . the dominant linguistic medium that led to an outburst of art, music, literature and theatre [in the 1960s and 1970s]." Aragón, "Niños Y El Teatro," 8–9.

37 "Farmworkers are the subjects, the privileged ones within the frame of the narrative, and are not pathetic objects to be pitted [*sic*] or scorned. Valdez's Pastorela is transgressive and subversive because it empowers the downtrodden through an artistic production." Herrera-Sobek, "Luis Valdez's *La Pastorela*," 332. This curious lack of engagement with the actual religious content of the play, which is the birth of Christ as told in the Christian Scriptures, fails to note that before this lifting of the lowly was the subject of a work of art, it was the subject of the work

of Christ. What this cultural critic names as transgressive and subversive in the play is actually its coherence and faithfulness to the gospel message. For more on the farmworker movement's Christian roots, see Frederick John Dalton, *The Moral Vision of César Chávez* (Maryknoll, N.Y.: Orbis Books, 2003).

38 "We must keep our own amazement, our own eagerness alive. And if we ever fail in our quest for insight, it is not because it cannot be found, but because we do not know how to live, or how to beware of the mind's narcissistic tendency to fall in love with its own reflection." Heschel, *Man Is Not Alone*, 14.

39 Although speaking of the work of philosophers, John Paul II's comments here could well apply to the arts, as "those whose vocation it is to give cultural expression to their thinking no longer look to truth, preferring quick success to the toil of patient enquiry into what makes life worth living." *Fides et Ratio* (Vatican City: Vatican, 1998), §6.

40 It is likely that this figure will have been surpassed by the time this book goes to press.

41 Kelly Crow, "Sotheby's Sells Giacometti for Record $104.3 Million." *Wall Street Journal*, February 3, 2010.

42 Steve Martin, *An Object of Beauty: A Novel* (New York: Grand Central Publishing, 2010), 16.

43 The most expensive home in the world was completed in 2010, at a cost of a billion dollars, in one of the poorest cities in the world, Mumbai, India. The occupants of the twenty-seven floors are a family of five, waited on by six-hundred servants. Ilyce Glink, "The Most Expensive House in the World," in *CBS Moneywatch* (2010).

44 The top five procedures in 2009 were breast augmentation, nose reshaping, eyelid surgery, liposuction, and tummy tuck. *Cosmetic and Reconstructive Plastic Surgery Trends* (American Society of Plastic Surgeons, 2009).

45 Photographer Philip Toledano noted this in the introduction to his portraits of surgically altered people (2008–2010): "Is beauty informed by contemporary culture? By history? Or is it defined by the surgeon's hand? . . . When we re-make ourselves, are we revealing our true character, or are we stripping away our very identity?" See http://www.mrtoledano.com/A-new-kind-of-beauty.

46 Sandra G. Boodman, "For More Teenage Girls, Adult Plastic Surgery," *The Washington Post*, October 26, 2004. Boodman notes a 300 percent increase in breast implants in teen girls from 2003–2004.

47 As Dewey explains, using Macbeth as an example, only those "frustrated in a particular object of desire" find life utterly meaningless. *Art as Experience*, 203.

48 García-Rivera, *Garden of God*, 51–52.

49 Dewey, *Art as Experience*, 203.
50 The call for "soul-searching" was repeated by many to deal productively with the horror of a mass shooting in Tucson, Arizona, on January 8, 2011. See, e.g., the following articles in the *New York Times*: Carl Hulse and Kate Zernike, "Bloodshed Puts New Focus on Vitriol in Politics," January 8, 2011; David M. Herszenhorn, "After Attack, Focus in Washington on Civility and Security," January 9, 2011; Paul Krugman, "Climate of Hate," January 9, 2011; Sam Dolnick and Timothy Williams, "Talk Radio Hosts Reject Blame in Shooting," January 10, 2011. See also theater critic Chris Jones' pointed analysis of the power of rhetoric and theatricality, "The burden of depicting 'truth': Political or not, words come with responsibilities," *Chicago Tribune*, January 15, 2011.
51 "What we know to be most proper to God—his self-revelation in history and in the Incarnation—must now become for us the very apex and archetype of beauty in the world." Von Balthasar, *Glory of the Lord*, 1.69.
52 Dionysius the Areopagite, or Pseudo-Dionysius as he has come to be known, donned the writing persona of an Athenian converted by the Apostle Paul in the first century, and as such greatly influenced theology in the Middle Ages and the Renaissance. He is now believed to have been a purposefully anonymous monk writing in the late fifth or early sixth century. His insightful influence on theology has not waned, especially with Roman Catholic theologian Hans Urs von Balthasar, who finds the theology of the writer he calls Denys "an original whole of such character and impact that none of the great theological thinkers of the following ages could avoid him." Hans Urs von Balthasar, *The Glory of the Lord: A Theological Aesthetics*, vol. 2, *Studies in Theological Style: Clerical Styles, trans. Andrew Louth, Francis McDonagh, and Brian McNeil* (San Francisco: Ignatius Press, 1984), 147.
53 Pseudo-Dionysius, *The Divine Names*, in Gesa Elsbeth Thiessen, *Theological Aesthetics: A Reader* (Grand Rapids: Eerdmans, 2005), 34–35.
54 This longing can be characterized as desire; see Klas Bom, "Directed by Desire: An Exploration Based on the Structures of the Desire for God," in *Scottish Journal of Theology* 62, no. 2 (2009): 135–48.
55 Vogt, *Art and Religion*, 36.
56 Ron Austin, *In a New Light: Spirituality and the Media Arts* (Grand Rapids: Eerdmans, 2007), 3–6.
57 "God did not reveal to the prophets the eternal mysteries but His knowledge and love of [humanity]. It was not the aspiration of Israel to know the Absolute but to ascertain what he asks of [humanity]; to commune with His will rather than with His essence." Heschel, *Man Is Not Alone*, 129. "The history of the love-relationship between God and Israel

consists, at the deepest level, in the fact that [God] gives her the Torah, thereby opening Israel's eyes to [humanity's] true nature and showing her the path leading to true humanism." Pope Benedict XVI, "Deus Caritas Est (On Christian Love)" (Vatican City: Vatican, 2005), §9.

58 1 Cor 13; John 3:16.

59 Heschel underscores the difference between the human person meeting the world with "the tools he has made"—a limiting and adversarial undertaking like that of hunter and prey—and another alternative, which is to meet the world "with the soul with which he was born . . . like a lover to reciprocate love." In meeting the world through love, we enter "a state of fellowship. . . . The sense of the ineffable does not stand between man and mystery; rather than shutting him out of it, it brings him together with it." *Man Is Not Alone*, 38.

60 Poet and critic James Longenbach suggests in religiously evocative terms that "Wonder is the reinvention of humility, the means by which we fall in love with the world." James Longenbach, *The Resistance to Poetry* (Chicago: University of Chicago Press, 2004), 95.

61 John Paul II, *Letter to Artists*, §10.

62 Critic Stephen Greenblatt confesses, "If I do not approach works of art in a spirit of veneration, I do approach them in a spirit that is best described as wonder." Stephen Greenblatt, "Resonance and Wonder," *Bulletin of the American Academy of Arts and Sciences* 43, no. 4 (1990): 19.

63 "In our day, it is not the evil that people make that needs to be explained. What needs to be explained is that, in spite of such evil, people are still capable of truth, goodness and, yes, beauty." Alejandro García-Rivera, *A Wounded Innocence: Sketches for a Theology of Art* (Collegeville, Minn.: Liturgical Press, 2003), 96.

64 As philosopher Josiah Royce concisely put it, "The massive sensation that all things are somehow well is not the highest good of an active being." *The Philosophy of Loyalty*, The Vanderbilt Library of American Philosophy (Nashville: Vanderbilt University Press, 1995), 46.

65 Thomas P. Rausch, *Who Is Jesus?* (Collegeville, Minn.: Liturgical Press, 2003), 67.

66 Emphasis added. See also Matt 11:4-6.

67 "As critical reflection on society and the church, theology is an understanding which both grows and, in a certain sense, changes." Gustavo Gutiérrez, *Gustavo Gutiérrez: Essential Writings* (Maryknoll, N.Y.: Orbis Books, 1996), 32.

68 Thornton Wilder, *Our Town: A Play in Three Acts* (New York: Perennial Classics, 2003).

69 The *Ode to Joy*, from Ludwig van Beethoven's 9th Symphony in D minor, Op. 125 (1823), was chosen by the European Ministers as the

Anthem for Europe in 1972. It is a setting for choir and orchestra of Schiller's 1785 poem An die Freude, which begins, "Oh friends, no more of these sad tones! Let us rather raise our voices together in more pleasant and joyful tones. Joy!"

70 Pablo Picasso (Spanish, 1881–1973), 1937.

71 "The alternative consciousness to be nurtured, on the one hand, serves to criticize in dismantling the dominant consciousness, to . . . engage in a rejection and delegitimatizing of the present ordering of things. On the other hand [it] serves to energize persons and communities by its promise of another time and situation toward which the community of faith may move. To that extent it attempts to . . . live in fervent anticipation of the newness that God has promised and will surely give." Brueggemann, *Prophetic Imagination*, 13.

72 Gutiérrez, *On Job*, xiii.

73 As he looks at prehistoric cave paintings, García-Rivera further complicates the fluidity of aesthetic works that are also religious in nature by intimating that they often also constitute "a call to the sacred to act upon the one seeking it." *Wounded Innocence*, 13.

74 "At the end of the day, the week, or the year, despite arduous labor, the Chávez family remained poor. In a perverse irony common to farm workers, they were too poor at times to afford to buy food." Dalton, *Moral Vision of César Chávez*, 7.

75 "I am interested in the imagination as a social force that allows for both critique and reinvention. This is something that happens not only in art (although it happens most powerfully in art), but in every area of the culture." Curtis White, *The Middle Mind: Why Americans Don't Think for Themselves* (New York: HarperSanFrancisco, 2003), 14; emphasis in original.

76 White asks, "Take our entertainment. . . . Does it help us to understand that the present world is not the only God-given, natural and inevitable world and that it could be different? Or does it stabilize the inevitability and naturalness of the present disposition of things?" *Middle Mind*, 5.

77 "Art that cannot see beauty in the midst of the evil that exists in the world is not worthy of its high calling. . . . The beautiful is not necessarily the 'pretty' or the 'pleasing' . . . the beautiful is not simply a quality that is self-evident or a judgment of taste but a reality, indeed, a community, being discovered and evolving." García-Rivera, *Wounded Innocence*, 11.

78 Gelpi, *Varieties of Transcendental Experience*, 297.

79 For me a great deal of the work by the famous photographer Diane Arbus (1923–1971) falls into this problematic category of glamorizing what most of humanity would consider ugly and thus of making evil

attractive, or, worse, of making the world appear particularly unattractive and ugly. I especially object to her voyeuristic representations of persons with deformities and/or psychiatric disabilities. Ratzinger underscores the danger of such works and argues that the reason they cause anguish is that they propose "that in the end it is not the arrow of the beautiful that leads us to the truth, but that falsehood, all that is ugly and vulgar, may constitute the true 'reality.'" Ratzinger, "The Feeling of Things, the Contemplation of Beauty," 51.

80 Austin, *In a New Light*, 10–14.
81 García-Rivera, *Wounded Innocence*, 4.
82 García-Rivera, *Wounded Innocence*, 4.
83 White, *Middle Mind*, 56.
84 García-Rivera, *Wounded Innocence*, 31.
85 García-Rivera, *Wounded Innocence*, 31; emphasis added.
86 Greenblatt calls this art's "resonance . . . the intimation of a larger community of voices." "Resonance and Wonder," 27.
87 García-Rivera, *Wounded Innocence*, 110.
88 Josiah Royce, *The Sources of Religious Insight* (New York: Scribner, 1963), 6.
89 Dewey defines what is felt as what is "immediately experienced," stressing that it cannot be described but only recognized as "present in [each person's] experience of a work of art." *Art as Experience*, 200.
90 In his famous phrasing of this radical transcendence and the importance for us of its discovery, Paul Tillich states, "The acceptance of the God above the God of theism makes us a part of that which is not also a part but is the ground of the whole." *The Courage to Be*, 2nd ed., Yale Nota Bene (New Haven: Yale University Press, 2000), 187.

Chapter 4

1 Neil MacGregor and Erika Langmuir, *Seeing Salvation* (London: BBC Active, 2000), DVD.
2 The addition of "as" came as a result of a conversation with Alex García-Rivera, for which I am most grateful.
3 The analogical imagination is a term explored in David Tracy's *The Analogical Imagination: Christian Theology and the Culture of Pluralism* (New York: Crossroad, 1981). The Catholic imagination is Andrew Greeley's term as he uses sociological research to see if Tracy's claim of a special kind of religious imagination as expressed in the Catholic tradition is indeed verifiable. Andrew M. Greeley, *The Catholic Imagination* (Berkeley: University of California Press, 2000).
4 García-Rivera, *Wounded Innocence*, 18.

5 Susan Horsburgh, "The Power and the Glory," *Time Europe*, March 20, 2000.

6 García-Rivera, *Wounded Innocence*, 121.

7 *Seeing Salvation: The Image of Christ*, February 26–May 7, 2000, Sainsbury Wing, National Gallery, London, England. Supported by The Jerusalem Trust and The Pilgrim Trust. Two books and a four-part BBC television series also resulted from the exhibition.

8 Gabriele Finaldi and Susanna Avery-Quash, *The Image of Christ: Catalogue of the Exhibition "Seeing Salvation"* (London: National Gallery; New Haven: Yale University Press, 2000).

9 Britain's National Gallery was founded in 1824.

10 Leo Steinberg, "The Seven Functions of the Hands of Christ: Aspects of Leonardo's Last Supper," in *Art, Creativity, and the Sacred: An Anthology in Religion and Art*, ed. Diane Apostolos-Cappadona (New York: Continuum, 2001).

11 Steinberg perceived the relationship between art and religion as suffering from the reductionist scientism of modernity that excluded the religious from the study of art (even explicitly religious art!), and removed art objects from their original settings by reproducing them or placing them in museums. "The Seven Functions of the Hands of Christ," 39–40.

12 Pope John Paul II, *Letter to Artists*, §10. I believe it important to note here that Karol Wojtyla (John Paul II) was himself an artist passionately involved in theater in his youth, and expressing himself as a poet his entire life.

13 *La Nona Ora*, Maurizio Cattelan, 1999. Life-sized installation. See Martin, 182.

14 News Teams BBC, "Religion, Not Sensation, Say Art Lovers," in *BBC News Online Edition* (London: BBC, 2001).

15 "Maurizio Cattelan," in *On The River* (Grand Rapids: Civicstudio.org, 2009).

16 BBC, "Religion, Not Sensation, Say Art Lovers."

17 A second version of the work sold for $886,000 the following year at Christie's, breaking Cattelan's previous record. Carter B. Horsley, "Art/Auctions: Contemporary Art Evening Auction at Christie's, May 17, 2001" (New York: The City Review Inc., 2001); online at http://www.thecityreview.com/s01ccon1.html.

18 "Only 1,647 visitors a day came to see [*Apocalypse*], compared with 5,002 to Seeing Salvation." BBC, "Religion, Not Sensation, Say Art Lovers."

19 This study is summarized by its author, sociologist of religion Graham Howes. It is unfortunate that no statistics or actual data is given or cited

in the text. Graham Howes, *The Art of the Sacred: An Introduction to the Aesthetics of Art and Belief* (New York: I.B. Tauris, 2007), 53–58.

20 Howes, *Art of the Sacred*, 53.

21 Howes, *Art of the Sacred*, 55.

22 "Maurizio Cattelan," in *On the River*.

23 See David Tracy, *Plurality and Ambiguity: Hermeneutics, Religion, Hope* (Chicago: University of Chicago Press, 1994).

24 "There's nothing like a little controversy to warm up the art market and the cover illustration of [Christie's] catalogue's auction shows a realistic image of Pope John Paul II felled by a large rock but still alert and clinging to his crozier. It is 'La Nona Ora (The Ninth Hour),' Lot 317, a work of art by Mauricio Cattelan (b. 1960)." Horsley, "Art/Auctions."

25 "The most visited show in the UK last year was *Seeing Salvation*, the National Gallery's millennium exhibition of images of Christ. . . . [T]he exhibition, which consisted of 70 portraits of Jesus, beat audience figures for contemporary shows like The Royal Academy's 'shocking' Apocalypse. . . . 'Exhibitions like Apocalypse get hyped up,' said Mr. Ward [editor of The Art Newspaper], 'but they just didn't live up to it.'" BBC, "Religion, Not Sensation, Say Art Lovers." It is difficult here to make a definite determination between what may have been most influential, the subject of the art in *Apocalypse*, or its quality. This highlights a distinction between art that is theologically powerful and art that is formally good. Clearly, we may have theological power in a work of "inferior" technical quality, and no religious resonance at all in work with great formal qualities. Thus, greatness in theological aesthetics works with very different measurements from conventional art criticism or art historical categories.

26 Howes, *Art of the Sacred*, 58.

27 Howes, *Art of the Sacred*, 48.

28 BBC, "Religion, Not Sensation, Say Art Lovers."

29 "In the American cultural realm The Art World is a comparatively small and elite entity. It takes itself very seriously as a harbinger of cultural progress; it is narrowly self-defined, self-referential, and self-important. This has made The Art World oblivious to artists and artistic currents beyond its confines. And because its ideology is also exclusive, it appears to function like a corporation seeking to protect and maximize its market share, erecting barriers against whatever it sees as interlopers." Gordon Fuglie, "Passion/Passover," in *Passion/Passover: Artists of Faith Interpret Their Holy Days* (Los Angeles: Cathedral of Our Lady of the Angels, 2005).

30 "Images of Christ and a Stroll in Highgate Cemetary [*sic*]," in Radio National's *The Religion Report* (Australia: Australian Broadcasting Corporation, 2000).

31 "With 79 works, mostly from British public collections but also bor-rowed from elsewhere, the exhibition argues that Christian imagery has formed the foundation of Western culture. Gallery director Neil MacGregor insists the show is not about organized religion, but rather Christianity as a cultural and historical force." Horsburgh, "Power and the Glory," 48.

32 Horsburgh, "Power and the Glory," 48.

33 Gabriele Finaldi, "Seeing Salvation: The Image of Christ," *Reformed* 3 (2000).

34 "The National Gallery was established for the benefit of all. With a com-mitment to free admission, a central and accessible site, and extended opening hours the Gallery has ensured that its collection can be enjoyed by the widest public possible, and not become the exclusive preserve of the privileged. The Gallery continues to pursue a vigorous and socially inclusive outreach programme, and caters to the needs of all groups in society." The National Gallery, Trafalgar Square, London. "About the Gallery: History of the Gallery," http://www.nationalgallery.org.uk/about/history/establish/gallery.htm.

35 Brown, *Good Taste, Bad Taste, and Christian Taste*, 15.

36 García-Rivera, *Wounded Innocence*, xi.

37 Mark Wallinger, British, b. 1959.

38 Finaldi and Avery-Quash, *Image of Christ*, 194–95.

39 "On the other plinths in the square stand General Napier, George IV on a horse and Major General Sir Henry Havelock, KCB. Gigantic in bronze, few notice who they are." Adrian Searle, "The Day I Met the Son of God," *The Guardian Unlimited*, July 22, 1999.

40 Searle, "The Day I Met the Son of God."

41 Searle may be referring to Piero della Francesca's *The Baptism of Christ* (1450s), also at the National Gallery, London. See Finaldi and Avery-Quash, *Image of Christ*, 6.

42 Searle, "The Day I Met the Son of God."

43 Longenbach, *Resistance to Poetry*, 96–97.

44 "One of Us," written by Eric Bazilian and performed by Joan Osborne, 1995.

45 Steinberg, "The Seven Functions of the Hands of Christ," 39. Another very helpful discussion of original placement is found in Greenblatt, "Resonance and Wonder," 23–27.

46 Horsburgh, "Power and the Glory."

47 This statement, while true for Europe, may not be nearly as indicative of attitudes in the United States, where 76 percent of the population identifies as Christian. I arrive at this figure by adding the particular Christian groups measured as a percentage of the population in the U.S.

Religious Landscape Survey, The Pew Forum on Religion and Public Life, 2008.

48 Neil MacGregor, *Seeing Salvation: Images of Christ in Art* (New Haven: Yale University Press, 2000), Introduction, 7.

49 *U.K. Census 1999.* Office for National Statistics, 1999. Online at http://www.statistics.gov.uk/downloads/theme_population/KPVS26_1999/KPVS26.pdf.

50 http://www.churchofengland.org/about-us/facts-stats.aspx.

51 Christopher C. Calderhead, "Seeing Salvation: The Image of Christ," *Anglican Theological Review* 82, no. 4 (2000): 795.

52 Another interesting example of the problems of religious/cultural illiteracy is apparent in Disney's animated film *The Hunchback of Notre Dame* (1996), which includes a moving rendition of a *Kyrie, Eleison* (Lord, have mercy) as the city of Paris burns that is most likely not grasped by most (if not all) of the film's viewers.

53 "The history of art . . . is not only a story of works produced but also a story of men and women. Works of art speak of their authors; they enable us to know their inner life, and they reveal the original contribution which artists offer to the history of culture." John Paul II, *Letter to Artists,* §2.

54 Greenblatt, "Resonance and Wonder," 25; emphasis added. What a theological understanding can bring to Greenblatt's insight is that the intimation of eternal life is indeed mysteriously present in the resonance of the beautiful objects, and that the presence of these "voices" (perceived through a sense that is not the auditory) suggests that there is *pace* his statement, an awareness that the voices were *not* forever silenced, but rather that they continue to speak.

55 Finaldi and Avery-Quash, *Image of Christ,* 6.

56 Alejandro García-Rivera, *The Community of the Beautiful: A Theological Aesthetics* (Collegeville, Minn.: Liturgical Press, 1999), 9.

57 García-Rivera, *Wounded Innocence,* 18.

58 Walter Kasper, *Jesus the Christ* (New York: Paulist Press, 1976), 81–82.

59 El Greco's workshop produced a number of different versions of the *Agony in the Garden;* MacGregor is not clear about which one he is referencing. For more on *Noli me tangere* by Titian (c. 1515), see Finaldi and Avery-Quash, *Image of Christ,* 172–73.

60 MacGregor, *Seeing Salvation,* 191.

61 MacGregor, *Seeing Salvation,* 191.

62 Ronald Jones, "Regarding Beauty," in *Artforum International Magazine* 38, no. 5 (2000). Online.

63 John Paul II, *Letter to Artists,* §19.

64 Longenbach, *Resistance to Poetry,* 99.

65 Thomas M. Alexander, "John Dewey's Theory of Art, Experience, and Nature the Horizons of Feeling," in *Classical American Pragmatism: Its Contemporary Validity*, SUNY Series in Philosophy (Albany: State University of New York Press, 1978), 165. Quoted in García-Rivera, *Wounded Innocence*, 32.

66 St. Bonaventure, *Legenda Maior*, IX, I: *Fonti Francescane*, no. 1162, 911. As quoted in John Paul II, *Letter to Artists*, §19.

67 "An anomaly . . . may be instructive and indeed, of considerable significance, when times and history change. One could make the point that anomalies of the past are instructive of the future, and occasionally much more so, than the continuities of history." John Dillenberger, "Artists and Church Commissions: Rubin's *The Church at Assy* Revisited," in *Art, Creativity, and the Sacred*, 199.

68 Finaldi and Avery-Quash, *Image of Christ*, 6.

69 "We have put some of the gallery's religious pictures in a new context, not—as in other exhibitions—beside works by the same artist or from the same period, but in the company of other works of art which have explored the same kinds of questions across the centuries." Finaldi and Avery-Quash, *Image of Christ*, 6. To piece together the sequence of the galleries, I relied on the two exhibition volumes *Seeing Salvation: Images of Christ in Art* (2000) and *The Image of Christ: Catalogue of the Exhibition "Seeing Salvation"* (2000), along with Christopher Calderhead's helpful article describing his visit to the exhibition in the *Anglican Theological Review*. Some examples of Christological categories would be: the earthly Jesus; Christ, risen and transcendent; and the mystery of Jesus Christ (Son of God and Son of Man), developed by Walter Kasper in *Jesus the Christ*. Or Jon Sobrino's grouping of questions for Christology, arising out of Liberation Theology, under the areas of "the method and faith of Jesus" and "the Cross of Jesus." Jon Sobrino, *Jesus the Liberator: A Historical-Theological Reading of Jesus of Nazareth* (Maryknoll, N.Y.: Orbis Books, 1993).

70 *The Madonna of the Meadow* by Giovanni Bellini (c. 1500); see Finaldi and Avery-Quash, *Image of Christ*, 63.

71 Finaldi and Avery-Quash, *Image of Christ*, 172–73.

72 *The Incredulity of Saint Thomas* by Bernardo Strozzi (c. 1620); see Finaldi and Avery-Quash, *Image of Christ*, 174–75.

73 *The Institution of the Eucharist* by Ercole de'Roberti (c. 1490s). *Christ in a Chalice Sustained by Angels* by Jacopo Negretti (Palma Giovane, c. 1620). See Finaldi and Avery-Quash, *Image of Christ*, 170, 180–81.

74 Calderhead, "Seeing Salvation: The Image of Christ," 800.

75 *The Art Newspaper: World-Wide Exhibition Figures in 2000* (Ministerio per i Beni e le Attivitá Culturali, 2000, accessed February 1, 2011);

available from http://www.colosseumweb.org/docs/Visitatori%20
mostre%20nel%20mondo/visitatori_mostre_2000.pdf.

76 A search of electronic catalogs confirms that both books are well repre-
sented in the library collections of many universities and colleges.

77 Howes, *Art of the Sacred*, 51. García-Rivera might call this "a marvelous
innocence, an openness to a larger world than our own that emerges not
in spite of our wounds but because of them." García-Rivera, *Wounded
Innocence*, 38.

78 "Museums function . . . as monuments to the fragility of cultures, the
fall of sustaining institutions and noble houses, the collapse of rituals,
the evacuation of myths, the destructive effects of warfare and neglect
and corrosive doubt." Greenblatt, "Resonance and Wonder," 21.

79 García-Rivera, *Wounded Innocence*, 121.

Chapter 5

1 "Aggressive secularism" is a term used in Europe to differentiate
between secular societies that are "peaceful and respectful of religions"
and those that "foster a more generalized alienation from religion, often
generated by false dichotomies." Adolfo Nicolás, "Depth, Universal-
ity, and Learned Ministry: Challenges to Higher Education Today,"
*Networking Jesuit Higher Education: Shaping the Future for a Humane, Just,
Sustainable Globe* (Mexico City: 2010), 8.

2 An example of what I would deem an unproductive approach is com-
mentary about Marc Chagall's *Calvary* (1912) and *White Crucifixion*
(1938) in the substantial exhibition catalog from the San Francisco
Museum of Modern Art. Trying to "explain" Chagall's stunning treat-
ment of the most central icon of Christianity, the catalogue tells us that
"*Calvary*'s title and its relationship to canonical painting would suggest
that the work's true subject is the Crucifixion . . . it is equally possible
that the painting's theme is the hybridization of disparate artistic con-
cerns and practices" (66). The two possibilities—that art's techniques
are a way of expressing, or that expressing in art is self-referentially only
about technique—are here given equal credence, in contradiction to
most of Chagall's work and writings. Likewise, the *White Crucifixion* is
treated in such a way that, lacking any understanding of the theological
complexity of redemption in the continuum of Judaism and Christian-
ity, the work is judged to lack "any suggestion of redemption" (178).
This assessment is the diametrical opposite of the interpretation that
my students, using theology in tandem with the arts, put forward when
viewing this work. One of the great works of art that can shed the
most light on Christ's salvific role in human history is thus tragically

impoverished. Jean-Michael Foray and Jakov Burk, *Marc Chagall* (San Francisco: San Francisco Museum of Modern Art, 2003).

3 For a thoughtful exploration of the question of alterity from a theological standpoint, see Carmen Nanko-Fernandez, *Theologizing En Espanglish* (Maryknoll, N.Y.: Orbis Books, 2010), 12–20. For the role of "the other" through an aesthetic lens, see Austin, *In a New Light*, 7–9.

4 Examples of this are too numerous to mention, but research of recent usage shows the term "intersection of art and religion" in use at Duke, Baylor, St. Andrews, and Macalester universities, and at my alma mater, the Graduate Theological Union's Center for Arts, Religion and Education (CARE). It is also the favored metaphor for museums such as the Getty and the Museum of Biblical Art.

5 H. Harvard Arnason and Elizabeth Mansfield, *History of Modern Art: Painting, Sculpture, Architecture, Photography*, 6th ed. (Upper Saddle River, N.J.: Pearson Prentice Hall, 2009), 423.

6 Art and religion scholar John W. Dixon Jr. describes it this way: "Nearly every attempt that has been made to incorporate art into the study of religion or to account for art theologically has to some degree done violence to one or the other, either by distortion or impoverishment." "Art as the Making of the World: Outline of Method in the Criticism of Religion and Art," *Journal of the American Academy of Religion* 51, no. 1 (1983): 15. Dixon is part of a generation of pioneers in the field of art and religion. Born in 1919, he was part of the Committee on Social Thought at the University of Chicago.

7 García-Rivera, *Wounded Innocence*, 40.

8 Gutiérrez, *On Job*, xiii.

9 "Art celebrates with peculiar intensity the moments in which the past reinforces the present and in which the future is a quickening of what now is." Dewey, *Art as Experience*, 17. As evidence of the coherence of the functions of the artistic and the religious, replacing the word "art" with the word "religion" yields a very good definition.

10 Dewey, *Art as Experience*, 43.

11 "The Church . . . absorbs into its transforming sacramental life all the deeper consciousness that [the human person] has gained, and . . . the Church then goes out again to men [*sic*] with this transformed understanding so that it can be the root of still further advance." Bernard Cooke, "The Sacraments as the Continuing Acts of Christ," in *Readings in Sacramental Theology*, ed. Stephen Sullivan (Englewood Cliffs, N.J.: Prentice Hall, 1964), 47.

12 Dewey, *Art as Experience*, 41.

13 MacGregor, *Seeing Salvation*, Introduction, 7.

14 Elizabeth A. Johnson, *Consider Jesus: Waves of Renewal in Christology* (New York: Crossroad, 1990), 1–15.

15 BBC News, "Martyrs of the Modern Era," in *BBC News* (UK: 1998).

16 Notion, from Middle English *nocioum*, or concept. Generally defined as "a vague idea in which some confidence is placed."

17 "Notional" is the word used by Adrian Searle in his report. Searle, "The Day I Met the Son of God."

18 Bonhoeffer said, "'Telling the truth' . . . is not solely a matter of moral character; it is also a matter of correct appreciation of real situations and of serious reflection upon them." Quoted in Wayne Whitson Floyd, "The Search for an Ethical Sacrament: From Bonhoeffer to Critical Social Theology," *Modern Theology* 7, no. 2 (1991): 187.

19 Quoted in Brown, *Good Taste, Bad Taste, and Christian Taste,* 33. Pope Gregory would not have made a distinction between being taught the articles of the faith by the arts and the strengthening of the faith that would result in both thanksgiving and imitation. This was further articulated by the Council of Trent in 1563 as the decree on sacred images added the hope that through the artistic portrayals the faithful "may be excited to adore and love God, and to cultivate piety." Alfonso Rodriguez G. de Ceballos, "Image and Counter-reformation in Spain and Spanish America," in *Sacred Spain: Art and Belief in the Spanish World*, ed. Ronda Kasl (New Haven: Yale University Press/Indianapolis Museum of Art, 2009), 20.

20 "Images of Christ and a Stroll in Highgate Cemetary [*sic*]."

21 The text is from the Council of Chalcedon, quoted in the *Catechism of the Catholic Church* (New York: Catholic Book Publishing, 1992), 118. The Catechism is a very complex and self-consciously didactic text that is normative for Roman Catholics. The complexity of navigating it might be illustrated by noting the actual location of this fragment from the Council of Chalcedon in the text: part 1: The Profession of Faith; §2: The Profession of the Christian Faith; chap. 2: I believe in Jesus Christ, the Only Son of God; art. 3: "He was conceived by the power of the Holy Spirit, and was born of the Virgin Mary"; "True God and True Man" (part 1, §2, chap. 2, article 3, ¶ III).

22 This is invariably the report I receive from my students upon their first encounter with Swanson's *Last Supper.*

23 Gelpi, *Varieties of Transcendental Experience,* 245.

24 "Self-awareness engages more than personal subjectivity. Initial self-awareness enables one to distinguish between one's own body and environmental stimuli." Gelpi, *Varieties of Transcendental Experience,* 234.

25 I realize that my example of a painting is fairly static, since as an object it indeed exists separately from me. There are works of creativity that

require our actual participation in them, for instance, a procession. Yet I think we can preserve the idea of "firstness." Even as a procession depends on time, space, and participation for its enactment, it is something in itself apart from all its moving parts, or better yet *because* of the way the moving parts interact at one particular moment in one particular place. If we cannot say a procession is a creative "object," we can certainly apply a negative definition and say it is not a piece of bread, or an apple either. Thus there is a suchness to a procession that is irreducible. See also Dewey, *Art as Experience*, 200.

26 Austin, *In a New Light*, 7–9.

27 Austin, *In a New Light*, 4.

28 The logician Charles Sanders Peirce developed this category of firstness in his pragmatist philosophy, which he sometimes also called a "quality." He understood this quality of firstness as "possibility. For as long as things do not act upon one another there is no sense or meaning in saying that they have any being, unless it be that they are such in themselves that they may perhaps come into relation with others." Quoted in Gelpi, *Varieties of Transcendental Experience*, 245.

29 Gelpi, *Varieties of Transcendental Experience*, 245.

30 Ron Austin contends that for us to be able to create or experience art, we must first practice a radical "emptying of ourselves of our desires and preconceptions." He sees this as essentially a moment of coming awake spiritually and he points out that "all traditional religions have spiritual practices designed simply to awaken us to reality, to the goodness of life and, on the other hand, to the illusions of desire." *In a New Light*, 3, 4.

31 Gelpi, *Varieties of Transcendental Experience*, 245.

32 Gelpi, *Varieties of Transcendental Experience*, 246.

33 Austin, *In a New Light*, 3–6.

34 For the idea of dispositions I am basing myself on the category of *habitus* present in Aquinas, which he derives from Aristotelian thought: "a man [*sic*] cannot know what a whole is or what a part is except through the possession of concepts derived through the senses. The understanding of self-evident principles is thus in one sense innate and in another sense acquired by experience." *Summa Theologiae*, xxvi.

35 Dewey, *Art as Experience*, 9.

36 As I will explore in more depth later, I use the qualifier "truthful" for works of art to differentiate an honestly expressive creative work (regardless of technical virtuosity) from manipulative, propagandist, or purely commercial works made for reasons alien to the process of creativity (also regardless of their technical virtuosity). Clearly, this idea of honesty or truthfulness in art can be challenged by positing that my judgment is my subjective opinion of a work, but this is why in

attempting to develop this method I contend that an entire universe of influences, reactions, and outcomes must be taken into account when judging a work. If we posit mere subjective opinion as the only way to judge a work's truthfulness, then we cannot denounce "art" works, such as Nazi propaganda films, which, despite their technical virtuosity, were directed toward sinful ends. In this as a community and through an understanding of their context, we can claim they are objectively lies.

37 Dewey, *Art as Experience*, 10.

38 From Charles S. Peirce, *Collected Papers of Charles Sanders Peirce* (Cambridge, Mass.: Harvard University Press, 1931), 536–37. Quoted in Gelpi, *Varieties of Transcendental Experience*, 246.

39 Gelpi, *Varieties of Transcendental Experience*, 246.

40 Gelpi, *Varieties of Transcendental Experience*, 234.

41 In my Roman Catholic tradition, the celebration of Holy Thursday during Holy Week is a complex, long, and exceedingly beautiful ritual. With some variations, it includes the celebration of the Mass with a reenactment of Jesus' actions of washing his disciples' feet, and often a procession whereby the Blessed Sacrament (the consecrated Eucharist) is taken, accompanied by song, and sometimes candles and incense, to a nearby chapel or altar to "rest" there until Good Friday.

42 This is just a sampling of the many questions my students ask when viewing Swanson's *Last Supper.*

43 Jacques Maritain, *Creative Intuition in Art and Poetry* (New York: Meridian Books, 1961), 8.

44 Peirce "believed devoutly in the fallibility of all human minds, including his own." It is possible to read Peirce's positive valuing of erroneous judgment as a way to speak of the disclosive power of ambiguity and equivocation in art. Peirce believed that "the discovery that what one assumed would happen differs from the actual event dramatizes the difference between the self viewed as a complex of personal expectations and the world which defeats those expectations." Gelpi, *Varieties of Transcendental Experience*, 232, 234.

45 John Paul II, *Letter to Artists*, §5.

46 Finaldi and Avery-Quash, *Image of Christ*, 9.

47 "A work of art does not stand simply as a unique expression of an individual artist but also expresses the deepest concerns of the artist's community." García-Rivera, *Wounded Innocence*, 35.

48 Bemoaning the consequences of art as commodity, Dewey writes, "Objects that were in the past valid and significant because of their place in the life of a community now function in isolation from the conditions of their origin." *Art as Experience*, 8.

49 Finaldi and Avery-Quash, *Image of Christ*, 6.

50 "Without wonder, men and women would lapse into deadening routine and little by little would become incapable of a life which is genuinely personal." John Paul II, *Fides et Ratio*, sec. 4.

51 García-Rivera, *Wounded Innocence*, viii.

52 See Dixon, "Art as the Making of the World," 15; and also White: "Art and the imagination lead us away from communication as domination, away from mere communication's impoverishing of the imagination, away from 'information,' and toward an intuition about our activities as the feeling of being alive." *Middle Mind*, 193.

53 Horsburgh, "Power and Glory."

54 García-Rivera, *Wounded Innocence*, ix.

55 García Lorca, "Imaginación, inspiración, evasión," in *Obras Completas*, 85–91.

56 García Lorca, "Imaginación, inspiración, evasión," in *Obras Completas*, 88.

57 García-Rivera, *Wounded Innocence*, 30.

58 MacGregor, *Seeing Salvation*, 7.

59 MacGregor, *Seeing Salvation*, 7.

60 The tiny Dolores Mission Church is located at 171 S. Gless Street in Los Angeles, California.

61 For more on the complexity of the Guadalupe event and its aesthetics, see Virgilio P. Elizondo, Allan Figueroa Deck, and Timothy M. Matovina, *The Treasure of Guadalupe, Celebrating Faith* (Lanham, Md.: Rowman & Littlefield, 2006).

62 José Ortega y Gasset, *La deshumanización del arte y otros ensayos de estética*, 14th ed. (Madrid: Revista de Occidente en Alianza Editorial, 2002), 92.

63 See the story of Job, which in its complexity repeatedly stresses that "God is great beyond our knowledge" and "does great things beyond our knowing; wonders past our searching out" (Job 36:26; 37:5). It is out of the whirlwind and storm that God addresses Job in chapters 38–41.

64 Ortega y Gasset, *La deshumanización del arte*, 92.

65 Hillel A. Fine, "The Tradition of a Patient Job," *The Society of Biblical Literature* 74, no. 1 (1955): 32.

66 "It might be said that all this 'stuff' that used to litter our churches is not essential to Catholicism . . . [but] added to the heritage over the centuries . . . God, Trinity, incarnation, church, pope—these are the essentials of our faith. However, such an argument confuses the way we first encounter our religious heritage and its stories with the way doctrines are systematically arranged by theologians and catechism writers. Stories come first, then theological and catechetical systematization, which

in turn enable us to critique the stories. But then in what Paul Ricoeur calls the second naiveté, we return to the stories. Religion begins and ends with them." Andrew Greeley, "A Cloak of Many Colors: The End of Beige Catholicism," *Commonweal* 128 (November 9, 2001): 10.

67 "The work of art develops and accentuates what is characteristically valuable in things of everyday enjoyment." Dewey, *Art as Experience*, 9–10.

68 Francis Schüssler Fiorenza and John P. Galvin, *Systematic Theology: Roman Catholic Perspectives*, 2 vols. (Minneapolis: Fortress, 1991), 2:185.

69 Cooke, "Sacraments as the Continuing Acts of Christ," 47.

70 García-Rivera, *Wounded Innocence*, 38.

71 Leonardo da Vinci. *The Last Supper*, c. 1495–1497. Refectory, S. Maria delle Grazie, Milan.

72 One of the best tools for research into Leonardo's *Il Cenacolo* is provided by haltadefinizione.com. The site, which uses extremely detailed high definition photographs that the viewer can manipulate (zoom, pan, etc.), is certified by Italy's *Istituto Superiore per la Conservazione ed il Restauro*. "The images of Haltadefinizione effectively support scientific surveys of restoration, and find application in areas of study dedicated to the enhancement and promotion of the art historical heritage."

73 It is possible to claim a "ritual" characteristic for religious creative works if we understand them in their role of "preservation and transmission of the historical recollection," which Cooke contends was the primary role of the religious cult in the Jewish tradition. This then sets the context for understanding one of the roles of the Christian liturgy, namely, the preservation and transmission of salvation history. Cooke, "Sacraments as the Continuing Acts of Christ," 35.

74 William James explains, "Faith, says Tolstoy, is that by which men live. And faith-state and mystic state are practically convertible terms." My reading of James suggests that what he terms the "mystic state" is also practically synonymous with aesthetic experience, so we can extend his analogy to say that the response of faith can be activated by aesthetic experiences that disclose theological truths to the believer. "Mysticism," 500.

75 "'Taking in' in any vital experience is something more than placing something on top of consciousness over what was previously known . . . esthetic experiences . . . are certainly not to be characterized as amusing and as they bear down upon us they involve a suffering that is none the less consistent with, indeed a part of, the complete perception that is enjoyed." Dewey, *Art as Experience*, 42–43.

76 Cooke, "Sacraments as the Continuing Acts of Christ," 41.

77 Cooke, "Sacraments as the Continuing Acts of Christ," 32.

78 The fullness of the importance of *The Last Supper*'s location was extraordinarily explored in Peter Greneaway's installation for the Fifth Avenue Armory in New York City (December 3, 2010–January 6, 2011). Although sadly I was not able to see it in person, it recreates the mural and refectory to scale, adding the play of light through the windows and the table of the friars laid before it. An excellent summary and short video is available at http://www.armoryonpark.org/index.php/programs_events/detail/last_supper_peter_greenaway.

79 Among the copies are Raphael Morghen's engraving (1800), and Giacomo Raffaelli's large mosaic set above the main altar at Minoritenkirche in Vienna from 1819. Steinberg, "The Seven Functions of the Hands of Christ," 45–57. Contemporary reinterpretations of the *Last Supper* are many, but most intriguing is Andy Warhol's almost obsessive exploration of Leonardo's iconic image in what is perhaps his largest body of work. For a fascinating account and well-executed reproductions, see Jane Daggett Dillenberger, *The Religious Art of Andy Warhol* (New York: Continuum, 1998), 79–121.

80 As theologian and pastor Fr. Richard Sparks explained to his gathered congregation on the Feast of Corpus Christi, "Like the Jews at Passover, we Catholics believe that whenever we do this memorial of Jesus, time stands still, *or* we are beyond time—everyone who has ever celebrated the Eucharist is together in the one and only, the eternal heavenly banquet." Richard Sparks, "Feast of Corpus Christi in Berkeley, 2006," Homily, Berkeley, Calif.

81 Steinberg, "Seven Functions of the Hands of Christ," 51.

82 Suger, *Abbot Suger on the Abbey Church of St.-Denis*, 14.

83 James, "Mysticism," 479.

84 Suger, *Abbot Suger on the Abbey Church of St.-Denis*, 16.

85 "But we profess that we must do homage also through the outward ornaments of sacred vessels. . . . For it behooves us most becomingly to serve our Saviour in all things in a universal way—Him Who has not refused to provide for us in all things in a universal way and without any exception." Suger, *Abbot Suger on the Abbey Church of St.-Denis*, 16.

86 Through his careful analysis of architectural plans, Steinberg posits that Christ's gestures in the mural affect the entire complex of S. Maria della Grazie. Steinberg, "Seven Functions of the Hands of Christ," 51–55.

87 "Grant them eternal rest, O Lord, and may perpetual light shine on them."

88 Janine Marchessault, *Marshall McLuhan: Cosmic Media* (London: Sage Publications, 2005), 69.

89 "Art's true beauty is not simply the pleasure it gives but, insofar as it gives witness to the spiritual struggle to truly see, it also affirms the

goodness of our humanity nourishing the hope that someday human evil shall transcend and 'all tears will be wiped away.'" García-Rivera, *Wounded Innocence*, 53.

90 García-Rivera, *Wounded Innocence*, 17.

91 Other scholars mounting similar arguments begin in modernity with Von Ogden Vogt in *Art and Religion* (1948). In recent years, the restoration and preservation of religious art, along with the support of the arts in general and the commissioning of new religious works has been argued for by Frank Burch Brown in *Religious Aesthetics* (1989) and *Good Taste, Bad Taste, and Christian Taste* (2000); William Dyrness in *Senses of the Soul* (2008); Robert Wuthnow in *All in Sync: How Music and Art Are Revitalizing American Religion* (2003); Doug Adams and the Center for Arts, Religion and Education (CARE); and Alex García-Rivera in the majority of his writings as well as the conferences he organized. This call is also supported by the research of the community of scholars and artists writing in *ARTS: The Journal of the Society for the Arts in Religious and Theological Studies* and the work of the Society, as well as the fine work of ECVA (Episcopal Church Visual Arts). Several institutes and centers are now also devoted to reuniting the church with art and artists, among them the Brehm Center at Fuller Theological Seminary, Pasadena.

92 MacGregor, *Seeing Salvation*, Introduction, 7.

Chapter 6

1 For references to "intersection" as a metaphor for the engagement between religion and the arts, see David Morgan and Sally M. Promey, *The Visual Culture of American Religions* (Berkeley: University of California Press, 2001), xiii, 130.

2 Illustrative of the popularity of "intersection" for interdisciplinary studies are Julie A. Hogan, *Substance Abuse Prevention: The Intersection of Science and Practice* (Boston: Allyn and Bacon, 2003); and Harry Lee Poe, *Christianity in the Academy: Teaching at the Intersection of Faith and Learning* (Grand Rapids: Baker Academic, 2004).

3 Ena Giurescu Heller, ed., *Reluctant Partners: Art and Religion in Dialogue* (New York: The Gallery at the American Bible Society, 2004), 8.

4 David Morgan, "Toward a Modern Historiography of Art and Religion," in *Reluctant Partners: Art and Religion in Dialogue*, 17–18.

5 Brown, *Good Taste, Bad Taste, and Christian Taste*, 14.

6 bell hooks without capitalization is the pen name for Gloria Jean Watkins (b. 1952). The name bell hooks is a combination of her mother's and grandmother's names and is meant to minimize the importance of

her individual authorship and refocus attention on the subject matter instead. hooks, who is African American, identifies as one of her major influences the Brazilian philosopher Paulo Freire. bell hooks, *Teaching to Transgress: Education as the Practice of Freedom* (New York: Routledge, 1994).

7 hooks, *Teaching to Transgress*, 30.

8 hooks, *Teaching to Transgress*, 30.

9 hooks, *Teaching to Transgress*, 30.

10 I use Andy Warhol as a frame of reference since his art is so recognizable in the United States that even schoolchildren can readily identify it. The inverse is true of García Lorca's work, which, outside certain circles, is surprisingly little known in this country.

11 "None of us hears a Bach cantata in just the way the people in Bach's day did; performance practices have changed, sometimes in ways we cannot know; and so have listening practices. . . . It is also entirely possible that some who study Bach's church music today, and who work out of a long tradition related to that music, actually hear the music more rewardingly—and in ways Bach would have approved—than many people in his own congregations did. We should not assume that Bach's historical context establishes all the norms." Brown, *Good Taste, Bad Taste, and Christian Taste*, 14.

12 Doug Adams, "Changing Perceptions of Jesus' Parables through Art History: Polyvalency in Paint," in *Reluctant Partners*, 69.

13 Adams recounts, "In the 1970s, I took one Rembrandt course taught by a leading art history scholar at a major secular university. We went through the course without ever seeing an image that had biblical subject matter. I thought that omission of works with religious subject matter might have stemmed from the professor's personal disinterest or even antagonism toward religion (an antagonism which we sadly often find in art history departments or even in religious studies departments of secular universities). However, when I inquired about the avoidance of works with religious iconography, the professor responded simply that such works would spark controversy which was better avoided." "Changing Perceptions of Jesus' Parables through Art History," 85.

14 A well-known example is Martin Scorcese's *The Last Temptation of Christ* (USA: Universal Pictures, 1988). When I attended a screening in Los Angeles in 1988, I was met by protestors outside the theater who wanted the film banned from exhibition.

15 "A major Rembrandt painting dating from circa 1635–36 is entitled, by a number of Rembrandt scholars, *The Prodigal Son Squanders His Inheritance*; but the museum in Dresden where the work hangs calls it *Self Portrait with the Artist's Wife*. Both are true; but the biblical allusions

are lost if one sees only the latter title." Adams, "Changing Perceptions of Jesus' Parables through Art History," 69.

16 "In monolithic institutional environments, whether the media or the academy, where distinctions make no difference, it is very difficult for the imagination to do what it must do: create an outside, create distance, create possibility/ . . . We become mere participants in or, worse yet, mere functions of the entertainment or educational systems in which we try to live." White, *Middle Mind*, 14.

17 Steinberg, "The Seven Functions of the Hands of Christ," 39.

18 The tragedy *Mariana Pineda* opened on stage on June 24, 1927. at the Goya Theater, Barcelona. The company was Margarita Xirgu's and the sets were by Salvador Dalí.

19 Elda Munch Comini, "Mariana Pineda, Nuevas claves onterpretativas desde la teoría de género," *Mujeres andaluzas. Biografía. Mujer historia feminismo Andalucía*, no. 2 (2000).

20 Ian Gibson, *Federico García Lorca: A Life* (New York: Pantheon Books, 1989), 142.

21 In a speech in 1838, Ralph Waldo Emerson attacked the long history of distorting Jesus' words and failing to see their poetry, with the result that "the tropes in which he spoke were taken literally, and 'the figures of his rhetoric have usurped the place of his truth.'" Jaroslav Pelikan, *Jesus through the Centuries: His Place in the History of Culture* (New Haven: Yale University Press, 1985), 203.

22 Gibson, *Federico García Lorca*, 142.

23 Leslie Stainton, *Lorca: A Dream of Life* (New York: Farrar, Straus & Giroux, 1999), 133–34.

24 Stainton, *Lorca: A Dream of Life*, 133.

25 "'Mariana Pineda' en Granada," in García Lorca, *Obras Completas*, 129; emphasis added.

26 Stainton, *Lorca: A Dream of Life*, 116.

27 Speaking of her work on Andy Warhol, art and religion scholar Jane Dillenberger explains, "Again and again colleagues have challenged me: How could such a dissolute and superficial artist produce genuinely religious art? But there is another Andy, a private Andy, who is stunningly opposite to his public persona . . . with some knowledge of the spiritual side of the artist, our viewing of his art is given another dimension. Ultimately, however, it is the paintings that, when studied searchingly, yield up their burden of meaning and disclose their religious content." Dillenberger, *Religious Art of Andy Warhol*, 11.

28 Dillenberger, *Religious Art of Andy Warhol*, 58.

29 Dillenberger, *Religious Art of Andy Warhol*, 63.

30 Searle, "The Day I Met the Son of God."

31 Jim McLean, *Seeing Salvation in the National Gallery* [online magazine] (Nottingham: St. Peter's Church, June 4, 2000).

32 *Christ of Saint John of the Cross*, 1951, by Salvador Dalí, Kelvingrove Art Gallery and Museum, Glasgow. Finaldi and Avery-Quash, *Image of Christ*, 198–201.

33 *The Bound Lamb (Agnus Dei)*, 1635–1640, by Francisco de Zurbarán, Museo Nacional del Prado, Madrid. Finaldi and Avery-Quash, *Image of Christ*, 36–37.

34 *The Resurrection, Cookham*, 1924–1926, by Stanley Spencer, Tate Gallery, London. Finaldi and Avery-Quash, *Image of Christ*, 204–7.

35 Kevin Burns, *Look, Up in the Sky!: The Amazing Story of Superman* (USA: Warner Brothers Pictures, 2006).

36 Richard Donner, *Superman* (USA: Warner Brothers Pictures, 1978), scene 91. Story and screenplay by Mario Puzo (1920–1999).

37 García-Rivera, *Wounded Innocence*, 18.

38 According to the Second Vatican Council's "Pastoral Constitution on the Church in the Modern World," the work of "pastors and theologians, [is] to listen to the various voices of our day, discerning them and interpreting them, and to evaluate them in the light of the divine word, so that the revealed truth can be increasingly appropriated, better understood and more suitably expressed." *Gaudium et Spes*, §44.

39 Writing about García Lorca, the poet Jorge Guillén illustrates this tension between freedom and faithfulness that results in the prophetic. "Brought up Catholic, though not practicing as many others, yet the roots of his beliefs were alive—'Ode to the Blessed Sacrament on the Altar'—he would have never made his the pronouncement made by Antonio Machado in one of his autobiographical moments: 'Catholicism must be defeated.'" García Lorca, *Obras Completas*, LXVIII–LXIX.

40 Martin Buber, *I and Thou*, trans. Walter Kaufman (New York: Touchstone, 1970), 127.

41 Brueggemann, *Prophetic Imagination*, 13.

42 "He said to me: O mortal, stand up on your feet, and I will speak with you. And when he spoke to me, a spirit entered into me and set me on my feet; and I heard him speaking to me. He said to me, Mortal, I am sending you to the people of Israel, to a nation of rebels who have rebelled against me; they and their ancestors have transgressed against me to this very day. The descendants are impudent and stubborn. I am sending you to them, and you shall say to them, 'Thus says the Lord God.' Whether they hear or refuse to hear (for they are a rebellious house), they shall know that there has been a prophet among them" (Ezek 2:1-5). The prophet Ezekiel, often called "the father of Judaism," is believed to have been a young priest (his writings show a singular

attention to liturgical practices) who was forcibly deported to Babylon with his fellow Israelites in 597 B.C.

43 Thiessen, *Theological Aesthetics: A Reader*, 204.
44 Paul Tillich, "Art and Ultimate Reality," in *Theological Aesthetics: A Reader*, 210. Major figures arguing for the legitimacy of art as a source of theology include Tillich, Karl Rahner, Hans Urs von Balthasar, and John Paul II.
45 Tillich, "Art and Ultimate Reality," 210.
46 Tillich, "Art and Ultimate Reality," 210–11.
47 Karl Rahner, "Theology and the Arts," in *Theological Aesthetics: A Reader*, 218.
48 Rahner, "Theology and the Arts," 219.
49 John Paul II, *Letter to Artists*, §12.
50 García-Rivera, *Wounded Innocence*, 34.
51 Alex García-Rivera and I began the development of this method at his insistence. He felt that although we knew the work of bringing together the arts and theology needed to be done, we did not know how to do it. I decided to call the method interlacing, and we have both written briefly about it, in Cecilia González-Andrieu, "Theological Aesthetics and the Recovery of Silenced Voices," in *The Journal of Hispanic/Latino Theology* [online] (New York: The Academy of Catholic Hispanic Theologians of the United States, 2008); and García-Rivera, *Garden of God*, x–xi; idem, "The Color of Truth," *ARTS: The Journal of the Society for the Arts in Religious and Theological Studies* 21, no. 2 (2010): 19.

Chapter 7

1 For a book length discussion of this, see Cynthia A. Freeland, *But Is It Art?: An Introduction to Art Theory* (Oxford: Oxford University Press, 2001).
2 Freeland, *But Is It Art?*, xviii.
3 Alex Kiefer, "The Intentional Model of Interpretation," *The Journal of Aesthetics and Art Criticism* 63, no. 3 (2005): 271.
4 White, *Middle Mind*, 2.
5 Viktor Borisovich Shklovsky and Benjamin Sher, *Theory of Prose*, 1st American ed. (Elmwood Park, Ill.: Dalkey Archive Press, 1990), 6.
6 Shklovsky and Sher, *Theory of Prose*, 5–6.
7 Marc Chagall, *My Life* (New York: Da Capo Press, 1994), 3.
8 Aristotle, *Aristotle's Poetics*, ed. Francis Fergusson and trans. S. H. Butcher (New York: Hill & Wang, 1961), 68.
9 Aristotle, *Poetics*, 69.

10 Lewis Hyde, *The Gift: Imagination and the Erotic Life of Property* (New York: Vintage Books, 1983), 198.

11 García Lorca, *Obras Completas*, 111.

12 García Lorca, *Obras Completas*, 110.

13 Tracy, *Plurality and Ambiguity: Hermeneutics, Religion, Hope*, 20.

14 Umberto Eco, ed., *History of Beauty* (New York: Rizzoli International Publications, 2004), 42.

15 Eco, *History of Beauty*, 45.

16 For good or ill, "There is a well-known saying that the whole of Western philosophy is footnotes to Plato." Magee, *Story of Philosophy*, 24. This phrase is often attributed to philosopher Alfred North Whitehead. For our purposes, it is important to note the enormous influence of Neoplatonism on some Christian theologies.

17 Philosopher Bryan Magee pronounces Plato "an *artist* as well as a philosopher." Magee, *Story of Philosophy*, 27; emphasis added.

18 "Analysis of the Republic," in Plato, *The Republic*, xxvii. "Then must we not conclude that all writers of poetry, beginning with Homer, copy unsubstantial images of every subject about which they write, including virtue, and do not grasp the truth? . . . will not the painter, without understanding anything about shoemaking, paint what will be taken for a shoemaker by those who are as ignorant on the subject as himself, and who judge by the colours and forms?" Plato, *The Republic*, book X, 377.

19 Plato, *The Republic*, book X, 377.

20 Plato, *The Republic*, book X, 379.

21 Plato, *The Republic*, book X, 388.

22 Aristotle, *Poetics*, book IX, 3, 68.

23 Aristotle, *Poetics*, book IV, 1–6, 55–56.

24 Shklovsky and Sher, *Theory of Prose*, 6.

25 Aristotle, *Poetics*, book IX, 8, 69.

26 Aristotle, *Poetics*, book IV, 3–5, 55–56.

27 Aristotle, *Poetics*, book XIII, 3, 76.

28 Aristotle, *Poetics*, book XIII, 2, 76.

29 Dewey, *Art as Experience*, 9.

30 Wassily Kandinsky, *Concerning the Spiritual in Art* (New York: Dover Publications, 1977), 53.

31 Modern art free from any sense of responsibility to society "has incorporated a lot of horror. Photographers have shown corpses or the grisly severed heads of animals, sculptors have displayed rotting meat with maggots, and performance artists have poured out buckets of blood." Freeland, *But Is It Art?*, 27.

32 I will treat these questions more fully in chapter 9 as we look at the problems at Assy in the 1950s. For a recent controversy involving art,

artists, religious sensibilities, matters of state, and lawsuits, see Steven Lee Myers, "Moscow Show Pits Art against Church and State," *New York Times*, November 26, 2005.

33 *Exit Through the Giftshop*, directed by Banksy, produced by Paranoid Pictures, 2010. This film deserves an extensive study of its own, and I regret that I cannot do that here; it is an important work in which artists cleverly and artfully denounce that which would destroy art from within art.

34 "The mercantile spirit . . . suppresses the sympathetic faculty and welcomes the brain that divides." Hyde, *The Gift*, 201.

35 To develop this category of gift in relation to art, I have relied on the prescient work of Lewis Hyde. See especially *The Gift*, 194–97.

36 Hyde, *The Gift*, 194.

37 Kandinsky, *Concerning the Spiritual in Art*, 6.

38 Kandinsky, *Concerning the Spiritual in Art*, 6.

39 Kandinsky, *Concerning the Spiritual in Art*, 7.

40 Kandinsky, *Concerning the Spiritual in Art*, 7.

41 Ortega y Gasset, *La deshumanización del arte*, 35.

42 Ortega y Gasset, *La deshumanización del arte*, 35.

43 Chagall, *My Life*, 65.

44 Chagall, *My Life*, 134.

45 Virgilio P. Elizondo, *The Future Is Mestizo: Life Where Cultures Meet* (Oak Park, Ill.: Meyer-Stone Books, 1988), 57, 58.

46 "Teoría y juego del duende," in García Lorca, *Obra Completas*, 110.

47 García Lorca, "Las Nanas Infantiles," in *Obra Completas*, 90, 93.

48 García-Rivera, *Wounded Innocence*, x.

49 John Paul II, *Letter to Artists*, §1.

50 Charles Baudelaire, *The Painter of Modern Life, and Other Essays*, trans. and ed. Jonathan Mayne (London: Phaidon, 1964), 12.

51 Warhol's Last Supper works were based not on Leonardo's mural, but on a popular rendition of it in a small holy card his mother carried. This to me implies that this pious popularizing of the classical image was art for Warhol. Jane Dillenberger does not see it this way, feeling that, "In copies like this [holy card] Leonardo's grand mural had become ubiquitous, despoiled and trivialized. And it had become tedious." Dillenberger, *Religious Art of Andy Warhol*, 80. I would suggest that this is not the case; rather, the "grand mural" had become beloved and accessible to communities well beyond the confines of fine art and of Milan.

52 Mark R. Francis and Arturo J. Perez-Rodriguez, *Primero Dios: Hispanic Liturgical Resources* (Chicago: Liturgy Training Publications, 1997), 119–23.

53 García Lorca, "Las Nanas Infantiles," in *Obras Completas*, 91–108.

54 Hyde, *The Gift*, 12.
55 Freeland, *But Is It Art?*, xviii.
56 Alejandro García-Rivera, "Sacraments: Enter the World of God's Imagination," *U.S. Catholic* 59, no. 1 (1994): 6–12.
57 Greeley, *Catholic Imagination*, 6, 7.
58 "The Catholic religious sensibility is often almost overwhelmed by the thickness of the metaphors in its dense forest of imagery and story. God and grave lurk everywhere. In the dictum 'grace is everywhere' the emphasis can be placed on any of the three words. I suspect that for the creative artist possessed by the Catholic imagination, the emphasis is on the third." Greeley, *Catholic Imagination*, 10.
59 Marshall McLuhan, *The Gutenberg Galaxy: The Making of Typographic Man* (Toronto: University of Toronto Press, 1962).
60 Greeley, *Catholic Imagination*, 11.
61 I would also add to the list of art the summer nights themselves, for the Creator is the ultimate artist.
62 "The very definition of a 'classic' in art is that it is polyvalent (just as a Jesus parable is polyvalent with many interpretations possible). A great story like a Jesus parable has many windows and many doors of interpretation so a hundred different sermons could be preached on that parable. Such a great story or great art work speaks beyond its own time and place. (Of course a poor story does not even allow a preacher to squeeze one sermon out of it; and a poor art work with only one meaning is more like propaganda than art.)" Doug Adams, interview, *National Debate: The Da Vinci Code*, Berkeley: Total Living Network, 2006.
63 I am aware that interpretation is itself contested as a process, as is the proposition that art is communication; however, the complexity of this debate precludes a discussion of these positions. My own position is that interpretation is indeed legitimate when carried out in community, and that art is relationship, not communication in the classic model of sender–medium–receiver.
64 Stephen De Staebler and Diane Apostolos-Cappadona, "Reflections on Art and the Spirit: A Conversation," in *Art, Creativity, and the Sacred: An Anthology in Religion and Art*, ed. Diane Apostolos-Cappadona (New York: Continuum, 1995), 33.
65 Cecilia Davis Cunningham, "Craft: Making and Being," in *Art, Creativity, and the Sacred: An Anthology in Religion and Art*, ed. Diane Apostolos-Cappadona (New York: Continuum, 1995), 10.
66 Jeremy Hawthorn, *A Glossary of Contemporary Literary Theory*, 4th ed. (London: Oxford University Press, 2000), 67.
67 Gao, *Return to Painting*, 24.

68 Ancius Manlius Severinus Boethius (c. 480–526), a scholar of Greek, especially Platonic philosophy, was tortured and executed by the Arian Roman Emperor Theoderic for trying to reconcile the Roman and Eastern Churches. He is best remembered for his work *De Consolatione Philosophiae*, written from prison, where he explores the chimera of fortune and prosperity and what has true worth in a human life.

69 "Nothing is more proper to human nature than to abandon oneself to sweet modes and to be vexed by modes that are not. . . . Thanks, therefore, to what is harmonious in us we perceive the harmonious composition of sounds, and we delight in them for we understand that we are made in their likeness. Similarity is pleasing, therefore, whereas dissimilarity is odious." Boethius, "De Musica," I.1, in Eco, *History of Beauty*, 62.

70 Hawthorn, *Glossary of Contemporary Literary Theory*, 67.

71 Austin, *In a New Light*, 8.

72 Kiefer, "Intentional Model of Interpretation," 271.

73 Kiefer, "Intentional Model of Interpretation," 274.

74 Kiefer, "Intentional Model of Interpretation," 274.

75 Kiefer, "Intentional Model of Interpretation," 276.

76 Gao, *Return to Painting*, 53.

77 "Teoría y juego del duende," in García Lorca, *Obra Completas*, 113.

78 Brown takes on the assumptions behind the adamant denial of meaning as he exposes the claim of such positions to be that "the self (or soul) as a whole, along with the very idea of an ultimately meaningful Whole beyond the self, is a kind of fiction; for it is this 'fiction' that certain forms of religion use in order to motivate loving relations and to undermine fictions they consider truly dangerous, such as the delusory denial that we are in fact responsible beings whose life is a gift and whose very existence is in relation." Frank Burch Brown, *Religious Aesthetics: A Theological Study of Making and Meaning* (Princeton, N.J.: Princeton University Press, 1989), 101.

79 Brown, *Religious Aesthetics*, 102.

80 Brown, *Religious Aesthetics*, 102.

81 The idea of insight is elaborated by Josiah Royce (1855–1916), an American philosopher who taught at the University of California Berkeley and Harvard. He is remembered as a proponent of "Absolute Pragmatism," which sees philosophy as relevant to a well-lived human life and stresses the role of community, loyalty, and interpretation. Some of his best known works are *The Religious Aspect of Philosophy* (1885), *The Philosophy of Loyalty* (1908), and *The Problem of Christianity* (1913). He is a major influence in García-Rivera's work.

82 García-Rivera, *Wounded Innocence*, 33.

83 Royce, *Sources of Religious Insight*, 5–6.
84 García-Rivera, *Wounded Innocence*, 34.
85 Buber, *I and Thou*, 127.
86 Thomas P. Rausch, letter [email communication] to the author, Los Angeles, 2006; emphasis original.

Chapter 8

1 It is likely that whenever the "now" happens to be that you are reading this sentence, the same need is urgently present.
2 Vogt first published his tome in 1921, revising it and reissuing it in 1948. Vogt, *Art and Religion*.
3 Vogt, *Art and Religion*, 1.
4 Vogt, *Art and Religion*, 4.
5 "A new age is coming. It will be upon us swiftly and we must bestir our imaginations to prepare for it." Vogt, *Art and Religion*, 1.
6 Vogt, *Art and Religion*, 9.
7 Vogt, *Art and Religion*, 9.
8 The cloth known as the shroud has been venerated for centuries as the burial cloth of Christ, due to the faint image of a tortured bearded man imprinted on it. The details of the image could not be appreciated until the advent of photography, when it was first viewed as a negative. See Finaldi and Avery-Quash, *Image of Christ*, 77, 102–3.
9 Vogt, *Art and Religion*, 9, 10.
10 As of this writing, Frank Burch Brown is Frederick Doyle Kershner Professor of Religion and the Arts at Christian Theological Seminary in Indianapolis. His Ph.D. is in Religion and Literature. He is also an accomplished composer with over twenty commissioned works, including *Ritual Compass* (1984) and *Canticles and Exhortations* (1996).
11 Alejandro García-Rivera (Cuban American, 1951–2010) was Professor of Systematic Theology at the Jesuit School of Theology at Santa Clara University, Berkeley Campus. Initially trained as a physicist, his journey and subsequent study of theology eventually brought him to the development of theological aesthetics. A fascinating autobiographical article is García-Rivera, "Sacraments: Enter the World of God's Imagination," 6–12.
12 Brown, *Good Taste, Bad Taste, and Christian Taste*, 34–35.
13 García-Rivera, *Wounded Innocence*, 1.
14 For García-Rivera's discussion of Kant's concept of "disinterestedness," see *Wounded Innocence*, 77–80. For Brown's interpretation of Kant, see Brown, *Religious Aesthetics*, 63–73.
15 As a scholar of religion, Brown tends to refer to his work as religious

aesthetics, while as a theologian, Garcia-Rivera refers to his work as theological aesthetics; the latter is the term and focus I also favor.

16 Brown, *Good Taste, Bad Taste, and Christian Taste*, 167–68.

17 The coinage of the word "Chrismons" and the craft of making them is traced to the late 1950s and to a Lutheran church in Virginia. According to Ascension Lutheran Church in Danville, Virginia, where the "Chrismons ornaments were first developed," the name is a combination of Christ and Monogram. See: http://www.chrismon.org/.

18 García-Rivera, *Community of the Beautiful*, 2.

19 García-Rivera, *Community of the Beautiful*, 2.

20 García-Rivera, *Community of the Beautiful*, 2. Brown, *Good Taste, Bad Taste, and Christian Taste*, 168.

21 García-Rivera, *Community of the Beautiful*, 2.

22 Brown, *Good Taste, Bad Taste, and Christian Taste*, 168.

23 Brown, *Good Taste, Bad Taste, and Christian Taste*, 168.

24 Brown, *Good Taste, Bad Taste, and Christian Taste*, 168. Brown here follows Garcia-Rivera's use of Beauty (capitalized) as a proper name and not a quality. Garcia-Rivera will explain this subsequently as a way of recognizing that "one of God's names is Beauty." See Garcia-Rivera, *The Garden of God: A Theological Cosmology* (Minneapolis: Fortress, 2009), 58.

25 Brown, *Good Taste, Bad Taste, and Christian Taste*, 169.

26 A very large part of what is today considered the United States was indeed a Hispanic land where Catholicism was "planted during the sixteenth through early nineteenth centuries in the regions from Florida to California." Matovina and Poyo, *Presente!: U.S. Latino Catholics from Colonial Origins to the Present*, 1.

27 One of the tragedies of contemporary culture is that only vestiges of the religious significance of Christmas as centered in the Nativity story remain in many parts of the Western world. The artistically religious explorations of *pastorelas*, *posadas*, and *nacimientos* are in need of vocal advocates, as these artworks stand as sites of resistance against the vacating of religious meaning from what is now called "the holiday season."

28 See Virgilio P. Elizondo and Timothy M. Matovina, *San Fernando Cathedral: Soul of the City* (Maryknoll, N.Y.: Orbis Books, 1998), 86–87.

29 The power of aesthetic traditions was evident to me when I could easily recall the music and lyrics of this song from the *Posadas*. One of the most interesting contemporary applications of the tradition I have been involved with was in 1993, as a project of the AIDS service organization founded by All Saints Church in Pasadena. A coalition of churches, temples, and the stunningly beautiful Pasadena City Hall were transformed by candlelight for one night, as many Southern Californians

joined the procession to raise money and also incarnate the need of shelter and care for people with AIDS, at that time a fatal disease.

30 Elizondo, *Future Is Mestizo*, 57, 58.

31 Brown, *Good Taste, Bad Taste, and Christian Taste*, 167–270.

32 "Scotosis results when the intellectual censorship function, which usually operates in a good and constructive manner to select elements to give us insight, goes awry. In aberrant fashion this censorship function works to repress new questions in order to prevent the emergence of unwanted insight." Elizabeth A. Johnson, *She Who Is: The Mystery of God in Feminist Theological Discourse*, 10th anniversary ed. (New York: Crossroad, 2002), 13. Johnson acknowledges this concept was prompted by the work of the Jesuit theologian Bernard Lonergan.

33 García-Rivera, "Sacraments: Enter the World of God's Imagination," 12.

34 García-Rivera, *Community of the Beautiful*, 4.

35 Brown does not capitalize or explain Chrismons as García-Rivera does; clearly it is a commonplace part of his tradition. See note 17 above.

36 As noted earlier, García-Rivera routinely capitalizes Beauty when he is speaking of it as one of God's attributes or as another name for God, see *Garden of God*, 56–60.

37 García-Rivera, *Community of the Beautiful*, 2.

38 "Good art can be abused religiously; and bad art can be saved, religiously." Brown, *Good Taste, Bad Taste, and Christian Taste*, 147.

39 Brown, *Good Taste, Bad Taste, and Christian Taste*, 99–100.

40 Brown argues that "one whole line of modern Protestant theologizing on art (at least nonmusical art) tended to obscure how art might at times have a thoroughly Christian calling: to bear good news with special grace, and not only to bear mere hints of hope or to bear the bad news (of sin and estrangement) with shattering power." *Good Taste, Bad Taste, and Christian Taste*, 7.

41 Greeley, "A Cloak of Many Colors," 10.

Chapter 9

1 See the Golden Gate Bridge Highway and Transportation District website at http://www.goldengatebridge.org/research/factsGGBDesign.php.

2 Recorded in 1982.

3 In one of the very first articulations of the joint work of religion and the arts in modernity, Pope Pius XII delivered a short address to artists in 1952. In "The Function of Art," the pontiff suggested what he saw as an "intrinsic 'affinity' of art with religion," as the work artists performed in becoming "interpreters of the infinite perfections of God,

and particularly of the beauty and harmony of God's creation." Pope Pius XII, "The Function of Art" (Vatican City: Vatican, 1952), §4.

4 A stellar example of this method is William James' landmark study *The Varieties of Religious Experience*, originally published in 1902. In lecture III, "The Reality of the Unseen" (22–31), James uses the personal experiences of very particular persons to "get at" the question of the human belief in a transcendent realm. Thus he employs experience as the central theoretical tool for the study of religion. John Dewey, likewise, sees experience as the key to understanding the aesthetic, such that we recover "the continuity of aesthetic experience with normal processes of living." Dewey, *Art as Experience*, 9.

5 While I was developing this methodology, Alex García-Rivera commented on it. See García-Rivera, "The Color of Truth," 19. He acknowledges our debt to philosopher C. S. Peirce, quoting Peirce's explanation that "an alternative way to build an argument is by 'reasoning [that] should not form a chain which is no stronger than its weakest link, but a cable whose fibers may be ever so slender, provided they are sufficiently numerous and intimately connected.'" See also García-Rivera, *Garden of God*, ix–x.

6 Some of the most accomplished artists I know have a very low opinion of most art criticism, as they note that what is expressed publicly is often nothing more than one person's opinion and rarely undertaken seriously and thoughtfully.

7 Dillenberger, "Artists and Church Commissions, 193–204. This article is reprinted from *Art Criticism* 1, no. 1 (1979): 72–82. In the essay, Dillenberger (a Protestant theologian informed by Paul Tillich and at the time married to art and religion scholar Jane Dillenberger) criticizes art historian and curator William Rubin's analysis of the controversy. Although Dillenberger's approach also amplifies the polemics of the discourse, he does help identify what some of the underlying issues may be, even if he does not constructively address these.

8 "Religion: Art for God's Sake."

9 "Religion: Art for God's Sake."

10 The village is in an area called Plateau D'Assy in the French Alps, northwest of Mont Blanc. The remote location, at an altitude of over 3,000 feet, was chosen for the sanatorium of Sancellemoz in 1928, and the legendary scientist Marie Curie died there in 1934. There are contradictory reports about the reasons for locating the Church here and how it grew from an initial design of "something completely traditional and in good taste" into an international symbol of modern art. William Stanley Rubin, *Modern Sacred Art and the Church of Assy* (New York: Columbia University Press, 1961), 31–32.

11 "The Assy Church," *Life*, June 19, 1950. Other accounts make clear that

although Couturier received the major press coverage, there were two other Dominican priests intimately involved, Canon Jean Devémy and Father Pie-Raymond Régamey. It is possible that one reason that Couturier was the single focus for the American press was that he spent five years in the United States during the Second World War. In France it is Devémy who is listed as the founder of this church by the Passy Tourism Office.

12 The church plan is available on the website of the Tourism Office of the Region of Passy at http://www.passy-mont-blanc.com/art-culture-uk.asp. It reproduces, with some additions, the plan in Rubin, *Modern Sacred Art and the Church of Assy*, 76–77.

13 A short list of the works, titles, and years is provided in Dillenberger, "Artists and Church Comissions," 197–98. Rubin's volume goes into details on most of the art. Rubin's writing plays right into the polemics of the period and many of his theoretical conclusions have been criticized by subsequent scholars, most notably by theologians John Dillenberger and Thomas F. O'Meara, O.P. However, the record of the works and the immediacy of Rubin's account is invaluable.

14 "Art: Removal at Assy," *Time*, April 23, 1951: 443–44.

15 To reconstruct events and debates I am relying on some helpful contemporaneous texts. Along with news accounts, we have the record by Rubin, which he explains was written between 1956 and 1958 as his doctoral dissertation. Rubin's text has the advantage of being very close in time to the events, and although haphazardly annotated and often lacking attribution, it preserves the fruits of his discussions with the artists involved. *Modern Sacred Art and the Church of Assy*, v. See also Arnason and Mansfield, *History of Modern Art*, 443.

16 "Monsignor Çesbron, The Bishop of Annecy." Rubin, *Modern Sacred Art and the Church of Assy*, 51.

17 Rubin adds the following note about the removal: "During these months the Crucifix, which has since been placed in the mortuary chapel, was located in a chalet behind the church near the rectory. Visitors with a special interest were discretely led to it." *Modern Sacred Art and the Church of Assy*, 52n.

18 Rubin, *Modern Sacred Art and the Church of Assy*, 2. Gallicanism means a position of advocacy for greater autonomy for the French Church and less papal control.

19 Rubin, *Modern Sacred Art and the Church of Assy*, 16.

20 A helpful summary of the multiple controversies in the Christian church that became radicalized or symbolized through the polemics between those who loved images (iconodules) and those who rejected them (iconoclasts) is found in Ronda Kasl, ed., *Sacred Spain: Art and*

Belief in the Spanish World (New Haven: Yale University Press, 2009), 15–35.

21 This unimaginably hyperbolic comment (especially because it was made during the postwar period) came from art critic Bernard Dorival in an opinion piece in *La Table ronde*, June 1951, no. 42. Quoted in Rubin, *Modern Sacred Art and the Church of Assy*, 51. Rubin tries to explain the reference to the White House as a possible swipe at "the personal taste of Mr. Truman." A similar comment was made in *Art News* by art critic and poet Jean Cassou and attributed to an unnamed Dominican priest. Rubin, *Modern Sacred Art and the Church of Assy*, 51.

22 This was originally from an article in *Osservatore Romano* by a Fr. Cordovani, and subsequently excerpted into a leaflet known as "The Tract of Angers" produced to respond defensively to Richier's crucifix. Rubin, *Modern Sacred Art and the Church of Assy*, 50.

23 Credit for this balanced and cautionary view goes to a document produced by an international group at the First International Congress of Catholic Artists in Rome, held in 1950. The main text is credited to Maurice Lavanoux, an architect, founder of the Liturgical Arts Society, and managing editor of Liturgical Arts. See Rubin, *Modern Sacred Art and the Church of Assy*, 46.

24 "The long tradition of interplay between the sacred and the arts, quite capable of sustaining the revolutions of the medieval, the renaissance and the baroque, had collapsed." Thomas F. O'Meara, "Modern Art and the Sacred: The Prophetic Ministry of Alain Couturier, O.P.," *Spirituality Today* 38, no. 1 (1986): 31–34. Rubin's book, researched and written only five years after the explosion at Assy, retains a very heated polemical voice that leads him to repeatedly contradict himself, or as John Dillenberger contends, leads him to "misdirected and overly pessimistic conclusions about art and the church." Dillenberger, "Artists and Church Commissions," 197.

25 Frank Burch Brown stresses that art cannot "be treated as a matter of religious indifference. Nor can art be treated as automatically religious or perfectly innocent." Brown, *Good Taste, Bad Taste, and Christian Taste*, 137.

26 García-Rivera underlines the centrality of the affective power of art as a marker of its religious and theological depth. *Wounded Innocence*, 3.

27 One of the ways Brown suggests we can evaluate the religious significance of a work of art is precisely through "relating an action or object to God." The ways in which this happens are all intentionally affective. We may dedicate something to God out of love, have the work itself address God, be at the service of God, share it with God (feeling that God is also enjoying it), or recognize something as coming from God

and making God present to us. Brown, *Good Taste, Bad Taste, and Christian Taste*, 117–19.

28 "Precisely on the issue of depicting the Christian mystery, there arose in the early centuries a bitter controversy known to history as 'the iconoclast crisis.' Sacred images, which were already widely used in Christian devotion, became the object of violent contention." John Paul II, *Letter to Artists*, §7.

29 Initial reactions in aesthetic matters should not just be dismissed, because the experience discloses much important information. See Cecilia González-Andrieu, "Ecce Homo," in *Encounters of Faith: Latin American Devotional Art*, ed. Alejandro García-Rivera and Mia Mochizuki (Berkeley: Jesuit School of Theology Santa Clara University, 2010).

30 "Art: Removal at Assy."

31 Rubin excludes from his research mainstream news reports, especially those coming from the U.S. press, and instead relies exclusively on the polemical writings between the two factions in France. I have no reason to believe that *Time* magazine manufactured the negative responses from the local community it reports, yet Rubin (relying on the accounts of the priests in charge of Assy) categorically denies that any of the parishioners complained to the bishop. Rubin, *Modern Sacred Art and the Church of Assy*, 51–52.

32 "Art: Removal at Assy."

33 Just who it was that complained to the bishop is a contested point, and Rubin accuses "the Vatican" of creating "an abstraction called 'the faithful,' to which it then attributes its own 'official' taste and attitude." Rubin, *Modern Sacred Art and the Church of Assy*, 52. I find Rubin's fevered involvement on one side of the controversy and his editorializing and selection of quotes to be at the service of portraying the backwardness of the Church. I am thus suspicious of the value of much that he recounts as reliable research data. I am, however, very appreciative of the fascinating window his book provides from which to view the heat of the moment.

34 With Assy, we are dealing with a pre–Vatican II Church that had not yet articulated the role of the bishop in the modern world (see Vatican II, *Christus Dominus*, Decree on the Pastoral Office of Bishops in the Church, 1965). Yet we can look at earlier documents for clues to the bishop's actions, for instance the Council of Trent's (1546) Decree on Reformation, from the fifth session, chapter II, "On Preachers of the word of God, and on Questors of alms," which underscores the central role of the bishop in overseeing that the growth of the faith of the local community be nurtured and strengthened, and with interdicting preaching that "spread errors, or scandals, amongst the people."

Additionally, in the decree about sacred images from the twenty-fifth session we read, "The holy Synod ordains, that no one be allowed to place, or cause to be placed, any unusual image, in any place, or church, howsoever exempted, except that image have been approved of by the bishop." "Twenty-Fifth Session," in *The Council of Trent* (London: Dolman, 1848), 28, 236.

35 What I call vigilance leads me to multiply my questions with care, to turn everything over a few times and to view what appears conclusive with suspicion. This is an awareness of "cognitive dissonance. What is, is not what ought to be. Not only that, but what we have been told ought to be, is not always what ought to be." Rosemary Radford Ruether, *Sexism and God-Talk: Toward a Feminist Theology* (Boston: Beacon Press, 1993), xviii.

36 Johnson, *Consider Jesus*, 11.

37 This is Karl Rahner's thesis in "Towards a Fundamental Theological Interpretation of Vatican II," in *Vatican II, the Unfinished Agenda: A Look to the Future*, ed. Lucien Richard et al. (New York: Paulist Press, 1987), 10; emphasis added.

38 "Attention as 'self-emptying' inescapably involves negation. It requires loss and suffering. We must, therefore, expect inner resistance, and remain aware of it. In fact, the observation of our various forms of resistance can lead to a greater self-understanding." Austin, *In a New Light*, 5.

39 John Paul II, *Letter to Artists*, §5.

40 "Religions rarely think about 'art' in the abstract—at least not in the sense of 'fine art.'" Brown, *Good Taste, Bad Taste and Christian Taste*, 27.

41 García-Rivera notices that the stained glass windows of the Gothic cathedrals were meant to present to memory, through their constant appreciation, the religious mysteries of the faith. Here we see religious art taking "on the dignity of sacred writing as opposed to sacred object." García-Rivera, *Wounded Innocence*, 60.

42 Frank Burch Brown suggests a practice he calls "cross-boundary listening." This entails "discipline" and "humility" and a willingness to "perceive attentively before judging." It also means we "judge provisionally" and that we "learn to listen differently to different styles." Brown, *Good Taste, Bad Taste and Christian Taste*, 189.

43 García-Rivera calls this a form of "aesthetic nominalism" that makes "an extremely sharp distinction between the world outside the mind and the mind itself." The results of such a separation are felt in an excessive individualism and the belief that "our actions have few if any consequences beyond one's own individual little world." *Wounded Innocence*, 27. We can see this play out in the Assy controversy in the debate's focus on radical artistic autonomy for works that were actually commissioned

for a church space. The defenders of the works argued that the art should
not have any relationship to the church, its teachings, or its communi-
ties beyond those that the artists in their individual discretion were
willing to entertain and allow.

44 My reaction was important here since I am also a professing Christian.

45 Rubin, *Modern Sacred Art and the Church of Assy*, 52.

46 Rubin, *Modern Sacred Art and the Church of Assy*, 162.

47 Rubin's explanation makes clear that Richier did not know the Isaiah
texts, but "she did not object to its being inscribed on a placard near the
work." Rubin, *Modern Sacred Art and the Church of Assy*, 162.

48 Rubin, *Modern Sacred Art and the Church of Assy*, 58. García-Rivera
devotes a substantial discussion to his category of "aesthetic nominal-
ism." In this articulation, he cites as enemies of art those tendencies to
push for innovation for the sake of innovation, the sense that viewers are
reduced to decoding what artists are attempting to do, the removal of
art from human concerns, and finally its commodification. See García-
Rivera, *A Wounded Innocence*, 28–30. What many of the arguments in
support of the art at Assy centered on was exactly what today is prob-
lematized by Banksy in *Exit Through the Giftshop*, namely, is saying one
is a famous artist all it takes to claim that something is good art?

49 It is difficult to take seriously Fernand Léger's self-serving and confident
pronouncement that, according to him, "it was *not faith* which inspired
the artists of the Middle ages to create great works . . . their work is
beautiful objectively in terms of reasons and relationships of a plastic
order, and not for sentimental motives." Rubin, *Modern Sacred Art and
the Church at Assy*, 71; emphasis added. Léger was a Communist and an
atheist, and we can only wonder why it was that he agreed to create the
façade of the Litanies of Mary for Assy—perhaps money and fame give
us a clue as to his source of inspiration.

50 It is significant that most of Chagall and Rouault's great religious works
were not created as church commissions, yet they are enduring master-
works. Thus, art's function as carrier of a religious tradition is in no way
predicated on a work being ecclesiastically commissioned or destined
for a church space. As the wide popularity of John August Swanson's art
in the United States shows, the wider Christian and Jewish community
recognizes itself in his art as faithfully interpreted. Beyond museums
and universities, most of Swanson's collectors are everyday people. One
group of college students raised funds to purchase one of his serigraphs
as a surprise for a graduating senior. The young man had expressed
love for the work (*Conductor*, 1987), seeing it as a meditation upon his
own ministry as a musician. Although not explicitly religious, the work
communicated to this student and his friends the ministerial quality of

bringing beauty to the world, and also of God as conductor of creation (Loyola Marymount University student choir, May 2011).

51 One way García-Rivera gets at the question of multiple influences is by exploring the insights of the ancient monastic order proposed in the rule of St. Romuald (c. 950–1027). In the rule for the Camaldolese monks, St. Romuald united three forms of previously separate monastic rules: the solitary, the common, and the missionary. This makes it so that a monk must simultaneously attend to interiority, community, and the outside world. García-Rivera sees this as analogous to the best practices of an artist. See *Wounded Innocence*, 50.

52 Many decades later, a short opinion piece in the *New York Times* praised Richier for her independence from artistic movements and influences, which the critic says makes her so much more "authentic" than someone like Max Ernst, who "somehow managed to signify that his subject matter was essentially mythic." Meanwhile, "Richier merely did what she felt like doing and left it at that." Of course today Ernst's stature as an artist far outstrips Richier's, so there is something to be said for authenticity that also includes the community. Michael Gibson, "Germaine Richier; an Original," *The New York Times*, May 4, 1996.

53 "Art: Removal at Assy."

54 I find this distinction in Rubin's writing between atheists and Communists strange, since Communists are necessarily atheists as part of their political ideology. My best guess is that some of the artists involved were atheists because of their rejection of religion (Rubin intimates that most if not all were former Catholics) and others had additionally embraced the Marxist/Leninist political agenda. But, we must be clear, both groups denied the existence of God. For a Communist understanding, religion is not a neutral feature of human life, but an enemy to be fought and destroyed.

55 Morvan Lebesque, "Le Scandale du Christ d'Assy," *Carrefour*, no. 356, July 11, 1951: 3; quoted in Rubin, *Modern Sacred Art and the Church of Assy*, 56.

56 Lebesque, "Le Scandale du Christ d'Assy"; quoted in Rubin, *Modern Sacred Art and the Church of Assy*, 56.

57 Celso Costantini, "Réponse à diverses critiques," *Osservatore Romano*, August 20, 1951; quoted in Rubin, *Modern Sacred Art and the Church of Assy*, 56; emphasis added.

58 Johnson, *Consider Jesus*, 2.

59 Rubin, *Modern Sacred Art and the Church of Assy*, 35.

60 Rubin, *Modern Sacred Art and the Church of Assy*, 31–32.

61 Rubin, *Modern Sacred Art and the Church of Assy*, 8.

62 Rubin, *Modern Sacred Art and the Church of Assy*, 12.

63 St. Thérèse was declared a Doctor of the Church in 1997 by Pope John
 Paul II, "in view of the soundness of her spiritual wisdom inspired by
 the Gospel." See http://www.vatican.va/news_services/liturgy/saints/
 ns_lit_doc_19101997_stherese_en.html.

64 Rubin, *Modern Sacred Art and the Church of Assy*, 9.

65 Rubin, *Modern Sacred Art and the Church of Assy*, 9.

66 "Religion: Art for God's Sake."

67 Pius XII, "Function of Art," §7.

68 Rubin, *Modern Sacred Art and the Church of Assy*, 19.

69 "Proceeding courageously, if naively, he selected artists largely on the
 basis of reputation." Rubin, *Modern Sacred Art and the Church of Assy*, 34.

70 Rubin, *Modern Sacred Art and the Church of Assy*, 69; emphasis in original.

71 Rubin notes this formally, failing to see its theological consequences.
 Inside the church "one is struck by a feeling of isolation of parts. . . .
 This sense of disjunction is reinforced by the marked difference in style
 from one work to the next." *Modern Sacred Art and the Church of Assy*, 39.

72 Rubin, *Modern Sacred Art and the Church of Assy*, 70. Rubin holds this
 view, and it is somewhat more explicitly expressed in *Time*: "From the
 first, his primary concern has been to preach and minister to men."
 "Religion: Art for God's Sake."

73 Rubin, *Modern Sacred Art and the Church of Assy*, 53.

74 Rubin, *Modern Sacred Art and the Church of Assy*, 53.

75 "Art must make perceptible, and as far as possible attractive, the world
 of the spirit, of the invisible, of God. It must therefore translate into
 meaningful terms that which is in itself ineffable." John Paul II, *Letter to
 Artists*, §12.

76 Rubin, *Modern Sacred Art and the Church of Assy*, 36; emphasis added.

77 Rubin, *Modern Sacred Art and the Church of Assy*, 39.

78 Rubin, *Modern Sacred Art and the Church of Assy*, 40.

79 Rubin, *Modern Sacred Art and the Church of Assy*, 41.

80 Rubin fails to make this connection in his analysis. He does speak in
 different parts of his account about the conservative obsession with
 Mary, the lack of Christ images in the church at Assy, and the Com-
 munists' stances about not compromising their ideological integrity.

81 Rubin, *Modern Sacred Art and the Church of Assy*, 44.

82 "Art: Removal at Assy."

83 Rubin, *Modern Sacred Art and the Church of Assy*, 160.

84 Dillenberger, "Artists and Church Commissions," 202. Art historian
 Sarah Wilson does not describe Richier as an atheist but rather as
 "agnostic." Sarah Wilson, "Germaine Richier: Tradition and Transi-
 tion, Sacred and Profane," *Sculpture Journal* (2006): 7. Rubin, on the
 other hand, is very clear.

85 Rubin, *Modern Sacred Art and the Church of Assy*, v, 160.

86 Pius XII contends that "beauty cannot prescind from God." Thus, if a work is to express beauty it will necessarily express God, whether this is intended to or not. He also stresses that since all of creation is in God, then the possibility that something be exclusively "human" or "natural" does not exist. Pius XII, "The Function of Art," §6. What we can infer is that all creative work is necessarily an expression of God in the world. The complication of applying this to art by atheists is that it appears that it is only through denying beauty, nature, and God's immanence in the created order that an atheist position can be staked out in art. This seems supported by some of the artworks at Assy.

87 Rubin, *Modern Sacred Art and the Church of Assy*, 160.

88 Wilson, "Germaine Richier," 5.

89 Rubin, *Modern Sacred Art and the Church of Assy*, 160.

90 Rubin, *Modern Sacred Art and the Church of Assy*, 160.

91 "Art: Removal at Assy."

92 "The representation of the body—Christ's body focally and other bodies by association with it—is the representation of all that can be meant by the elusive word 'God.' " John Drury, *Painting the Word: Christian Pictures and Their Meanings* (New Haven: Yale University Press; London: National Gallery Publications, 1999), 42.

93 John Paul II, *Letter to Artists*, §7.

94 Chiara Lubich, herself a survivor of the Second World War, eventually articulated a theology through which a Christian could see Christ precisely in the forsaken state of those who deny him (Matt 27:46). Recognizing that the Christian obligation to make Christ present in the world must move the Christian to manifest extraordinary compassion and solidarity with the suffering other, suffering is understood as existential and as encompassing the feeling of God's absence. In forming and manifesting a compassionate community, the Christian then becomes an effective conduit for Christ's active presence to the one who has felt forsaken (Matt 18:20). See Chiara Lubich, *The Cry: Jesus Crucified and Forsaken in the History and Life of the Focolare Movement, From Its Birth in 1943, Until the Dawn of the Third Millennium* (Hyde Park, N.Y.: New City Press, 2001).

95 "Art: Removal at Assy."

96 "In a world without beauty . . . the good also loses its attractiveness, the self-evidence of why it must be carried out." von Balthasar, *Glory of the Lord*, 19.

97 At the time *Life* magazine reported that Rouault, "a devout Catholic," had donated his works to the Church. "Assy Church," 75.

98 Although he does not answer the question, John Dillenberger asks rhetorically if the church at Assy has "become merely a museum?" "Artists and Church Commissions," 199.

99 "Art for God's Sake."

100 I am purposeful in using the word "prettiness," as I think the idea of "embellishment" denotes a superficial idea of beauty.

101 Pius XII, "Function of Art," §5.

102 A *destello* is defined by the Royal Academy of the Spanish Language rather poetically as a "bright and ephemeral luminescence, gust of light that lights up and diminishes or disappears almost instantaneously." It is also equated with the idea of *vislumbrar*, which means to see suddenly, even if incompletely, leading to a hypothesis or conjecture. The antonym is understood to be "to distill" or "to analyze."

103 I stress *re*-learned because the cultural heritage of Western civilization witnesses that the church and artists were quite adept at working together prior to the nineteenth century, and the final break came with the advent of modern art and the Church's aversion to modernity. See esp. §§7–10 in Pope John Paul II's *Letter to Artists*.

104 *Gaudium et Spes*, §4.

105 "Art: Removal at Assy."

106 *Gaudium et Spes*, §10.

107 *Gaudium et Spes*, §10; see also Heb 13:8.

108 "To grow up without an appreciation for symbol and image, icon and story is to grow up without a Catholic imagination. . . . Beige Catholicism is not just dull; it's essentially impoverished." Thomas P. Rausch, *Being Catholic in a Culture of Choice* (Collegeville, Minn.: Liturgical Press, 2006), 65.

109 The Cathedral of Christ the Light was dedicated on September 25, 2008. Begun under Bishop John Cummings, it was completed during the episcopate of Bishop Allan Vigneron, who stated, "Through the Cathedral, the idiom of our day can give voice to faith that is timeless." Photos, videos, and theological writings about the cathedral may be found at http://www.ctlcathedral.org/learn/learn.shtml.

110 The Cathedral of Our Lady of the Angels was dedicated on September 2, 2002, and was begun and completed during the episcopate of Cardinal Roger Mahony. A comprehensive website presents all of the artworks in the cathedral at http://www.olacathedral.org.

111 Suger, *Abbot Suger on the Abbey Church of St.-Denis*, 47–49.

112 "Often churches look on their sacred rituals and artifacts as different from art per se. The 'drama' of the liturgy and the 'art' of the icon, for instance, are not understood chiefly as aesthetic objects, let alone as products of artistic genius." Brown, *Good Taste, Bad Taste and Christian Taste*, 4.

113 "Art and technique . . . prepare the way for action but do not necessarily implement it." Servais Pinckaers, *The Sources of Christian Ethics* (Washington, D.C.: Catholic University of America Press, 1995), 84.

Chapter 10

1 John Paul II, *Letter to Artists,* §2.
2 "Beloved, let us love one another, because love is from God; everyone who loves is born of God and knows God. Whoever does not love does not know God, for God is love" (1 John 4:7-8).
3 Roberto Goizueta stresses this work of retrieval as integral to the work of theology and sees it particularly present in the creative religious expressions of communities. "Latino/a popular Catholicism represents a ressourcement, a retrieval of the borderland Church and the religiosity that global Christianity itself represents." Roberto Goizueta, "Corpus Verum: Toward a Borderland Ecclesiology" in *The Journal of Hispanic/ Latino Theology* (2007). Online.
4 Cecilia González-Andrieu, "Mañana Is Too Late to Learn How to Love," in *The Sky Is Crying: Race, Class, and Natural Disaster,* ed. Cheryl A. Kirk-Duggan (Nashville: Abingdon Press, 2006), 17–18.
5 *La Réponse imprévue,* Musée Magritte, Musées Royaux des Beaux Arts de Belgique, Brussels. See Plate 17 in David Larkin, ed., *Magritte* (New York: Ballantine, 1972). The collection may be viewed through a virtual tour at http://www.musee-magritte-museum.be/Typo3/index.php?id=89&L=0.
6 The image is bordered by a thin line of text. The flow of the text depends on where one begins to read. I begin here from the uppermost left corner, but one can begin anywhere along the picture's border. "Illusion and deception. One door opens, another one closes before their eyes. In the silence of the night, 'mojaditos' crying as they cross the line. The 'coyote' is on the run. They don't understand why. Dream and reality is their wonderland in disguise. Someone's children, anonymous shadows to the rest of us. Thousands of unspoken and ignored inconveniences. One bleeding border, one more night." For Gomez' very complete catalog of images and videos, see http://www.sergiogomezonline.com.
7 Finaldi and Avery-Quash, *Image of Christ,* 32–35.
8 Finaldi and Avery-Quash, *Image of Christ,* 32.
9 I do not know the provenance of this saying, but I heard it invoked by Alex García-Rivera as he worked on interfaith aesthetics with Ron Nakasone.
10 "Love of God which does not issue in justice for others is a farce" (173). For an articulation of the issue of justice in a contemporary Christian

context, see Pedro Arrupe, "Men and Women for Others," in *Pedro Arrupe: Essential Writings*, ed. Kevin F. Burke, Modern Spiritual Masters Series (Maryknoll, N.Y.: Orbis Books, 2004), 171–87.

11 Robert M. Grant, *Irenaeus of Lyons* (London: Routledge, 1996), 153. This famous saying is from *Against Heresies*, book IV, chap. 20, ¶7.

12 Pope Pius XII, "Function of Art," §6.

13 García-Rivera, *Wounded Innocence*, 2–3.

14 We began with a small group of doctoral students at the Graduate Theological Union during courses with Alex García-Rivera and Doug Adams. Also involved in these courses were: art historian Jane Daggett Dillenberger, playwright Harry Cronin, dancer Carla De Sola, library director Bonnie Hardwick, dancers from the Omega Dance Company, and a host of other distinguished guests, including sculptor Stephen De Staebler, poet Tim Nuveem, and artist Mel Ahlborn. The original student group included Jenny Patten, Bobbi Dykema, David Friend, N. Frances Hioki, and John Handley. Presentations were: "A Dynamic Method in Religious and Theological Aesthetics," Rethinking the Field Consultation, American Academy of Religion Annual Meeting, San Diego, November 2007; "Andy Warhol's Sixty Last Suppers: An Art and Religion Colloquium," Dominican School of Philosophy and Theology, July 13, 2008; "Theological Aesthetics and the Art of John August Swanson," Loyola Marymount University, March 2009. We lost Adams to cancer in 2007 and García-Rivera three years later. See Cecilia González-Andrieu and Ana Maria Pineda, "Alejandro García-Rivera (1951–2010): *Un Recordatorio*," *Journal of the American Academy of Religion*, 79, no. 2 (2011): 280–86.

15 See Alex García-Rivera, "Aesthetics," in *Handbook of Latina/o Theologies*, ed. Edwin Aponte (Saint Louis: Chalice Press, 2009), 98–104.

Bibliography

Adams, Doug. "Changing Perceptions of Jesus' Parables through Art History: Polyvalency in Paint." In *Reluctant Partners: Art and Religion in Dialogue*, edited by Ena Giurescu Heller, 69–87. New York: The Gallery at the American Bible Society, 2004.

————. *National Debate: The Da Vinci Code*. Interview. Berkeley: Total Living Network, 2006.

Antonielli, Ariana. "William Butler Yeats's 'The Symbolic System' of William Blake." *Estudios Irlandeses* 3 (2008): 10–28.

Aquinas, Thomas. *Summa Theologiae 1a2ae, 49–54*. Vol. 22. Edited by Anthony Kenny. New York: Cambridge University Press, 2006.

Aragón, Cecilia J. "Niños Y El Teatro: Critical Perspective of Children in Mexican-American Theatre." *Youth Theatre Journal* 22, no. 1 (2008): 4–17.

Aristotle. *Aristotle's Poetics*. Edited and with an introductory essay by Francis Fergusson. Translated by S. H. Butcher. New York: Hill & Wang, 1961.

Arnason, H. Harvard, and Elizabeth Mansfield. *History of Modern Art: Painting, Sculpture, Architecture, Photography*. 6th ed. Upper Saddle River, N.J.: Pearson Prentice Hall, 2009.

Arrupe, Pedro. *Pedro Arrupe: Essential Writings*. Selected and with an introduction by Kevin F. Burke. Modern Spiritual Masters Series. Maryknoll, N.Y.: Orbis Books, 2004.

The Art Newspaper: World-Wide Exhibition Figures in 2000. Rome: Ministerio per i Beni e le Attivitá Culturali, 2000. Accessed February 1, 2011.

http://www.colosseumweb.org/docs/Visitatori%20mostre%20nel%20 mondo/visitatori_mostre_2000.pdf.

"Art: Removal at Assy." *Time.* April 23, 1951. Online archive.

"The Assy Church." *Life.* June 19, 1950.

Austin, Ron. *In a New Light: Spirituality and the Media Arts.* Grand Rapids: Eerdmans, 2007.

Baird, Forrest E., and Walter Arnold Kaufmann. *Philosophic Classics, Ancient Philosophy.* Vol. 1. Upper Saddle River, N.J.: Prentice Hall, 2003.

von Balthasar, Hans Urs. *The Glory of the Lord: A Theological Aesthetics.* Vol. 1, *Seeing the Form.* Translated by Erasmo Leiva-Merikakis. Edited by Joseph Fessio and John Riches. San Francisco: Ignatius Press, 1983.

———. *The Glory of the Lord: A Theological Aesthetics.* Vol. 2, *Studies in Theological Style: Clerical Styles.* Translated by Andrew Louth, Francis McDonagh, and Brian McNeil. San Francisco: Ignatius Press, 1984.

———. *Theo-Drama: Theological Dramatic Theory.* Vol 2, *Darmatis Personae: Man in God.* San Francisco: Ignatius Press, 1990.

Baudelaire, Charles. *The Painter of Modern Life, and Other Essays.* Translated and edited by Jonathan Mayne. London: Phaidon, 1964.

Baum, Gregory. *Faith and Doctrine: A Contemporary View.* The David S. Schaff Lectures. Paramus, N.J.: Newman Press, 1969.

BBC News. "Martyrs of the Modern Era." BBC News online edition, 1998.

———. "Religion, Not Sensation, Say Art Lovers." BBC News online edition, 2001.

Benedict XVI. "Deus Caritas Est (On Christian Love)." Encyclical Letter. Vatican City: Vatican, 2005.

Berger, John A. *The Franciscan Missions of California.* New York: G. P. Putnam's Sons, 1941.

Bom, Klas. "Directed by Desire: An Exploration Based on the Structures of the Desire for God." *Scottish Journal of Theology* 62, no. 2 (2009): 135–48.

Boodman, Sandra G. "For More Teenage Girls, Adult Plastic Surgery." *The Washington Post*, October 26, 2004.

Brown, Frank Burch. *Good Taste, Bad Taste, and Christian Taste: Aesthetics in Religious Life.* New York: Oxford University Press, 2000.

———. *Religious Aesthetics: A Theological Study of Making and Meaning.* Princeton: Princeton University Press, 1989.

Brueggemann, Walter. *The Prophetic Imagination.* Philadelphia: Fortress, 1978.

Buber, Martin. *I and Thou.* Translated by Walter Kaufman. New York: Touchstone, 1970.

Burns, Kevin. *Look, Up in the Sky! The Amazing Story of Superman.* 110 min. USA: Warner Brothers Pictures, 2006.

Bychkov, O. V., and James Fodor. *Theological Aesthetics After von Balthasar.* Ashgate Studies in Theology, Imagination and the Arts. Burlington, Vt.: Ashgate, 2008.

Calderhead, Christopher C. "Seeing Salvation: The Image of Christ." *Anglican Theological Review* 82, no. 4 (2000): 795–801.

Catechism of the Catholic Church. New York: Catholic Book Publishing, 1992.

Chagall, Marc. *My Life.* New York: Da Capo Press, 1994.

Cooke, Bernard. "The Sacraments as the Continuing Acts of Christ." In *Readings in Sacramental Theology.* Edited by C. Stephen Sullivan, 31–52. Englewood Cliffs, N.J.: Prentice Hall, 1964.

Cornford, F. M. "The Divided Line." Diagram in *The Republic of Plato.* New York: Oxford University Press, 1945.

Cosmetic and Reconstructive Plastic Surgery Trends. American Society of Plastic Surgeons, 2009.

The Council of Trent. London: Dolman, 1848.

Crow, Kelly. "Sotheby's Sells Giacometti for Record $104.3 Million." *Wall Street Journal,* February 3, 2010.

Cunningham, Cecilia Davis. "Craft: Making and Being." In *Art, Creativity, and the Sacred: An Anthology in Religion and Art,* edited by Diane Apostolos-Cappadona, 8–11. New York: Continuum, 1995.

Dalton, Frederick John. *The Moral Vision of César Chávez.* Maryknoll, N.Y.: Orbis Books, 2003.

De Staebler, Stephen, and Apostolos-Cappadona, Diane. "Reflections on Art and the Spirit: A Conversation." In *Art, Creativity, and the Sacred: An Anthology in Religion and Art,* edited by Diane Apostolos-Cappadona, 24–33. New York: Continuum, 1995.

Dewey, John. *Art as Experience.* New York: Perigee Books, 2005.

Dillenberger, Jane Daggett. *The Religious Art of Andy Warhol.* New York: Continuum, 1998.

Dillenberger, John. "Artists and Church Commissions: Rubin's *The Church at Assy* Revisited." In *Art, Creativity, and the Sacred: An Anthology in Religion and Art,* edited by Diane Apostolos-Cappadona, 193–204. New York: Continuum, 1995; repr. 2001.

Dixon, John W., Jr. "Art as the Making of the World: Outline of Method in the Criticism of Religion and Art." *Journal of the American Academy of Religion* 51, no. 1 (1983): 15–36.

Donner, Richard. *Superman.* 151 minutes (2000 restoration). USA: Warner Brothers Pictures, 1978.

Dostoyevsky, Fyodor. *The Idiot: A Novel in Four Parts.* Translated by Constance Garnett. New York: Macmillan, 1916.

Drury, John. *Painting the Word: Christian Pictures and Their Meanings.* New Haven: Yale University Press, 1999.

Dulles, Avery. *Models of Revelation*. Garden City, N.Y.: Doubleday, 1983.
————. "Revelation in Recent Catholic Theology." *Theology Today* 24, no. 3 (1967): 350–65.
Ebert, Roger. Review of *Inception*, *Chicago Sun Times*, July 14, 2010.
Eco, Umberto, ed. *History of Beauty*. New York: Rizzoli International, 2004.
Edwards, Jonathan. *A Jonathan Edwards Reader*. Edited by John Edwin Smith, Harry S. Stout, and Kenneth P. Minkema. New Haven: Yale University Press, 1995.
Elizondo, Virgilio P. *The Future Is Mestizo: Life Where Cultures Meet*. Oak Park, Ill.: Meyer-Stone Books, 1988.
Elizondo, Virgilio P., Allan Figueroa Deck, and Timothy M. Matovina. *The Treasure of Guadalupe*. Celebrating Faith. Lanham, Md.: Rowman & Littlefield, 2006.
Elizondo, Virgilio P., and Timothy M. Matovina. *San Fernando Cathedral: Soul of the City*. Maryknoll, N.Y.: Orbis Books, 1998.
Espín, Orlando. "The State of U.S. Latina/o Theology." In *Hispanic Christian Thought: At the Dawn of the 21st Century*, edited by Alvin Padilla, Roberto Goizueta and Eldín Villafañe, 98–116. Nashville: Abingdon, 2005.
Exit Through the Giftshop. Directed by Banksy. Produced by Paranoid Pictures, 2010.
Finaldi, Gabriele. "Seeing Salvation: The Image of Christ." *Reformed*, no. 3 (2000).
Finaldi, Gabriele, and Susanna Avery-Quash. *The Image of Christ: Catalogue of the Exhibition "Seeing Salvation."* New Haven: Yale University Press, 2000.
Fine, Hillel A. "The Tradition of a Patient Job." *The Society of Biblical Literature* 74, no. 1 (1955): 28–32.
Fiorenza, Francis Schüssler, and John P. Galvin. *Systematic Theology: Roman Catholic Perspectives*. 2 vols. Minneapolis: Fortress, 1991.
Floyd, Wayne Whitson. "The Search for an Ethical Sacrament: From Bonhoeffer to Critical Social Theology." *Modern Theology* 7, no. 2 (1991): 175–93.
Foray, Jean-Michael, and Jakov Burk. *Marc Chagall*. San Francisco: San Francisco Museum of Modern Art, 2003.
Ford, David. *The Modern Theologians: An Introduction to Christian Theology in the Twentieth Century*. 2nd ed. Cambridge, Mass.: Blackwell, 1997.
Francis, Mark R., and Arturo J. Perez-Rodriguez. *Primero Dios: Hispanic Liturgical Resources*. Chicago: Liturgy Training Publications, 1997.
Freeland, Cynthia A. *But Is It Art?: An Introduction to Art Theory*. Oxford: Oxford University Press, 2001.

Fuglie, Gordon. "Passion/Passover." In *Passion/Passover: Artists of Faith Interpret Their Holy Days*. Cathedral of Our Lady of the Angels, Los Angeles, California, 2005.

Galerie Hervé Odermatt. *Hommage à Germaine Richier (1902–1959)*. Paris: Galerie H. Odermatt–Ph Cazeau, 1992.

Gallagher, Daniel B. "The Analogy of Beauty and the Limits of Theological Aesthetics." *Theandros* 3, no. 3 (2006): online.

Gao, Xingjian. *Return to Painting*. Translated by Nadia Benabid. New York: Perennial, 2002.

García-Rivera, Alejandro. "Aesthetics" in *Handbook of Latina/o Theologies,* edited by Edwin Aponte, 98–104. Saint Louis: Chalice Press, 2009.

———. "The Color of Truth." *ARTS: The Journal of the Society for the Arts in Religious and Theological Studies* 21, no. 2 (2010): 17–21.

———. *The Community of the Beautiful: A Theological Aesthetics*. Collegeville, Minn.: Liturgical Press, 1999.

———. *The Garden of God: A Theological Cosmology*. Minneapolis: Fortress, 2009.

———. "Sacraments: Enter the World of God's Imagination." *U.S. Catholic* 59, no. 1 (1994): 6–12.

———. *A Wounded Innocence: Sketches for a Theology of Art*. Collegeville, Minn.: Liturgical Press, 2003.

García Lorca, Federico. *Obras Completas*. 13th ed. Madrid: Aguilar, S.A. de Ediciones, 1967.

Gardner, Howard. *Intelligence Reframed: Multiple Intelligences for the 21st Century*. New York: Basic Books, 1999.

Gelpi, Donald L. *Varieties of Transcendental Experience: A Study in Constructive Postmodernism*. Collegeville, Minn.: Liturgical Press, 2000.

Gibson, Ian. *Federico García Lorca: A Life*. New York: Pantheon Books, 1989.

Gibson, Michael. "Germaine Richier; an Original." *The New York Times*, May 4, 1996.

Glink, Ilyce. "The Most Expensive House in the World." *CBS Moneywatch*, 2010.

Goizueta, Roberto. *Caminemos con Jesús: Toward a Hispanic/Latino Theology of Accompaniment*. Maryknoll, N.Y.: Orbis Books, 1995.

———. "Corpus Verum: Toward a Borderland Ecclesiology." *The Journal of Hispanic/Latino Theology*, 2007. Online.

González-Andrieu, Cecilia. "Cathedral: An Awe-Filled Space That Reveals God's Glory." *The Tidings*, September 7, 2007.

———. "Ecce Homo." In *Encounters of Faith: Latin American Devotional Art*, edited by Alejandro García-Rivera and Mia Mochizuki, 144–48. Berkeley: Jesuit School of Theology, Santa Clara University, 2010.

————. "Mañana Is Too Late to Learn How to Love." In *The Sky Is Crying: Race, Class, and Natural Disaster,* edited by Cheryl A. Kirk-Duggan, 13–21. Nashville: Abingdon, 2006.

————. "Theological Aesthetics and the Recovery of Silenced Voices." *The Journal of Hispanic/Latino Theology* (Winter, 2008). New York: The Academy of Catholic Hispanic Theologians of the U.S.

————. "Till There Was You." In *The Treasure of Guadalupe,* edited by Virgilio P. Elizondo, Allan Figueroa Deck, and Timothy M. Matovina, 65–71. Lanham, Md.: Rowman & Littlefield, 2006.

González-Andrieu, Cecilia, and Jean-Paul Andrieu. "Ministerio Y Cultura." In *Camino a Emaús,* edited by Ada María Isasi-Díaz, Timothy M. Matovina, and Nina Torres-Vidal, 63–72. Minneapolis: Fortress, 2002.

González-Andrieu, Cecilia, and Ana Maria Pineda, "Alejandro García-Rivera (1951–2010): *Un Recordatorio.*" *Journal of the American Academy of Religion,* 79, no. 2 (2011): 280–86.

González-Andrieu, Cecilia, Alejandro García-Rivera, Jenny Patten, John Handley, and Frances Hioki. "The Art of John August Swanson: Symposium." *ARTS: The Journal of the Society for the Arts in Religious and Theological Studies* 21, no. 2 (2010): 14–32.

Grant, Robert M. *Irenaeus of Lyons.* New York: Routledge, 1996.

Greeley, Andrew. "The Apologetics of Beauty." Chicago, 2005. http://www.agreeley.com/articles/beauty.html. Accessed November 26, 2011.

————. "A Cloak of Many Colors: The End of Beige Catholicism." *Commonweal* 128 (November 9, 2001): 10–13.

————. *The Catholic Imagination.* Berkeley: University of California Press, 2000.

Greenblatt, Stephen. "Resonance and Wonder." *Bulletin of the American Academy of Arts and Sciences* 43, no. 4 (1990): 11–34.

Gutiérrez, Gustavo. *Gustavo Gutiérrez: Essential Writings.* Maryknoll, N.Y.: Orbis Books, 1996. Reprinted, 3rd printing, January 2002.

————. *On Job: God-Talk and the Suffering of the Innocent.* Maryknoll, N.Y.: Orbis Books, 1987.

Harries, Karsten. *The Meaning of Modern Art: A Philosophical Interpretation.* Northwestern University Studies in Phenomenology and Existential Philosophy. Evanston, Ill.: Northwestern University Press, 1968.

Hawthorn, Jeremy. *A Glossary of Contemporary Literary Theory.* 4th ed. London: Oxford University Press, 2000.

Heller, Ena Giurescu, ed. *Reluctant Partners: Art and Religion in Dialogue.* New York: Gallery at the American Bible Society, 2004.

Herrera-Sobek, María. "Luis Valdez's *La Pastorela*: 'The Shepherd's Play': Tradition, Hybridity, and Transformation." In *Mexican American*

Religions: Spirituality, Activism, and Culture, edited by Gastón Espinosa and Mario T. García, 325–37. Durham: Duke University Press, 2008.

Heschel, Abraham Joshua. *Man Is Not Alone: A Philosophy of Religion*. New York: The Noonday Press, 1993.

Hogan, Julie A. *Substance Abuse Prevention: The Intersection of Science and Practice*. Boston: Allyn & Bacon, 2003.

Hofstadter, Albert and Richard Kuhns. *Philosophies of Art and Beauty*. Chicago: University of Chicago Press, 1976.

hooks, bell. *Teaching to Transgress: Education as the Practice of Freedom*. New York: Routledge, 1994.

Horsburgh, Susan. "The Power and the Glory." *Time Europe,* March 20, 2000.

Horsley, Carter B. *Art/Auctions: Contemporary Art Evening Auction at Christie's,* May 17, 2001. New York: The City Review, 2001. http://www .thecityreview.com/s01ccon1.html. Accessed 2010.

Howes, Graham. *The Art of the Sacred: An Introduction to the Aesthetics of Art and Belief.* New York: I.B. Tauris, 2007.

Hyde, Lewis. *The Gift: Imagination and the Erotic Life of Property.* New York: Vintage Books, 1983.

"Images of Christ and a Stroll in Highgate Cemetary [*sic*]." In Radio National's *The Religion Report*, 30 min. Australia: Australian Broadcasting Corporation, 2000.

Inception, 2010. Written and directed by Christopher Nolan (British, b. 1970). Produced by Warner Bros. Pictures, Legendary Pictures, Syncopy.

Isasi-Díaz, Ada María. *En La Lucha/In the Struggle: A Hispanic Women's Liberation Theology.* Minneapolis: Fortress, 1993.

James, William. "Mysticism." In *Readings in the Philosophy of Religion: An Analytic Approach*, edited by Baruch A. Brody, 478–502. Englewood Cliffs, N.J.: Prentice-Hall, 1974.

———. *The Varieties of Religious Experience: A Study in Human Nature.* Seattle: Pacific Publishing Studio, 2010.

Jensen, Robin Margaret. *The Substance of Things Seen: Art, Faith, and the Christian Community.* The Calvin Institute of Christian Worship Liturgical Studies Series. Grand Rapids: Eerdmans, 2004.

John of Damascus, St. *On the Divine Images: Three Apologies against Those Who Attack the Divine Images.* Translated by David Anderson. Crestwood, N.Y.: St. Vladimir's Seminary Press, 2000.

John of the Cross, St. *John of the Cross: Selected Writings.* The Classics of Western Spirituality, edited by Kieran Kavanaugh. New York: Paulist Press, 1987.

John Paul II. "Fides Et Ratio." Encyclical letter. Vatican City: Vatican, 1998.

———. *Letter to Artists.* Vatican City: Vatican, 1999.

Johnson, Elizabeth A. *Consider Jesus: Waves of Renewal in Christology*. New York: Crossroad, 1990.

———. *She Who Is: The Mystery of God in Feminist Theological Discourse*. 10th anniversary ed. New York: Crossroad, 2002.

Jones, Ronald. "Regarding Beauty." *Artforum International Magazine* 38, no. 5 (2000):109.

Kandinsky, Wassily. *Concerning the Spiritual in Art*. New York: Dover, 1977.

Kasl, Ronda, ed. *Sacred Spain: Art and Belief in the Spanish World*. New Haven: Yale University Press, 2009.

Kasper, Walter. *Jesus the Christ*. New York: Paulist Press, 1976.

Kiefer, Alex. "The Intentional Model of Interpretation." *The Journal of Aesthetics and Art Criticism* 63, no. 3 (2005): 271–81.

Larkin, David, ed. *Magritte*. New York: Ballantine, 1972.

Lonergan, Bernard J. F. *Method in Theology*. New York: Herder & Herder, 1972.

Longenbach, James. *The Resistance to Poetry*. Chicago: University of Chicago Press, 2004.

Lubich, Chiara. *The Cry: Jesus Crucified and Forsaken in the History of the Focolare Movement, From Its Birth in 1943, Until the Dawn of the Third Millennium*. Hyde Park, N.Y.: New City Press, 2001.

MacGregor, Neil. *Seeing Salvation: Images of Christ in Art*. New Haven: Yale University Press, 2000.

MacGregor, Neil and Erika Langmuir. *Seeing Salvation, The Video Series*. London: BBC, 2000.

Magee, Bryan. *The Story of Philosophy*. New York: DK Publishing, 1998.

Marchessault, Janine. *Marshall McLuhan: Cosmic Media*. London: Sage Publications, 2005.

Maritain, Jacques. *Creative Intuition in Art and Poetry*. New York: Meridian Books, 1961.

Martin, Steve. *An Object of Beauty: A Novel*. New York: Grand Central Publishing, 2010.

Matovina, Timothy M., and Gerald Eugene Poyo. *Presente!: U.S. Latino Catholics from Colonial Origins to the Present American Catholic Identities*. Maryknoll, N.Y.: Orbis Books, 2000.

"Maurizio Cattelan." In *On The River*. Grand Rapids: Civicstudio.org, 2009.

McBrien, Richard P. *Catholicism*. San Francisco: HarperSanFrancisco, 1994.

McLean, Jim. *Seeing Salvation in the National Gallery* [online magazine]. Nottingham: St. Peter's Church, June 4, 2000. http://www.stpeters nottingham.org/misc/salvation.html. Accessed April 28, 2006.

McLean, Kathleen, ed. *Minneapolis Institute of Arts' Handbook to the Collection*. Minneapolis: Minneapolis Institute of Arts, 2007.

McLuhan, Marshall. *The Gutenberg Galaxy: The Making of Typographic Man.* Toronto: University of Toronto Press, 1962.

Morgan, David. "Toward a Modern Historiography of Art and Religion." In *Reluctant Partners: Art and Religion in Dialogue*, edited by Ena Giurescu Heller, 16–47. New York: Gallery at the American Bible Society, 2004.

Morgan, David, and Sally M. Promey. *The Visual Culture of American Religions.* Berkeley: University of California Press, 2001.

Munch Comini, Elda. "Mariana Pineda, nuevas claves interpretativas desde la teoría de género." http://www.andalucia.cc/viva/mujer/mariana.html.

Myers, Steven Lee. "Moscow Show Pits Art against Church and State." *The New York Times*, November 26, 2005.

Nanko-Fernandez, Carmen. *Theologizing En Espanglish.* Maryknoll, N.Y.: Orbis Books, 2010.

New American Bible. Washington, D.C.: United States Conference of Catholic Bishops, 2002.

Newman, John Henry. *An Essay in Aid of a Grammar of Assent.* New York: Oxford University Press, 1984.

Nichols, Aidan. *No Bloodless Myth: A Guide through Balthasar's Dramatics.* Edinburgh: T&T Clark, 2000.

Nicolás, Adolfo. "Depth, Universality, and Learned Ministry: Challenges to Higher Education Today." Speech delivered in Mexico City, 2010. La Asociación de Universidades Confiadas a la Compañía de Jesús en América Latina. http://www.ausjal.org/files/Nicolas-2010.pdf.

O'Meara, Thomas F. "Modern Art and the Sacred: The Prophetic Ministry of Alain Couturier, O.P." *Spirituality Today* 38, no. 1 (1986): 31–40.

Ortega y Gasset, José. *La deshumanización del arte y otros ensayos de estética.* 14th ed. Madrid: Revista de Occidente en Alianza Editorial, 2002.

Otto, Rudolf. "The Fascinating and Awesome Mystery." In *Foundations of Theological Study: A Sourcebook*, edited by Richard Viladesau and Mark Stephen Massa, 29–39. New York: Paulist Press, 1991.

———. *The Idea of the Holy.* London: Oxford University Press, 1958.

Peirce, Charles S. *Collected Papers of Charles Sanders Peirce.* Cambridge, Mass.: Harvard University Press, 1931.

Pelikan, Jaroslav. *Jesus through the Centuries: His Place in the History of Culture.* New Haven: Yale University Press, 1985.

Pinckaers, Servais. *The Sources of Christian Ethics.* Washington, D.C.: Catholic University of America Press, 1995.

Plato. *The Republic of Plato.* Translated by Reginald E. Allen. New Haven: Yale University Press, 2006.

Poe, Harry Lee. *Christianity in the Academy: Teaching at the Intersection of Faith and Learning.* Grand Rapids: Baker Academic, 2004.

Pope Pius XII. "The Function of Art." Vatican City: Vatican, 1952.

Rahner, Karl. "Theology and the Arts." In *Theological Aesthetics: A Reader,* edited by Gesa Elsbeth Thiessen, 218–22. Grand Rapids: Eerdmans, 2005.

———. "Towards a Fundamental Theological Interpretation of Vatican II." In *Vatican II, the Unfinished Agenda: A Look to the Future,* edited by Lucien Richard et al., 9–21. New York: Paulist Press, 1987.

Ratzinger, Cardinal Joseph. "The Feeling of Things, the Contemplation of Beauty." In *The Essential Pope Benedict XVI: His Central Writings and Speeches,* edited by John F. Thorton and Susan B. Varenne, 47–52. San Francisco: HarperSanFrancisco, 2007.

Rausch, Thomas P. *Being Catholic in a Culture of Choice.* Collegeville, Minn.: Liturgical Press, 2006.

———. *Who Is Jesus?* Collegeville, Minn.: Liturgical Press, 2003.

"Religion: Art for God's Sake." *Time,* June 20, 1949. Online archive.

Rodriguez G. de Ceballos, Alfonso. "Image and Counter-reformation in Spain and Spanish America." In *Sacred Spain: Art and Belief in the Spanish World,* edited by Ronda Kasl, 15–35. New Haven: Yale University Press/Indianapolis Museum of Art, 2009.

Royce, Josiah. *The Philosophy of Loyalty.* The Vanderbilt Library of American Philosophy. Nashville: Vanderbilt University Press, 1995.

———. *The Sources of Religious Insight.* New York: Scribner, 1963.

Rubin, William Stanley. *Modern Sacred Art and the Church of Assy.* New York: Columbia University Press, 1961.

Ruether, Rosemary Radford. *Sexism and God-Talk: Toward a Feminist Theology.* Boston: Beacon Press, 1993.

Sartre, Jean-Paul. *No Exit, and Three Other Plays.* New York: Vintage Books, 1956.

Scorcese, Martin. *The Last Temptation of Christ.* 164 minutes. USA: Universal Pictures, 1988.

Scott, A. O. "Inception: This Time the Dream's on Me." *The New York Times,* July 16, 2010.

Searle, Adrian. "The Day I Met the Son of God." *The Guardian Unlimited,* July 22, 1999.

Segovia, Fernando. "Two Places and No Place on Which to Stand: Mixture and Otherness in Hispanic American Theology." In *Mestizo Christianity: Theology from the Latino Perspective,* edited by Arturo J. Bañuelas, 28–43. Maryknoll, N.Y.: Orbis Books, 1995.

Shklovsky, Viktor, and Benjamin Sher. *Theory of Prose.* Elmwood Park, Ill.: Dalkey Archive Press, 1990.

Sobrino, Jon. *Jesus the Liberator: A Historical-Theological Reading of Jesus of Nazareth.* Maryknoll, N.Y.: Orbis Books, 1993.

Sparks, Richard. "Feast of Corpus Christi in Berkeley, 2006." Homily, Berkeley, Calif.

Stainton, Leslie. *Lorca: A Dream of Life*. New York: Farrar, Straus & Giroux, 1999.

Steinberg, Leo. "The Seven Functions of the Hands of Christ: Aspects of Leonardo's Last Supper." In *Art, Creativity, and the Sacred: An Anthology of Art and Religion*, edited by Diane Apostolos-Cappadona, 37–63. New York: Continuum, 2001.

Suger, Abbot. *Abbot Suger on the Abbey Church of St.-Denis and Its Art Treasures*. 2nd ed. Edited, translated, and annotated by Erwin Panofsky and Gerda Panofsky-Soergel. Princeton: Princeton University Press, 1979.

Thiessen, Gesa Elsbeth. *Theological Aesthetics: A Reader*. Grand Rapids: Eerdmans, 2005.

Thompson, Derek. "The Art of Bubbles: How Sotheby's Predicts the World Economy." *The Atlantic Monthly*, (April 5, 2011). http://www.theatlantic.com/business/archive/2011/04/the-art-of-bubbles-how-sothebys-predicts-the-world-economy/236852/. Accessed November 26, 2011.

Tillich, Paul. "Art and Ultimate Reality." In *Theological Aesthetics: A Reader*, edited by Gesa Elsbeth Thiessen, 209–17. Grand Rapids: Eerdmans, 2005.

———. *The Courage to Be*. 2nd ed. Yale Nota Bene. New Haven: Yale University Press, 2000.

Tracy, David. *The Analogical Imagination: Christian Theology and the Culture of Pluralism*. New York: Crossroad, 1981.

———. *Plurality and Ambiguity: Hermeneutics, Religion, Hope*. Chicago: University of Chicago Press, 1994.

U.K. Census 2001. U.K. Office for National Statistics, 2002.

Valdéz, Luis. *Mummified Deer and Other Plays*. Houston, Tex.: Arte Público Press, 2005.

"The *Via Pulchritudinis*: Privileged Pathway for Evangelisation and Dialogue." Vatican City: The Vatican, 2006.

Vogt, Von Ogden. *Art and Religion*. Boston: Beacon Press, 1948.

White, Curtis. *The Middle Mind: Why Americans Don't Think for Themselves*. New York: HarperSanFrancisco, 2003.

Wilder, Thornton. *Our Town: A Play in Three Acts*. New York: Perennial Classics, 2003.

Wilson, Sarah. "Germaine Richier." In *Grove Art Online*. Oxford Art Online. www.oxfordartonline.com.

———. "Germaine Richier: Tradition and Transition, Sacred and Profane." *Sculpture Journal* (2006). http://www.courtauld.ac.uk/people/wilson-sarah/RICHIER.pdf. Accessed November 26, 2011.

Wuthnow, Robert. *All in Sync: How Music and Art Are Revitalizing American Religion.* Berkeley: University of California Press, 2003.

Yeats, W. B. *Collected Works.* Stratford-on-Avon: Shakespeare Head Press, 1908.

Zelensky, Elizabeth, and Lela Gilbert. *Windows to Heaven: Introducing Icons to Protestants and Catholics.* Grand Rapids: Brazos Press, 2005.

Index

Index

Index